In this collection of essays on aspects of the arts in Stuart England, fourteen distinguished scholars pay tribute to Sir Oliver Millar, whose pre-eminence as an authority on the visual arts in seventeenth-century England is well known. The essays concern themselves primarily with aspects of portraiture from Van Dyck to Sir Godfrey Kneller, a genre in which Millar's discoveries have been invaluable, but they also embrace a wide range of subjects which are important to our understanding of the arts during the period: artistic techniques, church building, the masque, print making, town planning, tomb sculpture, prose portraiture, the patronage of writers, and the politics of the years of Personal Rule under Charles I. The essays provoke interesting comparisons with one another, and all reflect the recent trend of early modern studies in England in relating art history to the wider concerns of Stuart culture.

Art and patronage in the
Caroline courts

ART AND PATRONAGE

— IN THE —

CAROLINE COURTS

Essays in honour of

Sir Oliver Millar

Edited by

DAVID HOWARTH

CAMBRIDGE
UNIVERSITY PRESS

Published by the Press Syndicate of the University of Cambridge
The Pitt Building, Trumpington Street, Cambridge CB2 1RP
40 West 20th Street, New York, NY 10011–4211, USA
10 Stamford Road, Oakleigh, Melbourne 3166, Australia

First published 1993

Printed in Great Britain at the University Press, Cambridge

A catalogue record for this book is available from the British Library

Library of Congress cataloguing in publication data

Art and patronage in the Caroline courts: essays in honour of
Sir Oliver Millar / edited by David Howarth.
p. cm.
ISBN 0 521 43185 9
1. Great Britain – Kings and rulers – Art patronage. 2. Arts,
British. 3. Arts and society – Great Britain – History – 17th century.
4. Arts and society – Great Britain – History – 18th century. 5. Great
Britain – History – Stuarts, 1603–1714. I. Millar, Oliver, Sir,
1923– . II. Howarth, David John, 1950– .
NX543.A78 1993
700'.941'09032 – dc20 92–576 CIP

ISBN 0 521 43185 9 hardback

CONTENTS

List of illustrations *page* ix

List of contributors xiii

Preface xv

Photographic acknowledgements xvii

1 · SUSAN BARNES
Van Dyck and George Gage 1

2 · CHRISTOPHER BROWN
Patrons and collectors of Dutch painting in Britain
during the reign of William and Mary 12

3 · SUSAN FOISTER
Foreigners at court: Holbein, Van Dyck and the
Painter-Stainers Company 32

4 · ANTONY GRIFFITHS
The etchings of John Evelyn 51

5 · DAVID HOWARTH
The politics of Inigo Jones 68

Contents

6 · MICHAEL JAFFÉ

The Standard Bearer: Van Dyck's portrayal of
Sir Edmund Verney 90

7 · ALASTAIR LAING

Sir Peter Lely and Sir Ralph Bankes 107

8 · RONALD LIGHTBOWN

Isaac Besnier, sculptor to Charles I and his work
for court patrons, *c.* 1624–1634 132

9 · JOHN NEWMAN

Laudian literature and the interpretation of Caroline
churches in London 168

10 · RICHARD OLLARD

Clarendon and the art of prose portraiture in the
age of Charles II 189

11 · GRAHAM PARRY

The Great Picture of Lady Anne Clifford 202

12 · MALCOLM ROGERS

'Golden Houses for Shadows': some portraits of
Thomas Killigrew and his family 220

13 · J. DOUGLAS STEWART

Sir Godfrey Kneller as painter of histories and
portraits historiés 243

14 · HUGH TREVOR-ROPER

Mayerne and his manuscript 264

Index 294

ILLUSTRATIONS

1 Sir Anthony Van Dyck, *George Gage*. The National Gallery, London *page* 2

2 Gerrit Dou, *The young mother*. The Hague, Mauritshuis. Signed and dated 1658 14

3 Jan Baptist Monnoyer, Charles Lafosse, Jaques Parmentier and Jacques Rousseau (after a design by Daniel Marot), Painted panel for the decoration of a cabinet, *c.* 1690. His Grace the Duke of Buccleuch, Boughton House 18

4 Hendrick Terbrugghen, *The concert*. The National Gallery, London 24

5 Samuel van Hoogstraten, *A view down a corridor*. The National Trust, Dyrham Park. Signed and dated 1662 25

6 John Evelyn, Titleplate, *Landscape with Roman ruins* (etching). British Museum 52

7 John Evelyn, *Landscape with Tobias and the angel* (etching). British Museum 52

8 John Evelyn, *Landscape with peasant and donkey* (etching). British Museum 53

9 John Evelyn, Titleplate, *Putto with tablet before view in Roman forum, with arch of Septimius Severus* (etching). British Museum 54

10 John Evelyn, *The three taverns or the Appian forum* (etching). British Museum 54

11 John Evelyn, *View of Naples from Vesuvius* (etching). British Museum 55

12 John Evelyn, Preparatory drawing for the etching *View of Naples from Vesuvius*. British Museum 55

13 John Evelyn, *Crater of Mount Vesuvius* (etching). British Museum 56

14 Inigo Jones, *'London farr off'*, design for Scene I, *Britannia Triumphans*. The Chatsworth Settlement 71

15 Sebastiano Serlio, *The tragic scene*. Edinburgh University Library 72

16 Wenceslaus Hollar, Frontispiece to James Howell's *Londinopolis* (1657). Edinburgh University Library 81

17 Inigo Jones, *A haven with a citadel*, design for Scene VI, *Britannia Triumphans*. The Chatsworth Settlement 82

18 Anon., *View of Sallee* (1670). Edinburgh University Library 85

19 Sir Anthony Van Dyck, *Sir Edmund Verney*. Sir Ralph Verney Bart., Claydon House, Buckinghamshire 91

20 Sir Anthony Van Dyck, *Sir Kenelm Digby 'armato'*. National Portrait Gallery, London 93

21 *Alvaro de Bazan, marqués de Santa Cruz*, engraving by Paul Pontius for Van Dyck's *Iconography*. 95

22 Sir Anthony Van Dyck, *Sir Edmund Verney: The Standard Bearer*. Private Collection, on loan to the Fitzwilliam Museum, Cambridge 97

23 Detail of fig. 22 100

24 Detail of fig. 19 100

25 Detail of fig. 19 101

26 Detail of fig. 22 101

27 Sir Peter Lely, *The penitent Magdalen*. The National Trust, Kingston Lacey 110

28 Sir Peter Lely, *N. Wray*. The National Trust, Kingston Lacey 110

29 Nicholas Wray, after Sir Peter Lely, *'Lady Newport'*. The National Trust, Kingston Lacey 111

30 Sir Peter Lely, *Sir Ralph Bankes*. The National Trust, Kingston Lacey 111

31 Sir Peter Lely, *Mary Bankes, Lady Jenkinson* (c. 1660–5). The National Trust, Kingston Lacey 114

32 Studio of Sir Peter Lely, *Arabella Bankes, Mrs Gilly*. The National Trust, Kingston Lacey 114

33 Sir Peter Lely, *Charles Brune*. The National Trust, Kingston Lacey 116

34 Sir Peter Lely, *Elizabeth Trentham, Viscountess Cullen*. The National Trust, Kingston Lacey 116

35 Sir Peter Lely, *'Mr Stafford'*. The National Trust, Kingston Lacey 118

36 Isaac Besnier, Design for tomb of Richard Weston, 1st Earl of Portland. The Public Record Office — 139

37 Isaac Besnier, Tomb of Richard Weston, 1st Earl of Portland. Winchester Cathedral — 140

38 Detail of fig. 37 — 143

39 Isaac Besnier, Tomb of George Villiers, 1st Duke of Buckingham. Henry VII Chapel, Westminster Abbey — 146

40 Detail of fig. 39 — 150

41 Detail of fig. 39 — 155

42 Isaac Besnier, Tomb of Ludovick Stuart, 1st Duke of Richmond and Lennox. Henry VII Chapel, Westminster Abbey — 157

43 'Vigilance'. Caryatid from the Lennox tomb — 160

44 Anon., *St Giles-in-the-Fields*, pen and watercolour drawing. Camden Borough Library — 176

45 R. West, *St Katherine Cree* (rebuilt 1628–31). Engraving, 1736. Guildhall Library, Corporation of London — 178

46 St Katherine Cree, interior looking east — 179

47 Nicholas Stone (attributed), St John the Evangelist, from the south-east. Great Stanmore, Middlesex — 180

48 Inigo Jones, *St Paul Covent Garden*, from the east. City of Westminster Victoria Library — 182

49 Anon., *Broadway Chapel*, from the south-west. Eighteenth-century watercolour. City of Westminster Victoria Library — 184

50 Plan of Broadway Chapel, Westminster — 184

51 Thomas Simon, *Edward Hyde, 1st Earl of Clarendon* (medal). National Portrait Gallery, London — 192

52 Canon Jackson, *John Aubrey*, nineteenth-century watercolour after painting by Sir Peter Lely. John Rylands Library, Manchester — 192

53 James Riley (after), *Bishop Gilbert Burnet*. National Portrait Gallery, Edinburgh — 193

54 Anon., *Sir Philip Warwick* (frontispiece to his *Memoires*, 1701). Edinburgh University Library — 193

55 Jan van Belcamp, *The Great Picture of Lady Anne Clifford*, 1646. Abbot Hall Art Gallery, Kendal — 203

56 Nicholas Hilliard, *George Clifford, 3rd Earl of Cumberland*. National Maritime Museum, Greenwich — 207

57 Sir Anthony Van Dyck, *Cecilia Crofts, Mrs Thomas Killigrew*. The Weston Park Foundation — 223

58 Sir Anthony Van Dyck, *Thomas Killigrew and (?) William, Lord Crofts*. Her Majesty The Queen, Windsor Castle — 224

59 Sir Anthony Van Dyck, *Thomas Killigrew*. The Weston Park Foundation — 227

60 Sir Anthony Van Dyck, *Cecilia Crofts, Mrs Thomas Killigrew*. Private Collection, London — 229

61 Sir Anthony Van Dyck, *Sir William Killigrew*. Private Collection — 232

62 Sir Anthony Van Dyck. *Mary Hill, Lady Killigrew*. Private Collection — 232

63 William Sheppard, *Thomas Killigrew*. National Portrait Gallery, London — 235

64 Anon., *Thomas Killigrew*. British Museum — 237

65 Jan van der Vaart, after Willem Wissing, *Thomas Killigrew*. The National Portrait Gallery, London — 239

66 Sir Godfrey Kneller, *Dismissal of Hagar*, c. 1670. Alte Pinakothek, Munich — 246

67 Sir Godfrey Kneller, *Elijah and the angel*, 1672. Tate Gallery, London — 246

68 Sir Godfrey Kneller, *The De Vere sisters* (detail of fountain), c. 1682–3. Private Collection — 249

69 Gian Lorenzo Bernini, *Triton Fountain*, c. 1642–3, Piazza Barberini, Rome. Engraving. National Library of Scotland — 249

70 Sir Godfrey Kneller, *Abraham Simon as a Pilgrim*, c. 1686–90. Private Collection — 252

71 Mezzotint by A. Blootelling, after Sir Peter Lely, *Abraham Simon*. British Museum — 253

72 Geoffrey Whitney, 'Deceit', from *A Choice of Emblemes*, 1586. Edinburgh University Library — 255

73 Francis Quarles, *Emblemes*, Book v, Emblem ix, 1635. Bodleian Library, Oxford — 256

74 Sir Godfrey Kneller, *Grinling Gibbons*, c. 1690. The Hermitage, St Petersburg — 257

75 Gian Lorenzo Bernini, *Head of Proserpina* (detail from *Pluto and Proserpina*) c. 1620–2. Villa Borghese, Rome — 258

76 Sir Peter Paul Rubens, *Sir Theodore de Mayerne*. The North Carolina Museum of Art, Raleigh — 273

77 Jean Petitot (attributed), *Sir Theodore de Mayerne*. National Portrait Gallery, London — 276

CONTRIBUTORS

SUSAN BARNES
Deputy Director and Chief Curator, Dallas Museum of Art

CHRISTOPHER BROWN
Chief Curator, National Gallery, London

SUSAN FOISTER
Curator, Early Netherlandish, German and British Art, National Gallery,
London

ANTONY GRIFFITHS
Keeper, Department of Prints and Drawings, The British Museum

DAVID HOWARTH
Senior Lecturer in the History of Art, University of Edinburgh

MICHAEL JAFFÉ
Formerly Director of the Fitzwilliam Museum, Cambridge, 1973–90, and
Professor of the History of Western Art, Cambridge University, 1973–90

ALASTAIR LAING
Adviser on Painting and Sculpture, The National Trust

RONALD LIGHTBOWN
Librarian, Victoria and Albert Museum, 1976–85, and Keeper of the Department
of Metalwork, Victoria and Albert Museum, 1985–9

List of contributors

JOHN NEWMAN
Reader, The Courtauld Institute of Art, University of London

RICHARD OLLARD
Historian. Formerly Senior Editor, Collins Publishers, 1960–83

GRAHAM PARRY
Reader, Department of English and Related Literature, University of York

MALCOLM ROGERS
Deputy Director, National Portrait Gallery, London

J. DOUGLAS STEWART
Professor of Art History, Queen's University, Kingston, Ontario

HUGH TREVOR-ROPER
Formerly Master of Peterhouse, Cambridge University, 1980–7, and Regius
Professor of Modern History, Oxford University, 1957–80

PREFACE

Art and patronage in the Caroline courts marks the occasion of the seventieth birthday of Sir Oliver Millar, Surveyor Emeritus of the Queen's Pictures. Sir Oliver's connection with the Royal Collection spans forty years: first as Deputy Surveyor, 1949–72; then as Surveyor, 1972–88; and finally as Director of the Royal Collections, 1987–88. Thus until recently Sir Oliver has been responsible for one of the greatest of all private collections of paintings, and he has made himself an expert in many fields, of which the recent publication of his catalogue of Victorian pictures in the Collection of Her Majesty The Queen is eloquent testament. However, it is perhaps with seventeenth-century English art that his fullest contribution has been made: in his editions of the inventory and of the sales of the collection of Charles I, published by *The Walpole Society* in 1960 and 1972; in books, exhibitions, lectures, articles and connoisseurship.

Oliver Millar made his first contribution to the study of Stuart culture with an exhibition on the Civil War artist William Dobson at the Tate Gallery in 1951. He then published *English Art, 1625–1714* (Clarendon Press, 1957), written jointly with the late Margaret Whinney. There the authors set out to provide a synoptic account, not only of painting and architecture, but of sculpture, the decorative arts and, not least, patronage. Patronage and portraiture are aspects of English seventeenth-century history which Oliver Millar has made peculiarly his own, and the fullest expression of this interest remains his two-volume *Tudor, Stuart and Early Georgian Pictures in the Collection of Her Majesty The Queen* (Phaidon, 1963). Accordingly, in *Art and patronage in the Caroline courts*, the main emphasis is on portraiture, with contributions on Belcamp, Van Dyck, Lely, Kneller, and prose portraiture. These essays owe much to the stimulus provided not only by Sir Oliver's writings, but also by his exhibitions at The Queen's

Gallery, established during the time he worked with the Royal Collections, and to exhibitions which he either organised, or acted as an adviser to: *The Age of Charles I* (Tate Gallery, 1972), *Sir Peter Lely* (National Portrait Gallery, London, 1978), *Van Dyck in England* (National Portrait Gallery, London, 1982) and *Anthony Van Dyck* (National Gallery of Art, Washington, DC, 1990).

The Stuarts were pre-eminent as patrons of the visual arts, and there are three essays which consider aspects of the patronage of the royal family: a study of the fortunes of the Painter-Stainers Company, a consideration of Inigo Jones's contribution to a royal masque, and the collecting of Dutch pictures in the reigns of William and Mary. Charles I was devoted to the Anglican settlement and an essay on church furnishing in the Laudian era touches upon something which was close to the king's heart. The essay in this volume devoted to the great Buckingham and Lennox tombs in Westminster Abbey amplifies what was discovered at the time of *The Age of Charles I*, an exhibition which was particularly illuminating for the emphasis it placed on sculpture. The seventeenth century, that unsurpassed period for painting in England, was richly endowed with writers on art. It is therefore appropriate to have separate essays about two of them who never met but who nonetheless shared a fascination for the techniques of the visual arts: Sir Theodore de Mayerne and John Evelyn.

I gratefully acknowledge advice, encouragement and help during the preparation of this book from Dr John Adamson; Sir Geoffrey de Bellaigue; Lowell Libson; Christopher Lloyd; James Miller; James Noble; Sir John Plumb; The Hon. James Stourton; my editor at Cambridge University Press, Rose Shawe-Taylor; my copyeditor, Chris Lyall Grant; and John Trevitt, formerly also of Cambridge University Press.

I would like to thank the following for valuable financial help in the production of the book: The Marc Fitch Fund, John Morton Morris, The Moray Fund, the University of Edinburgh, Sotheby's and Alex Wengraf Ltd.

DAVID HOWARTH
The University of Edinburgh

PHOTOGRAPHIC ACKNOWLEDGEMENTS

1, 4, by courtesy of the Trustees of The National Gallery, London; 2, Photograph C. Mauritshuis, The Hague; 5, 28–33, The Photographic Survey, taken on behalf of the National Trust; 34, 35, The Hamilton Kerr Institute, taken on behalf of the National Trust; 6–13, 64, 71, reproduced by permission of the Trustees of the British Museum; 14, 17, The Devonshire Collection, Chatsworth. Reproduced by permission of the Chatsworth Settlement Trustees; 15, 16, 18, 52, 72, Edinburgh University Library; 19, Sir Ralph Verney Bart; 20, 51, 63, 65, 77, by courtesy of the National Portrait Gallery, London; 23–6, The Hamilton Kerr Institute, Cambridge University; 37, 38, the Dean and Chapter, Winchester Cathedral, John Crook; 39–43, 47–8, The Courtauld Institute; 44, Camden Borough Library; 45, Guildhall Library, Corporation of London; 46, A. F. Kersting; 49, 50, City of Westminster Victoria Library; 53, in the collection of the National Trust for Scotland, Crathes Castle; 54, reproduced by courtesy of the Director and University Librarian, the John Rylands University Library of Manchester; 55, reproduced by kind permission of Abbot Hall Art Gallery, Kendal, Cumbria; 56, The National Maritime Museum, Greenwich; 57, 59, The Weston Park Foundation; 58, by gracious permission of Her Majesty The Queen (copyright reserved); 66, Bayerische Staatsgemaldesammlungen, Munich; 67, Tate Gallery, London; 69, National Library, Scotland; 70, A & C Cooper; 73, by permission of the Curators of the Bodleian Library, Oxford; 74, The Hermitage, St Petersburg; 75, Phaidon Press Ltd, London; 76, North Carolina Museum of Art, Raleigh. Purchased with funds from the State of North Carolina.

I

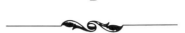

VAN DYCK AND GEORGE GAGE

Susan Barnes

Over twenty years ago Sir Oliver Millar made one of many key contributions to Van Dyck studies. In a characteristic feat of deduction, combining a profound knowledge of British heraldry and genealogy with a sure grasp of the creative spirit of the artist, he recognised that Van Dyck had included elements from the Gage family arms and crest in the conversation piece in the National Gallery (fig. 1).[1] The ram's head, the saltire, and the sun in splendour are prominently placed there, yet 'hidden' as the relief decoration of a piece of stone on which the sitter rests his elbow. Oliver Millar's suggestion that the dashing gentleman could be recognised as George Gage (1582?–1638), art agent, connoisseur, and a frequent visitor to Rubens's studio in 1616–17, resolved that issue once and for all.

With Gage's well-documented presence in Antwerp and England overlapping Van Dyck's in 1620–1, and the stylistic links between the portrait and other pictures of that period, there was ample reason to postulate, as Oliver Millar did, that Van Dyck had painted Gage in one of those two places. Since then a consensus has emerged, in which he shares, that Van Dyck did the portrait slightly later, in 1622 or 1623, and in Italy, almost certainly in Rome.[2] Although the simultaneous appearance of Gage and Van Dyck in these three disparate places in as many years may be of no particular moment, the coincidence suggests that we take a fresh look at Gage's activities in Italy and at the possible ties between the two men during the early years of the painter's burgeoning international career.

Documents, letters, and surviving works of art tell us a good deal about Van Dyck's short first visit to England. We know that he came to London by mid-October 1620 and remained until 28 February 1621.[3] We know that he painted for the Earl of Arundel and probably for the Marquis of

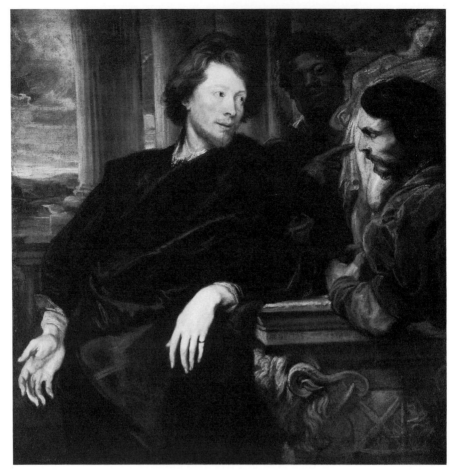

1 Sir Anthony Van Dyck, *George Gage*

Buckingham, and that he received a stipend of £100 from James I.[4] Among the questions asked but still unanswered are: what work if any he did to earn that royal stipend? One question that has not really been raised is: who first recommended Van Dyck to the king and his court?

A document published recently by David Howarth suggests that Buckingham's brother, Lord Purbeck, may actually have invited Van Dyck to England.[5] It is nevertheless apparent that James I was involved in the arrangements at the outset. Tobie Matthew's famous postscript from Antwerp in a letter of 25 November 1620 to Sir Dudley Carleton in The Hague already mentions the king's promised annual pension to the painter.[6]

The tone and contents of the note suggest that Van Dyck is a current topic among them. Matthew assumes that Carleton will have heard the news of Van Dyck's move. He refers to him as Rubens's 'famous Allievo', and speculates on the high quality of work which the young man might produce in England for advantageous prices when compared with his master's. Clearly, by this date Van Dyck is known and respected in this group of English collectors. How and when did that come about?

The first surviving reference to Van Dyck in English court circles came only four months earlier. The well-known letter of 17 July, ascribed to Vercellini who visited Rubens's studio with Lady Arundel, was addressed from Antwerp to Arundel in England. It already shows a familiarity with Van Dyck's living and working arrangements and makes evident that his services are sought in England.[7] Howarth suggested that Purbeck, who met Lady Arundel at Spa a few days after this letter was sent, was inspired by her report to invite Van Dyck to visit on his return.[8] But Van Dyck's reputation preceded him. The ground had been prepared months before by someone in the know.

A longtime friend of Arundel, George Gage is the logical candidate. Early in 1620 he had revisited Antwerp to negotiate with Rubens on behalf of Carleton. By then, although he was barely twenty-one, Van Dyck was the undisputed leader among Rubens's disciples. His independent talent was known and would be acknowledged in the following month with his named participation in the March 1620 contract between Rubens and the Antwerp Jesuit Church. For Gage, who had closely followed developments in the Antwerp artistic scene for several years, this probably only confirmed something he had seen coming. He most likely had noticed this rising star some time before.

'George Gage . . . knew his way around the Antwerp studios.'[9] Although Tobie Matthew was in charge of Sir Dudley Carleton's purchase of paintings from Rubens in 1616–17, George Gage was the principal agent in the commission and negotiations. Making successive trips to Antwerp on Carleton's behalf, Gage was an active participant in the evolving deal, as Matthew's letters from Brussels to Carleton reveal. Along with his celebrated skills in bargaining, Gage brought to bear real convictions in connoisseurship. He recommended at the outset, for instance, that Carleton commission a smaller hunting picture from Rubens, whose execution Gage could oversee himself, rather than purchase a large one already completed.[10] He had similar strong opinions about works by the other artists in town, including Snyders, Brueghel, and Vrancx.[11] He had his eyes open for new talent.[12]

3

And, with a dealer's nose for an opportunity, he recognised that Rubens would be interested in the acquisition of Carleton's collection of antiquities, and launched those negotiations while completing the others. Gage wrote to Carleton directly in August 1617 when he was sending the pictures by Rubens, Snyders, Brueghel and Vrancx. He was proud of the quality of the pictures he had purchased, proud that they were 'the best bargaines that I could make'.[13]

We know from their testimony that Gage's bargaining skills were the envy of his colleagues. On one point of dispute John Wolley assured Carleton that Gage would handle Rubens '(over whome he hath more authority than any man I know) and he will deale with him in such manner that yor Lo: shall have satisfaction'.[14] In contrast, Tobie Matthew found Rubens an immovable object; on prices his 'demands ar like ye lawes of Medes and Persians wch may not be altered'.[15] Gage's gains in negotiation were won with intelligence, conviction, and personal charm. Gillow described him as 'of graceful person, good address, well skilled in music, painting, and architecture'.[16] Gage's charm and his mastery of Latin and modern Romance languages made him well suited to represent the interests of the English abroad.

Gage was in England during Van Dyck's brief sojourn. It is easy to imagine him taking the young painter in tow. That Gage was a Catholic could have given comfort to the devout Van Dyck, who may have felt somewhat adrift in Protestant England. They next met in Rome. Van Dyck arrived there in February 1622, a year after he had left England. Gage had been sent in May 1621 by James I on a special and particularly delicate diplomatic mission – namely, to advance the negotiations for papal dispensation covering the planned marriage of Charles Prince of Wales to the Infanta Maria of Spain. The king was impatient to see his only son married and with an heir to secure the throne. Working with Lord Digby, his ambassador in Spain, over a period of five years he had come to terms for securing the dispensation with Rome through Madrid, only to face the fierce opposition of his own subjects and Parliament.[17] Then the terms were reopened to question by the deaths of Philip III and of Pope Paul V. Although Philip IV consented to honour his father's agreement, the same could not be said of Gregory XV. James's dispatching of the Catholic Gage to represent him directly with the new pope was a bold tactic, opening a second front in the campaign.

Gage was an interesting, unexpected choice for the assignment. As the Venetian ambassador in England noted:

This mission is replete with irregularities. He simply bears the title of gentleman; and it is certainly remarkable that one who is avowedly a Catholic should be employed in public functions by the king's own choice. Possibly they hope in this way to qualify him for other negotiations, save expense by withholding the title of ambassador and keep the royal reputation safe in case the negotiations turn out badly.[18]

Although Gage's religion aroused suspicion in England, it had decided advantages in Rome. There he could be seen to represent the interests of English Catholics as well as the king's.[19] Gage had matured in England in the wake of the Gunpowder Plot of 1605. The repressions of Catholics during that era had taught him as a young man the discretion and even dissemblance that can serve a diplomat in need. Gage's relations with his sovereign remain something of a mystery. He had been friends with Arundel and known to Sir Dudley Carleton since at least 1613.[20] Although he had no other mission for the king before or afterward, his part in the Spanish marriage treaty suggests that he had the real trust of James at the time. Indeed, his lengthy audiences with the king and prince were noted with jealousy and concern.[21]

Gage's activities in Rome on behalf of the king aroused the suspicions not only of Protestants, but also of officials in the English Catholic church. This surprising fact is explained because they suspected him of sympathising with the Jesuits.[22] Gage's mission to Rome coincided with a critical phase in the English Catholic clergy's fifteen-year campaign to persuade the pope to create an episcopal see for their church. The Jesuits steadfastly opposed this, knowing that it would limit their own power over the English Church.[23] Although many presumed that Gage was working in favour of the Jesuits, alarming the king with reports of numerous bishops and clergy to be appointed in England by Rome, Tobie Matthew was the more likely culprit in this falsehood.[24]

The English clergy had sent John Bennet from London to appeal to Rome for the appointment of an English bishop. James I also asked that he speak to the pontiff in favour of the marriage treaty.[25] Beginning in February 1622 Bennet made the case for a bishop to delegates from the College of Cardinals. They agreed in principle by June 1622.[26] It remained for the pope to name a bishop, but Gregory's delay in doing so gave the Jesuits time to push their oppositional deceits through Matthew in England and through other sympathisers within the Vatican. The cause of the English clergy was joined by such important figures as Cardinal Bentivoglio, who as nuncio to Flanders from 1607 to 1615 had also helped them fight off Jesuit hegemony

at the College at Douai.[27] When the Jesuit deceptions unravelled and the truth became apparent to James and to Gregory, William Bishop was appointed superior of the English church in March 1623.[28] That fact, coupled with the measures of religious tolerance that James was putting into effect in England, can only have promoted the marriage dispensation.

Gage's first stay in Rome lasted until 25 July 1622, when he returned to London to present to James I the new pope's terms for granting the dispensation. Stylistic evidence suggests that Van Dyck's portrait of Gage dates from this year. His broad, free application of dragged paint looks back to the technique of *The Continence of Scipio* (Christ Church, Oxford), painted in England, as well as the portrait of *Isabella Brant* (Washington, DC, National Gallery of Art), made on the eve of Van Dyck's departure for Italy. Formally the *Portrait of George Gage* also shares with these two paintings the use of architectural elements and of exterior vistas that introduce clear daylight.

Van Dyck depicted George Gage in the role of art agent that gave cover to his secret mission. His Gage is the very embodiment of grace and *savoir-faire*, as he looks over the sculpture being offered him by an intense and somewhat adversarial dealer. This picture is unusual in many respects, including the originality of its complex conversational conceit. Most remarkable is the penetrating image it presents, through Gage's deportment, of the personal character we recognise from Dodd's description. The ability to capture and convey personality through stance, gesture, and facial expression was Van Dyck's forte, of course, even at this relatively early time when the painter's ambitions sometimes outstripped his abilities. But in this painting, perhaps more than any other, he gives us the precise feeling of a person in a momentary, perfectly characteristic, activity. Clearly, so informed a likeness was shaped by Van Dyck's familiarity with his subject, whom he had observed in action over time. Indeed, Van Dyck was assisting Rubens all through 1616–17, the period of Gage's frequent visits to the studio. He probably saw Gage 'at work' often then, discussing the art scene, asking penetrating questions about studio participation in Rubens's pictures, and wrangling over prices. During that time Van Dyck must also have caught Gage's attention as a talent to be watched.

Because he was a connoisseur, Gage was the best kind of patron for Van Dyck's imaginative portrait. Gage would have appreciated the debt to Titian's triple portrait of *Paul III Farnese and his Cardinal Nephews* (Naples, Capodimonte), then still in Rome, that his own likeness incorporated.[29] The patron's consent, and even his encouragement, lies behind this exciting, unconventional image of a portrait sitter engaged informally in conversa-

tion. The portrait itself is solid evidence of contact between Gage and Van Dyck at this stage. The rest is speculation, but it may be that Gage introduced the young painter to his other English patron in Rome. Sir Robert and Lady Shirley arrived at the papal court on 22 July, just days before Gage departed, and it is likely that they knew one another. Shirley was a contemporary of Gage. Although he had left London for Persia in 1598, his life as a representative of the shah had kept him travelling back to England and to the courts of Europe since 1607. The Shirleys, who had come to pay respects to Gregory XV on behalf of the shah, stayed just over a month in Rome. In those weeks, Van Dyck painted their dazzling pendant portraits, today held at Petworth.[30] The Shirleys moved on to London in late August, and Van Dyck travelled to Venice the same month.

In Venice, Van Dyck renewed another English acquaintance.[31] Lady Arundel had been living there, while her sons attended university in Padua, for the two years that had elapsed since she visited Rubens's studio with Vercellini. Van Dyck, whose primary focus in Venice was the study of Titian and Veronese, seems not to have painted for Lady Arundel there. His two portraits of Lucas van Uffel, in Braunschweig and New York, are the only known paintings from that short stay. When Lady Arundel and her sons left Venice for Turin in early October 1622, Van Dyck might have accompanied them on a journey whose stops are thought to have included Mantua and Milan.[32] By the time Lady Arundel left Turin for Genoa in early March 1623, Van Dyck and George Gage were both back in Rome.[33]

While in London Gage had made great headway during three long audiences with the king and Prince Charles – the very sessions that raised such alarm among Gage's detractors.[34] The progress of the negotiations between London, Madrid, and Rome – which were enlivened and advanced by the surprise arrival on 17 March of Charles and Buckingham in Madrid – are not our subject, and are far too complex to summarise here.[35] Suffice it to say that Gage accomplished his mission. Having returned to Rome on 10 February, he obtained the dispensation, which arrived in Madrid on 4 May, and was back in London to celebrate the signing of the marriage contract at Whitehall on 20 July.[36] Even after his return to London, Gage continued through the fall of 1623 to work for a resolution of the terms for the marriage.[37] But the betrothal fell victim in the following months to the mutual antipathy of the betrothed, and to the political impasse between England and Spain over the restoration of the Palatinate to the Protestant Frederick, Charles's brother-in-law.

Van Dyck's own second Roman stay lasted about eight months in 1623.

Gage was there for much of the time. But while English patrons had dominated Van Dyck's first sojourn in Rome, now he was involved with a new set, from the inner circle of the papal milieu. We are uncertain how Van Dyck was introduced to Cardinal Guido Bentivoglio. Bentivoglio had many ties in Flanders from his eight-year residency as nuncio in Brussels, and a great interest in the country whose multi-volume history he would complete during his retirement. Bentivoglio's doors may have been opened to Van Dyck through his Flemish connections, or again through Gage. Gage knew Maffeo Barberini, who was involved in all manner of papal negotiations, including the dispensation.[38] Van Dyck's anonymous eighteenth-century biographer mentions that he did a portrait of Cardinal Barberini, but none has been identified.[39] Bentivoglio and his brother were among Barberini's closest advisers. According to Bellori, Van Dyck was retained at the court of the Bentivoglio, for whom he painted a lost *Crucifixion*, as well as the magnificent portrait of the cardinal, then, as now, in the Pitti Palace.[40] Although no more than a year separates it from the portraits of Gage and the Shirleys, *The Portrait of Cardinal Bentivoglio* already shows the deepening assimilation of Titian's legacy to portraiture and the smoother, more restrained brushwork that would characterise Van Dyck's painting thenceforth. Van Dyck's oil sketch for the large full-length lies beneath another portrait from this period, the half-length of a man in clerical garb in the Hermitage.[41] David Freedberg has recently recognised that this poignant portrait depicts Virginio Cesarini, who was an intimate of Bentivoglio's and, like him, a highly influential figure in the circle of Maffeo Barberini.[42]

A decade later Van Dyck was living in England. Gage had turned from diplomacy and art dealing to the unlikely sounding enterprise of the soap monopoly.[43] With Van Dyck at the centre of life at court, the two of them would have had little, if any, truck with daily affairs. Nor do sources attest their friendship during these years. Here, as in Italy, it is a work of art that speaks of their ties. In about 1635, Van Dyck dedicated an engraving of *The Lamentation* to Gage.[44] The print by Vorsterman reproduces one of the most heart-rending paintings of Van Dyck's English years, the canvas of 1634, now in Munich. This poignant image of the Virgin's grief is a fitting one for the Catholic painter to dedicate to the Catholic Gage. It may represent their on-going friendship. On the other hand, it may be special tribute to an old acquaintance, a man who could have had more than a passing role in helping launch the career of the young Van Dyck.

Notes

1 Oliver Millar, 'Notes on Three Pictures by Van Dyck', *Burlington Magazine*, 111 (1969), pp. 414–17.

2 For example: Christopher Brown, *Van Dyck*, London, 1982, p. 74; Susan J. Barnes, 'Van Dyck in Italy', Ph.D., 2 vols., Institute of Fine Arts, New York University, 1986, I, pp. 218–21; David Howarth, *Lord Arundel and His Circle*, New Haven and London, 1985, pp. 158–9, who suggests it was painted in Venice.

3 David Howarth, 'Van Dyck's Arrival in England', *Burlington Magazine*, 132 (1990), pp. 709–10; W.H. Carpenter, *Pictorial Notices Consisting of a Memoir of Sir Anthony Van Dyck*, London, 1844, p. 9.

4 He painted the portrait of Arundel now in the Getty Museum, Malibu, and also, I believe, *The Continence of Scipio* (Christ Church, Oxford) for Buckingham. John Harris argued that *The Continence* was painted for Buckingham in 'The Link between a Roman Second-Century Sculptor, Van Dyck, Inigo Jones and Queen Henrietta-Maria', *Burlington Magazine*, 115 (1973), pp. 526–30. By contrast, Howarth, *Arundel*, pp. 156–7, suggested it was commissioned by Arundel for Buckingham. I also think that Van Dyck painted for Buckingham the full-length double portrait, no. 17 in *Anthony Van Dyck*, Arthur K. Wheelock and Susan J. Barnes eds., National Gallery of Art, Washington, 1990, where it was exhibited as *Sir George Villiers and Lady Katherine Manners as Adonis and Venus*.

5 Howarth, 'Van Dyck's Arrival in England', p. 709.

6 *Correspondance de Rubens*, Max Rooses and C. Ruelens eds., 6 vols., Antwerp, 1887–1909, reprint edn, Soest-Holland, Davaco n.d., II, p. 262.

7 *Ibid.*, p. 250.

8 Howarth, 'Van Dyck's Arrival in England', p. 709.

9 Millar, 'Notes on Three Pictures', p. 414.

10 *Correspondance*, II, p. 93: 'Mr Gage will see that he shall perform it. He hath already seen so much of it as is done, and likes it exceedingly, and saith he had rather geve threescore pound for this, then fowerscore for the other. For besides that he assureth himself that this wilbe better finished. . .'

11 *Ibid.*, pp. 99, 104, 107.

12 *Ibid.*, pp. 104, 106: 'They have in Antwerp a yong man who hath lived long in Italy, who I think is the rarest man living in Lantscape', wrote Gage to Carleton on 14 March 1617. Rooses concluded that he was referring to Lucas van Uden.

13 *Ibid.*, pp. 116, 120.

14 *Ibid.*, p. 245.

15 *Ibid.*, p. 261.

16 Joseph Gillow, *A Literary and Biographical History or Bibliographical Dictionary*

of the English Catholics from the Breach with Rome, in 1534, to the Present Time, 5 vols., New York, n.d., II, p. 537.

17 *Dodd's Church History of England, from the Commencement of the Sixteenth Century to the Revolution in 1688*, M.A. Tierney ed., 5 vols., London, 1839–43, V, pp. 115–18.

18 Philippa Revill and F.W. Steer, 'George Gage I and George Gage II', *Bulletin of the Institute of Historical Research*, 31 (1958), p. 144.

19 F. Francisco de Jesus, 'Narrative of the Spanish Marriage Treaty', S.R. Gardiner trans., *The Camden Society*, 101 (1869), p. 164.

20 Mary Hervey, *The Life, Correspondence, and Collections of Thomas Howard, Earl of Arundel*, Cambridge, 1921, pp. 83–4.

21 When Gage returned to London in the midst of the negotiations in October 1622, W. Farrar wrote to John Bennet in Rome: 'Mr Gage and his employments are much talked of in England. They say the king and he spend whole hours, sometimes three or four, together, in private conference', Gillow, *Literary History*, II, p. xiv.

22 When Gage left Rome in July 1622, John Bennet wrote to William Bishop, 'He carrieth the conditions for the dispensation. He will endeavor to clear the Jesuits, I suppose, of the imputation of opposition to the match: but here that is so well known, that he shall wrong himself, if he go about it', Gillow, *Literary History*, II, p. xiv. The Venetian ambassador, Valaresso, also linked Gage with the Jesuits, Revill and Steer, 'George Gage', p. 145. Tobie Matthew's Jesuit sympathies were a matter of certainty. The Lord Keeper wrote to Buckingham: 'Tobie will prove but an apocryphal, and no canonical intelligencer; acquainting the state with this project, for the jesuits', rather than Jesus' sake', *Church History*, Tierney ed., V, p. 90, n. 3.

23 *Church History*, Tierney ed., V, pp. 10, 12, 49–52, 54.

24 *Ibid.*, p. 90, n. 2.

25 Gillow, *Literary History*, II, p. xiv. According to Francisco de Jesus, Bennet's passport was 'specialibus ex causis Majestatis suae negotia concernentibus', 'Narrative', p. 169.

26 *Church History*, Tierney ed., V, pp. 84–7.

27 *Ibid.*, pp. 69–71.

28 *Ibid.*, pp. 90–2.

29 Barnes, 'Van Dyck', I, p. 220, and *Anthony Van Dyck*, Wheelock and Barnes eds., p. 160.

30 *Anthony Van Dyck*, Wheelock and Barnes eds., nos. 28–9.

31 Raffaello Soprani, *Le Vite de' pittori, scoltori, et architetti genovesi*, Genoa, 1674, p. 305.

32 Although Lady Arundel's trip to Turin is documented, where she went and when are matters of dispute. See Barnes, 'Van Dyck', I, pp. 7–8.

33 *La vie, les ouvrages et les élèves de Van Dyck*, Erik Larsen ed., Brussels, 1974, p. 56; Revill and Steer, 'George Gage', p. 146.

34 Francisco, 'Narrative', p. 178.

35 *Ibid.*, pp. 176–206.

36 Revill and Steer, 'George Gage', pp. 146–7.

37 *Ibid.*, p. 147.

38 Francisco, 'Narrative', pp. 199–200.

39 *La vie . . . de Van Dyck*, Larsen ed., p. 56. The present writer has concluded that the author of that biography is not always reliable on the subject of Van Dyck's portrait sitters: Barnes, 'Van Dyck', 1, pp. 8–9.

40 G.P. Bellori, *Le Vite de' pittori, scultori, et architetti moderni*, Evelina Borea ed., Turin, 1976, p. 273.

41 *Anthony Van Dyck*, Wheelock and Barnes eds., no. 32.

42 Freedberg, paper presented at the National Gallery of Art, Washington, February 1991. The research is expanded in 'Van Dyck and Virginio Cesarini' in the proceedings of the symposium, *Van Dyck 350, Studies in the History of Art*, 47, Susan J. Barnes and Arthur K. Wheelock eds., forthcoming.

43 Revill and Steer, 'George Gage', p. 148.

44 Henri Hymans, *Lucas Vorsterman, 1595–1675*, reprint of 1893 edn, Amsterdam, 1972, no. 35.

2

PATRONS AND COLLECTORS OF DUTCH PAINTING IN BRITAIN DURING THE REIGN OF WILLIAM AND MARY

Christopher Brown

William III is better known as soldier and huntsman than as patron and collector of art; and it is certainly true that compared with his grandfather, Frederik Hendrik, or his wife's grandfather, Charles I, he was not in the first rank of princely or royal collectors.[1] However, both his interest in the visual arts and his activity as patron and collector have been consistently under-rated – when, that is, they have been discussed at all. This is surprising, as there is one particularly rich source for our knowledge of the king's artistic interests and activities. The *Journals of Constantijn Huygens the Younger*[2] record William's enthusiastic response to buildings and works of art which he saw while travelling, and on campaign, as well as his concern with the display of the royal collection at his favoured London residence, Kensington Palace, and at Hampton Court, the State Apartments of which he and the queen so effectively remodelled. A particularly striking example of William's responsiveness to works of art is given by Huygens in his entry for 4 December 1688.[3] On that day the prince, on his leisurely progress from Brixham to London, had travelled from Hindon to Salisbury. He made a detour to visit Wilton House, rebuilt after the great fire of 1647 by Inigo Jones or Isaac de Caus and completed by John Webb. William was particularly impressed by the Van Dycks at Wilton, notably, no doubt – although Huygens does not mention specific paintings – by the huge portrait of the 4th Earl and his family which still dominates the Double Cube Room. It was a freezing day and by the time he reached Salisbury the prince had caught a violent cold. This did not, however, dampen his enthusiasm for the Van Dycks he had seen and he urged Huygens to see them at the first possible opportunity. It should not, of course, surprise us that paintings by Van Dyck

caught William's eye: his grandfather, Frederik Hendrik, had been a patron of the artist, he and his wife having sat to him and also commissioned from him a number of history paintings.[4] William would have been familiar with Van Dyck's work from childhood.

Van Dyck had also painted William's parents on the occasion of their marriage,[5] and this portrait is one of thirty-two paintings which appear on a manuscript list of pictures and hangings sent into Holland which is among the Blenheim papers now deposited at the British Library.[6] It appears as item 25: 'The Prince and Princess of Orange the late Kings Father and Mother at length in One piece by Vandyke'. This unpublished list gives us a very clear insight into William's taste in painting, for these were the pictures taken by the king from the Royal Collection to be hung at Het Loo. It is in the handwriting of Henry Watkins, one of Marlborough's secretaries during his campaigns, and was drawn up after the king's death when Queen Anne made an unsuccessful attempt to reclaim the paintings.[7] Marlborough acted as intermediary in this matter. There were five paintings by Holbein including the great portrait of Robert Cheeseman with a hawk on his wrist and two in the manner of Dürer, all portraits; two religious paintings by Parmigianino, a Magdalen by Titian and a Bolognese Madonna; a Bruegel *Temptation of St Anthony* and a scene of sheep-shearing, presumably *Summer* from one of the seasons, by Bassano. Seventeenth-century painters who worked in Italy are represented only by a Claude landscape and a copy after Carlo Maratta. There are two Van Dycks, but no works by Rubens, although William's enthusiasm for his work is well documented.[8]

It is also striking how few seventeenth-century Dutch paintings are on the list. There are two by Gerrit Dou, a great favourite amongst royal collectors whose work had been enthusiastically sought after by Charles II and Queen Christina. One of these – the *Young Mother* (fig. 2) – is described as 'A Dutch Kitchin'. There is also a collaboration between Alexander Keirincx and Cornelis van Poelenburgh. William could, it should be remembered, have taken paintings by Rembrandt, Jan Lievens, Gerrit Honthorst, among many other Dutch painters. The final seven items on the list are copies of the Raphael Cartoons, the greatest works of Italian Renaissance art in Northern Europe, in which William took a very special interest, carefully supervising their hanging at Hampton Court.[9]

The 1697 'List of his Majesty's Pictures, as they are now placed in Kensington House'[10] and the lists of paintings there and in the king's private apartments at Hampton Court[11] made three years later, tell a similar story of a preference for Italian sixteenth-century painting: Correggio, Tintoretto,

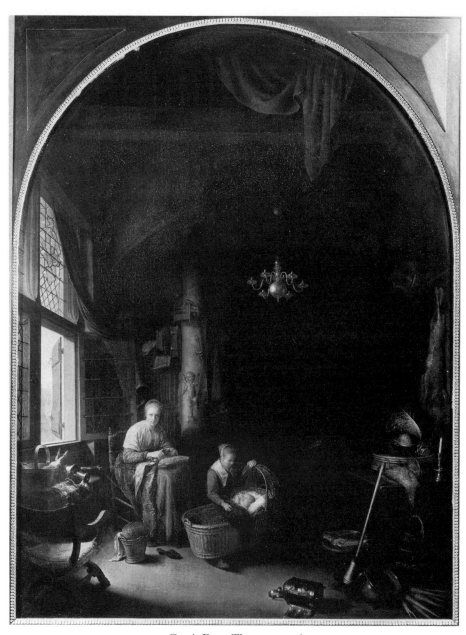

2 Gerrit Dou, *The young mother*

Schiavone, Palma Vecchio, Michelangelo, Giulio Romano, Veronese, Paris Bordone, and Andrea del Sarto are among those listed, in addition to the artists already mentioned. There is a smaller representation of seventeenth-century Italian painting – Caravaggio, Carracci, Guercino. Van Dyck, Rubens and Hendrick van Steenwyck, the architectural painter who came to London during the reign of Charles I, are the principal seventeenth-century Flemings. The contemporary Dutch are, once again, poorly represented; in addition to Dou and Poelenburgh, William chose only paintings by Maarten van Heemskerck, Abraham Bloemaert, a still-life by Willem van Aelst, and, more interestingly, two paintings by Philips Wouwermans and a landscape by Adriaen van de Velde.

Three-quarters of a century after William's death, his reign was looked back upon as something of a golden age in the arts. On 28 April 1777 John Wilkes rose in the House of Commons to deplore George III's removal of the Raphael Cartoons from Hampton Court to Buckingham Palace. The consequence of this move was that the Cartoons were no longer accessible to the public. Wilkes recalled that it was King William III who had restored the Cartoons and had them installed in a newly decorated gallery:

King William, although a Dutchman, really loved and understood the polite arts. He had the fine feelings of a man of taste, as well as the sentiments of a hero. He built the princely suite of apartments at Hampton Court on purpose for the reception of those heavenly guests [the Raphael Cartoons]. The English nation were then admitted to the rapturous enjoyment of their beauties.[12]

William's greatest single achievement as a patron was his employment of the French Huguenot architect and designer, Daniel Marot.[13] It was Marot, one of the many talented Protestant artists, architects and craftsmen who left France after the Revocation of the Edict of Nantes, who almost single-handedly brought the baroque style of the court of Versailles to Holland and England. He had been born in Paris in 1661, the son of Jean Marot, an architect and engraver. An important early mentor was Jean Bérain who, as *Chef des Menus-Plaisirs*, was second only to Charles Lebrun in the artistic hierarchy of Versailles. Marot engraved a number of Bérain's designs, and themes from his master's work, particularly his grotesques, ultimately deriving from Raphael's *Loggie*, run through Marot's own designs. At the time of the Revocation in 1685 Marot, who had already attracted attention as an engraver, was only twenty-four. He could have conformed – like his younger brother Jean who later became *architecte du roi* – but instead chose to go into

exile in Protestant Holland, settling at The Hague with his youngest brother Isaac, who later worked as a painter at Het Loo.

One of Marot's first important commissions in the Netherlands was to redesign the staircase and other interiors at the Castle of Zeist, near Utrecht.[14] His patron, William Adrian van Nassau-Odijk, had recently served as ambassador in France and it was probably he who introduced Marot to his cousin, William of Orange. It was also at Zeist that Marot first encountered the Leiden architect Jacob Roman with whom he was to collaborate closely throughout the 1690s – notably at Het Loo, where work continued until 1702, and the house at Voorst (1697–1700) built by William's favourite Joost van Keppel, Earl of Albemarle.[15]

Marot published many volumes of his engraved designs and on the title-pages he describes himself as 'architecte de Guillaume III, Roy de la Grande Bretagne'.[16] Vertue calls him 'Surveyor to the King and Director of the Works of building, painting ... etc., in great favour and esteem with that prince'.[17] He occupied a position more like Bérain than Hardouin-Mansart at Versailles. The form and decoration of interiors, the layout of gardens and design of garden buildings, even drawings for exterior façades lay within his province, but he remained a *maître-ornemaniste* rather than a practising architect in the modern sense. At Hampton Court, for example, he was employed as early as 1689 to design the great semi-circular parterre on the east front and to remodel the interiors of the Old Water Gallery for Queen Mary, but Wren and Talman between them retained control of the new buildings grouped round the Fountain Court.

Marot spent an extended period in London in the mid-1690s. As well as working for the king he was in the employ of the Duke of Montagu and of Montagu's stepdaughter, the Duchess of Somerset. By 1697 he was back in The Hague, where he redesigned the interiors of the Binnenhof, notably the Treveszaal. In patronising Marot, William and his courtiers were bringing not a Dutch but a French style, the baroque of Versailles, to England and Holland. In England these light, gilded and elaborately decorated interiors were to supersede the plain, dark, panelled interiors associated with the 'Dutch style'.

This sketch of the king's taste and his achievements as patron and collector, fascinating though they are and in need of reassessment, form the background to this study which principally concerns four Englishmen who, to a greater or lesser degree, were political allies and associates of William. All are of great interest in their own right, but a consideration of their patronage and collecting will also enable us to address some more general

16

questions about patterns of taste in Britain in the seventeenth century and the degree to which it was – or was not – affected by political allegiance; for the creation of a collection of works of art, within the setting of a town or country house was, of course, an expression of political alliance as well as of personal taste. All four were close to the king, in each case it is possible to reconstruct at least the bare bones of a collection, and they present interesting contrasts in the patterns of their taste. All are prominent political figures and, in each case, I give a brief sketch of their political careers.

The first is Ralph Montagu, earl and subsequently 1st Duke of Montagu.[18] Montagu was twenty-eight when in 1666 he was sent by Charles II as ambassador to France, and between then and 1678 he went to France on four separate embassies. Implicated in Monmouth's plots, he spent the years from 1682 to 1685 in voluntary exile in Paris. It therefore comes as no surprise that, although an early and enthusiastic supporter of William, he was a lifelong Francophile in matters of taste. He was a thoroughly unscrupulous figure and seems to have been in the pay of Louis XIV for much of his political career. He put his considerable wealth to good use, building two great houses, Montagu House in London, in which the British Museum was housed when it first opened and which was demolished to make way for Smirke's building, and Boughton House in Northamptonshire, which rises from the Northamptonshire countryside like a château in the Ile de France.

The first Montagu House was begun in 1675 to the designs of Robert Hooke, a contemporary and friend of Wren, and many of the rooms were painted by Antonio Verrio, whom Montagu had brought back from Paris in 1672, initially to make designs for the Mortlake tapestry factory of which he was director. Montagu House was gutted by fire in 1686, but Montagu set about rebuilding it shortly afterwards using an otherwise unrecorded French architect named in the documents as 'Boujet', perhaps a member of the Huguenot community in London, of which Montagu was a protector. Of the interiors of Montagu House Vertue wrote in 1722: 'the late Duke brought from France three excellent painters to adorn and beautify [Montague] House. Monsieur Lafosse History Painter. Monsieur Rousseau for landskip & Architecture & Baptiste for fruit and flowers . . . these three great masters have happily united their thoughts & skill to great perfection.'[19] Until recently it has been very difficult to know what the work of this *equipe*, active in Montague House in the years around 1690, looked like but Gervase Jackson-Stops discovered in a storeroom at Boughton five painted panels (fig. 3), the entire wall decoration for a small 'cabinet' or closet.[20] He has

3 Jan Baptist Monnoyer, Charles Lafosse, Jaques Parmentier and Jacques Rousseau
(after a design by Daniel Marot), Painted panel for the decoration of a cabinet, *c.* 1690

linked them with two drawings in the Victoria and Albert Museum which are certainly by Marot, whose direct involvement in either of Montagu's houses is otherwise undocumented. We now know that the decoration was designed by Marot and carried out by Jan Baptist Monnoyer, who painted the flowers and garlands of fruit; Charles Lafosse, who painted the mythological scenes; Jacques Parmentier, nephew and pupil of Sébastian Bourdon, who painted the supporting female figures and *putti*, sphinxes and griffons; and Jacques Rousseau, a Huguenot who had painted architectural *trompe-l'œil* scenes at Versailles, Marly and Saint-Cloud, but had fled to England because of his strong Protestant convictions. Rousseau painted the architectural elements. These panels – and we must imagine that much of the rest of the interior of Montagu House was similar in design – are a fascinating example of the full-blown Louis XIV style introduced into England in the early years of William III. We know that William himself was impressed: he recommended Huygens to go to see the interiors as early as 1690[21] and he later sent Parmentier to Holland to work at Het Loo and the Binnenhof.

On Montagu's death in 1709, inventories of the contents of his three houses, Montagu House, Boughton and Ditton Park, which he had inherited from his mother, were drawn up. They are extremely detailed in that every coffee cup and piece of linen is mentioned, but unfortunately the paintings are not fully described.[22] In the dining room at Montagu House, for example, there were 'twenty-six pictures in gold frames'. Among the painters mentioned by name are the team of Monnoyer, Lafosse and Rousseau; Van Dyck; Anthonis Mor; Holbein; Bassano; and Luca Giordano. The compiler of the Ditton inventory was more interested in paintings. Again Monnoyer and Rousseau but also several Bassanos, two cattle pieces by Rosa da Tivoli, copies after Titian and Veronese, a Tintoretto, two landscapes by Gaspar Poussin, a Snyders game still life and 'a Dutch peice' (*sic*). Elsewhere are portraits by Van Dyck and Mignard, a copy after Rubens and a landscape in the style of Bruegel. Also listed is a chimney piece by Chéron. Louis Chéron was one of the second generation of French decorative painters employed by Montagu: he was a Huguenot. Chéron drew up an interesting but partial inventory of Montagu's paintings, presumably in 1709.[23]

A list of Montagu pictures by Louis Chéron

37 Little pieces of Vandick at 3′ each	111
1 peece of Pousin	10
2 peeces of Rieussau litle	10
1 peece of Baptist	10

3 peeces over ye doors 5' each	15
2 peeces of Rieussau bigger	10
2 peeces of Baptist 6 each	12
4 more of Baptist 5' each	20
2 little peeces of Botson	8
1 landskip of Forest	8
2 landskips of Crebidge 7' each (a)	14
1 landskip of Fouquier (b)	10
3 peeces of Ldy Montagu & Monthermer & ye present Duke	20
1 Cleopatra after Guido	2

(a) In the Dks Dressing Room are 2 landscapes on copper by Asselyn called Crabetje amongst the Artists at Rome on account of a Contraction in his Fingers.
[Probably the two above alluded to.]
(b) In the D's Closet is a landscape by Fouquieres likely the same.

However, the most detailed list of paintings in Montagu House dates from 1780. All the paintings on the list were collected by the 1st Duke and also by the Marquis of Monthermer, whose portrait was painted by Mengs while he was on the Grand Tour in Rome in 1758. It is difficult to be absolutely sure which collector bought the paintings by Dou and Frans van Mieris; the pair of landscapes by Adriaen van de Velde; the Italianate landscape by Adam Pynacker; the Aert van der Neer sunrise; the Potter cattle scene; the two Ostade Peasant interiors; the two Van der Heyden townscapes; the two Wouwermans of 'Horses and Figures'; the two sea-pieces by Willem van de Velde; and, most interestingly, 'A Woman knitting and other figures' by Pieter de Hooch, an artist who was very little known or regarded at this date.

Three observations are provoked by a study of this inventory. First, Montagu's collection was clearly very eclectic: the Dutch paintings are found among paintings attributed to Claude, Poussin, Michelangelo, Correggio, Leonardo, Veronese and Carracci. It is an eclecticism which we have already noted in William's choice of paintings in Kensington Palace. Secondly, the emphasis among the Dutch painters is on the *fijnschilders* of Leiden, the Italianate landscapists and Philips Wouwermans, an emphasis we also find in William's paintings at Kensington. Thirdly, Montagu clearly felt that these Dutch paintings – genre paintings, townscapes and landscapes – would hang as happily within the elaborately gilded, light-toned interiors of Montagu House as very similar paintings hung, for example, in the dark,

panelled interiors of Ham House decorated and furnished in the 'Dutch style' by the Duke and Duchess of Lauderdale in the 1670s.[24]

The second collector is Charles Montagu, the Earl of Halifax.[25] Born in the year after the Restoration, Halifax was a signatory of the invitation to William, and his career depended very much upon royal favour. His financial expertise was widely acknowledged and he was appointed Chancellor of the Exchequer in 1694. He held the post for five years but was subsequently impeached, although the impeachment was dismissed by the House of Lords in 1701. He was a prominent Whig and member of the Junto, a President of the Royal Society and a generous patron of literature. He was the subject of one of Sarah, Duchess of Marlborough's stinging portraits in her *Private Correspondence*. The published account is well known but there is another, unpublished version in the Althorp papers deposited at the British Library.[26] Here she writes:

He had certainly a great deal of wit & humour. And I have seen very pretty ballads of his making. He had a great deal of vanity & loved money as much as any body ever did. He had a most hideous ugly person, had no more breeding than any body that had never seen anything but the Inns of Court, & yet remarkable to be in love with all the fine ladies, by whom he could only be laughed at. But for a great while he was very considerable in the Whig party.

Halifax, unlike his near namesake Ralph Montagu, was not a house-builder but he was an important collector. His collection – 'The Entire and valuable collection of Paintings, Bronzes, Busts in Porphyry and Marble, and other Curiosities, of the Most Noble Charles Earl of Halifax, deceased' – was sold over a four-day period in March 1740, twenty-five years after the collector's death.[27] There were 150 paintings in total, which display the eclecticism which is beginning to emerge as characteristic of this period of collecting. A large number of portraits of literary figures attests Halifax's interest in and patronage of literature: he first attracted attention as the author of fulsome Latin verses on the death of Charles II and his collected works were published in 1715. (He was, incidentally, described by Addison, somewhat hyperbolically, as 'the greatest of English poets'.)

In the sale of Halifax's collection were paintings by or after Carlo Maratta, Salvator Rosa, Caravaggio, Luca Giordano, Pietro da Cortona, Guido Reni, Guercino, Andrea Sacchi, Domenichino and, more esoterically, Ribera and Cignani. There are also pictures by Poussin and Claude. These were presumably bought for Halifax by agents in Italy. The Dutch paintings, of which there are a large number, are by artists all of whom worked in

England: they include Adam Colonia, Cornelis Johnson, Thomas Wyck, Lely, Dankerts, Edema (a 'Frost-piece'), Willem van de Velde, Godfried Schalken ('Scalken's Daughter, big as the life, by Himself': it fetched 16 guineas) and Egbert van Heemskerck. The Flemish were represented by Rubens, Van Dyck, David Teniers and Pieter Neefs, the painter of church interiors.

The third collector was a fellow member of the Whig Junto, an old friend and political ally of Halifax, John, Lord Somers, the Lord Chancellor.[28] He was ten years older than Halifax, having been born in 1651. An early patron was Charles Talbot, 12th Earl and afterwards Duke of Shrewsbury, whose estates Somers's father managed: Shrewsbury was another great collector who has left a fascinating journal of his self-imposed exile in Rome from 1701 until 1705.[29] Somers was involved in the negotiations to bring William to England and, in the debates which followed William's arrival, this great parliamentary orator argued that by his flight James II had abdicated the throne. His subsequent advancement was swift: he became Solicitor-General in May 1689, Attorney-General three years later and Lord Chancellor in 1697. An immensely learned and cultivated man, he corresponded with Le Clerc and wrote excellent Italian: whether Dutch was among the five other languages he was fluent in is not known, but he could certainly talk to the king in French and we know that he had a closer relationship with William than any other Englishman except the 2nd Earl of Sunderland. There is a much-quoted couplet by Addison written in 1695: 'Britain advanced and Europe's peace restored / By Somers' counsels and by Nassau's sword.'

Somers was a member of the Kit-cat Club and the dedicatee of Swift's *Tale of a Tub*, a friend of Locke and Newton and, like his friend Halifax, a President of the Royal Society. He was George Vertue's first important patron, commissioning him to engrave a portrait of Archbishop Tillotson.

Somers was not a builder on the scale of Montagu: he had a London house and a small country house, Brookmans Park in Hertfordshire. He formed a famous library which contained more than 9,000 printed books (at a time when the Bodleian had only 30,000 volumes) and of which the catalogue survives. It is not just a lawyer's library, but reveals the broad intellectual interests of a highly cultivated collector. He also made an extensive collection of prints and drawings; the entire collection was sold at auction in 1717 and the catalogue lists more than 600 drawings, more than 400 prints and 200 illustrated books.[30] The majority are Italian, French and Dutch. He did not travel and apparently relied on agents and friends: as is stated on the first

page of the catalogue, Padre Resta ('A Person very well known among the Curious') bought prints and drawings for him in Rome as did Shrewsbury and Henry Newton while they were there.

I have not been able to discover a list of Somers's paintings or an inventory including them.[31] However, his paintings have found their way by inheritance to Eastnor Castle in Herefordshire. There is a Somers family legend, which was given credence by Benedict Nicolson who repeated it in print,[32] that the Lord Chancellor used the same distinctive frames for all his paintings, so that in order to reconstruct his collection all one has to do is to walk round the castle looking for them. Unfortunately it is not as simple as that: while at Eastnor I came across two mid-eighteenth-century portraits in so-called 'Lord Somers' frames (the Lord Chancellor died in 1716). On stylistic grounds, too, the frames cannot be as early as 1700. They should be dated about 1780. However, having said that, there do not seem to have been any significant collectors in the Somers or Cocks family between the Lord Chancellor's death and 1780 and so, the evidence of the frames apart, it is probable that those paintings which are not family portraits were collected for Somers by his agents on the Continent. They are a most intriguing group. They include the great *Concert* by Hendrick Terbrugghen (fig. 4), the artist's greatest secular painting, purchased in 1983 by the National Gallery; *Diana and Actaeon* by Cornelis van Poelenburgh; two small copper panels by Bril; an intriguing octagonal Portrait of a Young Man, perhaps by Jan de Bray; another Portrait of a Man by Cornelis Johnson; and a superb full-length portrait of Somers's friend the Duke of Shrewsbury by Kneller. There are also the inevitable Van Dyck school pieces, and notable among the small group of Italian paintings is Salvator Rosa's large canvas of *Empedocles throwing himself into the crater of Etna*.

Once again, it is an eclectic collection, but with a strong Italian bias. It was no doubt its powerful Caravaggesque qualities that recommended the Terbrugghen to Somers, and Poelenbergh and Bril both worked in Italy. They were, however, presumably bought for Somers in the Netherlands.

The fourth collector bought paintings on his frequent trips to the Netherlands and, being a conscientious civil servant, kept the records of his purchases. He was William Blathwayt, William's Secretary of War, who spent many summers on campaign with the king in Flanders.[33] He extensively remodelled and extended Dyrham Park in Gloucestershire and it was there that he housed his collection of paintings.[34]

Blathwayt began his career as an administrator and diplomat, serving as secretary to Sir William Temple, ambassador in The Hague. He rose to

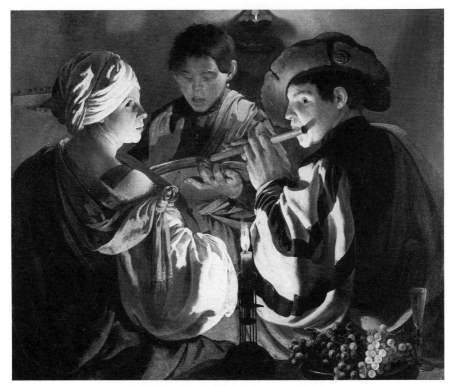

4 Hendrick Terbrugghen, *The concert*

become Secretary at War under James II and was confirmed in the post by
William III. William had a high opinion of Blathwayt's abilities and his
fluency in Dutch was especially valued. In June 1688 John Evelyn dined 'at
Mr. Blaithwaite's – this gentleman is secretary at War, Clerk of the Council
etc having raised himself by his industry from very moderate circumstances.
He is a very proper, handsome person, very dexterous in business, and
besides all this, has married a great fortune.'[35] The fortune was that of Mary
Wynter, the heiress of Dyrham, whom Blathwayt married in 1686, when he
was thirty-seven. Shortly after the marriage Blathwayt began work on the
house, superimposing a new west front on the Tudor manor house. For this
task he employed a certain 'S. Hauduroy', probably a Huguenot refugee
chosen by Blathwayt because he was conscientious, penniless and cheap. In
one letter in the Dyrham archives Hauduroy complains of the miserable
payment he received, which scarcely covered the cost of his travel.[36]

Blathwayt had an influential patron in his uncle Thomas Povey, Treasurer
to the Duke of York. His personal taste and his delight in possessing works

24

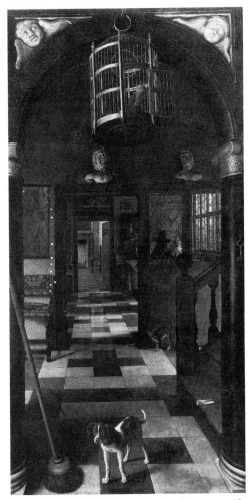

5 Samuel van Hoogstraten, *A view down a corridor*

of art were a reflection of Povey's, whose collection of no fewer than 112 paintings Blathwayt purchased from his uncle, 'together with a quantity of books', for £500 in November 1693. The inventory made of Povey's paintings at the time of this transaction survives but does not give the names of the artists.[37] There can be no doubt, however, that it contains a large number of Dutch paintings – there are many 'landskips', still-lifes, 'prospects', as well as pictures of 'a Dutchwoman' and a 'Dutchman' which are all presumably by Dutch painters. The inventory does not apparently record Povey's most famous Dutch painting, which did, however, enter Blathwayt's collection and is still at Dyrham today (fig. 5). This was seen by Pepys when

25

he went to dinner in Povey's house in Lincoln's Inn Fields on
19 January 1663: 'After dinner [he] showed me from room to room, so beset
with delicate pictures and above all, a piece of perspective in his closet in the
low parler.'[38] Pepys was back a week later and was shown it again: 'But above
all things, I do the most admire his piece of perspective especially, he
opening me the closet door and there I saw there is nothing but only a plain
picture hung upon the wall.'[39] Pepys admired the perspective yet again when
he dined with Povey a year later and on that occasion he noted that his host
had a second, larger perspective 'upon his wall in his garden'.[40] This
'perspective in his court' was also seen by Evelyn, who visited Povey's house
shortly after Pepys in 1664:[41] Evelyn says it was by Streater, a corruption of
Samuel van Hoogstraten, who painted the two perspectives during his stay
in London in the 1660s. Povey's taste was, at a more elevated and expensive
level, similar to that of William Cartwright who formed his collection in
London shortly after the Restoration.[42] Blathwayt not only acquired his
uncle's collection but continued to buy along similar lines well into the
eighteenth century. From the same year that he acquired Povey's collection
we have that rarest of documents, a receipt for the purchase of paintings.
These were all bought in Antwerp and include the two paintings by Henrick
van Minderhout still at Dyrham, as well as a view of the façade of the Jesuit
Church at Antwerp and four flower pieces. The bill, which unfortunately is
undated, was paid by a 'Mr Hill', presumably a servant of Blathwayt and the
receipt is also signed by Jan Siberechts, the Flemish painter who must have
acted as an agent for him.[43]

The clearest picture of Blathwayt's large collection of paintings is given
by the sale catalogue of 1765. It was intended to disperse the collection, but
either the sale did not take place or most of the paintings were brought back
by the family. The strong Dutch emphasis of Blathwayt's taste is apparent: a
Holy Family by Dou, a flower still-life by Verelst, Schalcken, the
Hoogstratens, many Hondecoeters, 'King William when Young' by Nets-
cher, Colonia, Bloemaert, Ostade, Poelenburgh, Van Goyen, several
Wouwermans, marine paintings by Abraham Storck, three putative Rem-
brandts and many unattributed landscapes and flower pieces.

The paintings, many of them no doubt bought on Blathwayt's numerous
visits to the Netherlands, were hung in a Dutch interior at Dyrham. Blath-
wayt decided in 1698, by which time he was in possession of a large income,
to demolish what remained of the Tudor house and build an elaborate
garden front containing the state apartments. It was the prerogative of

senior officials to obtain an architect from the Office of Works and it was no less than the Comptroller of the Royal Works, William Talman, who designed the east front in a style which borrows from Rubens's *Palazzi di Genova* and J.-H. Mansart. Blathwayt hung the interior with Spanish leather and amassed a large collection of walnut furniture and blue Delft, all imported from the Netherlands.

This essay has discussed four collectors. Many of their contemporaries would, of course, repay further study and it is remarkable how little has been done in a systematic manner. Major patrons and collectors who deserve further study include Daniel Finch, 2nd Earl of Nottingham who, although a Tory, was a supporter of William and a close adviser of the queen.[44] He had been in Italy in the 1660s and he closely supervised the building of his great house at Burley-on-the-Hill. It contained a large collecton of paintings, Dutch and Flemish – including a major decorative scheme by Samuel van Hoogstraten – alongside Italian. Shrewsbury has been mentioned in the context of Halifax and Somers, and is certainly an influential figure in the development of the taste for Italian paintings. Others whose taste has yet to be studied in any detail are the Earl of Devonshire, a passionate supporter of William who created him a duke in 1694, who was rebuilding and decorating Chatsworth; the Duke and Duchess of Somerset at Petworth; and the Earl of Exeter at Burghley.

Even in this small sample, however, a pattern does emerge. The 'Dutch style' is a phenomenon of the years immediately following the Restoration. William Cartwright, Thomas Povey and the Duke of Lauderdale all shared in it at their different levels of society. Rather than giving an impetus to this style, the accession of William hastened its end. His enthusiasm for Marot and Verrio, a taste for the style of Versailles, enthusiastically proselytised by the Duke of Montagu, replaced the plain, dark, panelled interiors of Ham with the light, gilded and highly decorated rooms at Montagu House. In these interiors it was bright Italianate landscapes and the highly wrought paintings of the *fijnschilders* which were favoured, in preference to the peasant interiors of Egbert van Heemskerck.

An eighteenth-century guidebook to Gloucestershire says of Dyrham that 'every caprice of the Dutch style which could be affected by Art, abounded ...'[45] Blathwayt's career had ended in 1710 when at the age of sixty-one he lost his seat in the House of Commons and retired to Dyrham. By the time he died fourteen years later, the decoration of the house and its

contents must have seemed very old-fashioned indeed. It is ironic that it was a Dutch king, whose entire political and military career was devoted to curbing the power of France, who had done much to bring about this change in taste.

Notes

This essay stems from a lecture delivered in a substantially different form, at a symposium jointly organised by the British Academy and the Royal Netherlands Academy, which took place on 28–30 September 1988, under the title 'Wetenschap en Cultuur onder Willem en Mary'. I would like to thank the following for their help with various aspects of this essay: His Grace the Duke of Buccleuch; Gareth Fitzpatrick; Tessa Murdoch; B. Hervey-Bathurst; Gervase Jackson-Stops; Christopher White; Beatrijs Brenninkmeyer-de Rooij; Frances Harris; Anthony Mitchell; and Sir Oliver Millar.

1 For William III as collector and patron, see J.G. van Gelder, 'The Stadholder-King William III as Collector and "Man of Taste"', in *William and Mary and Their House*, catalogue of an exhibition held at the Pierpont Morgan Library, New York, 1979, pp. 29–41. See also the essays on the visual arts in *The Age of William III and Mary II: Power, Politics and Patronage 1688–1702*, R.P. Maccubbin and M. Hamilton-Phillips eds., Williamsburg, 1989, pp. 217–307.

2 *Journaal van Constantijn Huygens de Zoon* ... (Werken van het Historisch Genootschap, NS 23), Utrecht, 1876.

3 *Ibid.*, p. 28.

4 For Van Dyck and the House of Orange, see J.G. van Gelder, 'Anthonie van Dyck in Holland in de zeventiende eeuw', *Bulletin des Musées Royaux des Beaux-Arts*, 8, Brussels, 1959, pp. 73ff.

5 Canvas, 182.5 × 142 cm. Rijksmuseum, Amsterdam (Inv. no. A102). They married on 12 May 1641.

6 The 'List of pictures carried into Holland' is British Library Add. MS. 61359, fols. 80–1, n.d. Watkins was one of Marlborough's secretaries during the campaigns of 1702–11.

7 For a recent discussion of this matter (citing all previous bibliography), see B. Brenninkmeyer-de Rooij *et al.*, *Paintings from England: William III and the Royal Collections*, catalogue of an exhibition held at the Mauritshuis, The Hague, 1988.

8 For example, he bought two works by Rubens on a visit to Antwerp in June 1677. See J.G. van Gelder, 'Rubens in Holland in de zeventiende eeuw', *Nederlands Kunsthistorisch Jaarboek*, 3 (1950–1), pp. 102–50, and van Gelder, '"Man of Taste"', p. 32.

9 J. Shearman, *Raphael's Cartoons in the Collection of Her Majesty the Queen*, London, 1972, pp. 148–9.

10 The inventory is British Library Harleian MS. 7025, item 16, pp. 188–94 (Sir Oliver Millar kindly made his transcription available to me). The inventory is discussed by Th. H. Lunsingh Scheurleer, 'Documents on the Furnishing of Kensington House', *Walpole Society*, 38 (1962), pp. 15–58; and by C. White, *The Dutch Pictures in the Collection of Her Majesty the Queen*, Cambridge, 1982, pp. xlix–l, lxxvi–lxxvii (Inv. no. 20).

11 British Library, Harleian MS 5150, includes a 'List of his Majestie's Pictures as they are now placed in Kensington House 1700', and 'Pictures in the King's Private appartm^ts at Hampton Court' (White, *Dutch Pictures*, p. lxxvi, Inv. no. 21). John Evelyn's comments on the paintings hanging at Kensington Palace in 1696 can be found in *The Diary of John Evelyn*, E.S. de Beer ed., 6 vols., Oxford, 1955, v, p. 237.

12 Quoted in Shearman, *Cartoons*, pp. 152–3.

13 The Marot literature is considerable. The basic study is still M.D. Ozinga, *Daniel Marot: De schepper van den Hollandschen Lodewijk XIV-stijl*, Amsterdam, 1938. See also G. Jackson-Stops, 'Daniel Marot and the 1st Duke of Montagu', *Nederlands Kunsthistorisch Jaarboek*, 31 (1980), pp. 244–62, and the catalogue by R. Baarsen, *et al.*, *Courts and Colonies: The William and Mary Style in Holland, England and America*, Cooper-Hewitt Museum, New York, 1988.

14 G. Jackson-Stops, 'Slot Zeist Netherlands', *Country Life*, 160 (1976), pp. 534–7 and pp. 594–7.

15 Th. H. Lunsingh Scheurleer, 'Het Huis de Voorst in zijn Glorietijd', *Bulletin van de Koninklijke Nederlandse Oudheidkundige Bond*, 16 (1963), pp. 193–220.

16 See P. Jessen, *Das Ornamentwerk des Daniel Marot*, Berlin, 1892.

17 G. Vertue, 'Notebooks', *Walpole Society*, 20 (1931–2), p. 32.

18 Jackson-Stops, 'Daniel Marot', pp. 248ff.

19 Vertue, 'Notebooks', *Walpole Society*, 22 (1933–4), pp. 32–4.

20 Jackson-Stops, 'Daniel Marot', pp. 248ff.

21 Huygens, *Journaal*, p. 365.

22 The inventories of Boughton, the duke's lodgings in Whitehall and Ditton, are at Boughton.

23 Chéron's 1709 inventory is transcribed and discussed by Tessa Murdoch in her unpublished thesis, 'Huguenot Artists, Designers and Craftsmen in Great Britain and Ireland 1680–1760', University of London, 1982, pp. 71–2. The valuation, which came to a total of £266, is signed 'Valued by us Cheron, M. Antonie'. Antonie was the name of the duke's steward, most probably also a Huguenot.

24 P. Thornton and M. Tomlin, *The Furnishing and Decoration of Ham House*, London, 1980. P. Thornton, *Seventeenth-Century Interior Decoration in England, France and Holland*, London, 1978.

25 *Dictionary of National Biography*, vol. XIII, pp. 665ff.

26 Sarah's published account of Halifax is to be found in *Private Correspondence of Sarah, Duchess of Marlborough*, 2 vols., London, 1838, II, pp. 261–3 ('There was no falser man than Lord Halifax was'). Her private account is in the Althorp Papers at the British Library (my thanks to Dr Frances Harris for supplying this reference).

27 A typescript copy of the sale catalogue is in the National Gallery Library (Box A xi.5.1).

28 William L. Sachse, *Lord Somers: A Political Portrait*, Manchester, 1975, *passim*.

29 Shrewsbury's Journal of his stay in Rome *c.* 1700–5 has been published by the Historical Manuscripts Commission, Buccleuch MSS (Montagu House), vol. II, pp. 746–99.

30 'A Collection of Prints and Drawings of the Late Right Honourable John Ld Sommers To be Sold by Auction on Monday the Sixth of May 1717 at Mr. Motteux's Auction-Rooms in the Little Piazza in Covent-Garden' (copy in the British Library, at 821.e.4).

31 In 1988 I made extensive searches in the Muniment Room at Eastnor Castle.

32 B. Nicolson, *Hendrick Terbrugghen*, London, 1958, cat. no. A37.

33 G.A. Jacobsen, *William Blathwayt, A Late Seventeenth Century English Administrator*, New Haven, 1932; S.S. Webb, 'William Blathwayt, the "Never-erring Minister"', in *The Age of William III and Mary II*, Maccubbin and Hamilton-Phillips eds., pp. 65–70.

34 There have been two major sales from Dyrham. The first was held by Thomas Joye on 20 November 1765 (copy of catalogue at Dyrham), and is an invaluable source for establishing a list of the contents of Blathwayt's collection. Many items were apparently bought in. There was also a sale at Sotheby's on 29 February 1956.

35 Evelyn, *Diary*, de Beer ed., IV, pp. 554–5 (16 June 1687).

36 Many of the Blathwayt papers, including the inventories of 1703 and 1710, have been deposited at the Gloucestershire Record Office. The inventory of 1710 has been published by K.-M. Walton in *Furniture History*, 22 (1986), pp. 25–76.

37 It is among the Blathwayt papers in the Gloucestershire R.O.

38 Pepys, *The Diary of Samuel Pepys*, R. Latham and W. Matthews eds., 11 vols., London, 1971, IV, pp. 17–18 (19 January 1663).

39 *Ibid.*, p. 26 (21 January 1663).

40 *Ibid.*, V, p. 161 (29 May 1664).

41 Evelyn, *Diary*, III, p. 375 (1 July 1664).

42 For Cartwright, see the catalogue of the exhibition, *Mr Cartwright's Pictures*, Dulwich Picture Gallery, 1987–8.

43 Siberechts seems to have come to England in the entourage of the Duke of Buckingham in 1672 and settled in London, where he died in about 1700. He presumably travelled back to the Netherlands periodically and acted as an agent

for Blathwayt in the purchase of paintings. G. Martin, *The Flemish School c. 1600–c. 1900: National Gallery Catalogues*, London, 1970, p. 236.

44 Nottingham's 1676 household inventories are in the Leicestershire Record Office, where there is also a detailed inventory of furniture and pictures of 1772.

45 Bigland's *Gloucestershire* (1791): quoted in the Dyrham Guide Book, p. 60.

3

FOREIGNERS AT COURT: HOLBEIN, VAN DYCK AND THE PAINTER-STAINERS COMPANY

Susan Foister

On 30 November 1637 Charles I's Painter Sir Anthony Van Dyck was invited to dine at Painter-Stainers Hall in the City of London by the London Company of Painter-Stainers, as their minute book records. The other guests were to include the Royal Surveyor Inigo Jones and the King's Serjeant Painter John De Critz, and his wife, as well as the herald Edward Norgate.[1] As the Painter-Stainers Company had been engaged in a bitter struggle against foreign painters such as Van Dyck, as well as native painters who, like De Critz, did not belong to the Company, and also against the Company of Heralds, this dinner appears to have been a concerted attempt at burying the hatchet in what is otherwise a history of conflict.[2]

Van Dyck, who had been given a royal pension on his first brief visit to England in 1620–1, arrived back in England in 1632 after long absences in Italy and the Low Countries. He settled at Blackfriars which was, significantly, although just inside the City of London, a 'liberty' and hence out of reach of the jurisdiction of the Painter-Stainers Company.[3] In 1627 however, the London Company of Painter-Stainers was already preparing to support a petition to King Charles I complaining that certain named painters, notably foreigners employed by the king such as Mytens, Gentileschi, Van der Doort and Steenwijck, were presenting a threat to their livelihood. The petition was instigated by a group of English painters who were not members of the Company, including Robert Peake and Richard Greenbury of the Goldsmiths' Company, as well as a 'Mr Coddington painter'. The dispute rumbled on until 1636, when Inigo Jones seems to have been called on to act as go-between. The invitation to dinner issued to Van Dyck came shortly after this dispute had reached a crisis: an alien painter, a Mr Crosse,

was imprisoned after proceedings had been taken by Peake, Greenbury, Coddington and others, apparently without the Company's knowledge; subsequently, a complaint against the Painter-Stainers Company was made to the king.[4] The invitation to Van Dyck might be viewed as a direct response to this low point in the relations between English and foreign painters.

Complaints against foreign painters had a very long history in England. More than a hundred years earlier, in 1517, the rioters of Evil May Day had demanded an end to the threat posed by foreign workers in many trades, including foreign painters.[5] A few years after these hostilities Holbein – like Van Dyck a foreigner – was appointed painter to Henry VIII. This was just one of many court positions over the next century to be taken by painters who were not native-born or who did not belong to the London Painter-Stainers Company.

The Painter-Stainers have usually remained in the background in studies of painting in England in the sixteenth and seventeenth centuries, sounding what often seems a tediously shrill note of protest against foreign intrusion. But more than mere xenophobia was involved: the purpose of this essay is to try to clarify the relations between the Painter-Stainers Company, the foreigners and the court in the period between the arrival of Holbein and the death of Van Dyck.

The records of the London Painter-Stainers Company go back to the thirteenth century when, like other painters' guilds elsewhere in Europe, the Painters Guild was part of the Saddlers Company, since its members earned much of their income from painting harnesses.[6] The Stainers were at first a separate company, carrying out painting on cloth, like their counterparts in the Netherlands.[7] In the fifteenth century the Painters Guild became established in its own right and increased in importance, and in 1502 the Painters and Stainers joined together.[8] In 1532 the Company obtained its own hall in the City and in 1581 it was granted a royal charter.[9]

Although records of the membership of the London Company of Painter-Stainers in the sixteenth century are scanty (the first surviving minute books of their court, listing Company officials present, date from 1623),[10] it is possible to retrieve some lists of names of officials and members. In particular, the documents dealing with the transfer of ownership of Painter-Stainers Hall in 1532, 1549, 1580 and 1605 are a valuable source of names, as is the Company's petition to Lord Burghley of 16 July 1578,[11] but they are not the only sources in which names are mentioned.

A much longer list of names seems to have gone unnoticed. This occurs in one of a series of lists of liverymen of the City in 1537–8, headed 'The

general companyes of all the mysteryes, crafts and cumpanies within the Cyties of London with the names of eny free man beyng householder within the same.'[12] It records fifty-three Painter-Stainers' names, as opposed to the nine, and seventeen, listed in the 1532 and 1549 documents of transfer. There would, in addition, have been further painters not in livery, as well as apprentices.[13] These names can then be compared to the records of the royal accounts and other documents.[14] Without this list it would be difficult to recognise that so many of the names that crop up again and again in the accounts of the Tudor court for painting tasks, belonged to the London Painter-Stainers Company. In some cases, significant parts of the livelihood of Company members must have depended on it. The foreign painters who came to work at court in the sixteenth and seventeenth centuries were therefore likely to pose a potential threat to Company members.

Most painted work carried out at court in this period was decorative; the painting of pictures was by comparison a very occasional activity. Painters had long been required by courts, in all parts of Europe, to decorate palaces, to provide painted furniture, to produce banners and heraldic painting for weddings, funerals and other ceremonial occasions.[15] England was no exception to this, and records of such painting can be found as far back as the thirteenth century, when Henry III was employing painters to decorate Westminster Palace.[16] Such activities continued over the following centuries, when palaces still had to be suitably adorned, funerals still took place with due pomp, and court entertainments still involved the creation of much elaborate, but temporary, splendour.

It was not unusual for the members of a local painters' guild to be summoned to work at court on occasion. Court festivities – weddings, funerals, royal entries for instance – often produced a need for far more painted work than one court painter could easily supply. In the Netherlands in the fifteenth century, when painted work was needed for such occasions at the Burgundian court, often at short notice, the town painters, members of the local guild, might be called upon to provide such work, sometimes by supplying ready-made items, sometimes by painting in person at court.[17] It can now be suggested that by the early sixteenth century – and possibly much earlier – a similar relationship existed between the English court and the London Painter-Stainers Company.[18]

Certainly, some names in the guild list of 1537–8 had been working for the court since the beginning of the sixteenth century. Others provide a degree of continuity extending further into the century.[19] It is possible to make a similar comparison between the names in royal accounts, and those

listed in the four records of transfer of ownership of the Company's Hall between 1532 to 1605. To these can be added names of Company members in the petition of 1578 mentioned above, as well as those in the Company minute books from 1623 onwards. Apart from the names in the transfer document of 1532 (when nine out of twelve names agree), far fewer Company names appear to be mentioned in the royal accounts in the second half of the sixteenth century and the early seventeenth century.[20] However, it would be unsafe to draw any conclusions from this diminution, as not only are these lists of names only partial lists of the Company, the royal accounts of the second half of the sixteenth century and the early seventeenth century are often themselves less informative, sometimes referring to groups or 'companies' without specifying more than one individual: for instance, Lewis Lyzard was working with 'a company on a banqueting house' in 1584–5.[21]

Analysis of the list of 1537–8, however, reveals that nineteen names, nearly half of the membership of this period, are recorded as having worked on the preparations for the revels at Greenwich in 1527, a high proportion indeed. The work on which they were engaged consisted of decorating two parts of a temporary building at Greenwich Palace: a Banqueting House and a Theatre. Some painters worked on one, some on the other, and a few on both. Workers on the Theatre were part of 'Mr Hans's company', and this Hans was almost certainly Hans Holbein. In the Banqueting House, the painters worked chiefly on the 'staynyng and payntyng' of the canvas walls and ceiling. Holbein supplied a painting on canvas of the Battle of Thérouanne which he must have painted at another site and shipped down to Greenwich by boat. For the Theatre the arrangements were different: Holbein worked day after day at Greenwich alongside the English painters who were apparently helping him to paint an elaborate astronomical design which covered the ceiling.[22]

It is the Serjeant Painter, the official responsible for the painted work needed by the monarch, who appears to provide the key to the relationship between the Company and the court painters in the early sixteenth century. Most of the tasks associated with the decoration and maintenance of the royal palaces appear from an early date to have been put under the direction of individual Serjeant Painters who were specialised craftsmen.[23] In the case of painting, individuals with the title of King's Painter (used before the change to that of Serjeant Painter was made in 1527) can be documented from the fourteenth century. Both the terms on which John Brown was appointed King's Painter to Henry VIII in 1511, and the work which he

carried out, of a decorative or heraldic nature, are closely comparable to that of his predecessors in the fourteenth century.[24] The tasks carried out by his successors were identical to those undertaken by Brown and there were to be no changes in the seventeenth century; as is demonstrated by the joint grant issued in 1605 to Leonard Fryer and John De Critz, when the responsibility for the familiar heralds' coats, banners, painted coaches, barges and bed hangings, as well as for palace decoration and royal entertainments, is reiterated.[25]

The quantity of work was very large, and can be divided into tasks which had to be done on site, into which category palace decoration clearly fell, and those such as banners and other heraldic items which could be supplied from a workshop elsewhere, perhaps in the City where, unlike most foreign painters, Serjeant Painters usually resided.[26] Royal employ had long brought profit as well as prestige, and the opportunity to make money out of supplying such items to the court was one of the rewards.[27] For instance John Brown, Serjeant Painter, was paid in 1515, 1516 and 1531 for supplying banners and scutcheons for royal funerals, and in 1514 was paid £4 8s 8d 'for payntyng of diverse of the popes armes in diverse collours'.[28] As well as banners, Brown supplied gold to royal projects such as the 1527 Greenwich revels.[29] As the will of Andrew Wright, Serjeant Painter to Henry VIII from 1532–45, shows, he had a business manufacturing pink, a yellow pigment known to have been used in royal projects such as that at Greenwich in 1527,[30] and it is highly likely that he frequently supplied the court. George Gower, Serjeant Painter 1581–96, was specifically authorised in an undated commission to supply 'All maner of colors oyle vernishe' needed.[31]

Much work, however, was carried out within the royal palaces, and even if some finished work was brought down from the City, there was at Whitehall in 1542 a room 'Wher the paynters make ther collors within the palaic', and a possibly identical place in Lamb Alley, Whitehall, 'occupied with the kyngs serdyante paynter as well for the greyndyng of cullers as ffor the kepyng of dyverse and sondrye stuffe paynted and gyllte'.[32] Certainly a great deal of labour was required for at least some of the decorative projects, whether painting palace walls or creating elaborate settings for revels, and it was evidently the Serjeant Painter who would usually supply it. George Gower, for instance, in the undated commission referred to above, was authorised to supply labour, described – perhaps significantly – 'as well free as forreigne'. In the case of the work at Greenwich in which Holbein was involved, referred to above, it is highly probable that the painters working with him, many Company members as has been observed, were selected by

the Serjeant Painter John Brown; it seems most unlikely that Holbein, newly arrived in England, would have been in a position to select or commission them.

Both John Brown and Andrew Wright were Painter-Stainers. Although it is not possible to say with certainty what offices they held in the Company, it is likely that both men were Masters at least once: in the seventeenth century the offices of Master and Wardens passed between a relatively limited group and some became Master more than once.[33] John Brown, a wealthy City alderman, bequeathed to the Company the building that became their Hall.[34] The relationship between the London Company of Painter-Stainers and the men who, during much of the reigns of Henry VII and Henry VIII, probably supplied both materials and labour was therefore inevitably a close one. They perhaps also encouraged others of the Company to act as suppliers.[35] It would have been entirely natural for the Serjeant Painter, himself a Company member, to ensure a steady flow of work and profit at court for Company members. The many correspondences between the names of Company members in 1537, and the names of those appearing in the court accounts, strongly suggest that this was the case.

Ties of both Company membership and kinship linked those who carried out this potentially lucrative painted work for the court. They were perpetuated over more than one generation, and echo the close relationships between other craftsmen involved with the maintenance and decoration of the royal palaces.[36] Sometimes these links suggest that certain painters were Company members, although no other record of their membership exists in the sparse documentation between 1537 and 1623. For instance, the brother-in-law of the Elizabethan Serjeant Painter William Herne (not recorded as a Company Member) was apparently one Arthur Cutler, a Painter-Stainer who signed the 1578 petition and who is frequently recorded at court. He was presumably related to Peter Cutler, who worked on the revels in the reign of Edward VI and probably also to a John Cutler; and a Glawde Cutler is recorded at court as early as 1509, making a dynasty of Cutlers at court who were likely also to have been Painter-Stainers.[37]

Again, Richard Isaackson was one of a number of members of this family connected with the Painter-Stainers in the late sixteenth and early seventeenth centuries and working at court. His son Paul, also a Company member, carried out much work at court in the early seventeenth century, and their relative George Isaackson also worked at court. Richard Isaackson had as his son-in-law John Potkin, probably a relative of the Painter-Stainer, Christopher Potkin, and himself a Painter-Stainer.[38] There are other names

as well as these which suggest painter dynasties: Andrew Wright's painter children;[39] sons or relatives of John Hethe,[40] John Child,[41] Leonard Fryer, Serjeant Painter 1598–1605;[42] the Goodrickes, Samuel and Matthew,[43] and the Pierces.[44]

But what must have seemed a comfortable and fairly long-lived relationship between the Company and the court in the early sixteenth century, during the period when John Brown and Andrew Wright held office, was not maintained. It was first brought to an end by the advent of a foreigner. In 1544 Andrew Wright's successor as Serjeant Painter was neither a Company member nor an Englishman, but an Italian, Antonio Toto del Nunziata.[45] Although Wright was not the last Company Serjeant Painter this succession may have been perceived as disturbing: from then on members of the Painters-Stainers Company were only intermittently holders of this crucial office, which hereafter would be held at least as often by foreigners or Englishmen who were not Company members. Thus, after Toto, the Serjeant Painters were as follows: Nicholas Lizard, apparently a Frenchman,[46] William Herne, a Yorkshireman not recorded as a Company member, despite his Cutler relatives, and the Serjeant Painter complained of in the petition of 1578, George Gower, a Yorkshire gentleman, Leonard Fryer, possibly a Company member,[47] John De Critz, an immigrant goldsmith's son and Robert Peake, a member of the Goldsmiths Company.[48] This development coincided with both an increasing number of foreign painters working in London and an increasing number of foreign painters working at court.

The London Painter-Stainers in the sixteenth century had already good reason to be concerned about foreign competition. Painted cloths were among the imports long complained of.[49] Already at the beginning of the sixteenth century there were painters established south of the City at Southwark.[50] By the end of the century Southwark painters (and sculptors) had commanded many of the most important commissions and positions available.[51] These were the forerunners of the foreigners against whom the petition of 1627 was raised: many of them were to be highly successful at court.

As such immigrant families – mostly from the Low Countries – succeeded in making their way at court, they also tended to intermarry and establish their own networks of family and friends among whom work might be passed, rivalling those of the Painter-Stainers Company.[52] For instance, the German painter Harry Blanckston, who worked at Hampton Court Palace in the 1530s, refers in his will to the King's Glazier, the Netherlandish

Galyon Hone.[53] In his will of 1570 the Serjeant Painter Nicholas Lizard, probably an immigrant, refers to his friends Thomas Fowler Comptroller of the Works, and Anthony Walker Clerk of the Wardrobe, powerful friends for a court painter to have.[54] Lizard's sons, and their Lymbey and Depree relatives, subsequently seem to have established a virtual monopoly over work for the revels.[55] The De Critz family, who were related to a number of other painter and sculptor families who had come to England from the Netherlands at the end of the sixteenth century, are another notable example. John De Critz was Serjeant Painter from 1605–42, and in 1660, Emanuel De Critz petitioned the king to be made Serjeant Painter, pleading that he had naturally expected to succeed to this post.[56]

It was in defence of the livelihood of the painters and their fellow guildsmen that it was enacted in 1523 that no one, denizen or not, who had been born abroad, should be allowed to take on foreign-born apprentices; that in 1530 only denizens were allowed to set up new shops, and that in 1541 no subject was to have more than four alien servants (in 1523 the rule was two).[57] Such restrictions meant that when in 1534 Lucas Horenbout was created King's Painter, he had to be given special permission to employ four foreign journeymen.[58] These restrictions remained in force, and it is noticeable that in one of the Painter-Stainers Company's petitions of the seventeenth century there are a number of marginal references to these statutes and even to earlier ones.[59] It was of course for this reason that Van Dyck, who himself in 1634 employed six foreign servants, some of whom may have helped in his studio, settled at Blackfriars.[60]

The Painter-Stainers kept up a continuing struggle against the foreign competition during the period stretching from Holbein's residence in London to that of Van Dyck's. In 1575 they presented a petition to the queen lamenting the 'decay' of painting and their lack of powers. If they could not stem the flow of foreigners into London, they could at least have more powers over them, which incorporation would provide.[61] The charter granted in 1581 remedied this and gave the Company stronger powers to deal with foreigners. In the seventeenth century the struggle continued with increased powers being given to the Company in 1612, and again in 1633 to search out the work of 'strangers'.[62] The Company also continued to wage war against those – wire-drawers and plasterers as well as heralds – it considered were infringing the monopoly on painted work which the Company attempted to maintain.[63] As we have seen, a considerable impetus in the seventeenth century came from painters who were outside the Painter-Stainers Company, some of whom, such as Richard Greenbury, eventually

decided to join the Company, the better to defend their position against the foreigners.[64]

It is noticeable that all the identifiable painters in the 1627 petition were painters of pictures.[65] The Painter-Stainers Company, however, was not represented among this increasingly important breed of court painters, among whom foreigners were predominant. From the early sixteenth century, as earlier abroad,[66] we can trace the emergence of court painters whose work was set apart from the tasks undertaken by the Serjeant Painter and his associates. Already during the reign of Henry VIII several foreign painters at court are documented as salaried King's Painters: not only Hans Holbein, but also Lucas Horenbout, Antonio Toto, Vincent Volpe, a Neapolitan,[67] and, probably at the end of the reign, Guillim Scrots.[68] Precisely what these painters produced is not always clear (Volpe seems to have been largely an extra heraldic painter), but in some cases it was certainly pictures, and more especially portraits. Under Charles I, the foreign painters of pictures included Orazio and Artemisia Gentileschi, Gerrit Honthorst, Daniel Mytens, Hendrick van Steenwijck, Cornelis van Poelenburgh, as well as Van Dyck, nearly all of whom are listed in the 1627 petition.[69]

The only pattern to the employment of these additional painters seems to be found in the area of portraiture. Portraits were the pictures most essential to the monarchy.[70] Portraits of the monarch for distribution to foreign embassies, for propaganda at home, for the affirmation of the ruling dynasty, and for the identification of potential royal spouses are all well documented as essential to the conduct of the English court in the sixteenth and early seventeenth centuries. Holbein was employed by Henry VIII to paint his famous dynastic wall-painting with portrait figures at Whitehall Palace, and was also sent abroad to produce portraits of potential wives. Most, if not all, of the rest of his work seems to have been produced for private clients.

Van Dyck too had a large private clientele, and painted a number of religious and secular pictures for his royal employers, but also numerous portraits, his 'Great Peece' perhaps echoing Holbein's painting, then still extant.[71] Others, however, undertook some of the traditional tasks. When portraits of the King and Queen of France were to be made, Jan Belcamp, one of the painters named in the petition supported by the Painter-Stainers Company, was sent abroad to do them, and it was Belcamp who painted a number of imaginary portraits of royal ancestors.[72] However, Van Dyck did make at least two of the full-length copies of dead ancestors that seventeenth-century court painters such as Belcamp and Daniel Mytens were

instructed to produce.[73] He also restored pictures, as some Serjeant Painters, such as Fryer and De Critz, were entrusted to do.[74]

Although from the reign of Henry VIII to that of Charles I several Serjeant Painters are documented as painters of pictures – for instance, Antonio Toto, George Gower, Robert Peake and John De Critz[75] – none were members of the Painter-Stainers Company. Of these only Gower and Peake were of English descent. It is debatable whether this reflects a change in the requirements of the Serjeant Painter's post which may then have resulted in it being much less frequently held by a member of the Company. Certainly Peake and De Critz produced portraits for their royal employers while Serjeant Painters. Gower may also have done so, thus filling much of the gap between Holbein and Van Dyck: the draft patent drawn up in his favour would have allowed him a monopoly on all forms of royal portrait bar limning, but leaves open the question of whether this was actually part of his duties; certainly he was expected to oversee the quality of others' portraits.[76]

There are a few indications that some of the other Serjeant Painters – Wright, Herne and Fryer – may have had figurative skills of a kind,[77] and this may have applied to a number of the members of the Painter-Stainers Company employed on decorative projects at court. Yet the bias towards heraldic painting in the Painter-Stainers Company from the sixteenth to the seventeenth centuries was strong. Not only were there the numerous heralds' disputes, signalled in the 1578 petition, which became especially fierce in the early seventeenth century,[78] there is other evidence to suggest that a number of Painter-Stainers were specialised heraldic painters. The Serjeant Painter John Brown's will refers to his heraldic books and his 'colours silke or golde'.[79] Many Painter-Stainers worked supplying heraldry to the City pageants.[80] The Master of the Company in 1636, Thomas Babb – who worked at court – was one of a number of painters agreed as official heraldic painters.[81]

The strongest indication that in the second half of the sixteenth century members of the Painter-Stainers Company were producing portraits lies in the fact that they petitioned against the unregulated production of those of poor quality, which were presumably in competition with their own.[82] There is otherwise little evidence that Painter-Stainers in the sixteenth and early seventeenth centuries were 'picture-makers' in the sense in which the term is understood today,[83] or had the training to be so: a seven-year term of apprenticeship was set out in the 1581 Charter, but no detailed schedule of the training is given.[84] By the early seventeenth century however, there

began to be a rapprochement between the Company and painters outside it, many of whom were undoubtedly 'picture-makers' in the modern sense, but who sometimes seemed to have belonged to other City companies. This is clearly reflected in the joint petition against foreign painters at court of 1627, with which this essay began, and in the cases of the painters who, over the next decade or so, subsequently decided to join the Company. They included several of the most prominent painters of pictures of this period: Richard Greenbury, a member of the Goldsmith's Company; John Eycke, Gilbert Jackson, Robert Walker and Edward Bower.[85]

In his *The Boke Named the Gouernour* of 1531 Sir Thomas Elyot complained that the English 'be constrayned, if we wyll have any thinge well paynted, kerved, or embrawdred, to abandone our own countraymen and resorte unto straungers'.[86] Elyot's complaint about the paucity of native talent is echoed by the Company itself in its petition of 1575, complaining that poor workmanship was 'a great discouraging to divers forward young men verie desirous to travell for knowledge in the same'.[87] It was natural for the London Company of Painter-Stainers energetically to continue over two centuries to defend its interests against foreigners, heralds, and others outside the Company who might infringe on its members' livelihoods. However, between the visits of Holbein and Van Dyck, the demand for pictures in England appears greatly to have increased, not just at court but also in the country.[88] It was a demand that was evidently being supplied not only by foreigners, but also by native painters outside the Painter-Stainers Company, some of whom may have trained abroad in countries such as Holland.[89] The Company had evidently yet to come to terms with this, for it would only have been by encouraging training in picture-making that it could hope to provide a native alternative of quality to the foreigners listed in the petition of 1627; even thirty years later it was refusing to allow its premises to be used for life-drawing.[90] The consolidation with painters outside the Company in supporting the petition rather than the maintenance of exclusivity is perhaps an indication of the way forward. But it would be another half century before English painters were receiving the training they needed to compete effectively at court or elsewhere with the foreigners.[91]

APPENDIX

The members of the
London Painters-Stainers Company in 1537

The painters are listed in the order in which their names occur in a list of the Company (and of other London Companies) of 1537, PRO E 36/93 fos. 11v ff (printed in Edward Salisbury, 'List of Liverymen and Freemen of the City Companies, A.D. 1538', *Middlesex and Hertfordshire Notes and Queries*, Vol. III 1897, pp. 39–43, 80–2, 97–8, 151–4). A (1) against the name means that it is recorded in the accounts for the Banqueting House in the 1527 Greenwich revels preparations, PRO E 36/227; a (2) refers to the accounts for the Greenwich Theatre in 1527, PRO SP 2/Folio C, fos. 321r–355v, SP 1/41, fos. 234r–271v or BL Egerton MS 2605 fos. 1r–14r.

Name	Notes
Thomas Alysaunder	Worked on funeral of Henry VII[1]
Richard Callard	Named in John Brown's will[2]
John Smyth (1)	
John Hethe	Worked on many royal projects[3]
Richard Rippingale (2)	Worked on revels in 1508[4]
Thomas Prior (1)	
Andrew Wright	Serjeant Painter 1532–44
Richard Gates	Named in John Brown's deed of 1532[5]
Richard Lane	Named in John Brown's deed of 1532
Humphrey Harcourte	
Robert Wrythoke (2)	Also supplied materials
Davy Martyn	?Relative of Peter Marten (listed below)
William Lucas (1)	Named in John Brown's deed of 1532: see note 5
Thomas Cristyne (1)	Named in John Brown's deed of 1532: same or relative of supplier of heraldry to court[6] of the same name
Richard Hale	
William Calton	Involved in law-suit in 1548[7]
John Wysedom	Named in 1549 deed[8]
Thomas Hilton (1)(2)	
Guy Benet (1)	

John Parys
John Child (1) Named in John Brown's will: see note 2
William Blakmore
Robert Rowse Painter at Whitehall in 1531[9]
Ffowk a Conwey
Hugh Ewyn
Davy Palne
Laurence Underwood
John Asplyn
Geffrey Brown
Richard Welshe (1)
William Camden (1) Identical with William Carden?[10]
John Grenwood (1)
William Chessherd
John Leeds Worked on many royal projects[11]
Thomas Spencer Named in 1549 deed: see note 8
Walter Grome (2) Worked on later revels[12]
Thomas Cobbe Named in 1549 deed and 1578 petition[13]
Thomas Bulloke Painter at Whitehall 1531[14]
Guy Cobage (1) Worked on 1508 revels[15]
Henry Lord (1)(2)
Thomas Bucle
George Dauntry
George Byrrell
John Feltis Named in 1549 deed: see note 8; supplier
 of heraldry to court[16]

Thomas Clerke

Nicholas Rogerson
John Pegryme (1)(2) Named in Volpe's will[17]
John Wolmote (1)(2) Perhaps relative of Roger Wilmot[18]
Nicholas Wolmote (1) Perhaps relative of Roger Wilmot
James Trevisan (1)(2)
Thomas Gybson
Thomas Overed
Peter Marten Painter at Whitehall 1531[19]

Notes (to appendix)

1 PRO LC 2/1 fol. 100v; painter of same name listed in 1549 deed: see note 8.
2 PRO PROB 11/24, 1532.
3 Auerbach *Tudor Artists*, London 1954, p. 167; named in 1549 deed: see note 8.
4 PRO LC 9/50, fol. 144v.
5 Deed passing ownership of Company's Hall from John Brown to Company, Guildhall Library MS 5670, no. 14.
6 LC 9/150f, 137v.
7 Auerbach, *Tudor Artists*, p. 156.
8 Deed conveying ownership of Company's Hall in 1549 to named members of Company: Guildhall Library MS 5670, no. 16.
9 Auerbach, *Tudor Artists*, p. 183.
10 For Carden, see Auerbach, *Tudor Artists*, p. 156.
11 Auerbach, *Tudor Artists*, pp. 156, 174.
12 Auerbach, *Tudor Artists*, p. 166.
13 1578 petition PRO State Papers 12/125 no. 28, fos. 59r–60v.
14 Auerbach, *Tudor Artists*, p. 155; also in 1549 deed: see note 8.
15 See note 4.
16 LC 2/1 fols. 181v, 132v.
17 Auerbach, *Tudor Artists*, pp. 140–1.
18 LC 2/1 fol. 18v.
19 Auerbach, *Tudor Artists*, p. 176.

Notes

1 Guildhall Library, MS 5667 fo. 124, 22 November 1637.
2 W.A.D. Englefield, *The History of the London Company of Painter-Stainers*, London, 1923, pp. 81–2.
3 Mary Edmond, 'Limners and Picture Makers', *Walpole Society*, 47 (1978–80), pp. 60–242, p. 203 note 296 and pp. 64–5.
4 Guildhall Library MS 5667, fo. 28, 8 March 1627 (1626 Old Style) and fos. 61, 91, 110.
5 Edward Hall, *The Union of the Two noble and illustre Famelies of Lancastre and York (Hall's Chronicle)*, Henry Ellis ed., London, 1809, pp. 586–91.
6 Englefield, *Painter-Stainers*, p. 21.
7 Diane Wolfthal, *The Beginnings of Netherlandish Canvas Painting: 1400–1530*, Cambridge, 1989, pp. 6–7.
8 Englefield, *Painter-Stainers*, p. 46.
9 *Ibid.*, pp. 51–3, 57–65.

10 Guildhall Library MS 5667.

11 Guildhall Library MS 5670 nos. 12, 13, 14, 15, 16, 17 and 18 and PRO State Papers 12/125, no. 28, fos. 59r–60v.

12 See appendix.

13 *Hall's Chronicle*, p. 587.

14 Erna Auerbach, *Tudor Artists*, London, 1954, Edward Croft-Murray, *Decorative Painting in England 1537–1837*, London, 1962, and Edmond, 'Limners' all provide copious references to court painters in Tudor and Early Stuart England; see also *History of the King's Works*, H.M. Colvin ed., 6 vols., London, 1982, IV, *1485–1660* (part II). For the first half of the sixteenth century especially I have, where possible, checked these published references against my own transcriptions of the relevant royal accounts.

15 Andrew Martindale, *The Rise of the Artist*, London, 1972, ch. 2, especially pp. 50–2.

16 David Park, 'Wall Painting', in *The Age of Chivalry*, Jonathan Alexander and Paul Binski eds., Royal Academy, London, 1987, pp. 127–8.

17 Lorne Campbell, 'The Early Netherlandish Painters and their Workshops', in *Le problème Maître de Flémalle-van der Weyden*, Dominique Hollanders-Favart and Roger van Schoute eds., Le dessin sous-jacent dans la peinture, colloque 3, Louvain-la-Neuve, 1981, pp. 43, 45.

18 For example, Gilbert Prince and Richard II, John Harvey, *Gothic England*, 2nd edn, London, 1948, p. 62; also Thomas Rede and Henry VII, Englefield, *Painter-Stainers*, pp. 42, 221 and Auerbach, *Tudor Artists*, p. 7.

19 See appendix.

20 In 1532 the names recorded on royal work are: John Brown, Richard Rypyngale, Thomas Alexander, John Hethe, Richard Gates, Andrew Wright, Thomas Crystyne, William Lucas and Robert Cope. In 1549: Thomas Alexander, John Hethe, William Lucas and John Feltes. In 1578: John Byrd, John Knight and Richard Scarlett. In 1580 the names are the same as in 1578, minus John Knight. In 1605: Richard Scarlett, John Knight, Samuel Goodricke, John Lover and Pawle Isackson.

21 Croft-Murray, *Decorative Painting*, p. 184.

22 Sydney Anglo, *Spectacle, Pageantry and Early Tudor Policy*, Oxford, 1969, pp. 209–25, Susan Foister, 'Holbein and his English Patrons', unpublished Ph.D. thesis, University of London, 1981, pp. 218–33, and *Henry VIII: a European Court*, David Starkey ed., National Maritime Museum Greenwich, 1991, especially essays by Susan Foister, pp. 58–64, and Simon Thurley, pp. 64–70.

23 David R. Ransome, 'The Administration and Finances of the King's Works 1485–1558', unpublished D.Phil. thesis, University of Oxford, 1960, and *History of the King's Works*, H.M. Colvin, D.R. Ransome, J. Summerson eds., III, *1485–1660* (part I), London, 1973.

24 W.A. Shaw, 'An Early English Pre-Holbein School of Portraiture', *The Connois-*

seur, 31 (1911), pp. 72–81; also T.F. Tout, *Chapters in the Administrative History of Medieval England*, 6 vols., Manchester, 1920–33, IV, p. 391.

25 PRO C66/1666, unnumbered membranes, and Auerbach, *Tudor Artists*, p. 143.

26 Auerbach, *Tudor Artists*, pp. 144–9.

27 Sylvia Thrupp, *The Merchant Class of Medieval London*, Ann Arbor, 1948, pp. 33 and 5.

28 PRO LC 2/1 fos./145v, 148r, 174r for funeral payments, BL Add MS 21481 fo. 136r for the pope's arms.

29 PRO State Papers 2/Folio. C fol. 329v.

30 Wright's will PRO PROB 11/29/20; for Greenwich PRO State Papers 1/41 fos. 247v–250r.

31 BL Lansdowne MS 105 no. 37, transcribed by Auerbach, *Tudor Artists*, appendix 1, p. 142 (with the misreading 'lres' for 'licence'), also pp. 14, 109.

32 Bodleian Library MS. Eng Hist b 192/1, fo. 7v.

33 Englefield, *Painter-Stainers*, pp. 222–3.

34 Croft-Murray, *Decorative Painting*, p. 156, Edmond, 'Limners', p. 177.

35 For instance, Robert Wrythoke: see appendix.

36 David Ransome, 'Artisan Dynasties in London and Westminster in the Sixteenth Century', *Guildhall Miscellany*, 2 (October 1964), pp. 236–47.

37 For Arthur and Peter Cutler, see Auerbach, *Tudor Artists*, pp. 161 and 80; for Arthur and Glawde, see Croft-Murray, *Decorative Painting*, p. 190, where see also the reference to a Glawde Cutler in 1509; for John Cutler, see Edmond, 'Limners', p. 183.

38 For the Isaacksons (Richard, Paul and Henry) as Painter-Stainers, see Englefield, *Painter-Stainers*, p. 222; for Paul, Richard and George Isaackson and the court, see Croft-Murray, *Decorative Painting*, pp. 204, 205 and 181; for Paul Isaackson's will, see Edmond, 'Limners', p. 213, n. 546; for Richard Isaackson's will, where John Potkin is mentioned, see PRO PROB 11/137/7, and for John Potkin as a Painter-Stainer in 1627, see Guildhall Library MS 5667 fo. 28; for Christopher Potkin as a Painter-Stainer in 1605, see Guildhall Library MS 5670 no. 18.

39 Edmund, 'Limners', p. 177, Auerbach, *Tudor Artists*, p. 193, and Guildhall Library MS 5670 nos. 14 and 16.

40 For Lancelot Hethe and a George who may also be a son, see Croft-Murray, *Decorative Painting*, p. 160, also Auerbach, *Tudor Artists*, p. 167; PRO State Papers 12/125 no. 28 for Lancelot, and Guildhall Library MS. 5670 no. 18 for George.

41 For Thomas and William Child, ?sons of John Child, see Croft-Murray, *Decorative Painting*, p. 158.

42 For John and Reynold Fryer, probably relatives but apparently not sons of Leonard Fryer, see Croft-Murray, *Decorative Painting*, pp. 178 and 179 (and Edmond, 'Limners', p. 185, for sons recorded in Fryer's will).

43 For Matthew Goodricke and his son Samuel, see Edmund, 'Limners', pp. 175–6

(with reference to Matthew as a Painter-Stainer) and Guildhall Library MS 5670, no. 18, for Samuel.

44 For William Pierce see Edmond, 'Limners' p. 183, and for Edward see Croft-Murray, *Decorative Painting*, p. 206.

45 Auerbach, *Tudor Artists*, pp. 16–17, 145.

46 *Ambassades de Messieurs de Noailles en Angleterre*, M. l'Abbé de Vertot ed., 5 vols., Leyden, 1763, II, p. 255; I am grateful to Lorne Campbell for this reference.

47 Edmond, 'Limners', pp. 185, 186; a widow Fryer mentioned in Guildhall Library MS. 5667 fo. 17 in 1625 might conceivably be the widow of the Serjeant Painter.

48 Edmond, 'Limners', pp. 150 and 129.

49 *Hall's Chronicle*, p. 587.

50 Sylvia Thrupp, 'Aliens in and around London in the Fifteenth Century', in *Studies in London History*, A.E.J. Hollander and W. Kellaway eds., London, 1969, pp. 251–72.

51 Edmond, 'Limners', pp. 134–52, Margaret Whinney, *Sculpture in Britain 1530–1830*, Harmondsworth, 1964, pp. 12–23.

52 Ransome, 'Artisan Dynasties', also Lorne Campbell and Susan Foister, 'Gerard, Lucas and Susanna Horenbout', *Burlington Magazine* 127 (1986), pp. 719–27.

53 PRO PROB 11/28/27; for Hone, see Ransome, 'Artisan Dynasties', p. 239.

54 PRO PROB 11/52/18.

55 Croft-Murray, *Decorative Painting*, pp. 182, 190 and 191, Edmond, 'Limners', p. 178, 183.

56 Edmond, 'Limners' pp. 167–74 and for Emanuel De Critz see p. 160.

57 *Statutes of the Realm*, 11 vols. in 12, London, 1810–28, III, p. 208 (14 & 15 Henry VIII c.2); p. 297 (21 Henry VIII c.16); p. 765 (32 Henry VIII c.16).

58 Campbell and Foister, 'Horenbout', p. 722.

59 BL Harleian MS 1099, no. 29 fos. 79r–80r. This petition has been variously dated from 1625 to after 1660, but probably dates from before 1640 on the evidence of the script: I am most grateful to Frances Harris of the British Library for her opinion.

60 Oliver Millar, 'Van Dyck in London' in *Anthony Van Dyck*, Arthur K. Wheelock and Susan J. Barnes eds., National Gallery of Art, Washington, 1990, pp. 53–8, p. 56, and Christopher Brown, *Van Dyck*, Oxford, 1982, pp. 215–16.

61 BL Lansdowne MS 20 no. 9.

62 Englefield, *Painter-Stainers*, pp. 75–6, 101.

63 BL Harleian MS 1099.

64 For Greenbury and others who joined the Company, see Croft-Murray, *Decorative Painting*, p. 204, and Margaret Whinney and Oliver Millar, *English Art 1625–1714*, Oxford, 1957, p. 81, also note 80 below.

65 Whinney and Millar, *English Art*, pp. 75, 81, also Croft-Murray, *Decorative Painting*, pp. 204, 207.

66 Martindale, *Rise of the Artist*, pp. 35–46.

67 Erna Auerbach, 'Vincent Volpe, the King's Painter', *Burlington Magazine*, 92 (1950), pp. 222–7.

68. Catherine Macleod, 'Guillim Scrots', unpublished MA thesis, Courtauld Institute, London, 1990.

69 Whinney and Millar, *English Art*, pp. 4–5, and O. Millar, *The Age of Charles I*, Tate Gallery, London, 1972.

70 Lorne Campbell, *Renaissance Portraits*, London and New Haven, 1990, pp. 196–208.

71 Brown, *Van Dyck*, pp. 164–5, Whinney and Millar, *English Art*, pp. 73–4.

72 Whinney and Millar, *English Art*, p. 74, note 2, and Oliver Millar, *Tudor, Stuart and Early Georgian Pictures in the Collection of Her Majesty the Queen*, 2 vols., London 1963, pp. 111–12.

73 Millar, *Tudor, Stuart*, pp. 92–3, and Whinney and Millar, *English Art*, pp. 61, 74 note 2.

74 Whinney and Millar, *English Art*, p. 69 note 3, and Edmond 'Limners', p. 185 and pp. 173–4.

75 Auerbach, *Tudor Artists*, pp. 16–17, 145, J.W. Goodison, 'George Gower', *Burlington Magazine*, 90 (1948), pp. 261–5; Roy Strong, *The English Icon*, London, 1969, pp. 225–54 and pp. 259–68.

76 BL Cotton charter IV 26; J.R. Dasent, *Acts of the Privy Council of England*, N.S., 26, London, 1902, p. 69.

77 Bodleian Library MS Rawlinson D 775 fo. 186, Croft-Murray, *Decorative Painting*, p. 181, Edmond, 'Limners', p. 185.

78 PRO State Papers 12/125 no. 28, Englefield, *Painter-Stainers*, pp. 81–2.

79 PRO PROB 11/30/14.

80 Croft Murray, *Decorative Painting*, pp. 188–91 and 213–15.

81 Englefield, *Painter-Stainers*, p. 82, Croft-Murray, *Decorative Painting*, p. 193.

82 BL Lansdowne MS 20, no. 9.

83 See Croft-Murray, *Decorative Painting*, p. 178, for a heraldic work executed by Peter Cole, described as a picture-maker, which urges caution in the interpretation of the term.

84 Englefield, *Painter-Stainers*, pp. 62–3.

85 Croft Murray, *Decorative Painting*, p. 19, J.W. Goodison, 'John Eycke – A Seventeenth Century English Portrait Painter', *Burlington Magazine*, 73 (1938), p. 125 and Whinney and Millar, *English Art*, pp. 75, 81, 76–7 and 79.

86 Sir Thomas Elyot, *The Boke Named the Gouernour*, H.H.S. Croft ed., 2 vols., London, 1883, I, pp. 139, 140.

87 BL Lansdowne MS 20 no. 9, fo. 22.

88 Compare Susan Foister 'Paintings and Other Works of Art in Sixteenth Century English Inventories', *Burlington Magazine*, 123 (1981), pp. 273–82, and 'Staf-

fordshire Inventories – Lichfield and District 1568–1680', P.G. Vasey ed., *Staffordshire Records*, 4th series, 5, 1969.

89 Ellis Waterhouse, *Painting in Britain 1530–1790*, 4th edition, Harmondsworth, 1978, p. 61 and note 11.

90 Englefield, *Painter-Stainers*, p. 115.

91 Ilaria Bignamini, 'George Vertue, Art Historian and Art Institutions in London 1689–1768', *Walpole Society*, 54 (1988), esp. pp. 21–30.

4

THE ETCHINGS OF JOHN EVELYN

Antony Griffiths

The thirteen recorded etchings made by John Evelyn have found only two students. The first was Horace Walpole, who devoted a long section to them in his *Catalogue of Engravers*; the second, a century and a half later, was the bibliographer of English printmaking, Howard C. Levis.[1] The neglect is not surprising. No one could claim that they are masterpieces, and printmaking has played a small role in studies on seventeenth-century British art – not even in Sir Oliver Millar's work. What scholarship there has been in the field has tended to concentrate on engraving. Thus Sidney Colvin's pioneering study explicitly omitted etching and woodcut, and A.M. Hind's later three-volume work followed in Colvin's footsteps.[2] Indeed, there is still something of a hiatus in the literature on printmaking between the end of Hind's trilogy in the 1630s and the studies on the new technique of mezzotint in the 1680s, which has only recently been partly filled by Alexander Globe's remarkable study of the printseller Peter Stent.[3]

Evelyn's prints are not the simple curiosities that Walpole imagined. They are among the earliest etchings made by an Englishman, and their study reveals the existence of a short-lived English school of etching in the mid-seventeenth century. They are the first prints made by an amateur in this country, and thus stand at the beginning of a tradition that was to become of some significance.[4] Finally, they are the first landscape prints made by an Englishman.

The starting-point is the prints themselves, of which all but two belong to two sets: these I shall call for brevity's sake the London and Paris sets. The London set (numbers 1 to 5 in the appended catalogue; figs. 6–8) consists of four imaginary landscapes and a titleplate with a dedication to Lady Isabella Thynne. It is dated 1649, and bears the address of the publisher Thomas Rowlett in London. They are so unlike the prints in the Paris set that they

6 John Evelyn, Titleplate, *Landscape with Roman ruins*

7 John Evelyn, *Landscape with Tobias and the angel*

8 John Evelyn, *Landscape with peasant and donkey*

may be copied from French prints, for they are somewhat like the composi-
tions of Henri Mauperché. This type of semi-Dutch landscape issued in sets,
with only few identifiable subjects (*Tobias and the angel* in this case) is very
typical of French work of the period, as can be seen in the work of Gabriel
Perelle or his sons Adam and Nicholas. But neither I nor Maxime Préaud of
the Bibliothèque Nationale, who knows the prints of this period better than
anyone, have succeeded in finding a prototype.

The second set (cat. 6 to 11; see figs. 9–13) is of six small views between
Rome and Naples. This has the name of one R. Hoare as publisher, and a
long Latin and Greek dedication: 'Sketches and examples of a number of
famous and renowned places between Rome and Naples; these first worth-
less sheets engraved and printed by etching are dedicated to Thomas Hen-
shaw of England, an admirer and strong proponent of all outstanding and
famous arts and himself a fellow eyewitness, by John Evelyn, their drafts-
man, not on account of their worth but as a singular testimony of his regard.'
There can be no doubt that Evelyn was accurate in claiming these as his own
compositions, for a preparatory drawing in his hand for cat. 8 (fig. 11)
survives in the British Museum.[5] All would have been drawn on the spot in
the fortnight between 28 January and 11 February 1645,[6] when Evelyn,
accompanied by Henshaw, made a tour south from Rome to see Naples and
its surrounds. Although the *Diary* does not record the making of drawings at

9 John Evelyn, Titleplate, *Putto with tablet before view in Roman forum,*
with arch of Septimius Severus

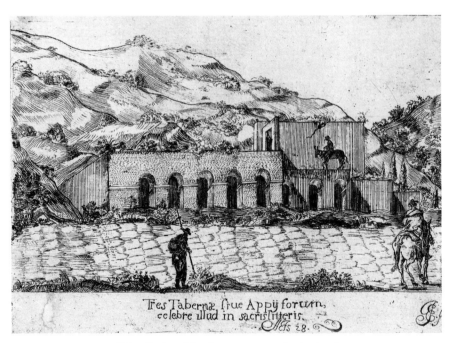

10 John Evelyn, *The three taverns or the Appian forum*

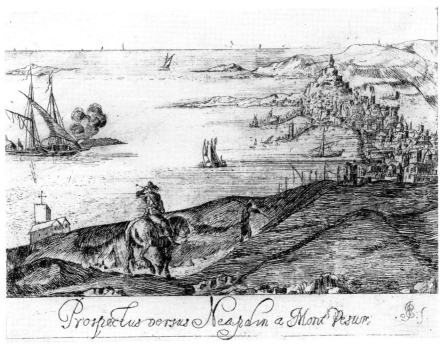

11 John Evelyn, *View of Naples from Vesuvius*

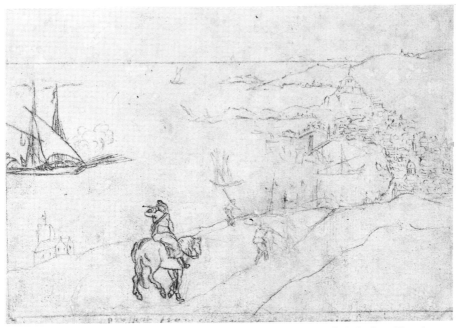

12 John Evelyn, Preparatory drawing for the etching *View of Naples from Vesuvius*

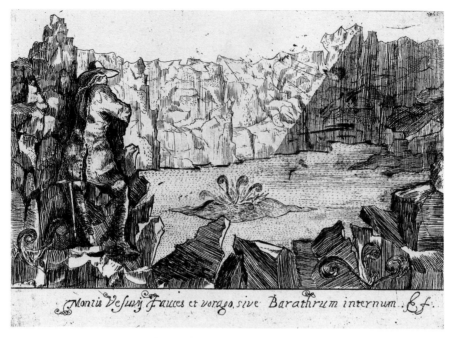

Montis Vefuvij Fauces et vorago, sive Barathrum internum . F.f.

13 John Evelyn, *Crater of Mount Vesuvius*

this time, the entry for 2 November 1644 records his visit to Monte Pientio in Tuscany, where he dined at the inn, and 'with my black lead pen took the prospect'. This is important early evidence for the practice of amateur drawing which can be added to the evidence for amateur painting assembled by Sir Oliver Millar.[7]

The prints themselves are undated, but Walpole published an interesting letter sent to him by the collector Nathaniel Hillier (1707–83), who argued strongly (and utterly convincingly) that Evelyn himself was the etcher, and not R. Hoare as some had supposed, and noted that a set of the prints in his own possession (which cannot now be located) was inscribed in pen 'my journey from Rome to Naples' and in black lead pencil 'sculpsit Johannes Evelynus Parisiis 1649'. This is confirmed by an unpublished letter dated 20 June 1650, in which Henshaw in London thanks Evelyn in Paris for the dedication of the set.[8]

Thus both sets of prints belong to 1649; one was made in London, the other in Paris. But disappointingly there is no reference to any of his own prints in Evelyn's *Diary*. The starting-point for further investigation must

be the surprising fact that both sets were published. This is not the most obvious proceeding for an amateur, who would normally print a few sets for distribution to select friends, but modestly shun anything approaching a public exposure. Publication in the seventeenth century involved handing the plates over to another party, who, by putting his name and address on the plates, ensured that potential purchasers knew where to buy impressions. Who then were Evelyn's trusted agents, Thomas Rowlett and R. Hoare, neither of whose names can be found in the only modern study of seventeenth-century British print publishers?[9]

Thomas Rowlett gives his address on his plates as a 'shop neere Temple Barre', that is, presumably in the Strand. He was no book publisher: among the standard works on seventeenth-century publishing, Wing has only one reference and that to a set of prints.[10] The assumption therefore is that he was purely a print publisher, and with the help of Globe and a search of the British Museum collection, the following list of his publications can be produced:

1 Portrait of Endymion Porter, engraved by William Faithorne after William Dobson (Globe 133)
2 Portrait of Prince Rupert, engraved by Faithorne after Dobson (Globe 274)
3 Portrait of Charles II as Prince of Wales, engraved by Faithorne after Dobson
4 Portrait of Sir Thomas Fairfax, engraved by Faithorne after Robert Walker (Globe 139)
5 Self-portrait of William Dobson etched by Josiah English (Globe 111)[11]
6 Isaac de Caus, set of twenty-seven etched plates of the gardens at Wilton House (Globe 563)
7 Frans Cleyn, set of seven Liberal Arts, etchings 1645 (Globe 433)
8 Frans Cleyn, set of ten *Varii Zopharii*, etchings 1645 (Globe 554)
9 Edward Pearce, set of twelve (or sixteen) grotesques, etchings 1647 (Globe 556)[12]
10 John Evelyn, set of five landscapes, etchings 1649.

All of these plates must belong to the 1640s, for by 1650 or soon after Rowlett had sold up. Almost all his plates were acquired by Thomas Hinde 'at the Black Bull in Cornhill nere the Royall Exchange', who in his turn ceased business around 1652/3, after which his plates were acquired by that ubiquitous remainderer, Peter Stent.[13] This history establishes that Evelyn's

prints were indeed published by Rowlett in 1649, since he went out of business too soon to have added his name to a restrike at a later time.

The originality of Rowlett's output is startling, for no other London publisher of the time had a stock anything approaching his. Unlike his nearest competitor Hinde, none of Rowlett's plates was a restrike, and all were the most advanced work made in England at the time. Rowlett was a quite new phenomenon in British print publishing, and since his published output seems too small to found a business, we might guess that he also had a stock of the most up-to-date prints imported from abroad.

Two further points of interest emerge from studying Rowlett's production. The first is the close link with William Dobson. This is proven by studying Faithorne's *œuvre*.[14] Faithorne was apprenticed for ten years to William Peake in 1635, and after his death in 1639 maintained his connection with his son Robert, who published some of Faithorne's early plates at his 'shopp near Holbourne Conduitt'. In 1645 Faithorne was in the garrison at Basing House under Peake's command along with Hollar, Inigo Jones and other royalist artists. The sixteen Faithorne plates that Peake published were all after Van Dyck or Faithorne's own drawings. But Faithorne also engraved three plates after Dobson, and one after Walker, and it is surely significant that it was precisely these plates, and only these plates, that were published by Rowlett. The only possible explanation is that Rowlett and Dobson were close associates, and that Faithorne's engravings were promoted by the pair of them in such a way as to cut Peake out as publisher.[15] Since Dobson had also been a Peake apprentice, his link with Rowlett has to be seen as a conscious decision.

The second point of interest is the association between Rowlett and etching. The important figure here is Francis Cleyn, the Netherlands-trained artist who settled in London in 1625 after spending the previous fifteen years in Italy and Denmark. He would have learned to etch abroad, and it is curious that it took twenty years after his settling in London for him to make his first set of etchings. The existence of Rowlett may have prompted this. Significant too is the etching Rowlett published after a Dobson self-portrait by 'J.E.', who has to be identified as Josiah English, a Mortlake associate of Cleyn. This is probably a memorial plate made after Dobson's death in 1646, and the choice of etching is of importance as it associates Dobson with continental etched portraits, represented most notably by Van Dyck's *Iconography* and Morin's contemporary portraits after Philippe de Champaigne, rather than the traditional English engraved portraits.

It is difficult to realise just how backward British print production was

before the 1640s when compared with the Continent. In Italy, the Netherlands and France, the range of print production was already very wide and sophisticated. The medium was being regularly used to reproduce designs by the leading painters, to record great events, the appearance of places and costumes, to illustrate books, to promulgate patterns to inspire designers and, above all, to create works of art in their own right. In Britain, as anyone who examines Hind's three volumes will sadly acknowledge, the only real use found for it was for portraiture and titlepages. On the Continent, etching had already been widely practised for a century; in Britain it was almost unknown before 1640.

Yet the under-developed print market co-existed with a standard of connoisseurship in painting and sculpture that matched anything on the Continent. The 1640s, I would like to argue, is the decade when this expertise began, however dimly, to affect native British printmaking, and Rowlett's production is the most significant evidence for this. The fashion for etching spread beyond Cleyn and his associates English and Carter to Fuller, Gaywood, Barlow and others. In this process Hollar and Hendrik van der Borcht must have played an important part. Hollar had arrived in the train of the Earl of Arundel in 1636.[16] But as a member of Arundel's household there was no need for him to work for London publishers, and I can find no evidence that any of his output went through their hands before 1641. In this year Robert Peake published the three-quarter length *Seasons*; in 1642 Hendrik van der Borcht published two reproductive plates after old master drawings; and in 1644 Stent may have put out the half-length *Seasons* before Hollar left for Antwerp:[17] that is all, if we ignore a few trivial or uncertain items. But even if he acted as his own distributor, his work must have been well known in London.

Evelyn, for one, certainly knew it. Arundel was a close neighbour, Wotton being a few miles from Albury, and they met in the Netherlands in 1641 and again in Padua in 1645. On 28 June 1641 Evelyn had his portrait painted by Hollar's associate Hendrik van der Borcht, and in 1644 Hollar dedicated to him his etching after a Van Dyck self-portrait. This provides a *terminus ante quem* for their acquaintance, and shows that Evelyn was already interested in printmaking. This interest can be tracked through his continental tours, when he began to assemble his print collection. The residue of this was unfortunately sold in 1977,[18] but Evelyn's own catalogue of his collection, which survives unnoticed and unpublished,[19] shows that it was vastly larger than the 1977 catalogues would suggest. Annotations on the prints, and his letters and references in the *Diary* show that he had bought some in the Low

Countries in 1641, more in Paris in 1643, and others in Rome in 1645.[20] He pursued this interest on his return there in 1649: the *Diary* for 30 April 1650 records 'I went to see the collection of the famous sculptor Steffano de la Bella, returning now into Italy, & bought some prints; & visited Perelle the landskip graver.'[21]

Thus, when he returned to England in September 1647 he already possessed enough of a collection of prints to give him a secure place among those interested in the subject at the time. His *Diary* shows that he pursued his artistic interests – and doubtless continued to expand his print collection – in the twenty-two months until his return to Paris in July 1649. There are numerous notes of his visits to see private collections, and records of works that particularly struck him. On 28 February 1648 he went to Thistleworth where he saw Sir Clipsby Crew's collection which included 'a very good chimny-piece of water colours don by Bruegle which I bought for him'. On the first of January the following year he visited his old friend Thomas Henshaw, where he saw some perspectives by Steenwyck. On 15 February he went to see the collection of one Friars, 'from whence to other virtuosos', namely Le Neve, Webb, Du Bois, Belcamp and Ducie. On 12 May he met Endymion Porter when viewing Geldorp's collection, and on 19 May saw the 'rare cabinet of one Delabarrs'.

It is to this year that Evelyn's etchings belong. The set of ideal landscapes published by Rowlett was dedicated to Lady Isabella Thynne (1623–57), daughter of Henry Rich, 1st Earl of Holland. He had been beheaded as a royalist on 9 March 1649, which merited an entry in Evelyn's *Diary*: 'Now were the Lords murder'd in the Palace Yard.' According to de Beer's notes,[22] Lady Isabella left for France in June 1649, and the set was therefore probably dedicated to her between March and June. She was herself a prominent royalist, and such a dedication was an obvious mark of defiance towards the new regime.

On 20 June 1649 follows an entry that is of great significance for our study: 'I went to Puttny & other places on the Thames to take prospects in crayon, to carry into France, where I thought to have them engrav'd.[23] These drawings do not survive and the set seems never to have been completed. There is very strong evidence, however, that one plate was etched by Evelyn himself (see cat. 13 p. 65), despite the fact that no impression can now be located. This shows not only that printmaking – in this case a set on the topography of the Thames – was very much on his mind in these months, but that he viewed the matter as being of some consequence.

Just over three weeks later, on 12 July, he departed for France, having

been visited the previous day by 'Mr Henshaw, Mr Scudamore, and other friends', who had come to take their leave. The entry for 12 July noted: 'I carried over with me my servant Ri. Hoare, an incomparable writer of several hands, whom I afterwards preferr'd in the Prerogative Office, at the return of his Majesty.' This identifies the publisher of the second Paris set of Evelyn's etchings, and explains why no Richard Hoare is to be found in any reference work relating to the book or the print trade. Fortunately Hoare, although only mentioned twice in the *Diary*, is not an entirely shadowy figure, thanks to his work on Evelyn's library and in the surviving letters which he sent to him. On the titlepage of one of the catalogues he drew up for Evelyn, he signed himself 'Ricardus Hoare, Authoris Bibliothecarius, Amanuensis, Famulusque', which establishes his role as Evelyn's secretary, librarian and factotum.[24]

A letter he sent from Paris on 9 July 1650 refers to the famous engraved portrait that Evelyn commissioned from Robert Nanteuil, from the drawing for which he sat on 13 June: 'Monsieur Nantu: hath begun your plate, and (as he tells mee) it will be most convenient to grave the face last, wherefore you may not expect a proofe as soone as you thought; how ever he is not altogether determined on that matter, and perchance I may send you a proofe of the effigies within this fortnight, or three weeks at the farthest.'[25] In July Hoare writes: 'I shall not faile to order your prints, according to your commands, observing all the method quite throughout. But as I have intimated to you in my former, that your Greate Booke will not hold halfe of them, so I hope you will not be wanting long, for ordering and disposing those which I cannot put in, yourself.'[26] A later invoice dated May 1652, from Bosse, on behalf of work done by himself and Nanteuil for Evelyn, is addressed to Hoare for payment.[27] Thus it is clear that Hoare was the obvious man to handle the distribution of Evelyn's etchings in Paris.

The other important witness to Evelyn's interest in printmaking in these years is his book *Sculptura*, published in 1662.[28] This was presented to the embryonic Royal Society on 16 January 1661 as part of a projected 'Circle of Mechanic Trades' or 'History of Arts Illiberal and Mechanical', but this was somewhat misleading as it is entirely about history and not technique. It has been traditional to dismiss *Sculptura* as empty and worthless, or only to read the pages about the discovery of mezzotint, but this is to miss the point entirely. It is the first manual for the print collector in any language. A modern reader, who has access to Hollstein, does not need to be told (to take a random example) that Lambert Suavius 'set forth 13 prints of Christ and his disciples far better graved than design'd, also the Resurrection of

Lazarus, and a St Paul, which are skilfully, and very laudably handled'. But a student in 1662 not only had no other English-language source for this information, but no source in any other language either. Evelyn, in short, could take some biographical information from earlier books, but the specific documentation of particular prints (with the exception of what he could take from Vasari and from Bosse)[29] had to be gathered from his own print collection or information obtained from fellow collectors and dealers. The *Diary* locates the period of greatest interest in prints in the years between 1644 and 1655, and the compilation of material for *Sculptura* must belong to this period.

The study of seventeenth-century print collecting in Britain and France is still in its infancy,[30] and it is difficult to place Evelyn in a clear context. The same is true of his practice as an etcher. No study has yet been devoted to the beginnings of amateur printmaking, and I can only offer a random gathering of what I have happened to find. There is a woodcut by Marie de' Medici of which she gave an impression to Philippe de Champaigne in 1629.[31] In 1637 Prince Rupert at the age of eighteen etched a beggar in the manner of Callot.[32] Most significantly Louis XIV himself, at the age of thirteen, etched a small square landscape with a bridge and tower. Evelyn himself owned an impression of this, which was inscribed in pen: 'Première ouvrage a leau forte de Louis 14me Roy de france et de Navarre &, faite en lannee 1651 sur la fin.'[33] These two examples suggest that it was already a part of aristocratic education to be instructed in the art of etching.

More significant, perhaps, was the publication in 1645 of Abraham Bosse's *Manière de graver à l'eau-forte en cuivre* (as the titleplate puts it). This was the first such manual ever to be devoted to etching, and was significantly dedicated 'aux amateurs de cet art'. Professionals need no treatises; they learn the techniques as apprentices. It is the amateur printmaker who is addressed by Bosse: 'J'ay pense qui'il ne vous seroit pas desagreable de la voir publiée avec toute la franchise & naifveté qui m'a esté possible, afin que ceux qui voudront commencer à se donner cette sorte d'occupation ou de divertissement, y puissent trouver d'eux-mesmes s'il y a moyen, quelque sorte d'introduction a l'Art.' (I thought that you might be pleased to see it published with all the openness and simplicity that I could manage, so that those who wish to take up this type of occupation or diversion may find in it for themselves, if possible, some sort of introduction to the art.)

Finally, it is worth asking why Evelyn's prints are all landscapes. An answer to this is found in *Sculptura* in the paragraph following his account of the British school of printmakers. He entreats its members first 'to publish

such excellent things as both his Majesty and divers of the Noblesse of this Nation have in their possession', and then continues:

especially, if joyned to this, such as exceed in the talent, would entertain us with more landskips, and views of the environs, approaches and prospects of our nobly situated Metropolis, Greenwich, Windsor and other parts upon the goodly Thames; and in which (as we said) Mr Hollar has so worthily merited, and other countries abound with, to the immense refreshment of the curious, and honour of the industrious artist: and such we farther wish, might now and then be encourag'd to travail into the Levantine parts; Indies east and West; from whose hands we might hope to receive innumerable, and true designes drawn after the life, of those surprising landskips, memorable places, cities, isles, trees, plants, flowers, and animals &c. which are now so lamely, and so wretchedly presented. (pp. 100–1)

In view of what we know of Evelyn's own etchings, this reads very much as an apologia for his own practice. He must have been struck by the plethora of topographical and imaginary landscape prints on the market on the Continent, and the complete absence of anything comparable (excepting Hollar) in England. It was because he was an amateur that he managed so easily to step outside the bounds of the traditions of British print production. It was because he was so earnest that he followed his own logic so far as to have them published.

JOHN EVELYN: CATALOGUE OF ETCHINGS

1–5 *Set of five large landscapes*, London, March–June 1649

GENERAL: all the plates are in pure etching, but have been reworked with the burin. The measurements are in millimetres.

1. Titleplate: *Landscape with Roman ruins.*
On slab across centre: 'Honoratissimae Dominae. / Isabellae Illust: Comitis Holland / filiae: Haec aeri incisa J.E. / devotissimus suae servus, / dat dedicat, consecratq. 1649'. In bottom right margin: 'Sould by Thomas Rowlett att his Shop neere Temple Barre'
Etching. 119 × 188 (image); 123 × 190 (sheet, cut on or inside platemark)

2. *Landscape with Tobias and the angel*
Etching. 130 × 194 (image); 133 × 197 (sheet, cut on or inside platemark)

3. *Landscape with peasant driving a laden donkey*
Etching. 126 × 202 (image); 129 × 205 (sheet, cut on or inside platemark)

4. *Landscape with horseman leading two horses beside a pond*
Etching. 128 × 194 (image); 132 × 197 (sheet, cut on or inside platemark)

5. *Landscape at night with two hunters by a fire*
Etching. 129 × 205 (image); 132 × 208 (sheet, cut on or inside platemark).
There are three burnishing marks in the background.

COLLECTIONS British Museum, 1850–2–23–800 to 804, acquired from Messrs Smith as by Josias English; (formerly) H.C. Levis (ex-Fredk Hendriks) (titlepage only).

6–11 *Set of six small views between Rome and Naples.* Paris, August–December 1649 (arranged in the sequence of Evelyn's travel)

6. Titleplate: *putto with tablet before a view in the Roman forum with the arch of Septimius Severus*
Inscribed: 'Locoru aliquot Insignium et celebe= / =rimorum inter ROMAM et NEAPO= / =LIN jacentium *hypodeixeis* et- / exemplaria / Domino Dom. / THOMAE HENSHEAW / Anglo omnium eximiarum et / praeclarissimarum Artium / Cultori ac propugnatori maximo et / *sunopsamenōi autōi* (non- / propter Operis pretium, sed ut- / singulare Amoris sui Testimon= / ium exhibeat) primas has *adoxi=* / =*masias* Aquaforti- / Excusas & insculptas / Io: Euelynus Delineator / D.D.C.Q. / R.Hoare excud' (the words in italic are in Greek characters.)
Etching. 101 × 139 (image); 109 × 146 (platemark)

7. *The three taverns or the Appian forum*
In margin: 'Tres Tabernae sive Appij forum. / celebre illud in sacris litteris. / Acts 28. JE.f'
The reference is to Acts 28.15, the arrival of Paul at Rome: 'And from thence, when the brethren heard of us, they came to meet us as far as Appii forum, and The three taverns: whom when Paul saw, he thanked God, and took courage.' Evelyn has in fact confused two separate places: according to the *Diary*, he visited the Tres Tabernae on 28 January, and the Appii Forum, the location of the monastery where Thomas Aquinas was buried, on the following day.

8. *Cape Terracina*
In margin: 'Terracini olim Anxuris Promontorium. IE f.'
Etching. 88 × 137 (image); 106 × 143 (trimmed to platemark)

9. *Landscape with the twin peaks of Mount Vesuvius*
Below: 'Montis Vesuoij juxta Neapolin externa Facies. JE. f'
Etching. 87 × 140 (image); 98 × 140 (trimmed)

10. *The crater of Mount Vesuvius*
In margin: 'Montis Vesuvij fauces et vorago, sive Barathrum internum. JE f.'
Etching. 101 × 141 (image); 109 × 148 (platemark).

11. *View of Naples from Vesuvius*
In margin: 'Prospectus versus Neapolin a Mont Vesuv. JE: f.'
Etching. 92 × 140 (image); 106 × 142 (trimmed)

COLLECTIONS British Museum 1838–5–30–4 to 9 (ex-William Upcott); (formerly) Nathaniel Hillier, annotated 'my journey from Rome to Naples' and 'sculpsit

Johannes Evelynus Parisiis 1649' (see Walpole); (formerly) Ralph Thoresby (*Ducatus Leodiensis*, London 1715, p. 496); (formerly) Howard Levis (ex-Fredk Hendriks) (lacking 10)

12–13 *Two English views*

12. *View of Wotton in Surrey* ?1653
Etching. 103 × 210 (image); 136 × 236 (platemark)
BM 1838–5–30–11 (ex-William Upcott)

There is a second state with etched letters added in the early nineteenth century in a facsimile of Evelyn's handwriting: 'Wotton in Surrey / The house of Geo: Evelyn Esqr. / taken in perspective from / the top of the Grotto by / Io: Evelyn 1653.' This was published in volume II of the 1818 and 1819 editions of Bray's edition of Evelyn's memoirs.

13. *View of Putney*
Etching. No impression known to me or Levis. Recorded by Walpole (p. 152). A footnote in Bray's edition of the *Memoirs* (1818, vol. I p. 236) to the *Diary* entry for 20 June 1649 reads 'One of these he etched himself. The plate is now at Wotton.' A later editorial comment (vol. II p. 121) includes in a list of Evelyn's etchings, 'Putney ad Ripam Tamesis – corrected in one impression by himself to Battersey.'

Notes

I would like to thank Maxime Préaud and John Wing for their help, and Richard Godfrey for reading a draft. Information supplied by him is incorporated into notes 11 and 12.

1 H. Walpole, *A Catalogue of Engravers who have been born, or resided in England; digested by M^r H. Walpole from the MSS of G. Vertue: to which is added an account of the life and works of the latter*, 5th edition, London 1786, pp. 145–52. H.C. Levis, *Extracts from the Diaries and Correspondence of John Evelyn and Samuel Pepys Relating to Engraving*, London, 1915, pp. 99–109.

2 S. Colvin, *Early Engraving and Engravers in England 1545–1695*, London, 1905, especially p. 75. A.M. Hind, *Engraving in England in the Sixteenth and Seventeenth Centuries*, 3 vols., Cambridge, 1952–64.

3 A. Globe, *Peter Stent, London Printseller circa 1642–1665*, Vancouver, 1985.

4 Walpole's interest in Evelyn was partly inspired by his own collection of prints by amateurs, which is now in the Lewis Walpole Library at Farmington. But so rare were Evelyn's etchings that neither he nor Richard Bull (whose collection is now in the British Museum) possessed any impressions.

5 E. Croft-Murray and P. Hulton, *Catalogue of British Drawings I: XVI and XVII Centuries*, London 1960, pp. 306–9.

6 These are the corrected dates suggested by de Beer in *The Diary of John Evelyn*, E.S. de Beer ed., 6 vols., Oxford, 1955, II, p. 315, note 1.

7 M. Whinney and O. Millar, *English Art 1625–1714*, Oxford, 1957, index s.v. 'Amateur painting'. Other references in the *Diary* to Evelyn making drawings are under the dates 26 and 30 September 1644. In 1687 his library contained 'A portfeuile of rede draughts of landscapes, bildings, surveys, & other papers drawne by J. Evelyn casualy' (see note 19).

8 Evelyn papers, Christ Church, Oxford: letter no. 893. 'But Sir you should now looke to some mortification for mee, for you have made mee strangely proud to have my name praefix'd to the first publicke endeavour of your Burin, when you have so many freinds that so much better deserve that honour, when it would have been a sufficient happines fore mee to have those places which I once view'd with so much pleasure and delight in your company, brought again before my eyes by the skill of your hand' (quoted by courtesy of the Evelyn Trustees).

9 L. Rostenberg, *English Publishers in the Graphic Arts 1599–1700*, New York, 1963.

10 Donald Wing, *Short-title Catalogue of Books Printed in England, Scotland, Ireland, Wales and British America, and of English Books Printed in Other Countries, 1641–1700* (New York, 1945), 1st edition, vol. I, C 1530 (p. 266).

11 An unrecorded first state before letters, was sold at Sotheby's, London, June 1986, lot 598.

12 Simon Jervis, 'A Seventeenth-Century Book of Engraved Ornament', *Burlington Magazine*, 128 (1986), pp. 893–903, corrects Globe by establishing that there are two sets of Pearce ornamental prints.

13 The evidence for this is complicated, but most is assembled by Globe, *Stent*, pp. 215 and 220. The key print is the portrait of Fairfax (no. 4 above, p. 57), which appears in Stent's list of 1653.

14 L. Fagan, *A Descriptive Catalogue of the Engraved Works of William Faithorne*, London, 1888.

15 I have published a similar argument relating to Peter Lely in 'Early Mezzotint Publishing in England II: Peter Lely, Tompson and Browne', *Print Quarterly*, 7 (1990), pp. 130–45.

16 See David Howarth, *Lord Arundel and his Circle*, New Haven and London, 1985, pp. 171–84.

17 R. Pennington, *A Descriptive Catalogue of the Etched Work of Wenceslaus Hollar*, Cambridge, 1982, cat. nos. 610–13; 74 and 134; and 614–17.

18 The collection was dispersed at a series of sales at Christie's. The prints and drawings were sold in 1977 on 14 June (lots 152–68), 29 June (lots 1–126), 6 July (lots 1–20), 12 July (lots 48–51) and 26 July (lots 156–99), with a few strays in other sales.

19 It is to be found on folios 193–200 of Evelyn's 1687 library catalogue, which is among the Evelyn papers at Christ Church. It is the earliest catalogue of a British print collection that I know, with the possible exception of Richard Symonds's list (see H. and M. Ogden, 'A Seventeenth Century Collection of Prints and Drawings', *Art Quarterly*, 11 (1948), pp. 42–73.

20 In *Sculptura*, C.F. Bell ed., Oxford, 1906, p. 56, he records that he purchased a set of Muziano's *Trajan's Column* from Villamena's widow.

21 H.C. Levis, *Extracts*, pp. 17–41, contains a useful collection of passages from Evelyn's *Diary* relating to prints.

22 *Diary*, E.S. de Beer ed., v, p. 549, note 9.

23 *Ibid.*, II, p. 557.

24 G. Keynes, *John Evelyn, a Study in Bibliophily*, 2nd edn, Oxford, 1968, pp. 22–4. The letters from Hoare that Keynes saw are not to be found at Christ Church, although two other letters are there.

25 British Library, Add. Ms. 15948, fo. 53. C. Petitjean and C. Wickert, *Catalogue de l'œuvre gravé de Robert Nanteuil*, Paris, 1925, cat. 71, pp. 187–90.

26 Evelyn papers, letter no. 908. Keynes, *John Evelyn*, p. 23, publishes the sequel to this, dated early August.

27 This is kept with Bosse's design for Evelyn's bookplate among the Evelyn papers.

28 See Keynes, *John Evelyn*, pp. 116–22.

29 This is not contained in Bosse's 1645 *Traité des Manières de graver en taille douce*, but in his 1649 *Sentimens sur la distinction des diverses manières de peinture, dessein et graveure*, pp. 73–86.

30 See M. Grivel, *Le commerce de l'estampe à Paris au XVIIᵉ siècle*, Paris, 1986, pp. 207–14.

31 P.F. Robert-Dumesnil, *Le peintre-graveur français*, 11 vols. Paris, 1841, v, pp. 66–7. See also vol. XI, pp. 189–90, where the attribution is illogically rejected.

32 A. Andresen, *Der deutsche peintre-graveur*, 5 vols., Leipzig, 1878, v, pp. 91–104.

33 Christie's London, 29 June 1977, lot 32. These last two etchers are mentioned on p. 131 of *Sculptura*, together with the Earl of Sandwich.

5

THE POLITICS OF INIGO JONES

David Howarth

On 17 January 1638 Queen Henrietta Maria and 'spectators of quality' assembled at Whitehall Palace in the new temporary masquing chamber, used for the first time that night, to watch Sir William Davenant's masque *Britannia Triumphans*.[1] It is the purpose of this essay to suggest that Jones's work for this masque is of particular value to an understanding of his position at court. Through scrutiny of his designs, we observe a different man from the ambitious Italianate impresario, so keen to match the splendour of Florentine *intermedi*. *Britannia Triumphans* suggests just how closely Jones was involved, not only in the buildings, but in the very policies of the years of Personal Rule. We are confronted with an important public figure who used his contribution to masques to express political and social values that reflect intimate contact with King Charles himself. Much has been made of Jones's discipleship of Palladio and his criticism of Scamozzi; his judgement of Leonardo and his dependence on Callot; but not enough of where he stood politically. Here, it will be suggested that in *Britannia Triumphans* Jones is to be observed fashioning the Surveyorship of the King's Works into an avowedly political office. Inigo Jones is unique in the history of English architecture before Wren, not so much because of his rare grasp of the integrity of an architectural system – there were others capable of that – but because of his view that architecture was an aspect of social engineering. For Jones, architecture was the physical expression of a carefully constructed system of social and political values.

The argument of *Britannia Triumphans* must be rehearsed before its designs can be considered. The text, by Davenant, is at one with other masques in the bathos of its lines and the whimsy of its action. Charles I, who took part as Britanocles, 'the glory of the western world', has 'vindicated not only his own, but far distant seas infested with pirates, and reduced

68

the land, by his example, to a real knowledge of all good arts and sciences'. In other words, Britanocles has made international shipping safe from piracy and provided those settled conditions which has allowed his kingdoms to flourish in peace. Bellerophon, eager that such achievements should be appreciated by the present, as well as by future ages, urges Fame to ensure that all are sensible of their good fortune. This is to be done by awakening them to an admiration of Britanocles. Action engages in a dialogue with Imposture in which Imposture argues that men are governed by their sensual appetites and:

> Imposture governs all, even from
> The gilded ethnic mitre to the painted staff
> O'th'Christian constable, all but pretend
> Th'resemblance of that power which inwardly
> They but deride.[2]

Although Imposture concedes that there are a few who live by reason and a moral code, he suggests that they are ineffective in shaping the mores of society. The dialogue is then followed by a mock romansa orchestrated by Merlin, who has been summoned in support by Imposture. There follows an anti-masque, which includes characterisations of rebels famous in English history: Cade, Kett and Jack Straw, who symbolise the tyranny of chaos and sensual license. Action has not yet lost the argument to Imposture, though he is in retreat, when Bellerophon comes to his rescue, dismissing Merlin and his romansa with the verdict, 'How trivial and lost thy visions are!'. Thereafter the earth opens to reveal the Palace of Fame, from which issue masquers who are instructed by Bellerophon to pay homage to Britanocles, who now appears. Fame, together with Music and a Chorus, extol Britanocles and his middle path between the extremes of sensuality and reason; a middle path which is symbolised, in the real world, by the temperate equilibrium of the royal marriage. The masque ends in 'A Valediction'. In this the audience are urged to retire and enjoy the pleasures of the bed in a sensual union sanctified by the restraint of marriage. Here the audience are to be inspired by the example of the royal couple, whose mutual and fruitful love provide both model and assurance for their loyal subjects.

A number of scholars have written about *Britannia Triumphans*, although only the arguments of two need consideration here. For Graham Parry the masque had 'a clear political motivation':[3] it was to provide a justification for the much-hated ship money tax; a tax ostensibly used to build up the naval strength of the country. Ship money had first been raised in 1634 and only

from the maritime counties. However, in 1635, with the second writ for the tax, it was imposed on the inland counties as well; that is to say, between the enactment of the court masque *The Temple of Love*, performed at New Year 1635, and *Britannia Triumphans* of 1638. The imposition of the tax upon counties that had no direct dependence on, or vulnerability to, the sea was much resented by their inhabitants. Indeed it was only since the performance of *The Temple of Love* that the crown had encountered vociferous opposition to ship money. This, then, is the background to Parry's contention that Davenant, with his prologue to *Britannia Triumphans*, and Jones with his designs, supported the 'dubious demand for ship money'. Parry's argument rests principally on the design for Scene Six where we see a three-master sailing into a harbour which Parry, following Orgel and Strong, believes to be a representation of the *Sovereign of the Seas*.

In contrast to Parry, Kevin Sharpe, our second writer, sees *Britannia Triumphans* as more assertive than defensive; more court than country orientated. For Sharpe, Davenant was less concerned to justify governmental policies.[4] Sharpe argues that it is Davenant who is important, not Jones: the crux of the masque is Davenant's powerful attack on the cult of neo-Platonism. It was a cult which had been central to the Caroline masque, and nurtured particularly amongst the intimates of Henrietta Maria. Davenant, according to Sharpe, believed that the cult was in danger of emasculating the court. Davenant infers that such a cult was creating a division between a coterie of devotees and the larger society of the court. This could happen because of a cast of mind which inhibited this minority from engaging with the pleasures of this world. For Davenant, the sensual was important and should be enjoyed, provided 'every act be squared by virtue's rule'. Davenant's method of persuasion is to lead his audience to consider the success of the royal marriage in which intellectual, spiritual and sensual appetites are harmonised and satisfied. Thus Davenant offered his audience inspiration to create a universal harmony by observing the union of king and consort.

Sharpe provides an illuminating view of *Britannia Triumphans*, but it is perhaps one which underestimates how writer and artist complemented each other's work. Sharpe is too inclined to see Davenant as the dominant partner in their creative relationship. The argument that Sharpe persuades us is offered by Davenant is in fact promoted by Jones. Indeed, Jones does so with the very first of his designs. The opening scene, entitled *London farr off*, reveals a splendid Renaissance perspective, conceived in the 'artisan mannerist' style (fig. 14). For this, Jones has turned to Sebastiano Serlio's

14 Inigo Jones, *'London farr off'*, design for Scene 1, *Britannia Triumphans*

woodcut of *The tragic scene*, from Book III of his *Trattato*. Book III had been
published in Venice a century earlier, but had then become more accessible
to Jones's audience through Robert Peake's English edition of 1611. Peake's
translation of the text accompanying Serlio's famous woodcut, *The tragic
scene*, specifically equates the tragic mode as appropriate for the actions of
kings – whether amorous or murderous: 'Houses for Tragedies must bee
made for great personages, for that actions of love, Strange adventures, and
cruell murthers (as you reade in ancient and moderne Tragedies) happen
alwayes in the houses of Great Lords, Dukes, Princes and Kings. Wherefore
in such cases you must make none but Stately houses, as you see it here in
this Figure.'[5] (fig. 15) Thus, although the Serlio–Peake woodcut is entitled
The tragic scene it provided an appropriate context for Davenant's exploration
of the royal marriage, so central to *Britannia Triumphans*.

Sharpe is convincing in his suggestion that Davenant had become
exasperated by the *précieuses* who inhabited the world of make-believe. He
offers an important critique to the assumption that the cult of neo-Platon-
ism continued to wax until the Civil War provided an eclipse. But then Parry
is also correct in arguing that *Britannia Triumphans* is an unusually 'commit-
ted' statement of royal policies. It is possible, however, to go further than
Parry in suggesting that Jones's designs reveal, not merely a preoccupation

HOuſes for Tragedies, muſt bee made for great perſonages, for that actions of loue, ſtrange aduentures, and cruell murthers, (as you reade in ancient and moderne Tragedies) happen alwayes in the houſes of great Lords, Dukes, Princes, and Kings. Therefore in ſuch caſes you muſt make none but ſtately houſes, as you ſee it here in this Figure, wherein (for that it is ſo ſmal) I could make no Princely Pallaces: but it is ſufficient for the workeman to ſee the manner thereof, whereby he may helpe him-ſelfe as time and place ſerueth: and (as I ſayde in the Comicall) hee muſt alwayes ſtudy to pleaſe the eyes of the beholders, and forget not himſelfe ſo much as to ſet a ſmall building in ſtead of a great, for the reaſons aforeſayd. And for that I haue made all my Scenes of laths, couered with linnen, yet ſometime it is neceſſary to make ſome things riſing or boſſing out; which are to bee made of wood, like the houſes on the left ſide, whereof the Pillars, although they ſhorter, ſtand all vpon one Baſe, with ſome ſtayres, all ca-ueered ouer with cloth, the Cornices bearing out, which you muſt obſerue to the middle part: But to giue place to the Galleries, you muſt ſet the other ſhortening Cloth ſomewhat backwards, and make a cornice aboue it, as you ſee: and that which I ſpeake of theſe Buildings, you muſt vnderſtand of all the reſt, but in the Buildings which ſtand far backward the Painting worke, muſt ſup-plie the place by ſhadowes without any bearing out: touching the artificiall lights, I haue ſpoken thereof in the Comicall workes. All that you make aboue the Rooſe ſticking out, as Chimneyes, Towers, Piramids, Obliſces, and other ſuch like things or Images; you muſt make them all of thin bords, cut out round, and well colloured: But if you make any flat Buildings, they muſt ſtand ſome-what farre inward, that you may not ſee them on the ſides. In theſe Scenes, although ſome haue painted perſonages therein like ſupporters, as in a Gallery, & bores, as a Dog, Cat, or any other beaſts: I am not of that opinion, for that ſtandeth ſo long without ſtirring or moouing; but if you make ſuch a thing to lie ſleeping, that I hold withall. You may alſo make Images, Hiſtories, or Fables of Marble, or other matter againſt a wall; but to repreſent the life, they ought to ſtirre. In the latter end of this Boke I will ſhew you how to make them.

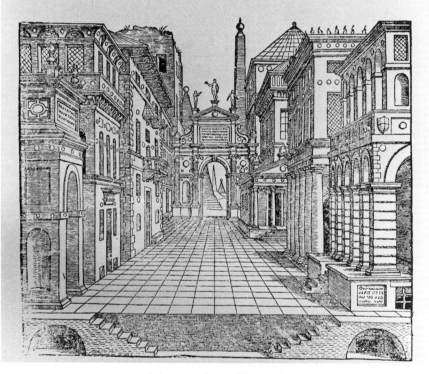

15 Sebastiano Serlio, *The tragic scene*

with royal policies, but an eloquent defence of them. Indeed, it would seem that the architectural backdrop to the first scene is connected with how Jones saw himself as a leading apologist, not only of the theory, but also of the practice, of Stuart kingship. Jones alludes both directly and indirectly to some of the contentious issues of the winter of 1637–8; issues which many believed more pressing than ship money itself. These were the incorporation of the suburbs of London, and, intimately associated with that initiative, the Commission for New Buildings; the imposition of the Anglican Prayer Book in Scotland; and the question of who had authority within the parishes of the City of London.

Jones's first backdrop invited a consideration of what by the winter of 1637–8 had become a bitter and contentious issue between the crown and the City of London. This was Charles's successful bid to incorporate the suburbs of London – including Southwark itself, that is to say, the foreground buildings here (fig. 74).[6] It was a policy initiated in 1635. Its purpose had been to clip the wings of the City; to impose social control over the chaotic growth of trades in London; and to raise money for the Exchequer, through fees charged for those seeking the freedom of the new Corporation. Originally Charles had invited the City Corporation itself to act on his behalf, but the City had feared to set up a rival commercial force. They had refused to organise the incorporation of the suburbs. They had proved ambivalent to attempts at regulating the economic and social life of the metropolis. In the light of obstruction, Charles had simply gone ahead alone. The new Corporation, independent of the City, established by proclamation on 2 June 1636,[7] had covered most of the centres of rapid population and economic growth which lay close to, but outside, the jurisdiction of the City wards. The dispute between Charles I and the City proved to be decisive. Together with the issue of the Londonderry plantation, when the crown took lands in Ireland which the City believed it owned, the formation of the new Corporation turned the City against the court before the Civil War.

But, although Charles had overborne the objections of the City, and the suburbs had received their royal charter, it had been a Pyrrhic victory. In the months before the staging of *Britannia Triumphans*, it had become clear that men were simply not joining the royal Corporation. Such was the concern at court that Charles felt it necessary to issue a proclamation on 22 November 1637. The purpose of this was to extend the deadline which had been imposed for taking up membership. The king declared: 'We taking the premises into Our serious consideration, here thought meet to give a further time for the admittance of such Tradesmen and Artificers, as being capable

of the said Freedome, have not yet taken the same, then to exclude such of them not yet admitted. . .'[8]

The timing of that proclamation is of particular interest. By late November, Jones must have been closeted with Davenant discussing the 'argument' of the new masque. By then they would have been aware that the king's initiative over the new Corporation was faltering. The king's policy for imposing order upon London life needed all the support it could get. Thus, in the opening scene of the masque, Jones's backdrop may have been providing a vision of royal intentions for the new Corporation; a fanciful vision certainly, but one suitably elevated in the context of regal ambitions. What we are looking at in this opening scene of *Britannia Triumphans* is, therefore, a seventeenth-century developer's prospectus.

Any Caroline building initiative in the metropolis involved the Commission for New Buildings. Created by James I, its job was to control the chaotic growth of London. Its presiding genius would always be Jones himself, but it was a body in which Charles I came to take a marked interest. On 13 December 1637, just five weeks before *Britannia Triumphans* was staged, the Earls of Arundel and Dorset, central to the Commission by virtue of rank and years of service, had ordered Sir Thomas Grimes to make a thorough survey of all new building in Southwark. This was to enable the Commission to decide which buildings should be demolished, and which were sufficiently, 'decent and uniform', to be allowed to stand.[9] Thus it may be suggested that Jones's buildings, more appropriate for Van Dyck's patrons of the Strada Nuova in Genoa than for his London burgesses, had foundations on the bedrock of conflict between Charles I and the City of London. The relationship between the king and the City had been strained in other ways too. It is necessary to explore these longer-term tensions to make sense of much else, both explicit and implicit, in *Britannia Triumphans*.

We begin by exploring the Commission for New Buildings in more depth. One of the perennial difficulties faced by Tudor and Stuart monarchs had been how to control the unruly growth of London. By the late 1570s, Elizabeth I had become concerned that overcrowding was perceived to represent a threat to social order. On 7 July 1580 at Nonsuch she issued a proclamation specifying strict rules as to what was permitted by way of development.[10] However, for a decade the proclamation was not followed up, by which time Elizabeth herself was faltering. Thereafter her successor James I established a standing Commission upon an altogether surer footing. This he introduced with something of a flourish: 'As it was said of the first emperor of Rome, that he had found the city of Rome of brick and left it

of marble, so Wee, whom God hath honoured to be the first of Britaine, might be able to say in same proportion, that we had found our Citie and suburbs of London of stickes, and left them of bricke, being a material farre more durable, safe from fire and beautiful and magnificent.'[11]

In theory, then, the Commission was to be a body of wide, not to say Imperial, vision. It was to be devoted to the creation of an elegant and commodious capital to the benefit of sovereign and people alike. However, it would appear that the people themselves took a rather different view. John Chamberlain, the earliest witness, suggests that there was disquiet, if not outright hostility. Chamberlain was an informed observer of the Jacobean court, and, though never a significant office-holder, knew everyone of note. He provided Sir Dudley Carleton, the most effective English diplomat of his generation, with gossip whilst Carleton was in Venice or the Hague. Chamberlain wrote:

Among many other projects and devises for monie here is a commission to inquire and survay all buildings ... they thincke to raise a great masse of monie by this course, but I feare they will come very short of theyre reckoning, for most of the builders are beggerly companions, and so are the inhabitants, and withall yt is thought straunge that yt should extend to so large a circuit, and to houses that have goode store of land laide to them, so that population shalbe as much punishable as depopulation.[12]

Chamberlain's comment suggests that from the very first people seem to have believed that the real motive for establishing the Commission was to find new ways of generating extra-parliamentary taxation. That was hardly surprising, since only a year before the Commission came into being, James had asked the Addled Parliament of 1614 for £100,000, only to receive £10,000. Thus, such good as some saw in attempts to prevent slum tenements may have been offset by those who perceived that Londoners would be pressed for money. Chamberlain's comment, coming as soon as the Commission was established, represents a sceptical view which would become more widespread. Eventually, indeed, the matter became important enough to appear as Article 30 in the Grand Remonstrance.[13]

Chamberlain refers to the Commission in another letter to Carleton in which he predicts that it could become an effective means of easing the financial burdens of the crown, but only at a price which might be too high. Furthermore, he makes it clear that many of the most important court officers were becoming involved in the policy: 'But the inquirie after new erected buildings ... goes on amaine, and the last weeke the whole counsaile

from the highest to the lowest brought down a commission and sat at Guild Hall about yt: yf they shold procede with rigor and extremitie, they might raise a great masse of monie as is thought, but yt would cause much murmur and complaint.'[14] The Privy Council appear to have put their shoulder behind the Commission, whatever murmurings may have been heard. A month later Chamberlain wrote: 'All manner of projects are still on foote, but the new buildings bring in most present profit.'[15]

Such then are the views of one with an excellent understanding of the seen and the unseen. But what are we to make of Chamberlain on the beginnings of the Commission? In the first place, it seems that the Commission was perceived in the same hostile light as monopolies; a growing source of tension between the crown and its critics. Chamberlain felt that the crown stood to lose respect in the eyes of its subjects. Men observed a palpable difference between what were claimed to be the aims of the Commission and what it actually set out to achieve. As the years passed, the common assumption became current that the crown cynically manipulated the Commission by making demands which it knew could not be met. Nevertheless, those demands enabled miscreants to be heavily fined, not once but repeatedly. This served only to bring into disrepute what might otherwise have been respected. The Commission was seen to be vexatious for the individual but, more importantly, it was thought to be driving a wedge between the king and his subjects. On 28 May 1624, the House of Commons presented an Address to the king in which they aired their grievances. In a long list, item eleven was headed, 'Proclamations concerning Buildings'.[16] James I replied to the demands of the Commons the next day, promising to take a course for relieving those grievances presented, but then going on to complain himself 'of their making one of the orders on buildings about London, which he will maintain for improvement of the metropolis'.[17]

The Commission was not a continuous source of resentment. It appears to have dropped away temporarily as a cause of friction with the death of James. While Charles I was trying to find an accommodation with Parliament, it was almost supine: there are few references in the State Papers between the accession of Charles I in the spring of 1625, and his dismissal of the 1629 Parliament. This was not due to a sense of tact on Charles's part which somehow biographers have missed – that was a quality he never had. Rather, it was because of the extraordinary demands made on king and Privy Council by the administrative burden of running a series of disastrous wars. These left little time to turn to domestic issues. It would appear, though, that matters changed once Charles had shaken the parliamentary

dust off his heels. On 16 July 1630,[18] he issued a proclamation to recon-
stitute the Commission, followed by a lengthy Privy Council paper on the
subject in November 1633.[19] These moves suggest that the crown may have
been looking to re-invigorate the Commission in the light of needing to
raise more revenue. From 1636 the Commission quite suddenly began to
act with a vigour and momentum that had never been seen before. It is
significant that action seems to have been taken in 1630 and 1636; the
earlier year saw a frightening outbreak of plague in London which flared up
again, though less severely, in 1636. Thus there can be little doubt that the
Commission, at moments at least, was motivated by the commendable
desire to improve standards of hygiene and sanitation. But, as with so many
policies in the years of Personal Rule, it was the practice rather than the
principle of the Commission which created problems. All sorts of men felt
London was getting out of control. It is richly ironic that none other than
William Prynne, scourge of Henrietta Maria and victim of the Star Cham-
ber, lent his support to this vexatious body. Perhaps it was with tongue in
branded cheek that he put his signature to a petition sent on 16 August 1641
by the barristers of Lincoln's Inn, 'begging for some mechanism to ensure
continued prosecutions for illegal building now that proclamations, decrees
of Star Chamber and orders of the Privy Council as means to achieve that
end, had all become discontinued'.[20] Even Jones himself, whose conduct on
the Commission gave him such a bad name, continued to oversee its work,
even after Charles I left London for Oxford. Jones was still submitting
reports to Parliament as late as March 1643.[21] That is to say, long after
Edgehill.

Nevertheless throughout the summer and autumn of 1637 – weeks only
before the staging of *Britannia Triumphans* – justices of the peace, sheriffs,
constables, peers of the realm, the College of Physicians, all and sundry,
found themselves before the commissioners for a variety of offences. The
supplicants, pillars of the London community, were dealt with in the
manner suggested by the supercilious language of a letter sent to the sheriffs
of London and Middlesex on 22 November 1637. This stated that the
delinquents had disregarded the 'inhibitions of the commissioners with
manifest refractoriness contempt and high-handedness'.[22] What is perhaps
the most notable aspect of the proceedings as they unfolded that autumn was
the tone with which the commissioners went about their business: powerful
men came to be humiliated and for many that was unforgivable.

To see how far the officers of the Commission for New Buildings
alienated many important men, we look not to the likes of Prynne or

Hampden, then quarrelling so importantly with the king about religion and taxation, but to George Garrard, Master of the Charterhouse. By no stretch of the imagination could it be said that Garrard had a settled hostility to the regime. He was the confidant of the Earl of Strafford who was certainly adept at riding rough-shod over men's sensibilities. Garrard performed exactly the same function from London for Strafford in Dublin as Chamberlain had done for Carleton abroad, and, like Chamberlain, he did not like what he saw. Garrard wrote to Strafford: 'Here are two Commissions afoot, which are attended diligently, which will bring in, as it is conceived, a great Sum of Money to his Majesty: The one concerning the licencing of those, who shall have a Lease for Life to sell Tobacco in and about *London*, . . . The other is for Buildings in and about *London* . . .'[23] Garrard felt disquiet about the ethics of what was being done. He was prepared to go along with what he regarded as an over-zealous method of raising revenue provided the money went into the Royal coffers. But current practice was intolerable; the job of extracting fines had been given to disreputable men who had farmed the office in the best monopolistic tradition. As time passed, Garrard came to feel that the way the commissioners set about their business affronted natural justice.

Closely allied to the Commission was a body set up to try to ensure that cottagers should have at least four acres to sustain themselves, thus guarding against the meaner sort running up jerry-buildings – or so the theory went. Although the overseers of cottage dwellings in surburban London constituted a separate body from the Commission for New Buildings, they were held to be the same by the ordinary man. Thus Garrard's startlingly vigorous criticism of enactments on behalf of cottagers, which he saw as more provocative even than ship money itself, suggests just how important were issues associated with London building in explaining the growing hostility to the crown. Garrard wrote to Strafford:

Here is at this present a Commission in Execution against Cottagers who have not four Acres of Ground laid to their Houses, upon a Statute made the 31 Eliz., which vexeth the poor People mightily, and is far more burdensome to them than the Ship-monies, being all for the benefit of the Lord *Morton* and the Secretary of *Scotland*, the Lord *Sterling*. Much crying out there is against it, especially because mean, needy, and Men of no good Fame, Prisoners in the *Fleet* are used as principal Commissioners to call people before them to fine and compound with them.[24]

The first scene of *Britannia Triumphans* suggests immediate ambitions and longer-term hopes. It reflects the concern of the king and his Surveyor to

make a success of the new Corporation for which they had fought so hard against vested interests. This demanded the raising of decorous buildings out of the mire of Jacobean speculative endeavour. The second ambition was to make the Commission for New Buildings an effective instrument of policy. Now this second strategic aim was one which happened to touch the king almost literally.

Charles I's policy of fining unlicensed builders through the Commission for New Buildings might have proved a simpler business if the problem had not presented itself on his own doorstep. Some of the most notorious cases which came before the Commission involved those living within the precincts of the royal palaces. Arthur Cundall had sheds in Palace Yard at Westminster which he stubbornly refused to demolish, despite frequent commands to do so;[25] Mary Baker was fined £1,000 because the drains from her development putrified the springs running to Somerset House and Whitehall.[26] It may seem surprising that Charles I should have allowed these undesirable accretions to survive; after all, these were the very years he was poring over Inigo Jones's drawings for a new palace. However, magnificence and squalor were often found together in the Renaissance, and the Caroline court was a cliff-face of gannets. By 1637 accommodation at court was woefully inadequate and Garrard suggests how uncomfortable it must all have been: 'The Court is now filled with the Families of every mean Courtier, Dwelling-houses are daily erected in every Corner of the *Meuse*, proper only for Stables.'[27] Thus, once again, there may have been a certain topicality to Jones's first design for *Britannia Triumphans* which underscored the overt fantasy. Jones may have been presenting his audience of Royal Mews-dwellers with a vision of a future which would give the English court a setting consonant with its inherent dignity.

Hitherto, it has been assumed that the depiction of Old St Pauls in *Britannia Triumphans* (fig. 14) alludes to the restoration of the cathedral by Jones. The restoration had really begun in earnest on 23 April 1634, when the king had promised to pay for the entire west front himself.[28] Evidently, Old St Paul's was dear to the king's heart, and certainly in the winter of 1637–8 a great deal still needed to be done to the building. This in itself provides a good *prima facie* case for assuming that Charles I was using Jones, through his designs for *Britannia Triumphans*, to ask men to dip into their pockets. But if that was the case, is it not curious that Jones's cathedral remains resolutely northern and gothic? By contrast, his foreground buildings have pleasing classical touches. Of course Jones's allusion to Old St Paul's is summoned up only in a wraith-like outline which perhaps cannot bear too rigorous an

analysis. But it seems strange indeed that there was not a column to be seen in Jones's design, to entice those who were expected to believe that with their contributions a glorious new church would emerge. Perhaps, however, Jones's concern in depicting the church as a timeless gothic monument had more to do with supporting the English Prayer Book, then in need of considerable buttressing, than in providing a fund-raising appeal. It may be recalled that the previous autumn had seen the first moves down that fatal road to St Giles's, Edinburgh, and the attempt to introduce the English Prayer Book to the Calvinists of Scotland. From the very outset of that policy, promoted so vigorously by the king and his Archbishop, William Laud, men were full of foreboding. George Garrard thought there was 'Small hope yet in *Scotland* to bring in our Church-Service into Use there, they still oppose it with great Violence.'[29] Thus it may well be that Jones, in the face of gathering difficulties, wished to symbolise the authenticity of Anglicanism with its roots in a pre-Augustinian primitive church. What better way to do this than to emphasise the gothic style of the metropolitan cathedral; a style which, given the uncertain chronology of gothic architecture, was believed to have origins as venerable as the very religion itself?

A consideration of Jones's panorama, anticipating as it does the famous etchings of Hollar, suggests that '1 sceane with London farr off' may contain further topographical pointers to issues then causing strife between the court and the City of London. If the tower to the south-east of Old St Pauls in Jones's backdrop is compared with Hollar's frontispiece to James Howell's *Londinopolis* (1657) (fig. 16), it might well appear that Jones intended an allusion to the important church of St Michael-Le-Querne in Cheapside. During the summer of 1637, a furious quarrel had begun between Jones and the parish of St Michael-Le-Querne.[30] The row shows in the most marked degree what Jones's enemies in Cheapside would later, and in another context, describe as his tendency to wish always to be 'sole monarch'.[31] The quarrel centred on the rebuilding of the church: something that all agreed had to be done. However, whereas the Privy Council wished to see the erection of a church which would be an ornament to the street, the parish wanted something altogether plainer. Protracted as the issue of the new church became, it was only part of a still larger ambition of the crown. This was to restore Cheapside to the status it had enjoyed before the Goldsmiths Company, intent on increasing income from its Cheapside building known as Goldsmith's Rents, had put in high-paying tenants who were not themselves goldsmiths, to the great irritation of the crown, which

16 Wenceslaus Hollar, Frontispiece to James Howell's *Londinopolis*

had been gratified by foreigners who would visit Cheapside to observe a 'mine of Ophir'.[32]

The issue of what exactly the new St Michael's should look like had involved Jones substituting his design for one provided by the parish. Now it may be no coincidence that after many months of conflict between the parish on the one side and the king, Privy Council, Archbishop of Canterbury, Bishop of London, and Jones himself on the other, *Britannia Triumphans* was performed as work began on the rebuilding of the church. Victory had been won by Jones, since it was to go up to his design, though at what would be an eventual cost of £9,000.

It can be appreciated from the importance of those drawn into the quarrel that what may have begun as a parochial matter, both literally and

metaphorically, had come to be seen as the much larger question of who had authority in a parish: the parishioners, or the Defender of the Faith? Thus it may be suggested that in *Britannia Triumphans* Jones was urging his audience to contemplate the mother and her daughters: St Paul's with the great medieval parish churches of London, separate in their history, but united in their obedience to their metropolis. From the very first, Jones had been no less attracted to order than to the Orders, and thus his allusion to this important quarrel between the king and his subjects demonstrates his sympathy with the temperamental thrust of those two great exponents of the policy of 'thorough': the Archbishop of Canterbury and the Lord-Lieutenant of Ireland.

Turning to the design for Scene vi, most commentators have seen the ship in Jones's design as the *Sovereign of the Seas*; (fig. 17) the pride of Charles's navy, sailing majestically into harbour, carrying the burden of ship

17 Inigo Jones, *A haven with a citadel*, design for Scene vi, *Britannia Triumphans*

money to a safe haven. Once again, at first this seems surely correct. Charles I had taken a close interest in that great vessel, upon a whim commanding that its ordnance be increased from 90 to 102 guns, thus rendering it almost as hazardous to navigate as Henry VIII's *Mary Rose*. However, what we may be looking at is an altogether more ambitious image; cast in the genre of a battle-piece, rather than a portrait. To understand this it is necessary to return for a moment into the vital sphere of taxation.

Whilst ship money was not regarded as 'illegal', it was certainly much resented. Its detractors questioned whether it had been, and would be, put to good uses. In 1636 mariners in Devon, Dorset, and Hampshire had petitioned the Privy Council. They stated that Barbary pirates had taken eighty-seven ships with their cargo worth £96,700, and enslaved 1,160 souls, besides another 2,000 taken from other ships. The infidels had invaded Lundy for a fortnight, landing in Mounts Bay one Sunday to take seventy Christians out of church. What, they asked, was the king going to do about it?[33] Whilst ship money was not raised directly for the purposes of defeating piracy, which was indeed practised on an extraordinary scale by the middle of the 1630s, failure to drive African pirates from the Downs, the English Channel, the Bristol Channel and the Irish Sea meant that the king would not be able to sustain domination of home waters, which was the declared aim of ship money. In *Britannia Triumphans* Davenant, apologist for the king's maritime initiatives, and, we may suspect, almost certainly guided by Jones, makes the sea central to the masque. The ornament which greeted Henrietta Maria as the curtain was removed included a female statue: 'with one hand holding the rudder of a ship, and in the other a little winged figure with a branch of palm and garland' and, the audience was told, 'this woman represents Naval Victory'. The pilasters, adjacent to the statues, 'bore up a large frieze with a sea triumph of naked children riding on sea-horses and fishes, and young tritons with writhen trumpets, and other maritime fancies'. In the final part, Fame appeals to Britanocles to issue forth from the House of Fame by proclaiming:

> What to thy power is hard or strange.
> Since not alone confined unto the Land,
> Thy sceptre to a trident change,
> And straight unruly seas thou canst command!

Just before the fleet appears in Scene VI, 'Galatea came waving forth riding

on the back of a dolphin. Being arrived to the midst of the sea, the dolphin stayed, and she sang with a chorus of music':

> So well Britanocles o'er seas doth reign,
> Reducing what was wild before,
> That fairest sea-nymphs leave the troubled main,
> And haste to visit him on shore.[34]

So then *Britannia Triumphans* was a distinctly nautical affair. But why? As regards Scene Six itself, Jones is not alluding to what *The Sovereign of the Seas* might achieve, but rather to a triumph of arms, accomplished whilst *The Sovereign* lay at Deptford, being painted in her proper colours for her launching. Rather, Jones is referring to the exploits of a certain Captain William Rainborowe who, the previous March, had taken his flagship *The Antelope*, together with the *Hercules*, *Leopard*, and *Mary*, into Sallee harbour. Sallee, that is to say modern-day Rabat, was an important nest of pirates in Morocco. Rainborowe had accomplished his dashing enterprise under the guns of the kasbah: the great fort which then dominated New Sallee. Fortunately for Rainborowe, Old and New Sallee, separated by an inlet and harbour, were ruled over by two murderous sea lords, more intent on exterminating each other than Rainborowe. Once inside, Rainborowe had teamed up with Sidi-al-Ayachi, known to English sea captains, for reasons which are not entirely clear, as the 'Saint'. Thereafter, Rainborowe and the 'Saint' together severely damaged the kasbah and 'burnt and battered to pieces twenty eight of their Ships before the new Town'.[35]

Here Jones is being no less circumstantial, not to say topographical, than he had been with his view of Old St Paul's, seen from Southwark. Surely this is not an allusion to *The Sovereign of the Seas*, which has been described as 'the largest, most ornate, and most useless ship afloat'.[36] She had 102 guns, whereas Rainborowe's *Antelope* had only 34, much more in keeping with the craft in Jones's drawing. What is more, Rainborowe had had four men of war and so here too in this backdrop the number of ships corresponds to the principal combatants. As for topography, scrutiny of Dapper's view of Sallee in his *Beschreibung von Africa* (1670) (fig. 18) suggests an uncommon resemblance between his kasbah and the castle conceived by Jones.

Everything conspired to induce Jones to give the Sallee expedition a central place: not only had it been a fillip for ship money, it had also been a vindication. Without those funds, the king's supporters argued, the expedi-

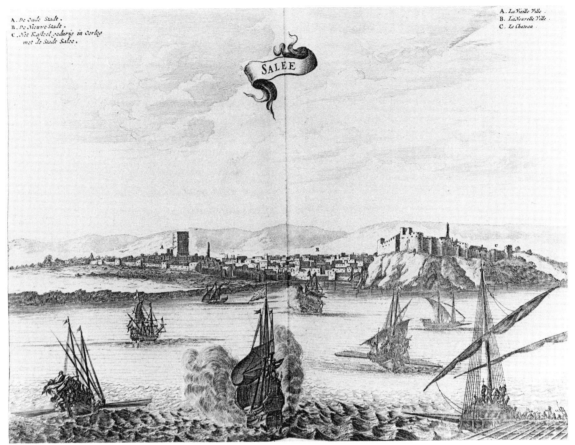

18 Anon., *View of Sallee*

tion would have failed. Furthermore, although the expedition had been
mounted and accomplished some eight months before the masque,
Rainborowe was a war hero in the winter of 1637. He had crossed the chain
on the Thames amidst much public rejoicing. A popular account had been
published, and this surely provided Jones with a theatre programme for his
masque.[37] There had also been a pageantry epilogue to the whole adventure.
Rainborowe had returned with Alcayde Jaurar Ben Abdella, 'a Portugall dis-
testicled'; sent as plenipotentiary by the King of Morocco as representative
of Charles I. Abdella had been received with much pomp by the king on
5 November; that day of mystic import to the Stuart dynasty. A long

procession, superbly mounted and turned out, led Abdella from Wood Street through Temple Bar to Whitehall, where 'the Resplendancy of the Royall Maiesties, the luster of the Nobility, and the Variety of Eye-dazelling Beauties made him wonder beyond admiration'.[38] For his part, Charles 'was very willing and forward to have knighted Captain *Rainsborough*, but he declined it; so Order was given that he should have a Gold Chain and Medal of 300l Price'.[39] For the spectators of this street performance, starved of masques for three years, such colour must have been something of a consolation. As for Alcayde Jaurar Ben Abdella, he continued to sport himself in London until May 1638. Thus it is highly probable that he was in the audience on the night of *Britannia Triumphans*. If so, doubtless he would have been intrigued by the appearance of the 'Giant' from the mock romansa, dressed in armour and a Moorish turban.[40]

But pageantry apart, serious challenges underlay Jones's reference to Sallee. Jones may have been Janus-like. Perhaps he was celebrating triumph, while anticipating trouble. Whereas £200,000 per annum had been raised from ship money in the years 1635–7, the king may have been expecting a significant non-payment in the year which lay ahead. And he was right to do so. Only £70,000 was to come in for 1638. Jones, by virtue of his intimacy with the king, would have been privy to such anxieties. Thus it may be thought that he is presenting Rainborowe's expedition by way of providing assurance that the tax was worth paying.

Consideration of Jones's designs for *Britannia Triumphans* provokes some challenging questions. Perhaps there has been a misplaced emphasis in considering Jones at court? The drawings which have formed the basis of my argument suggest that there was more politics about these than we have realised. In *Britannia Triumphans* there are pointers to what was preoccupying Inigo Jones in that winter of 1637–8. In fact, this need cause no surprise as it must be remembered that for Jones, artistry was the hand-maid of policy. The truth is that during the years of Personal Rule, he was to be found far more often in the Star Chamber or at the Privy Council than in his library. We should remember that Jones was a justice of the peace as well as something of an expert on Renaissance architectural theory. Furthermore, through his talents rather than his birth, he came to spend days on end sitting in committees, next to the most powerful in the land. As more of his masque designs are scrutinised for their political content, it may well come to be seen that he made an important contribution in a great age of pamphlets. These will not turn out to be of the sort which could be bought

for a coin on the Strand, as with the scurrilous attacks on the bishops, but an altogether more elevated production created for the exclusive clientele of a West End club. In *Britannia Triumphans*, as perhaps in other masques too, Jones can be observed stepping into the arena of accessible social and political debate; to paraphrase the well-known prefatory argument of the 1606 masque, *Hymenaei*, his pencil had been taught to 'design to present occasions'.[41] Certainly, two drawings alone do not allow for the recreation of a man's beliefs. Nevertheless, scrutiny of these splendid designs for *Britannia Triumphans* allow us to observe how, by 1638, if not before, Jones had transformed the Surveyorship of the King's Buildings. He had succeeded in making it into a more avowedly political office than even Sir Christopher Wren was to do when, thirty years later, he came to be entrusted with the social reconstruction of London after the Great Fire.

Notes

This essay is a much expanded and changed argument, first put forward in a paper given in July 1991 at the Anglo-American Historians Conference, The Institute of Historical Research, London University, entitled, 'The Early Stuarts and the Commission for New Buildings: Proclamation and Practice'. I would like to thank James Robertson of the Department of History, Washington University, St Louis, for reading this and making a number of helpful suggestions.

1 Complete text, and some commentary on *Britannia Triumphans*: Stephen Orgel and Roy Strong, *Inigo Jones. The Theatre of the Stuart Court*, 2 vols., London, Berkeley and Los Angeles, 1973, II, pp. 661–703.
2 Lines 103–7.
3 Graham Parry, *The Golden Age Restor'd*, Manchester, 1981, pp. 198–9.
4 Kevin Sharpe, *Criticism and Compliment*, Cambridge, 1987, pp. 247–51.
5 Robert Peake, *Sebastiano Serlio. The Five Books of Architecture*, reprint, New York, 1982, The Second Booke, the third chapter, fol. 25 [v].
6 Valerie Pearl, *London and the Outbreak of the Puritan Revolution*, Oxford, 1961, pp. 31–7.
7 James F. Larkin, *Stuart Royal Proclamations*, 2 vols. Oxford, 1983, II, no. 234.
8 *Ibid.*, no. 248.
9 PRO, Privy Council Registers, *Facsimile*, vol. II, London, 1967, fo. 231a.

10 Paul L. Hughes and James F. Larkin, *Tudor Royal Proclamations*, 2 vols., New Haven and London, 1969, II, no. 649.

11 James F. Larkin and Paul L. Hughes, *Stuart Royal Proclamations*, 2 vols., Oxford, 1973, I, no. 152.

12 N.E. McClure, *The Letters of John Chamberlain*, 2 vols., Philadelphia, 1939, II, p. 559.

13 S.R. Gardiner, *The Constitutional Documents of the Puritan Revolution 1625–1660*, Oxford, 1906, p. 212.

14 McClure, *Chamberlain*, I, p. 601 (15 June 1615).

15 *Ibid.*, pp. 609–10 (20 July 1615).

16 PRO, State Papers (Domestic), CLXV, 53.

17 *Ibid.*, 57.

18 Larkin, *Stuart Proclamations*, vol. II, no. 136.

19 State Papers, Dom., CCL, 51.

20 Thomas G. Barnes, 'The Prerogative and Environmental Control of London Building in the Early Seventeenth Century: The Lost Opportunity', *California Law Review* (1970), p. 58.

21 *HMC 5th Report, Part 1, Report and Appendix*, London, 1878, p. 76.

22 State Papers, Dom., CCCLXXII, 12.

23 *The Earl of Strafford's Letters and Dispatches*, W. Knowler ed., 2 vols., London, 1739, I, p. 206 (27 February 1633 [4]).

24 *Ibid.*, II, p. 117 (9 October 1637).

25 State Papers, Dom., CCCLXXIV, 80.

26 *Ibid.*, CCCLXXX, 73.

27 *Strafford*, Knowler ed., II, p. 140 (16 December 1637).

28 John Harris and Gordon Higgott, *Inigo Jones Complete Architectural Drawings*, London, 1989, pp. 238–48.

29 *Strafford*, Knowler ed., II, p. 129 (9 November 1637).

30 Howard Colvin, 'Inigo Jones and the Church of St Michael Le Querne', *The London Journal*, 12, no. 1 (1986), pp. 36–40.

31 J. Alfred Gotch, *Inigo Jones*, London, 1928, pp. 154–60.

32 T.F. Reddaway, 'Elizabethan London – Goldsmiths' Row in Cheapside, 1588–1643', *Guildhall Miscellany*, 2 (1963), pp. 181–206.

33 Kenneth R. Andrews, *Ships, Money and Politics: Seafaring and Enterprise in the Reign of Charles I*, Cambridge, 1991, pp. 160–83.

34 Orgel and Strong, *Theatre*, II, lines 40–2, 50–3, p. 662; lines 523–6, p. 666; lines 604–7, p. 667.

35 *Strafford*, Knowler ed., II, p. 116, (9 October 1637).

36 M. Oppenheim, *The Administration of The Royal Navy 1509–1660*, London, 1896, p. 252.

37 John Dunton, *A True Journal of the Sally Fleet*, 1637.

38 Sir George Cateret, *The Barbary Voyage of 1638*, Boies Penrose ed., Philadelphia, 1929, p. 12.
39 *Strafford*, Knowler ed., II, p. 129, (9 November 1637).
40 Orgel and Strong, *Theatre*, II, fig. 375.
41 *Ibid.*, I, p. 106.

6

THE STANDARD BEARER: VAN DYCK'S
PORTRAYAL OF SIR EDMUND VERNEY

Michael Jaffé

At Claydon House in Buckinghamshire an Inventory of Paintings, drawn apparently on 16 June 1647, itemises: 'In the Great Parlour Sir Edmund Verney his left hand on his headpiece by Van Dyck' with a pendant portrait of his daughter-in-law 'Mary Lady Verney with her hand on her belly'.[1] Over the chimney in this room, sometimes called 'the Salloon', hung *King Charles*, a three-quarter-length also by Van Dyck; and at the right of the king's portrait hung the portrait of his loyal subject Verney.

The likeness of the second *Sir Edmund Verney* by Van Dyck is well known: Verney, who was born on 1 January 1590, who was made Knight-Marshall of the Palace in 1626 and who on 23 October 1642 carried Charles I's standard at Edgehill. The valiant knight fell in that battle, having carried the standard into the thick of the king's enemies and then, being surrounded, refused to surrender it in exchange for his own life. His hand, one of those elegant hands with the tapering fingers depicted by Van Dyck perhaps two years earlier, was found on the field hacked off but still grasping a piece of the standard. This relic was buried in the crypt of Middle Claydon church. His body was never recovered.[2]

The Claydon version of Sir Edmund's portrait, three-quarter-length and appropriately in armour (fig. 19), always in the possession of the Verney family, has hitherto been accepted as the prime original by Van Dyck.[3] As such it was published twice in 1900: once by Max Rooses in *Fifty Masterpieces of Anthony Van Dyck, Selected from the Pictures Exhibited at Antwerp in 1899*,[4] as painted *c.* 1640; and once by Lionel Cust in his monograph.[5] Previously it had been exhibited in London at the South Kensington Museum in 1866, in the exhibition of Old Masters at the Royal Academy in 1871 and 1883, and in the Van Dyck exhibition at the Grosvenor Gallery in 1886–7,[6] besides the

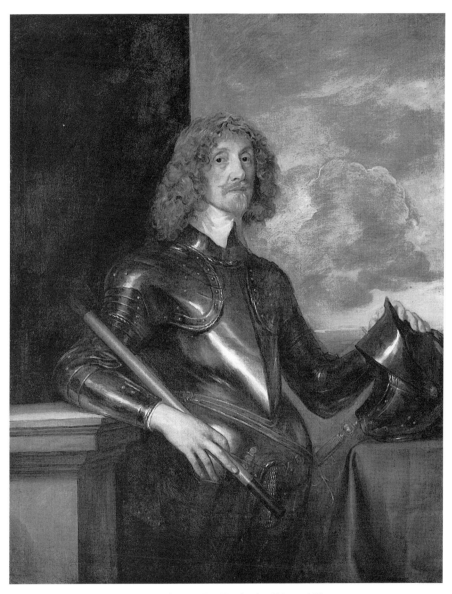

19 Sir Anthony Van Dyck, *Sir Edmund Verney*

Antwerp exhibition in 1899, and again at the Royal Academy in London in 1900.[7] It was included in both the Emil Schaeffer (1909)[8] and the Gustav Glück (1931)[9] editions of the 'Klassiker der Kunst' volume for *Van Dyck* as a work of *c.* 1640. Since the 1899 catalogue which suggested 1632–40, that is to say the whole span of years in which Van Dyck is likely to have painted an English sitter, only Erik Larsen,[10] in his 1988 attempt at a *catalogue raisonné* of Van Dyck paintings, has dated the portrait as loosely as *c.* 1636–40. Both by the style of painting and by the apparent age of the subject it is more sensibly to be dated close to the end of this period. It is to be borne in mind that when Sir Edmund in 1639 was summoned by Lord Pembroke to put on armour to join the king against the Scots he found his helmet too small for his head: he wrote to his eldest son Ralph, 'I have tryed my Arms & the Hedd peece is very much to little for mee; if the Pott I expect dayly from Hill (*the armourer*) bee soe too I am undone; the rest of my Armes are fitt.'[11] The helmet arrived only after peace was declared. Sir Edmund said he should keep it henceforth as a 'Pott to boil his porridge in' – or to sit for his portrait to Van Dyck.

The derivation of the pattern of portrayal is sufficiently clear. We are familiar, through the engravings of Aegidius Sadeler, with the appearance of Titian's *Caesars* acquired for Charles I from the Palazzo Ducale at Mantua;[12] we know that Van Dyck was paid '5 li' for mending the *Galba* and '20 li' for a *Vitellius*,[13] presumably to replace the one damaged beyond repair; we can observe how Van Dyck *c.* 1636 adapted the composition of no. VIII in the series, *Salvius Otho*, to portray *Charles I in armour*,[14] a modern ruler standing three-quarter-length holding in both hands his bâton of command, his helmet and crown placed beside him, with his head positioned in a similar fashion to his portrait in state robes which Van Dyck signed and dated 1636. The composition of *Charles I in armour* was later to be modified by Van Dyck for portraits of two knightly figures among the king's subjects: the Edmund Verney, and that Kenelm Digby *armato*[15] which Bellori records in his *Vita* of Van Dyck on the evidence of Digby, his acquaintance in Rome (fig. 20).[16] In each of these portrayals, the helm is placed on a table which is covered with a cloth, instead of the stone parapet in the king's portrait; and in each the left hand rests on the helmet, instead of grasping the bâton as in Titian's *Otho* and the *Charles I*. Nevertheless, in each the right hand with fingers outstretched supports the bâton against the upper arm just above the crook of the elbow; and, although the background was kept neutral in the *Digby*, the background in the *Verney* is articulated by a masonry embrasure and by broad daylight from a clouded sky, more or less equivalent to the use

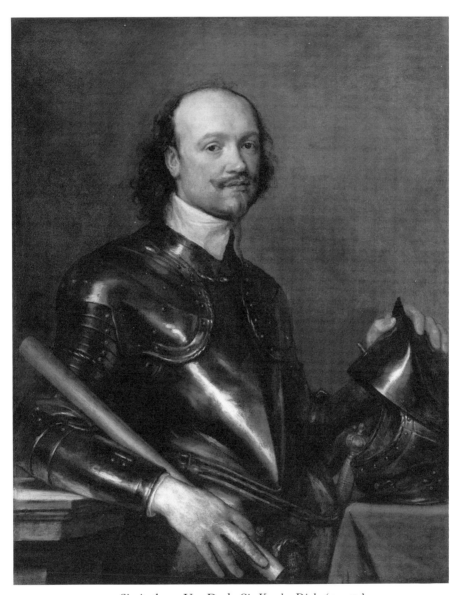

20 Sir Anthony Van Dyck, *Sir Kenelm Digby 'armato'*

in the *Charles I* of the golden brocade hangings and the late afternoon light rendered in the manner of Titian. That the *Verney* and the *Digby*, 'slightly contracted in pattern', were close in Van Dyck's presentation was clearly realised by David Piper in his 1963 *Catalogue of Seventeenth Century Portraits in the National Portrait Gallery*.[17] Piper catalogued the *Digby* cautiously as 'copy after Sir Anthony Van Dyck(?)', noting that 'the condition of the paint is very poor, making precise attribution a difficulty; its present quality barely suggests that it is an autograph by Van Dyck'. However, in a footnote Piper allowed that it could be 'a portrait left unfinished by Van Dyck and completed after his death'. Since the recent cleaning, this portrait has been upgraded to 'attributed to Van Dyck'; and, in the opinion of Malcolm Rogers, the head at least is of sufficiently high quality to be accepted as autograph. Although the armour and the rest show now as rather rubbed, 'they are the remains of something very fine'.[18] The simpler portrayal, of which no other version is at present recorded, most plausibly came after the more elaborate; and the sequence may therefore be taken that *Sir Kenelm Digby* portrayed *armato* follows, if only by a brief space, the *Sir Edmund Verney*. Digby in 1640 was thirty-seven. That the substance of the pattern was first tried perhaps as early as *c.* 1635 by Van Dyck to accommodate his portrait of the Spanish general *Alvaro de Bazan, marqués de Santa Cruz*, which was to be engraved by Paul Pontius for *The Iconography*, seems to have escaped remark (fig. 21). In the *grisaille* model which he painted for that the sense of left hand, right hand is basically the same as was to be used both for the *Verney* and the *Digby*. In the engraving the *chiaroscuro* articulation of the background of *Alvaro de Bazan* is provided by introducing the light on a fluted pilaster.[19] The pose in this pattern was then followed *c.* 1639 for the *Strafford* at Euston.[20]

Invention toward the end of Van Dyck's career at Blackfriars tended to flag.[21] The fluency and allure of his personal touch did not; although insufficiently critical acceptance of secondary or studio versions, albeit of celebrated provenance, has ignored, in numbers of twentieth-century appraisals, even by the specialists most reputed since the Second World War, those very qualities to be prized in his primary versions. That applies to the Claydon *Sir Edmund Verney* of *c.* 1640, to the *Charles I in armour* of *c.* 1636 at Longford Castle and to other examples such as the 1639 three-quarter-length of *Anne Carr, Countess of Bedford*, seemingly from the Wharton collection, sold at Christie's eight years ago,[22] also to those secondary versions of the Fitzwilliam Museum *Archbishop William Laud* of 1635, which hang in the St Petersburg Hermitage and in the Library of St

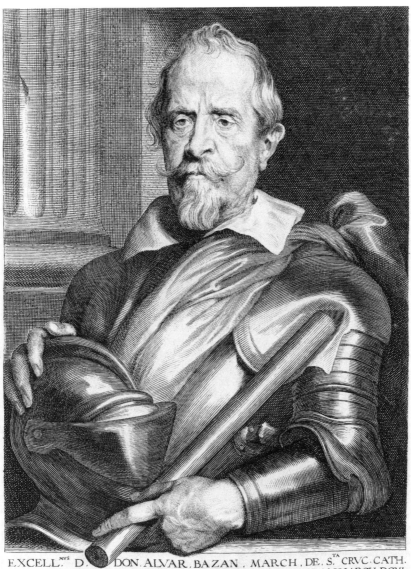

EXCELL.^{MVS} D. DON. ALVAR. BAZAN. MARCH. DE. S.^{TA} CRVC. CATH.
MA. A. STAT. CONSIL. ET. CVBICVL. OCEAN. QVACVNQ. HISP. MONARCH. DOMI_{N.}
PROPRÆT. REGIOR. ARM. PER. BELG. GVBERN.
Paul. Pontius sculp. Ant. van Dyck pinxit. Cum priuilegio

21 *Alvaro de Bazan, marqués de Santa Cruz*, engraving by Paul Pontius for
Van Dyck's *Iconography*

John's College, Oxford, Laud's own college. In fact, a kinsman of Sir Ralph Verney of Claydon has generously lent for an indefinite period the prime original of *The Standard Bearer*, their common ancestor, to the Fitzwilliam Museum after cleaning and repair at its Hamilton Kerr Institute (fig. 22);[23] and the portrait is now on view. Presumably because no one saw fit to make any challenging comparison between this masterly version and the Claydon version, there was no serious art-historical enquiry during the years that it was lent to the National Portrait Gallery by Mrs F.W. Verney. The loan there was stretched to a decade, from 1913 until it was withdrawn from public gaze in March 1924 by Lt-Colonel Ralph Verney, grandfather of the present owner.

It seems reasonable to assume that this prime version of the *Sir Edmund Verney*, unfinished in the sky and in some details of the architecture and the tablecloth, was painted on the knight's order either for his elder son Ralph, aged twenty-six, or for Lady Herbert. This Lady Herbert was neither Anne Sophia Herbert, Lady Carnarvon, although a replica of her portrait by Van Dyck was at Claydon, nor Elizabeth, Lady Herbert of Ragland, but Margaret Smith, who had herself sat to Van Dyck. By her second marriage Margaret became wife of Sir Edward Herbert, who was Attorney-General to Queen Henrietta Maria and from 1653 Lord Keeper to Charles II, and a friend of Ralph Verney.[24] Since Ralph was married to the daughter of John Blacknall, Mayor of Abingdon, an heiress in her own right who had come of age, it is even conceivable that the young couple contributed *c.* 1640 toward Van Dyck's charges. Otherwise it is obscure how Sir Edmund, recurrently in need of money although, like his son Ralph, an enthusiast for Van Dyck,[25] afforded both versions. Ralph's wife, her family having attempted to repudiate their marriage, did not come to live at Claydon until 1631. He himself, after his father was killed at Edgehill, went into exile in France for ten years with his wife, who was to die there in 1650. There was sequestration of his goods: but he had his Van Dycks with him abroad. A 'Bundel' of picture frames were still awaiting safe passage home in August 1653, and the portraits themselves lying rolled up at Rouen. He died in 1690.

If the former possibility of provenance might seem worth consideration, as Sir Oliver Millar has tentatively suggested to me,[26] we should have to explain how Ralph Verney, a jealous guardian of the Van Dycks shipped from Claydon, could have been induced to part with his father's portrait in the prime, albeit not quite finished version to Lady Herbert. It was anyway from her estate that it came for sale, as emerges from unpublished letters of April and May 1678 to Sir Ralph from his agent in London, William Fall:[27]

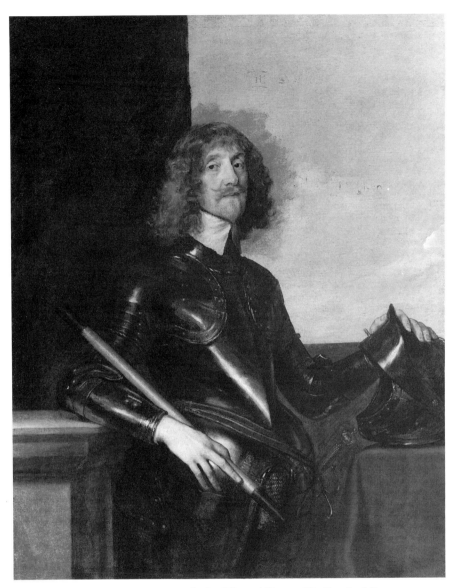

22 Sir Anthony Van Dyck, *Sir Edmund Verney: The Standard Bearer*

London 11.Ap.78

 Sr. I have spoken with Sr.Thomas Smith about the picture w^ch he sayes is valued at forty five pounds but what abatem^t may be; he cannot yet tell me; I understand by him that my Lady Osborne hath beene Inquireing after it, but whether for herselfe or another I know not.

London 18.Ap.78

 I have not seene Sr.Tho:Smith since I wrote last to you, soe can give noe farther Acc^t of y^e picture. But Mr.Wright and I intend to make a visit to it w^thin three or foure dayes.[28]

London 12.May 78

 Sr. Whilst the picture was at Parsons Greene I could never have it under forty pounds; But it being now brought to Somerset House, to be sold amongst many others at a publique out-cry; I went on Wednesday last, and it was then sett up at 38^l 10^s My Ld. of Leicest^r my Ld. Sunderland & others, bid them put a lesse value, w^ch they refused to doe, and soe it was not sold nor bid for. But I was informed y^t Sr.John Oxenden & my Ld. Leicest^r afterwards offered 30^ls for noe other reason, But because it was don by Vandike. I have by Mr. Wrights assistance soe prvayld w^th the Sellers (who have noe advantage but 12^d ye £ of what they sell) y^t it shall not be set up againe till Thursday. next And last night I took them and Mr.Wright to the Taverne and spent 8^s upon them they at last told me that if I would give 30^ls for it I should have it, for they would willingly loose 10^s to save me ten pounds I replied they should have an Answeare on Tuesday next, therefore I pray let me know your pleasure by the Mundayes Coach, It is in a very pitifull frame Covered w^th Gilt leather, don it seeme by my Lady Herbert her selfe and one little hole in the cloth, but not neare the head nor armour, w^ch Mr.Wright tells me is noe damage to it, for it shall be mended by the Seller Mr Powell. This is all can be said of it.

London 16.May 78

 Sr. I rec^d yo^rs by Aylesbury Coach and another yesterday by Plesto, and have performed your Commands in buying the picture. It hangs up in my house; (I hope) very securely; I paid thirty pounds for it; they would not abate a farthing, nor send it home into the Bargaine.

 So in 1678 the portrait came, or came back, to Claydon for an outlay of £30 *plus* carriage, and the price of a night's hospitality for Mr Wright and the sellers at a London tavern; and the interest of Lady Osborne, Lord Leicester, Lord Sunderland and Sir John Oxenden in acquiring it for themselves or others was frustrated. Eventually it left Claydon, coming in 1894 by the gift of another Sir Edmund Verney to the possession of his brother Frederick. At Frederick Verney's death in 1913 it went to his widow, Margaret Verney, and was duly inherited by their son, Colonel Ralph

Verney, and from him in 1939 by his son John. In 1973 a thief slashed it crudely from its frame in what had been John Verney's mother's London flat. Ten years later, having suffered minimal damage apart from being cut out, it was recovered by the police in a deserted house in Basildon. It was then recognised by Colonel Ralph's heir when it was screened in November 1983 in a television programme. After this happy chance, in May 1984 Sir John Verney, on the advice of Sir David Piper and Mr Roderic Thesiger, entrusted the delicate work of cleaning and mending the portrait almost invisibly back into the remains of the canvas, which had been abandoned in the frame by the vandal, to the Hamilton Kerr Institute; and after the work was completed, he transferred ownership to his heir. The 'very pitifull frame Covered wth Gilt leather, don it seeme by my Lady Herbert her selfe' has disappeared, possibly replaced after the transaction of 1678. The 'one little hole in the cloth' could have been either in the old repair to the sky above the penumbra surrounding the head or, lower left, in the piece missing from the pedestal.

In being privileged to compare the two versions, consideration had to be given to the somewhat abrasive treatment of the Claydon picture thirty odd years ago, especially noticeable in the umber of the background; likewise in the picture on loan to the Fitzwilliam to the scarcely visible effect of the canvas being slashed by the thief, also to the lack of finish in its sky and, to a lesser extent, in the foldings of the tablecloth and in the detailing of the carved pedestal. Van Dyck naturally began in the prime version with the head; and in the version at the Fitzwilliam a characteristic penumbra, not scumbled over, sets the head off (fig. 23) in just the same way as in the prime original of the magnificent full-length of the *Abbate Cesare Scaglia*.[29] The problem of the head having been solved in the version at the Fitzwilliam, there is no trace of, nor was need for, such a penumbra in the Claydon version. In the latter version the hair is straggly (fig. 24) with inconsequential strokes, lacking the flocculence of Van Dyck's own touch. Correspondingly the iris of Sir Edmund's right eye seems lifeless; the strokes which shade the hollows above his eyelids miss the quivering sensitivity of the master's brushwork; and the mouth is coarsened, especially at the parting of the lips. So it is with the knight's apparel. His linen collar as painted sloppily misses the join at the throat and the tension of the folds towards that joining; instead there are meaningless strokes of white lead. The highlight on the gorget is a scrabble of dabs, instead of those decisive marks which in the version at the Fitzwilliam show true creativity. Similarly on the visor the painter of the Claydon version produces a stodgy highlight which straggles

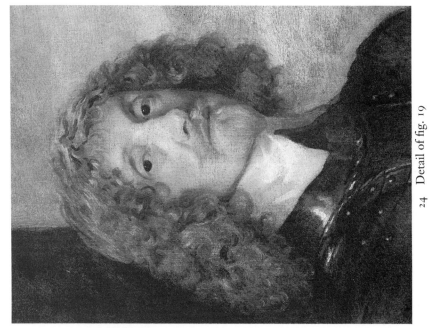

24 Detail of fig. 19

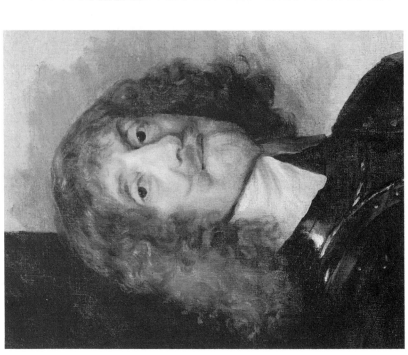

23 Detail of fig. 22

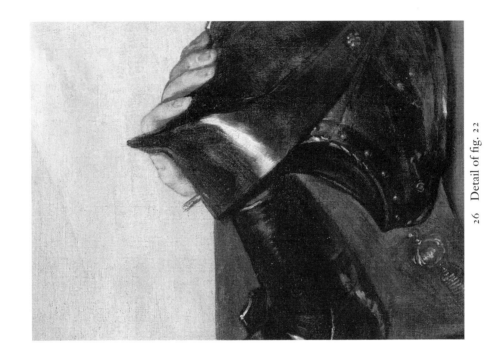

26 Detail of fig. 22

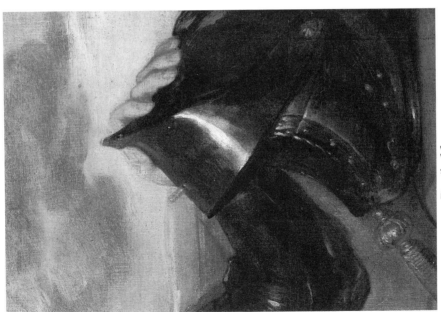

25 Detail of fig. 19

upward, a jointless thumb and rather doughy fingers (fig. 25) without convincing grip on the steel. The version at the Fitzwilliam shows a *pentimento* in the pummel of the sword, which was apparently a studio property, for it appears also in Van Dyck's full-lengths of *Strafford* and of *Northumberland* (fig. 26). On the armour it is not only the highlights of the Claydon version which can be seen by comparison to follow feebly and unconvincingly those projected by the version at the Fitzwilliam, but also the colour reflections, both of the red tablecloth and the gilded sword-hilt, were misunderstood. In the Claydon version the painter has slightly but significantly changed the intervals between solid masses so that the black and gold staff is not properly couched and the knight's left arm sags.

In sum the Claydon version can pass only as a secondary production painted by one of Van Dyck's assistants working in the Blackfriars studio from the version, albeit not quite finished, by the master's own hand. The Claydon version has always belonged at Claydon. The primary version now on loan to the Fitzwilliam may or may not have been also at Claydon before it belonged to Lady Herbert, who framed it according to her fancy. In Lady Herbert's possession about 1652, it may well have served as a model for the sculptor of the bust of Sir Edmund to be set in a niche of the marble tomb erected by Sir Ralph in Middle Claydon church to the memory of his parents.[30] It certainly belonged at Claydon from its delivery in 1678 to Sir Ralph Verney until it was given in 1894 by Sir Edmund Verney to his brother. Hitherto, it has not had the attention which it deserves as one of the last works by Van Dyck of an English sitter. The police in 1983 understandably reckoned that it might be a portrait of Charles I. Sir John Verney, having the border of the canvas and its then frame, could prove to the satisfaction of the magistrates that it was truly the portrait of the Standard Bearer, his ancestor, a man torn between chivalry in long-standing service and friendship to his liege lord, and doubts as to the wisdom of the king's quarrel with parliamentary powers. Readers of *The Life of Clarendon* will recall Edward Hyde's account of his conversation with Sir Edmund when the king's standard was set up at Nottingham. 'I will willingly join with you as best I can', said Sir Edmund, 'but I shall act it very scurvily. My condition is much worse than yours, and different, I believe from any other man's, and will very well justify the melancholick that I confess to you possesses me.'[31]

The invention of the pattern may not have been an exceptionally strong mutation in Van Dyck's portraiture: but the quality of execution and the vivid sense of noble anguish thus conveyed makes for our understanding how William Fall in writing on 12 May 1678 should record that 'Sr.John

Oxenden & my Ld.Leicestr afterwards offered 30 ls for noe other reason, But because it was don by Vandike.'

Wryly enough, the exact pattern used by Van Dyck for *The Standard Bearer*, who was to be slain at Edgehill in the service of his king, was to be used by Robert Walker within a decade for his portrait of *Oliver Cromwell*,[32] painted for the Protector's daughter, Bridget Ireton.

Notes

I am grateful to Sir Ralph Verney Bart. for his permission to refresh discussion of the portrait at Claydon of his ancestor, together with quotations from papers in his family archive. He was kind enough to allow direct confrontation of his cousin's version of the portrait with his own.

1 Mary Verney, the wife of Sir Edmund's elder son Ralph, was portrayed pregnant, 'bigg with E.V.' (her eldest son, Edmund Verney). Aged thirteen as a Ward of Court, both her parents having died of the plague in 1625, she was married in 1629 to a husband not yet sixteen.

2 For the life and death of Sir Edmund Verney, I have consulted also Frances Parthenope Verney, *Memoirs of the Verney Family during the Civil Wars*, 2 vols., London, 1892, I, esp. pp. 257–60 (the Claydon version of Sir Edmund's portrait being the frontispiece to vol. II); Margaret M. Verney (Mrs Frederick Verney), *Memoirs of the Verney Family during the Commonwealth*, 3 vols., London, 1894–9; and Sir Harry Verney, *The Verneys of Claydon*, London, 1968 (the Claydon version of Sir Edmund's portrait being illus. opp. p. 68).

3 Oils on canvas, 135 × 106.7 cm; cuspings along the top and bottom edges; treated and relined by Savage of Northampton in the 1950s; cleaned and brought into keeping by the Hamilton Kerr Institute of the Fitzwilliam Museum, Cambridge, 1991. Frances P. Verney (see note 2) writes in vol. II, p. xiii, that this portrait was painted to the order of Charles I, who gave it to Sir Edmund: but she produces no evidence in support of this statement.

4 At p. 110.

5 Lionel Cust, *Anthony Van Dyck*, London, 1900, p. 285.

6 No. 45.

7 No. 215; reproduced in the Album of this exhibition.

8 At p. 359.

9 At p. 448.

10 Erik Larsen, *The Paintings of Anthony Van Dyck*, 2 vols., Luca Verlag Freren, 1988, no. 1021. Larsen no. 1022 illustrates the *Mary Verney* as of *c.* 1636–40 also. To judge by style and by the likely age of this heiress, whom Sir Edmund secured

as a child bride for his elder son, her portrait could have been painted before that of her father-in-law by several years, and probably in 1636.

11 Frances P. Verney, *Civil Wars*, I, pp. 313f.

12 'Abraham Van der Doort's Catalogue of the Collections of Charles I', Oliver Millar ed., *Walpole Society*, 37 (1958–60), pp. 226–7, 235.

13 Oliver Millar, 'Van Dyck in London', in *Anthony Van Dyck*, Arthur K. Wheelock and Susan J. Barnes eds., Washington, 1990, p. 53.

14 Private Collection. Exhibited for the first time as the print version, and illustrated in colour, *Anthony Van Dyck*, Washington 1990, cat. no. 77. Glück, *Van Dyck*, Stuttgart, 1931, p. 559, cited the secondary version at Longford Castle as the primary, and the model for Pieter de Jode's engraving for *The Iconography*.

15 National Portrait Gallery; purchased for the Trustees after the Vernon sale, Christie's, 21 April 1877 (68). Oil on canvas, 168 × 89.5 cm.

16 G.P. Bellori, *Le Vite de' pittori, scultori ed architetti moderni*, Rome, 1672, p. 156.

17 D. Piper, *Catalogue of Seventeenth-Century Portraits in the National Portrait Gallery, 1625–1714*, Cambridge, 1963, no. 486; oils on canvas, 116.8 × 914 cm (enlarged from *c.* 106.7 × 78.7 cm).

18 ALS to the present writer, dated 16 August 1991, from Dr Malcolm Rogers, Deputy Director, National Portrait Gallery.

19 M. Mauquoy-Hendrickx, *L'Iconographie d'Antoine Van Dyck*, Brussels, 1956, no. 43. Van Dyck's model, painted in oils on oak panel, is in the collection of the Duke of Buccleuch & Queensberry at Boughton House, Northamptonshire.

20 In the collection of the Duke of Grafton, Euston Hall, Thetford, Suffolk; see Oliver Millar, *Van Dyck in England*, National Portrait Gallery, London, 1982, p. 97 (under cat. no. 57), fig. 43.

21 Julius S. Held, *Flemish and German Paintings of the 17th Century. The Collection of the Detroit Institute of Art*, Detroit, 1982, p. 38 (re *Portrait of a Young Gentleman*, half-length), 'Compositionally, the painting is unimaginative, but still well within the range of comparable portraits generally accepted as Van Dyck's work. The sharp vertical behind the figure, dividing the background into a flat dark area and an open view, is found for instance in several canvases – for instance the portrait of Sir Edmund Verney at Claydon House.'

22 Christie's sale, London, 23 November 1984 (68, as 'Sir Anthony van Dyck') bought Agnew's, oils on canvas, 101 × 82.5 cm; inscribed in the fashion of the collection of Philip, 4th Lord Wharton (1613–96): 'Anne Countes(s) / of Bedford so(le) / Daughter and / heyre of Rober(t) / Earle of Somerse(t) / 1639 out y(e) / age of 22 / p. S^r.Ant Vandike'; the inscription indicates trimming of the canvas. The prime original, not cut down, belongs to the Trustees of A.R.I. Hill's Heirloom Settlement, oils on canvas, 136.5 × 110.5 cm. The sitter was the wife of William Russell, eldest son of the 4th Earl of Bedford and later created 1st Duke. His youngest brother, Edward, married Penelope Hill, daughter of Sir Moyses Hill. The second of their three sons, Edward (Earl of Oxford from

1697), died in 1721 without issue, his wife presumably having predeceased him. His estate was left to his mother who survived both him and his father. So the painting returned to the Hill family. Both versions were cleaned in London by Mr Herbert Lank. I am grateful to him and the two owners for the opportunities to study these pictures.

23 Private collection, oils on canvas, 134 × 107.5 cm. Appears to have been slightly trimmed in the old relining. I am grateful to the former owner, Sir John Verney, for permission to publish this version here, and for his enabling the two versions to be directly compared first at Claydon and, after cleaning the Claydon version, in the Fitzwilliam Museum. I congratulate Mr Ian McClure, Director of the Hamilton Kerr Institute, on his skill and discretion in bringing both paintings to the most satisfactory state possible.

24 Smith no. 653; see Millar, *Van Dyck in England* cat. no. 51 repr. (from the Wharton Collection, painted *c.* 1636). Margaret Herbert wrote from Paris in April 1650 to her fellow exile Ralph Verney, then living with his ailing wife Mary at Blois, to have of her portrait by Van Dyck belonging to the Verneys a Jean Petitot copy in enamels: 'If my picture of Vandike be with you, I pray speak with the man that did Sr Richard Hastingses watche, to see at what rate he will make one in amell . . .' A three-quarter-length of her by Van Dyck is at Claydon.

25 In November 1639 Sir Edmund Verney begged Eleanor Wortley, Countess of Sussex, to commission Van Dyck to paint her portrait full-length, 'in a blew gowne with pearle buttons' – at his expense. Lady Sussex wrote to Sir Edmund's son Ralph,

> I am glade you have prefaleded with Sir Vandike to make my pictuere lener, for truly it was to fat, if he made it farer, it will bee for my credit – I see you will make him trimme it for my advantage every way'; and in a letter of January 1640 she wrote, 'I am glade you got hom my pictuer but I doubt he hath nether made it lener nor farer, but to rich in jhuels, I am suer, but it is no great mater for another age to thinke me richer then I was . . . I see you have imployede one to coppe it, which if you have, i must have that your father hade before, which i wish could be mendede in the fase, for tis very ugly. I becech you see whether that man that copes out Vandicks coulde not mende the fase of that – if he can any way do it, i pray get him and i will pay him for it. it cannot bee worse then it tis – and sende me worde what the man must have for copinge the pictuer, if he so it will, you shall get him to doo another for me. let me know i becech you how much i am your debtor, and whether Van Dicke was content with the fifty ponde.

The price of the copy was to be 'eyght ponde'. Van Dyck evidently did not flatter even such an influential sitter as Lady Sussex. Frances Verney, *Civil Wars*, I, pp. 257–60.

26 ALS from Sir Oliver Millar to the present writer dated 22 February 1991.

27 Verney MSS. for 1678.

28 'Mr Wright', as David Howarth has suggested to me, may have been the portrait painter John Michael Wright, a picture-dealer on the side, having worked as an agent for the Archduke Leopold Wilhelm at the Commonwealth sales. Wright may well have been in London in spring 1678, before being driven to Dublin as a Catholic who had much to fear from the Popish Plot, orchestrated by Titus Oates, in the late summer of 1678.

29 Lord Camrose. Exhibited and illustrated in colour, *Anthony Van Dyck*, Wheelock and Barnes eds., no. 70.

30 Margaret M. Verney, *Commonwealth*, vol. III, pp. 125–6. The monument is illustrated opposite p. 124 of this volume, the bust itself is illustrated opposite p. 126 of vol. II. 'The man that should drawe the designe of the Tombe is so imployed by the Pope's Officers about Shewes for Easter' that Sir Ralph's order is laid aside (letter of 8 March 1652).

31 Frances P. Verney, *Civil War*, II, pp. 125–6.

32 So far the best of several versions to be recognised (but without reference to the pattern established by Van Dyck for the *Edmund Verney* and the *Kenelm Digby*), it was published in the collection of Mr Isaac Foot by D. Piper, *Walpole Society*, 34 (1958), pp. 38–9. A perfunctory copy from Walker's studio, hanging at Dunster Castle, was exhibited in 'The Age of Charles II', London, Royal Academy, 1960–1, no. 24, as 'a respectable version, probably by Walker himself, of a type, perhaps evolved as early as 1646'. This Luttrell version measures a standard $49\frac{1}{2}$ × 41 inches.

7

SIR PETER LELY AND SIR RALPH BANKES

Alastair Laing

Sir Joshua Reynolds's visit with Samuel Johnson to Kingston Lacy in 1762 left him with two memorable recollections. The first was his quite Boswellian observation of Johnson, bored by a conversation about pictures his myopia prevented him from seeing, retiring to a corner of the room, and abstractedly, like a child, extending his legs along the floorboards.[1] The second concerned what may have been the subject of this conversation, the Lelys then in the Great Parlour.[2] As he noted at the time: 'I never had fully appreciated Sir Peter Lely till I had seen these portraits.'[3] Many of us, I suspect, our eyes dulled by seemingly endless repetitions of the same poses and physiognomies in dirty copies and over-varnished studio repetitions, optimistically ascribed to Lely himself, in country houses up and down the land, must have felt the same when confronted with the range, sensitivity, and variety of the artist, as presented by the exhibition of his work staged at the National Portrait Gallery's exhibition rooms in Carlton House Terrace, London, by Sir Oliver Millar over the winter of 1978–9.

No pictures from Kingston Lacy featured in this exhibition, because by that date the house was no longer open to the public, and seemed to have given up almost all commerce with the outside world. Then in 1981 Ralph Bankes died, leaving the extraordinarily generous bequest of Kingston Lacy, Corfe Castle and the 16,000 acres of their Dorset estates to the National Trust. It is thus only relatively recently that the collections have become known again, and serious study of most of the pictures is in its infancy, so that many misconceptions about them still prevail. One of these is the mistaken belief – to which the National Trust in the early days of its stewardship contributed – that all the Lelys now in the library represent kin and family connections of Sir Ralph Bankes. Others concern the status and identities of some of the other Lely portraits in the house. One object of this

essay is to show that Ralph Bankes's patronage of Lely is more interesting than the mere commissioning of portraits of members of his family. The second is to publish what may be the first lists of a 'gentry' collection of pictures, of which the core still survives intact: Ralph Bankes's three tabulations of his own collection, made when he was still only a member of Gray's Inn in the 1650s (see appendix, docs. 1–4).

These three lists of Ralph Bankes's pictures were taken before the Restoration, and his return to the sequestered Corfe Castle and its estates, and before the building of Kingston Lacy by Sir Roger Pratt in 1663–5.[4] The longest of the three (doc. 3) bears the superscription: 'A noate of my Pictures att Grayes Inn & wt thay Cost. X.ber ye 23rd. 1659.' It covers one and one-third sides of a sheet of foolscap without a watermark, and lists thirty-seven pictures, with a total value of £363. Five of the pictures have a graphic notation of the cipher of Charles I upon them. Now attached to this is a similar sheet of foolscap (doc. 4), but with a watermark of three circles above one another, topped by the tines of a trident, and containing (in descending order) a cross, an anvil, and an 'M'. This is titled 'The Value of my Pictures', and contains exactly the same pieces, but with much higher valuations, amounting to £536.6s.od *in toto*. A third sheet of paper (doc. 2), with the same watermark as the foregoing, titled 'A Noate of my Pictures & wt they Cost wth frames', contains fourteen numbered pictures, and three unnumberd additions. All but one of these pictures recur in the longer list of 23 December 1659 (doc. 3), albeit with significantly higher valuations. None of the pictures denoted in 1659 as having Charles I's mark on the back (which Bankes clearly had to surrender at the Restoration) is in this – evidently earlier – list, but it does include a *Jupiter and Leda* by Palma Giovane, of which there is no subsequent trace, presumably because it had been sold or exchanged for something else.

This *Jupiter and Leda* is also to be found in the shortest – and what must be the earliest – of the three lists (doc. 1), which is in a commonplace book of Ralph Bankes that has only recently been discovered in the library. It takes up only half a page of this, below a curious list in French of five – drawings apparently – by Titian, Raphael, Rubens, Dürer, and Michelangelo. It contains fifteen pictures (two of them listed together, as a pair), only six of which are – arguably – carried over into the second list (doc. 2), and five (the *Jupiter and Leda* having gone) into that of 23 December 1659 (doc. 3). It lists titles alone, save in the case of two pictures for which the artist's name is given, and another three (none of which recurs in the later lists) which are said to have come from Naples.

This, the earliest of the three lists, must postdate May 1656, when Ralph Bankes was admitted member of Gray's Inn.[5] Yet it does not include the large Berchem landscape found in the second list (doc. 2) and still in the house, which is signed and dated 1655, but for which there was once a receipt for £32 at Kingston Lacy, summarised in a note made in the nineteenth century as: 'painted to order in Haarlem in 1658' (the third edition of Hutchins' *Dorset* [1868] says that it was commissioned by Lely for Ralph Bankes, but gives the date as *1665*, an obvious literal; the December 1659 inventory (doc. 3) simply records it as acquired from 'mr Lilly', without specifying how); perhaps the date on the document was not mis-transcribed as 1658, but recorded the date of the picture's actual receipt (there was a war on); so that the first list (doc. 1) would then be datable to between 1656 and 1658, and the second list (doc. 2) to between 1658 and 1659.

The Berchem is one of two pictures (both still at Kingston Lacy) that the December 1659 list (doc. 3) records as having been acquired through Lely; the other is 'A Coppy of a night Peice', which the earliest list (doc. 2) more – but not completely – informatively describes as: 'A Dutch peice of A man & woman singing/Night peice on A small board/of Dows of Leyden mr/Lylly hath the Originall twas Coppied by one ' (regrettably left blank, but the omission of the name perhaps suggests that the copy was painted in Holland rather than England, where the copyist would more probably have been known to Bankes: could he have been Schalken? His is the name given in the ms catalogue of 1762).[6] The Dou was not in the posthumous sale of Lely's collection (in which the Dutch pictures – unlike the Italian – anyway suggest the random stock of a dealer);[7] but it is interesting to find him using his Dutch contacts to furnish English clients with pictures under the Commonwealth.

The first list (doc. 1) contains one painting by Lely himself, a *Magdalen* (fig. 27). The second two (docs 2 and 3) include both this and a portrait (fig. 28) – which (no doubt both because it is in his earlier manner and because the word 'of' in them was misinterpreted) has ever since been believed to be a portrait of Lely by the painter who is actually its subject, *N. Wray* (and was so inscribed on the back of the lining canvas applied to it in the eighteenth century) – as well as a copy by this same Wray of a much-repeated early portrait of Lely's (fig. 29).

Rather curiously, given the existence of two portraits of *Ralph Bankes* by Lely, one in the house (fig. 30) and the other a variant now in the Yale Center for British Art, the prime version of which must date from the later

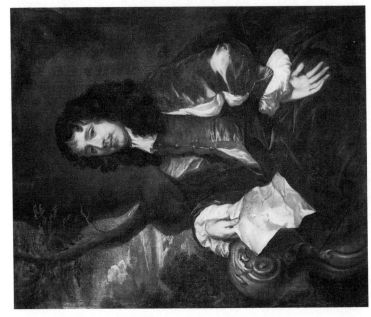

28 Sir Peter Lely, *N. Wray*

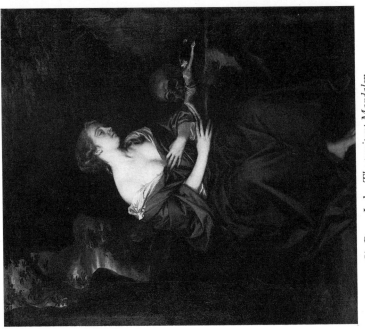

27 Sir Peter Lely, *The penitent Magdalen*

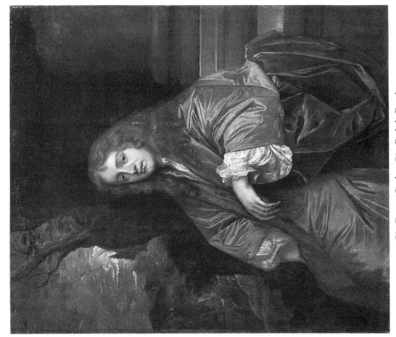

30 Sir Peter Lely, *Sir Ralph Bankes*

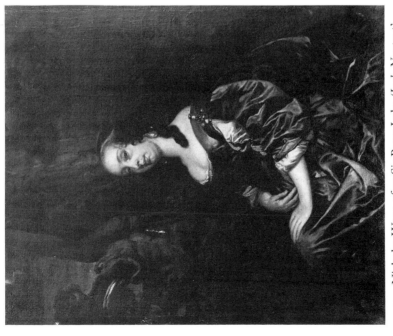

29 Nicholas Wray, after Sir Peter Lely, *'Lady Newport'*

1650s, there is no mention of any portrait of Bankes himself by Lely – perhaps the one that was to become an heirloom at Kingston Lacy was then with his mother, the redoubtable Dame Mary Bankes, who did not die until 1661, whilst the other (which has no known provenance) was presumably painted later for giving away.[8]

The first of the paintings by Lely (see fig. 27) is described as 'A Magdalen in large Knee Cloth don by mr Lylly' in the second list (doc. 2), and, more briefly, as 'A Magdalen of mr Lyllys' in the third list (doc. 3) of 23 December 1659.[9] In both, it is said to have cost, or to be valued at, £20 (inclusive of its frame). The other (see fig. 28) is described in the second list (doc. 2) as: 'mr Wrays Picture of mr Lylly on A knee Cloth', and recorded as having cost £21/10s. but – exceptionally – it was only valued at £20 in December 1659, which was nonetheless the same as the value put upon the *Magdalen*.

The copy of Lely (see fig. 29) is by this same Wray, who otherwise seems only to be recorded elsewhere as telling Richard Symonds a 'way to coppy faces'.[10] In the second list (doc. 2) it is described as 'The Lady Newports Picture drawne by mr Lylly & Coppied by Mr wray a knee Cloth', and recorded as having cost a mere £6; it is valued at the same in the December 1659 list (doc. 3). The picture is still in the collection, and one can only speculate upon the reason for its presence. This may be connected with the identity of the 'Lady Newport' depicted. She is often said to be Lady Diana Russell (1621/2–94) successively Baroness (1651) and Viscountess (1674/5) Newport, and, for eight months, Countess of Bradford (1694),[11] as if there were no other candidate. Yet not only was this Baroness Newport quite young to have been shown in the early or mid-1650s as the decidedly matronly woman in Lely's portrait, but it has also been difficult to see why her portrait should be found here, in the Clarendon Collection, and at Hardwick Hall. Moreover, there is no version of the picture at Weston Park now, nor is one listed amongst the pictures belonging to the Dowager Countess of Bradford sent down there from London in 1735. Nor, though there are heads of a '*Lord Newport*' amongst the Lelys in the artist's posthumous sale, is there any picture of a '*Lady Newport*'. But there is an autograph 'half-length' (i.e. three-quarter-length) of '*The Lady Portland*'. This could have been the widow of the 2nd Earl of Portland, but it could also have been his first wife, Anne Boteler, Countess of Newport (*c.* 1605/10–1669), and, following her remarriage after the death of her first husband, Countess of Portland, who was, by contrast, not only in the early or mid-1650s more the age of the sitter shown in the Kingston Lacy portrait, but had also been a prominent figure at court, was sister of the wife of Sir Endymion Porter, and

had first been married to the much-portrayed Mountjoy Blount, 1st Earl of Newport (*c.* 1597–1665/6), so that her portrait is much more likely to have been in demand. The presence of the prime original in the Clarendon Collection, however, must settle the matter the other way. A passage omitted from Edward Hyde, Lord Clarendon's *History of the Rebellion* (which makes no allusion to Anne Boteler) makes it clear that the author (and creator of the Clarendon Gallery) was a friend of Lady Diana Russell's husband, Francis Newport, and had helped to persuade Charles I to confer the barony of Newport on his father in 1642, against the latter's gift of £6,000 to the royal cause.[12]

It is not only as the sitter in a portrait by Lely and as the copyist of a portrait by him that Wray appears in Ralph Bankes's list of his pictures; he also appears as the copyist, in Rome, of another picture: 'A Madonna ... from a Print of Milan' (= Claude Mellan), still in the collection;[13] and as the dealer from whom three other pictures were purchased: 'A little (darck) head' by an unspecified artist, and: 'Europa A large Peice of History supposed to be of Bourdon' and 'Another of the same hand of Pan and Apollo'.[14] This pair of pictures is also still in the collection, and is a fairly surprising purchase. So too is the cautiousness over their attribution. This may partly have been because they are large, early works, very different from the later (and engraved) classicising compositions by Sébastien Bourdon, and so eclectic that it is not at first self-evident that they are by the same hand. They were very probably painted in Italy (where the artist was between 1634 and 1637) – which raises the intriguing possibility that it was there that Wray had acquired them, the hesitation over their attribution reflecting their confusing provenance.

Wray is only one of a number of dealers or intermediaries to figure in the list (doc. 3), but the variety of guises in which he appears in it makes him the most interesting. Many of the names are familiar as those of individuals involved in the dispersal of Charles I's collection, including – possibly – the most frequently cited here, 'Mr Matthewes', but also [Edmund] Harrison, and the painters De Critz and Geldorp.[15] Five of the pictures are indeed noted as having the brand-mark of Charles I's collection upon them – three of them bought from Harrison – and were evidently surrendered at the Restoration. Geldorp's single appearance is amusing, because the picture bought from him for £2 (valued at £5) as: 'A Head of A Dutch mans Drawne by Vandyke. Not finished and 3qr' (the 'not finished' struck through in both lists, suggesting that it was 'finished' after its arrival in the collection) is almost certainly the head of Jacomo de Cachiopin *after* Van Dyck, still at

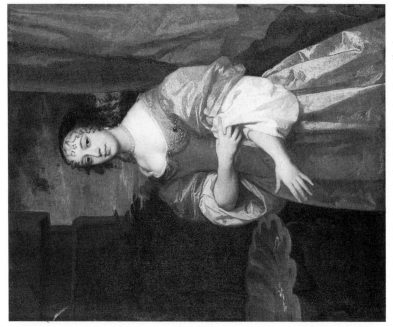

32 Studio of Sir Peter Lely, *Mary Bankes, Lady Jenkinson*

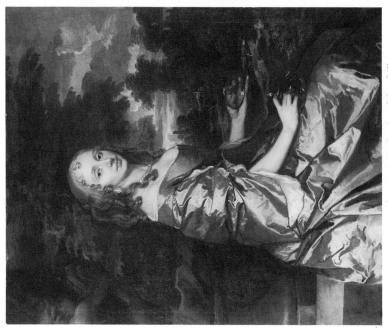

31 Sir Peter Lely, *Arabella Bankes, Mrs Gilly*

Kingston Lacy.[16] This tallies with Richard Symonds's observation at Geldorp's house in Archer Street on 4 June 1653, of 'abundance of copies of Ritrattos of Vandyke', which Geldorp was evidently not above passing off as originals.[17]

Much more could be said about the pictures in these two early 'Noates' (docs. 2 and 3), including the fascinating double portrait by De Cleyn of 'My Brothers Picture and Sr. M(aurice) Williams' still in the collection, but we must pass on to the other Lelys in it, those commissioned or bought after 1659. Most of these are indeed, as has long been repeated, of members of Sir Ralph Bankes's family, but they are not all so; and the unsystematic way in which some of his sisters, and the husband of one of them, are represented by autograph Van Dycks or Lelys, and others only by studio works or not at all, taken together with the presence of portraits of strangers, suggests that in acquiring them Bankes was motivated more by admiration of the painter (as already indicated by the pictures he had acquired by 1659) than by pride of family. It must be stressed, however, that we have no absolute proof that Sir Ralph commissioned or bought each and every one of the Lelys at Kingston Lacy subsequent to the Commonwealth lists. They are first documented in a list of all the pictures cleaned by George Dowdney in 1731.[18] Nonetheless, their coherence as a group (including the same model of frame employed for most of them), together with the association of most of their sitters with Sir Ralph, makes his ownership of them a reasonable conclusion.

Sir Ralph (?1631–77) had at least nine siblings who survived into the 1660s; three younger brothers: Jerome (1635–86), Charles (b. 1639) and William (b. 1644, but who died between their mother's death in 1661 and Ralph's erection of a monument to her in the church at Ruislip); and six of his eight sisters: including certainly Alice (1621–83, m. 1637 Sir John Borlase) and Mary (1623–91, m. 1653 Sir Robert Jenkinson, 1st Bt), and then four of the other six: Elizabeth (b. 1627; m. Mr Prince), Joan (b. 1629, m. William Borlase), Arabella (b. 1642, m. Samuel Gilly), and the three daughters who did not marry: Jane, Bridget, and Ann.[19] Of these, Jerome is reputedly represented at Kingston Lacy by a portrait by Massimo Stanzione,[20] and the other two brothers not at all; Sir John and Lady Borlase are represented by a pair of Van Dycks;[21] Mrs Gilly by a Lely (fig. 31), and Lady Jenkinson possibly by the Lely studio (fig. 32)[22] but none of the other sisters by any portrait either. More surprisingly, there is no portrait of Sir Ralph's wife, Mary Brune (before 1646–1711), yet there is a superb autograph portrait of her uncle, *Charles Brune* of Athelhampton, by Lely (fig. 33);

115

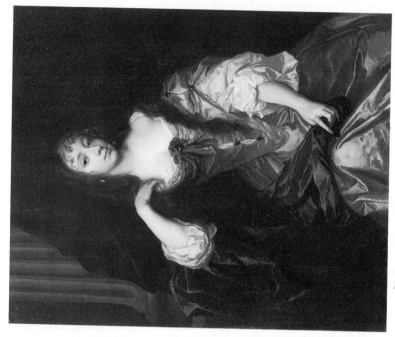

34 Sir Peter Lely, *Elizabeth Trentham, Viscountess Cullen*

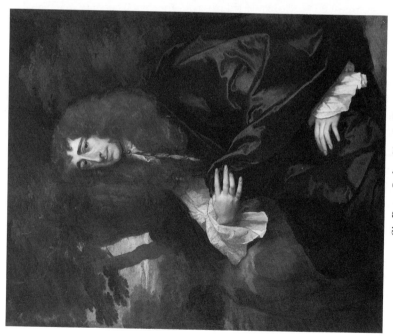

33 Sir Peter Lely, *Charles Brune*

and there are three more Lelys perfectly extraneous to the family: two fine autograph pictures of *Lady Cullen* (fig. 34) and *Mr Stafford* (fig. 35), and a studio piece of *Jane Needham, Mrs Myddelton*.

So disconcerting was the lack of family connections of two of the four autograph portraits to subsequent cataloguers that, by the first edition of John Hutchins' *History and Antiquities of the County of Dorset* (1774), a mythical 'Sir George Cullen' had been invented and made into the husband of the – in fact unmarried – fifth daughter, Jane (*b.* 1633);[23] by the present century Charles Brune had been turned into his brother, Lady Bankes's father, John Brune (who had in fact died in 1645/46);[24] and when the National Trust took over the house, it converted *Mr Stafford* into *Sir Robert Jenkinson*, simply because he seemed such a perfect pendant to *Lady Jenkinson*.[25] Thus do the hoary accretions of false identity grow upon portraits in English country houses!

The real identity of *Lady Cullen* presents no problem, but it does come as some surprise amongst the decorous surroundings of Kingston Lacy. For this can be none other than Elizabeth Trentham, Viscountess Cullen (1640–1713), daughter and heiress of Francis Trentham of Rocester Priory, Staffs., and from 1657 or before, wife of Brian Cokayne, who succeeded in 1661 as 2nd Viscount Cullen (1631–87).[26] Having inherited the Trentham estates at the death between 1649 and 1651 of her great-uncle, Sir Christopher Trentham (who was, incidentally, the father of the contrastingly virtuous Winifred Trentham, Lady Strickland), who had a life-interest in them, and then the de Vere estate at Castle Hedingham in 1654, she had an independent income of £6,000 a year. Such was her extravagance, however, that she ran through it all, and in 1676 her husband had to obtain a private Act of Parliament to break the entail, so as to pay her debts and raise portions for their children. Nor did her faults stop at extravagance: known as 'the beautiful Lady Cullen', she was, it is claimed, 'very coarsely alluded to' in the scurrilous *State Poems*, and – astonishingly – was painted as a naked, reclining Venus with doves (in fact, her face was clapped onto a copy of the celebrated composition by Spadarino).[27]

There is absolutely no traceable genealogical connection between Sir Ralph Bankes and Lady Cullen, so that one is left with one of two possible conclusions: either that he had some connection with the sitter, or that he had been intent upon having a portrait of a celebrated 'Beauty'. The fact that he also apparently had a studio version of Lely's 'Beauty' portrait of *Jane Needham, Mrs Myddelton*,[28] might be thought to point to the latter conclusion. But it is precisely the fact that it was the original of *Viscountess Cullen*

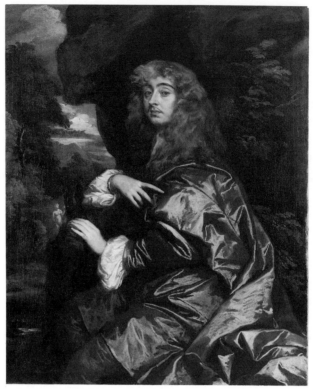

35 Sir Peter Lely, *'Mr Stafford'*

that he owned that points away from it. Hers was indeed a popular image; there are numerous versions of it (there was even one recorded as a copy in Lely's posthumous sale[29]): but to have owned the original suggests some especial position of privilege. It might be advanced that this position was his long-standing association with Lely – that the original had been left on the artist's hands because of the sitter's inability to pay for it, or else, more simply, that she had been forced to sell her pictures, including this portrait of herself, to discharge her debts, and that Bankes had been the buyer (though he in fact only outlived her financial crisis by a year and was by then in money troubles of his own). It could even be proposed that it was his son or – more probably – his grandson – both called John – who had a taste for portraits of notorious mistresses, since, in addition to these two Lelys of *Viscountess Cullen* and *Mrs Myddelton*, the collection also includes Benedetto Gennari's portrait of Monmouth's mistress, *Lady Elizabeth Howard, Lady Felton as Cleopatra*, of about 1680,[30] and Kneller's portrait of his own mis-

tress, *Mrs Voss, with her daughter Catherine*, of about 1692 (but which is unlikely to have come onto the market until after Kneller's death in 1723).[31] John Bankes the Younger (1692–1772) certainly had some taste for earlier portraits, since on 1 September 1738 he paid 2 guineas for Dahl's portrait of Mary Lutterell, Lady Rooke (1681–1702/3).[32]

The likelihood is, however, given the agreement of the portrait of *Viscountess Cullen* in quality and apparent date with those of *Mrs Gilly*, *Charles Brune*, and *Mr Stafford*, that all four portraits were commissioned together, as the seventeenth-century Sunderland frames on three of the four of them would support.[33]

By the time of the first surviving inventory taken of the pictures at Kingston Lacy in October 1762, all the Lelys, whether autograph or studio, had been gathered together in the Great Parlour. It was no doubt this ingathering that led to those pictures that were not already in Sunderland frames having imitations made for them. This was also the array that fired Reynolds with such enthusiasm. However, there are indications of an earlier arrangement, in the order in which the pictures are cited in a list of paintings that were given what was apparently an *in situ* clean by George Dowdney in 1731. In this, the portraits of *Sir Ralph Bankes, Charles Brune, Mr Stafford, Lady Jenkinson, Mrs Gilly*, and *Viscountess Cullen* are grouped together, apart from the other Lelys, and this may reflect their original collocation in the house as it was built for Sir Ralph Bankes by Sir Roger Pratt, around the time that most of them were painted.

All this is necessarily inconclusive. There remains one further conundrum, which, could we but resolve it, might shed more light upon how this particular selection of sitters in Lely's portraits at Kingston Lacy was arrived at. This is: who was '*Mr Stafford*'? (fig. 35)[34] Unfortunately, combing the printed family trees of every discoverable Stafford family has provided no self-evident answer, despite the small number of families of that name having an eligible family member – one who would have to have been in his later twenties or early thirties in the early 1660s. The first identification of him, as William Stafford, a royalist, of the family long established at Blatherwycke, Northamptonshire, occurs so late that it is more likely to be the result of intelligent conjecture than the genuine record of family tradition.[35] Nor is there any evidence that the paths of him and Sir Ralph might have crossed – unless perhaps as Members of Parliament (though William soon went abroad for his health).

The most tempting alternative candidate was the first of two Thurlow Staffords to marry into the family of the Pratts of Ryston Hall, Norfolk –

that is to say, into the family of the architect Sir Roger Pratt, who built Kingston Lacy.[36] Even more temptingly, the first of them is described as 'of Derwer' – a place that does not exist, but which could be an anglicisation of some Latin form of Derwentwater – the lake next to Keswick, from which the Bankeses originally hailed, and from whose black-lead mines they continued to draw a significant portion of their income. But sadly, though the Pratt family tree is almost devoid of dates, such as there are indicate that this Thurlow Stafford must have flourished at the beginning of the eighteenth century. However, there is another Stafford who may be our man.

This is Edmund Stafford, son and heir of one Thomas Stafford, of somewhere unspecified in Buckinghamshire.[37] Not only did he matriculate at Oxford only seven months before Ralph Bankes, on 18 November 1650; admittedly not at the latter's college, Corpus Christi, but nonetheless at Queen's, the college of Ralph's father and of his brother, Jerome; but he also went on to be admitted to Gray's Inn, on 20 November 1652, this time three and a half years before Ralph Bankes (in whose case the long interval is another indication that he went on the grand tour). It is true that the overlap is far from perfect, yet Jerome Bankes was admitted a member of Gray's Inn on 27 April 1653 (but, curiously, matriculated at Oxford only two months later), and it may be that the friendship was initially between what seems (from his portraits) to have been Ralph Bankes's favourite brother and 'Mr Stafford' – if Edmund is indeed the man.

It is frustrating to end this offering upon a note of uncertainty, but I hope that, by raising the question of the mysterious 'Mr Stafford's' identity, the spur to its resolution may have been given. If whatever turns out to be known of him adds to the portrayal of the artistic circles in which Sir Ralph Bankes moved, it will contribute further to making what might otherwise seem a somewhat dry exercise of tracing kinship and friendship worth while. Already, Sir Ralph Bankes stands revealed as more than simply a lawyer turned country squire commissioning a routine set of portraits of his relatives from Lely, but rather as something of a connoisseur, whose relations with Lely extended beyond commissioning and buying pictures by other artists through him, to acquiring not only the copy of a portrait by him, but also a portrait by Lely of the copyist. All these acquisitions were then placed in the new house built for him by Sir Roger Pratt. It will come as no surprise that by the end of his life, Sir Ralph Bankes was deep in debt and financial embarrassment; fortunately, his estates were saved by trustees; his collection remains substantially intact, and still at Kingston Lacy, more than 300 years later.

APPENDIX: DOCUMENT I

Pictures in my Chamber att Grayes Inne

[1] 2 fruict peices in Gold frames/ Dutch
[2] Jupiter and leda of Jacobus Palma Junior
[3] A Venus ⎫
⎬ from Naples
[4] A Venus A ⎭
 Bathing
[5] Sextus Quintus
[6] Laura del Petrarca
[7] An other of the same size
[8] Magdalen by mr Lilly
[9] A Night peice of A man A drinking
[10] A landskip
[11] A peice of fowle and fruict
[12] My Brother and Sr Maurice williams
[13] The Earle of (Dau [struck through]) young daughter By his
 side [?]
[14] A stone peice bought att Naples

APPENDIX: DOCUMENT 2

A Noate of my Pictures & wt thay/Cost wth frames

1. A Magdalen in (A whole [struck through]) large Knee Cloth
 don/by mr Lylly 20l—
2. My Brothers Picture & Sr M. Williams/ – A long Cloth by
 Decline about 30:—
3. A very large lanskip of Berkams 34:—
4. Jupiter and Leda of Jacobus/Palma Junior on A (three
 quarter [struck through]) large knee Cloth 6:—
5. mr Wrays Picture of mr Lylly on/A (three quarter. [struck
 through] knee Cloth 21:10–
6. A Cupid of on A (3q [struck through]) large knee
 Cloth 4:10–
7. The Lady Newports Picture drawne/by mr Lylly & Cop-
 pied by mr wray (3q [struck through]) a knee Cloth 6:—

121

8. A Head w^th A violin & A Glass/of wine Dutch peice on a 3q^r Cloth 3:—
9. A landskip on A 3q^r Cloth 3:—
10. A Head of a Dutch mans Drawne/by Vandyke (Not finished on A 3 q^r [struck through]) 3:—
11. A Dutch Peice on A board of fruict/fish & fowle 7:—
12. A Church Peice of Prospective on/A 3q^r long CLoth 10:—
13. A fruict Peice in An Ebony frame/very small 3:—
13 [sic]. A Landskip of Berkams on A small/board 3:—
14. A Dutch peice of A man & woman/singing, Night peice on A small/board of Dows of Leyden m^r/Lylly hath the Orig-inall twas Coppied by one 12:—

———————
166:—

[15] 2 Boyes Eating Grapes on a large knee/Cloth 15
[16] A landskip of Johnson on A board 4
[17] A landskip of du Witts on A board 3

APPENDIX: DOCUMENT 3

A noate of my Pictures att Grayes Inn/& w^t thay Cost. X^{ber} y^e 23^{rd} 1659

		£ s d
[1]	A Venus of Rous or Bronzino on a thick/board C R bought of m^r Harrison	26:00:00
[2]	A Susanna On A whole length of Gentilesco's/Daughter C R M^r Bates [?]	30:00:00
[3]	A Head of Tinturett on A board knee cloath/size C R of m^r De Creets	5:00:00
[4]	A Coppy of A Turks head from Rainebrand/The Orriginall is Cardinall Mazarins [–]	20:00:00
[5]	Europa A large Peice of History supposed/to bee of Bourdon. N Wray	20:00:00
[6]	Another of the same hand of Pan and/Apollo N. Wray	20:00:00
[7]	A Madonna, Coppied in Rome from/A Print of Milan N. Wray	12:00:00

[8] 2 Spanish Boyes Eating Grapes A Coppy/mr matthewes 15:00:00
[9] A Storme of Porcellus mr Powel 10:00:00
[10] A Church Peice of Perspective of Stennecks 15:00:00
[11] Cornelius Agrippa Head on A board C.R/ mr Harison 6:00:00
[12] A Boys head – C.R. from Mantua Harison 3:00:00
[13] A Magdelen of mr lillys 20:00:00
[14] Mr Wrayes Picture of mr lilly 20:00:00
[15] My Brother & Sr Maurice Williams of Decline 25:00:00
[16] A Greate Landskip of Bergens. mr Lilly 33:00:00
[17] A Head of Vandicke (Not [struck through] finished),
 Geldrop 2:00:00
[18] 2 Peices of barlows fowle 3:10:00
[19] Lady Newports Picture copied from lilly by N. Wray 6:00:00
[20] A Head wth A glasse of wine mr Tomson[?] 3:00:00
[21] A Landskip of Remors mr Bradshaw 4:00:00
[22] A Cupid of Hewsmans mrMathewes 5:00:00
[23] A fruit Peice of VanSon mrMathewes 3:10:00
[24] A Peice of fowle & fish Dutch 5:00:00
[25] A little head bought of N. wray 5:00:00
[26] A little Landskip of Bergen m Mathewes 4:00:00
[27] A little Landskip of Johnsons mr Mathewes 3:00:00
[28] A little Landskip of De Witts mr Mathewes 3:00:00
[29] A Coppy of a night Peice bought of mr lilly after/– – – –
 – – – – – – 12:00:00

[2nd side]

[30] A Head supposed to bee A Coppy after Holbein/bought
 of mr Powell 7:00:00
[31] A Madonna bought of mr Henshaw 3:00:00
[32] Our Savior A small peice bought of mr/Decreet 3:00:00
[33] A Peice In water Coulors of Pilats Judgement/of Our
 Savior of mr Dekins 5:00:00
[34] Another Peice In water Coulors of Our Savior/att Sup-
 per of mr Deakins 1:00:00
[35] A Landskip bought of mr Tompson 3:00:00
 ──────────
 22:00:00

[36] A Peice of water Coulours bought of/m^r Buttler, Coppy after Olivers/Coppy after Titian (A Venus & Satyre [struck through]) 10:00:00

32
331

363

APPENDIX: DOCUMENT 4
The Value of my Pictures

[1]	Venus	60:00:00
[2]	Susanna	30:00:00
[3]	Bergens Landdskip	40:00:00
[4]	Bourdons 2 Pictures	50:00:00
[5]	Madonna	15:00:00
[6]	Turks Head	20:00:00
[7]	The Boyes	30:00:00
[8]	The Storme	15:00:00
[9]	Church peice	20:00:00
[10]	Agrippa Head	20:00:00
[11]	Magdelen	20:00:00
[12]	m^r Wray	20:00:00
[13]	Tinturetts Head	20:00:00
[14]	Decline of my Brother	30:00:00
[15]	Vandicks Head	5:00:00
[16]	A Boyes Head of y^e Kings	5.___ ___
[17]	2 Peices of Barlowes	5.06:___
[18]	Lady Newport	6.___ ___
[19]	Head wth A glass of wine	8.___ ___
[20]	Remors	4.___ ___
[21]	Cupid	5.___ ___
[22]	Vansons fruict	5.___ ___
[23]	A Peice of fowle & fish Dutch	10.___ ___

124

[24]	A little Darck Head N.W.	6.__ __
[25]	Bergens Little landskip	7.__ __
[26]	Du Witts Land	4.__ __
[27]	Johnsons Land	6.__ __
[28]	Copy of A Night Peice bou. of Lilly	15.__ __
[29]	A Head of Holbein	10.__ __
[30]	A little Madonna wth A Savior	10.__ __
[31]	Our Savior bought of Du Crette	10.__ __
[32]	2 Peices In waterColours of Our Savior &/other figures	10.__ __
[33]	A Landskip boug of Tomson	3 __ __
[34]	A Venus WaterColours	12.__ __

536._06._

[Written on the verso: *Pictures*]

Notes

1 James Boswell, *Life of Johnson*, ed. R.W. Chapman, corr. by J.D. Fleeman, London, Oxford and New York, 1970, p. 106.

2 In 1762 Kingston Lacy had not yet undergone the first of its numerous transformations; the Great Parlour was the precursor of the present (Charles Barry's) Drawing Room.

3 According to the third edition of John Hutchins' *The History & Antiquities of the County of Dorset*, vol. III, London, 1868, p. 237, Reynolds' observation was set down amongst some notes of his on the pictures that were then to be found in the library at Kingston Lacy; but they have not been seen or recorded since. It can scarcely be a coincidence that Reynolds' visit was in August 1762, and that in October Henry Bankes commenced the first catalogue of the collection.

4 Many of the earlier papers at Kingston Lacy relating to pictures that could be found in the later nineteenth century were put into a red morocco portfolio labelled *Old & New Picture Catalogues*. They are (with one or two losses) still kept with that portfolio, amongst the Bankes papers in the Dorset County Record Office at Dorchester. I am most grateful to Mr Hugh Jaques for having helped me to consult them, and to Sarah Bridges for answering a number of enquiries

about them. The commonplace book containing the earliest list of Ralph Bankes's pictures is, however, still in the library at Kingston Lacy, where it was only discovered, by Yvonne Lewis, in March 1992.

5 Joseph Foster, *Register of Admissions to Gray's Inn 1521–1889*, London, 1889, p. 277.

6 Dou's original is now in The Royal Collection, see Christopher White, *The Dutch Pictures in the Collection of Her Majesty the Queen*, Cambridge, 1982, no. 47, p. 40 and pl. 36, called 'A couple *reading* by candlelight' and dated to *c.* 1660.

7 *Historical Manuscripts Commission, 15th Report, Appendix, Part VII*, London, 1898, pp. 179–83, esp. pp. 181–82.

8 Yale Center for British Art, no. B1978.22, $46\frac{1}{2} \times 38\frac{3}{4}$ ins. See Malcolm Cormack, *A Concise Catalogue of Paintings in the Yale Center for British Art*, New Haven, 1985, pp. 144–5; there dated to *c.* 1660–5.

I am most grateful to Malcolm Cormack for sending me a photograph of this, and for discussing it with me. Its provenance is, regrettably, unknown; but although it has generally been asserted that it is superior to the Kingston Lacy picture, this is not so, and it is also clear that it cannot be the prime version. Not only is the mastiff's head in the bottom right-hand corner clearly a subsequent insertion into the composition (but not – so far as I am aware – into the painting itself), but the SrR.B. on its collar clearly postdates the conferral of Sir Ralph's knighthood on 27 May 1660; whilst, from his age and from the style of the portrait, the original must have been painted in the 1650s.

A further three-quarter-length, exhibited in *The British Face*, Colnaghi, London, 1986, no. 4; published as a postcard by Anthony Mould Ltd (*c.* 1987/88); and auctioned at Sotheby's London (12 July 1989, lot 21) – always as *Sir Ralph Bankes* – is no such thing. The sitter is clearly different – presumably some ancestor of the Carberys, in view of its provenance from Castle Freke – and the portrait itself is of the 1660s, despite the anonymous sitter being of approximately the same age as Sir Ralph painted in the 1650s.

The half-length portrait by Lely in the Collection of the Corporation of London, *The City's Pictures*, Barbican Art Gallery, London 1982–3, no. 23, as of *Abraham Cowley*, was plausibly associated by Malcolm Rogers with the Carbery portrait, not with that of Sir Ralph Bankes.

The Kingston Lacy portrait (inv. P/2), measuring $50 \times 40\frac{1}{2}$ ins, and inscribed on the lining-canvas in an eighteenth-century hand Sr. *Ralph Banks*, is listed in the house from George Dowdney's cleaning and lining list of 1731 (as no. 71) onwards. R.B. Beckett, *Lely*, London, 1951, p. 36, no. 25, listed it as an autograph work of *c.* 1663; Oliver Millar (exh. cat. *The Age of Charles II*, Royal Academy of Arts, London, 1960–1, p. 66, no. 209, has dated it to '*c.* 1660 or perhaps slightly earlier'.

9 Kingston Lacy, inv. P/54, $64\frac{1}{2} \times 55\frac{1}{2}$ ins (including an added strip $8\frac{1}{4}$ ins wide on the left). Dated by Beckett, *Lely*, p. 67, no. 592, implausibly early, to *c.* 1645, and

by Ellis Waterhouse, *Painting in Britain: 1530–1790*, 2nd edn, Harmondsworth, 1962 (1st edn 1953), p. 242, n. 4, impossibly late, as one of the only two post-Restoration 'subject pictures' really representing 'the lighter ladies of the Court'. Oliver Millar, discussing the possibly autograph replica in the Royal Collections, first recorded in the collection of James II, *Pictures in the Royal Collection: Tudor, Stuart, and Early Georgian Pictures*, London, 1963, pp. 126–7, no. 268, dates the Kingston Lacy original more justly to *c.* 1650–5. He also points out that the model recurs in other Lely subject pictures of the period, as the *Europa* in the picture at Chatsworth, Beckett, *Lely*, p. 67, no. 582 and pl. 4, and as the pupil in *The music lesson*, signed and dated 1654, in the collection of Lord Dulverton, exh. cat. *Sir Peter Lely*, National Portrait Gallery, 1978–9, no. 24; see no. 71, *ibid.*, for a black chalk *Study of the bust of a girl in profile*, done from the same model, that might very well have been drawn on for both the *Europa* and the *Magdalen*, and for her possible identification with Richard Lovelace's 'Gratiana'.

10 George Vertue, 'Notebooks', *Walpole Society*, 18 (1930), p. 112. A '*Mrs Wray*' was amongst the 'half-length' originals by Lely in his posthumous sale.

11 Kingston Lacy, inv. P/119, 51 × 39 ins. Between 1731 and 1855/6 the sitter was wrongly identified as 'Lady Southesk'.

12 Edward [Hyde] Earl of Clarendon, *The History of the Rebellion, &c.*, 1826 edn, vol. III, p. 257, note b).

13 Kingston Lacy, inv. P/48. See the 1659 list (doc. 3), no. [7]: admittedly the text does not clearly state that the copy is by Wray, as opposed to simply bought off him, but it is hard to see why otherwise Bankes should trouble – or have had the knowledge – to record the fact that a painting done from a print had been executed in Rome.

14 Kingston Lacy, inv. P/64 and 63 (really *The judgement of Midas*). The Bourdons, which immediately precede the copy of Mellan in the 1659 list (doc. 3: possibly reinforcing the hypothesis that they too were acquired by Wray in Rome), are nos. [5] and [6]. I am grateful to Anthony Mould for confirming the attribution of the two pictures to Bourdon, which I was tempted into doubting by the uncertainty of their ascription to him in the 1659 list.

15 An [Edward] Mathewes or Mathews occurs just once, as the buyer of a variety of bits of old furniture and tapestry on 19 April 1650, (Oliver Millar, 'The inventories and valuations of the King's Goods 1649–1651', *Walpole Society*, 43 (1972), pp. 354, 440). It is rather a leap up from these to the pictures sold to Ralph Bankes, and since the latter are entirely Netherlandish, it may be that their vendor was instead some kind of merchant between England and the Low Countries.

16 Kingston Lacy, inv. P/66. Not previously identified, so not referred to in the very informative entry upon Cachiopin's portrait in *Anthony van Dyck*, National Gallery of Art, Washington, 1990–1, no. 69.

17 Vertue, 'Notebooks', *Walpole Society*, 18 (1930), p. 113.

18 This list, containing 128 pictures succinctly identified by subject, and only very occasionally by artist, and with standard formats generally put against portraits, has sums of between 2s. 6d. and 2 guineas put against each picture. It was John Cornforth who, by doing his sums, realised that the total corresponded to the £56.15s.0d. paid to George Dowdney 'for Lining, Cleaning, mending, & Varnishing all my Pictures' in 1731. Dowdney, who is otherwise unknown, also painted a couple of portraits still at Kingston Lacy, of *John Bankes the Younger, M.P.* and *Henry Bankes the Elder, M.P.*, dated 1733 and 1734 respectively.

19 The fullest details of Sir Ralph Bankes's siblings are to be found in Albert Bankes's MS. 'Parliamentary History of the Bankes Family 1589–1899', using sources that are not always still available. (I am most grateful to Sarah Bridges for supplying me with extracts from this.)

20 *Painting in Naples from Caravaggio to Giordano*, Royal Academy of Arts, London, 1982, no. 160, dated towards the end of Stanzione's lifetime (De' Dominici says he died in the great plague of 1656; a now half-ruined altarpiece was said in the nineteenth century to be dated 1658, but may have been misread).

Stanzione's death in 1656 would provide a *terminus ante quem* for the portrait, and one, what is more, that would square very well with the record of a 'D[ominus] Banks' dining with his cousin 'D. Alt[h]am' at the English College in Rome on 13 July 1654 (letter from Edward Chaney, *Country Life*, 22 May 1986). This is unlikely to have been John Bankes, whose presence in Italy seven years before is recorded by his signature in the University of Padua's visitors' book, 7 June 1647, but could in theory have been either Ralph or Jerome. 'Altam' was, however, certainly the Catholic convert Edward Altham, whose bizarre, Salvatorean *Self-Portrait as a Hermit* is at Kingston Lacy, and whose particular friend amongst his Bankes cousins seems to have been Jerome: see Jennifer Montagu, 'Edward Altham as a Hermit', in *England and the Continental Renaissance. Essays in Honour of J.B. Trapp*, Edward Chaney and Peter Mack eds., Bury St Edmunds, 1990, p. 276, n. 36 and p. 278; it was therefore probably through Jerome Bankes that Altham's *Self-portrait as a hermit* and the (lost) study of his head came to Kingston Lacy, along with the Stanzione of Jerome himself – if it is he, and not Ralph.

The portrait is first listed as that of '*A Gentleman*', in Dowdney's cleaning list of 1731 (no. 22), with the name '*Jer. Bankes*' inserted. The 1762 catalogue firmly identifies it as him, and ascribes it to 'Massimi of Naples' (no. 27). It seems odd, however, that it should have been the younger brother and not Ralph who had his portrait painted in Naples, when it was the latter who bought paintings there. That, at any rate, is the implication of the earliest list of Ralph Bankes's pictures, which contains three pictures identified as being 'from Naples': *A Venus, A Venus A Bathing* and *A stone piece bought att Naples*. The wording of this last suggests that the list-maker was himself the purchaser there.

21 *Van Dyck in England*, National Portrait Gallery, London, 1982, nos. 49 and 50.

22 Kingston Lacy inv. P/8 and P/7. Lely's portrait of (Mrs Gilly) was rightly singled out as 'unsurpassed in his career' by Oliver Millar, in Margaret Whinney and Oliver Millar, *English Art 1625–1714*, Oxford, 1957, p. 173 and pl. 47a, and dated by him there and in *British Portraits*, Royal Academy, 1956–7, no. 145, to *c.* 1660–2. Beckett, *Lely*, nos. 266 and 210, dated both her and (Lady Jenkinson) – whom he stands alone in considering autograph – to *c.* 1663. The recent re-emergence of another version of the supposed portrait of Arabella Bankes, Mrs Gilly, with a label indicating that it was bought as an anonymous *Portrait of a Lady* by Sir Peter Lely in the posthumous sale of Sir Charles Jenkinson, 3rd and last Earl of Liverpool (1784–1851) in 1852, crystallises further doubts about the true identities of two of the portraits of Chief Justice Bankes's daughters discussed in this essay. With this provenance, and in view of the sitters' respective ages and of the probable dating of their portraits on the grounds of style, it seems much more probable that this portrait, known from two versions with a Bankes and a Jenkinson provenance respectively, should be of Mary Bankes, Lady Jenkinson (b. 1623), painted around the time of her marriage in 1653, and quite possibly not by Lely at all. The supposed portrait of Mary Bankes, Lady Jenkinson, should instead by that of her nineteen-years-younger, youngest sister, Arabella Bankes, Mrs Gilly (b. 1642), painted around the probable time of her marriage, in the early 1660s. At some point their identities were simply transposed.

23 John Hutchins, *Dorset*, vol. II, 1774, p. 87.

24 Kingston Lacy, inv. P/81; *The Age of Charles II*, Royal Academy, 1960–1, no. 360, as *John Bruen*, and dated to *c.* 1670. Curiously omitted from Beckett's *Lely*, no doubt because of the confusion then reigning over the identities of Lely's sitters at Kingston Lacy.

For the pedigree of the Brunes, see Hutchins' *Dorset*, 3rd edn, vol. IV, 1870, p. 190, and the 'Visitation of Dorset, 1677', *Harleian Society*, 117 (1977), s.v. Brune, pp. 9–10.

25 Anthony Mitchell, *Kingston Lacy*, London, 1986, p. 40 (this had already been suggested in *British Portraits*, Royal Academy, 1956–7, no. 145, at a time when Lely's *Stafford* was confused with his *Wray*, and then further misidentified as a *Self-Portrait* – see Beckett, *Lely*, nos. 506 and 294).

26 G.E. C[okayne], *The Complete Peerage*, Vicary Gibbs ed., vol. III, London, 1913, p. 563. The portrait, Kingston Lacy inv. P/5, was dated by Beckett, *Lely*, no. 147, to *c.* 1663, which seems reasonable, though technical analysis might suggest a slightly later date (see n. 32).

27 I have not succeeded in locating the allusion to Lady Cullen in any of the volumes of the *Poems on Affairs of State*. Unless Cokayne had a key to one of them not available to the rest of us (and he was a descendant), he may have been confusing her with Elizabeth Culling, who is indeed 'coarsely alluded to' in Daniel Defoe's *Reformation of Manners*, 1702; see *Poems on Affairs of State*, ed.

Frank H. Ellis ed., vol. VI, New Haven and London, 1970, pp. 418–19 and n. 473. Of the two paintings of Lady Cullen that Cokayne, *c.* 1888, alluded to as 'in family possession' in his note on her in the original *Complete Peerage*, the straightforward portrait was early in this century in the possession of Brian Cokayne, 1st Lord Cullen of Ashbourne, and the picture of her as Venus was in the possession of Myles Pery-Knox-Gore at Coolcronan, Ballina, in 1949. I am indebted to Oliver Millar for giving me a photograph of the latter picture that he obtained at that time, the facial features of which finally made it clear that we had run the real identity of the '*Lady Cullen*' at Kingston Lacy to earth. The face is Lady Cullen's, but the body and composition are those of a *Reclining Venus with doves* now in the York Art Gallery (inv. 813, see *Catalogue of Paintings*, vol. I: *Foreign Schools 1350–1800*, 1961, pp. 17–18 and pl. 26, ascribed to Domenichino). First recorded in a French collection, when engraved as an Annibale Carracci with the title *L'attente du plaisir* (for which the engraving was banned from the Salon) by L.-S. Lempereur in 1781, it has most recently been attributed to Giuseppe Galli, Il Spadarino (*c.* 1580–after 1649).

The number of versions of Lely's portrait of Lady Cullen underscore her reputation as a 'Beauty'. In addition to the prime version at Kingston Lacy and that in the collection of Lord Cullen mentioned above, there are or were others in the Metropolitan Museum of Art, New York (acquired as the Duchess of Cleveland, but de-accessioned in 1979), and in Lely's posthumous sale (see below), as well as the version from Heytesbury that was with Leggatt's in 1961.

28 Kingston Lacy, P/4, 50 × 40½ ins. For the original, see Millar, *Tudor, Stuart, and Early Georgian Pictures*, p. 126, no. 266 and pl. 107, amongst the 'Windsor Beauties'. The five copies of her portrait in Lely's posthumous sale were only outdone by the dozen of the *Duchess of Cleveland*, and the ten of *Anne Hyde, Duchess of York* (for whom the 'Beauties' had been painted).

29 *Burlington Magazine* (1943), p. 188: as '*The Lady Colen*'.

30 Kingston Lacy, P/60. Recorded as no. 46 in Gennari's list of the paintings he executed in England between 1674 and 1688, as: '*Un ritratto mezza figura di Miledi Beti Felton figurata in una Cleopatra per il Duca di Moumot*', Prisco Bagni, *Benedetto Gennari e la bottega del Guercino*, Cento, 1986, p. 152.

31 Kingston Lacy, P/61. Not known to J. Douglas Stewart, who could only record J. Smith's mezzotint after this, *Sir Godfrey Kneller and the English Baroque Portrait*, Oxford, 1983, no. 824 and pl. 79c.

32 Record of payment in the MS. Account Book of General Expenses kept successively by Margaret Bankes and her son John, 1691–1740. The portrait was one of a number of items bought at the posthumous sale of Jacob Bancks of Milton Abbey. I am most grateful to George Clarke for this information.

33 The keen-eyed observation of the distinction between these and the very unusual eighteenth-century imitation of Sunderland frames on other pictures – not, as far as I know, previously noticed anywhere else – was made by John Cornforth,

see 'Kingston Lacy revisited – II', *Country Life* (24 April 1986), p. 1,126 and figs. 3, 6 and 7. It should be noted, however, that technical analysis suggests that the portrait of *Viscountess Cullen* differs from the other Lelys at Kingston Lacy in being painted over a single rather than a double ground, pointing to a date in the second half of the 1660s or after: see the forthcoming articles on Lely's studio practice by Karen Groen and Ella Hendricks, *Bulletin of the Hamilton Kerr Institute*, no. 2 (1993). I am most grateful to the authors, and to the Director of the Institute, Ian McClure, for allowing me to consult their articles before publication.

34 The portrait is Kingston Lacy inv. P/10. Dated by Beckett, *Lely*, no. 294, to *c.* 1663, but under its then confused identification as a self-portrait, which Beckett rebutted, suggesting that the sitter was instead a member of the Bankes family. The pose is that (in reverse) of a sketch *aux trois crayons* in the Fondation Custodia in Paris, which Oliver Millar has dated to *c.* 1661, see *Lely*, no. 62.

35 The 3rd edition of Hutchins' *Dorset*, vol. III (1868), p. 237, says that he was: 'Mr Stafford, his [Sir Ralph's] intimate friend, a Royalist who took part with the Earl of Holland in attempting to deliver King Charles in 1648', which identifies him with William Stafford of Blatherwycke, 1627–65; see John Bridges, *The History and Antiquities of Northamptonshire*, Peter Whalley ed., vol. II Oxford, 1791, p. 277; Basil Duke Hennings, *The House of Commons 1660–1690*, vol. III, London, 1983, p. 471. I am most grateful to the Revd Mervyn Wilson, Rector of Bulwick and Blatherwycke, for consulting the tomb slabs in the latter for me, so as to check William's date of birth.

36 John Burke, *A Genealogical and Heraldic History of the Commoners*, vol. I, London, 1836, pp. 231–2.

37 Joseph Foster, *Register of Admissions to Gray's Inn 1521–1889*, 1889, p. 262, and Foster, *Alumni Oxonienses 1500–1714*, vol. IV, 1892, p. 1,404.

Probable confirmation that Edmund Stafford is indeed Lely's '*Mr Stafford*' has just come from another discovery by Yvonne Lewis in the library at Kingston Lacy, which I am most grateful to her for passing on to me. A copy of G. T. Minadoi's *Historia della Guerra fra Turchi et Persiani*, Venice, 1594, bears the proprietary signatures of *J Bankes/1650*. lower left, and *Ed: Stafford* lower right. The first is that of John Bankes, not Jerome, so the friendship may have originally been between him and Stafford.

8

ISAAC BESNIER, SCULPTOR TO CHARLES I,
AND HIS WORK FOR COURT PATRONS
c. 1624–1634

Ronald W. Lightbown

The vogue for monumental sculpture in bronze, one of the most typical expressions of Mannerist and Baroque court patronage, was ultimately inspired, like so much else in Mannerist and Baroque taste, by humanist admiration of antique art. Sixteenth-century sculpture in bronze fused the two stylistic currents of Northern Renaissance and Italian Renaissance art. Its earliest great exponents in Italy were the Fleming, Giovanni Bologna (1524–1608), who settled there in 1551, and the Milanese sculptors, Leone Leoni (1509–90) and his son, Pompeo, who were also its earliest exponents in Spain. Visitors to Spain, however, were far less numerous than to Italy, and as Italy and the Netherlands were the two great centres of the arts for all cultivated Renaissance travellers and patrons, it was the bronze sculptures of Giovanni Bologna and the school of bronze sculptors he founded in Florence that provided exemplars of the art for the later sixteenth and early seventeenth centuries. The Grand Dukes of Florence had required of Giovanni and his followers bronze sculpture in several genres – the equestrian statue, the monumental fountain, portrait busts, ornamental sculptures, and small bronzes. The free-standing heroic bronze statue of the ruler was, however, as a genre North Italian rather than Florentine in origin: the bronze statue by Leone Leoni of Ferrante Gonzaga at Guastalla (1557–64) was conceived half a century before the first Medici commission of the kind, the statue of Grand Duke Ferdinando de' Medici at Leghorn. The seated bronze statue of Pope Julius III at Perugia, erected in 1553 by Vincenzo Danti, is a papal variant of this form. Like the equestrian statue, the free-standing heroic statue was ultimately inspired by Roman imperial sculptures of emperors, known both from historical records and from such surviving

works as the late-antique bronze figure of an emperor at Barletta. As in antiquity, bronze was also prized for sculpture for the perennity of fame its durability appeared to promise – hence the popularity it regained in the later Renaissance with princes for the erection of commemorative monuments. It was, moreover, extremely costly, so that it advertised the rank and magnificence of the patron in a medium, and in forms, that evoked the grandeur of imperial Rome.

The history of the tomb partly executed in bronze is more complex. Royal or princely tombs with an effigy in precious metal are recorded in France from the twelfth century, and royal effigies in gilt base-metal were executed in England in the late thirteenth, fourteenth and fifteenth centuries: the tombs of Henry III and Edward III in Westminster Abbey and the Beauchamp tomb at Warwick are celebrated examples. The flat engraved brass, ranging in size from the great royal brass-plate of King Eric VIII and Queen Ingeborg of Denmark (1319) in Ringstedt church to the familiar small brasses inset in gravestones of England, was a favourite form of commemoration throughout the later medieval period, not only in England, but in the Netherlands and North Germany. It is as well to remember, in this connection, that the distinction we make between the metal of brass and the metal of bronze was still not really current in early seventeenth-century England: for the Elizabethans and Jacobeans, the term 'brass' comprehended also bronze. Tombs, for instance, that to us are in the more lordly metal of bronze are, for Fynes Moryson, describing what he saw on his European travels in the 1590s, of brass or 'mixed metal', for him as noble a term as our 'bronze'.

The first Renaissance bronze effigy is that of Pope John XXIII in the Baptistery of Florence, executed by Donatello in the 1420s: bronze was to be used again for other papal tombs in Rome, like that of Martin V (c. 1432) and the great tomb of Pope Sixtus IV executed by Antonio Pollaiuolo. The tomb with gilt bronze effigy of Mary of Burgundy by Jan Borman, Renier van Thierman and Pierre de Beckere (1495–1502), in the church of Notre-Dame at Bruges, shows the continuity of the genre in the Low Countries; it, in turn, inspired the tomb in the same church of her father, Charles the Bold, executed in 1559–62, by the sculptor and founder, Jacques Jonghelinck and the sculptors M. Greeraerts, Josse Aerts and Jehan de Smet, which also has an effigy in gilt bronze. As a number of the English effigies we shall be discussing are in gilt bronze, it may be as well to emphasise here the princely splendour of expense implied by the costly gilding of life-size effigies. Far more ambitious than these in vastness of conception was the

cenotaph of the Emperor Maximilian I in the Hofkirche, Innsbruck, begun in design *c.* 1502 and continued well into the sixteenth century. In this a gigantic sarcophagus is surrounded by twenty-eight large-scale bronze figures of ancestors, relations and heroes.

In its Renaissance guise the tomb with an effigy in bronze was brought to England by the Florentine, Pietro Torrigiani (1472–1522) during that first Tudor Renaissance which preceded the storms of the Reformation and which saw a first temporary importation of Italian craftsmen by Henry VIII and Wolsey, in emulation of Francis I of France. Torrigiani contemplated tombs with bronze effigies for Henry VII, Henry VIII and Wolsey: that of Henry VII, the historian of ancient English tombs, John Weever, writing in 1631,[1] could still regard as 'one of the stateliest monuments of Europe'. Tombs with figures in bronze are not found in England during the second half of the sixteenth century, when the architectural forms and ornaments of Netherlandish Mannerism were introduced and superimposed on the traditional elements of the monumental tomb. The most important of these were the sarcophagus or tomb-chest, either isolated in the case of the greatest personages, or set against a wall for those of rather lesser degree, but always raised high above the ground on a plinth or base, the effigy or effigies lying flat, their heads supported by pillows, on its lid, with hands joined in prayer, and the images of the children of the deceased in prayer. Over the isolated tombs of the very great might be raised a canopy, resting on columns. This represented the catafalque erected over their bodies, according to custom, as they lay in state in church awaiting burial; and might support urns and obelisks and other funerary emblems. The whole would be executed in various coloured stones – 'alabaster, rich marble, touch, rauce, and porphery', in the words of Weever[2] – and richly painted besides, expressing in a northern guise the characteristic Mannerist taste for variety and intricacy and sumptuousness of materials, colours, forms and symbols. Elizabethan and Jacobean tombs of this kind are familiar to all English people.

Tombs were still designed in the early seventeenth century according to the rank or presumptuousness of those they commemorated: in 1631 Weever says that

sepulchres should be made according to the quality and degree of the person deceased, that by the tomb every one might be discerned of what rank he was, living: for monuments answerable to men's worth, estates and places have always been allowed, and stately sepulchres for base fellows have always lain open to bitter jests . . . Persons of the meaner sort of gentry were interred with a flat grave-stone . . . Noblemen, princes, and kings had (as it befitteth them, and as some of them have

at this day) their tombs, or sepulchres, raised aloft above ground; to denote the excellence of their state and dignity; and withal, their personages delineated, carved, and embossed, at the full length and bigness, truly proportioned throughout, as near to the life, and with as much state and magnificence, as the skill of the artificer could possibly carve and form the same.[3]

It was still not unusual in early seventeenth-century England for tombs of a certain stateliness to be made during the lifetime of those they were to commemorate: Weever explains:

It was usual in antient times, and so it is in these our days, for persons of especial rank and quality to make their own tombs and monuments in their life-time; partly for that they might have a certain house to put their head in (as the old saying is) whensoever they shall be taken away by death, out of this their tenement, the world; and partly to please themselves, in beholding of their dead countenance in marble. But most especially because thereby they thought to preserve their memory from oblivion.[4]

In sixteenth-century France, the traditions of tomb-sculpture in bronze were not interrupted as in England. The tomb of Henri II and his queen, Catherine de' Medici, in Saint-Denis, executed in 1563–70 by Germain Pilon, has a great catafalque canopy on which kneel bronze *priants*, figures of the king and queen in prayer, while bronze full-length figures of Virtues stand on protruding bases at each angle of the canopy. It is characteristic of the conservatism of sentiment of the northern Renaissance tomb that the catafalque surmounts *gisants* of the king and queen as naked corpses in their shrouds, a motif characteristic of late medieval piety. Similar survivals occur even in Jacobean tombs. In England, the *priant* of French tomb sculpture never displaced the recumbent effigy from its traditional favour, but as under Henry VIII it was largely the mediation through France and the Netherlands of new influences from Italy that introduced into England during the second decade of the seventeenth century the new forms of Mannerist court sculpture in bronze.

This was because of the failure of attempts to bring Florentine sculptors to London directly. After Giovanni Bologna's death, the leading bronze sculptor of Florence was his follower Pietro Tacca, who cast the small bronze statuettes that were sent as presents to Henry, Prince of Wales, in 1611–12, during the abortive negotiations for his marriage with Caterina, sister of the Grand Duke Cosimo II. But when the erection of a bronze equestrian statue to James I was mooted in 1619, in emulation of that Tacca had made of Philip III and sent to Madrid, and of the far more famous statue of Henri IV he had sent to Paris, Tacca declined to come to England. In

consequence, before the appearance at court about 1635 of the Florentine bronze-sculptor, Francesco Fanelli, English patrons were obliged to fall back on French or Flemish sculptors trained in the new style of bronze sculpture – essentially that of Giovanni Bologna. They in all probability owed some of their formation to the example of Tacca's equestrian Henri IV and to the four bronze figures of slaves cast for the base of this monument by Giovanni Bologna's other leading pupil, the Fleming turned Florentine Pietro Francavilla.[5] Until recently it has been customary to attribute almost all Caroline large-scale court-sculpture in bronze or incorporating bronze figures to one single sculptor of this kind, that self-described Praxiteles, Hubert Le Sueur (before *c.* 1585–1670), whose work has recently been more fully illuminated in an excellent study by Charles Avery.[6] Such has been the reputation of Le Sueur, so many are the documents that survive concerning him, that he has attracted to himself the attribution of almost all the large-scale bronze sculptures in northern Mannerist style that are known from Caroline England. In the case of two major Caroline tombs, which establish stylistic similarities for the attribution of a third, documents demonstrate that this all-comprehensiveness of authorship does not, in fact, belong to Le Sueur, and that he had a partner in Isaac Besnier, another sculptor of French origin. The tombs in question are those of Richard Weston (1577–1635), Earl of Portland and Lord High Treasurer of Charles I, in Winchester Cathedral, of George Villiers, Duke of Buckingham (1592–1628), the celebrated favourite of James I and Charles I, in Westminster Abbey, and of Ludovick Stuart, Duke of Richmond and Lennox (1574–1624), the cousin of James I, also in Westminster Abbey.[7]

A principal reason for the virtual disappearance of all knowledge of Besnier is the scarcity of documents concerning him. Although it is certain that French was his native language, he may, of course, have been born in the southern Netherlands, our modern Belgium, where French was current. Two sculptors named Besnier, François and Noël, are mentioned as sculptors in Le Mans in 1637[8] and it is possible that he belonged to the same family and was French at any rate in origin. It is clear that he was already a sculptor of considerable experience by the time of his arrival in England, though we have no record of any work he may have made in France or the Netherlands, and no information about his early training or stylistic formation. We shall find him employed by three of the greatest personages of the Caroline court, and that he had become Sculptor in Ordinary and Keeper of Statues to Charles I by 1643, when his son, Peter (*d.* 1693) was ordered to 'take into his custody and keeping all the moulds, statues and models which

were heretofore committed to the charge of Isaac Besnier'.[9] Besnier must have brought with him some assistants, given the great scale of the tombs he is known to have designed, and it can be assumed that Peter was one of them. As Isaac was almost certainly introduced to English court patronage by Balthasar Gerbier (1591–1663), who was a Huguenot, and as his family remained in England till the end of the century, it is possible that he, like his patron and like Le Sueur, was a Huguenot, though his name does not appear in any published records of the Huguenots in England. Indeed, the phraseology of the concluding sentence of a letter he wrote to Gerbier, which we shall read below, makes his Protestantism a virtual certainty. From 1630 to 1643 he lived at the west end of the north side of Long Acre, recorded in various spellings as Isaack(e) Benyer, Besnier, Besneir(e). He first appears in the St Martin-in-the-Fields overseers' accounts of April 1630–1, but their last entry of his name was in 1640–1. In the poor rate, however, his name continues to be listed until 1643, when it was crossed out: as this date corresponds to that of his son Peter's grant of his father's place at court, and as Peter himself was rated in White Rose Street, St Martin-in-the-Fields, in 1644–5, and again in 1658–9, Isaac must either have left England or died in 1643.[10]

Otherwise Besnier survives in known documents solely as the writer of a letter of 7/17 February 1631/2 to Balthasar Gerbier, then in Brussels as Agent for Charles I at the court of the Infanta. The letter[11] is concerned with the dispute over the authenticity of a picture of the *Virgin and St Catherine*, which Gerbier had bought late in 1631 in Brussels as a Van Dyck and sent to the Lord Treasurer, Richard Weston, Earl of Portland, as a suitable New Year's gift for Weston to make to the king. Shortly afterwards, Van Dyck wrote to Georg Geldorp, a German painter trained in Antwerp, but settled in London, that the picture Gerbier had sent was only a copy. Geldorp, who appears to have been no friend to Gerbier, and is described by him as a gossip, showed Van Dyck's letter to Weston, together with another letter he had already shown to the king. So much Besnier conveyed in a postscript to the letter he wrote to Gerbier in Brussels. Besnier's letter was brought to Brussels by the courier, Mr Killet, and reached Gerbier on 17 February: on 12 March the painter and picture-dealer, Salomon Nobliers, who had originally sold him the picture, appeared before a notary in Brussels to make a solemn attestation that it was, indeed, an original and had been approved as such by no less a judge than Rubens. Besnier's letter, rather haughtily called by Gerbier a letter 'de la main d'un pou're homme' and the attestation were both forwarded to Weston by Gerbier in proof of his good faith, and it is

only because of this that the letter has been preserved and, with it, precious evidence that Besnier was the designer and part sculptor of Weston's monument in Winchester Cathedral and of the Buckingham tomb in Westminster Abbey.[12]

The main body of the letter reads in translation:

Sir,

I will take the liberty to present to you my humble service, as does also Mr Killet, who tells me that you desired to know how the work [I am making] for My Lord Treasurer proceeds. Assuring you that I have been working on the marble busts by desire of Mr Guesches, and yet the bargain is not concluded, nor have I received any money, which Mr Guesches every day defers to pay. This scribbled sketch here is the last that the Lord Treasurer has approved. The qualities of the marbles will be as follows, the cornices and the sculpture of white marble, with grounds of Ranse marble, and the steps of Portland. I have been to the spot, the site is sixteen feet wide by twenty feet high. As regards the work [I am making], for the Lady Duchess, God be thanked, I am still continuing, as I promised. Mr St Gillis visits me often. Mr Balcan has not yet started for Paris. I make an end, praying the Eternal to continue to you his grace, and to grant you a long and happy life, and I remain always

> Sir,
> Your very humble obedient servant
> Isaac Besnier.[13]

This letter makes it clear that both the works with which Besnier was concerned had been undertaken under the aegis of Gerbier. Besnier included on the second leaf of his letter, under his postscript about Geldorp's manoeuvres in the affair of the Van Dyck, a sketch of the left half of the Weston monument, with indications of the different coloured stones to be used and a profile elevation of it, which proves that he was the author of its design and carver of the marble sculpted elements (fig. 36). It is published here for the first time, and is an important addition to the very small corpus of drawings for English sculpture that have survived from the first half of the seventeenth century. By February 1632, the date of the letter, the final design of the monument had plainly been settled, after other sketches had been submitted and rejected, and indeed there are only small differences between the monument as executed and Besnier's design (fig. 37). The single major omission in the design is the effigy, but this was plainly contemplated, for the four busts which originally stood in niches above the effigy are present in the design. The reason it is missing is probably because there was a division of labour, as we shall observe in the Buckingham monument. If the effigy was assigned to a specialist in bronze work, this would explain its absence.

36 Isaac Besnier, Design for tomb of Richard Weston, 1st Earl of Portland

37 Isaac Besnier, Tomb of Richard Weston, 1st Earl of Portland, as it looks now

Richard Weston (1577–1635) was the grandson of another Richard, who was Judge of The Common Pleas from 1559–72, and whose success as a lawyer enabled him to buy the estate of Skreens at Roxwell, in Essex.[14] Jerome, his son, served as High Sheriff of Essex in 1599 and was knighted in May 1603 by James I, who also knighted Jerome's son, Richard, two months later. Richard, who had been educated as a lawyer, pushed his fortunes by hanging about the court, and was already receiving considerable sums as royal gifts in the years 1605–9. He rose steadily in royal favour, and in 1620–2 was one of the English ambassadors sent first to the archdukes in Brussels, in an attempt to mediate between the emperor and James's son-in-law, Frederick Elector Palatine, and then to negotiate for the restoration to Frederick of the Palatinate. His first major office of importance, however, came with his appointment early in 1621 as Chancellor of the Exchequer. Under Charles I he continued in high favour, in spite of his general unpopularity in the country, and on 13 April 1628, the king created him Baron Weston of Neyland, making him three months later, on 15 July, Lord High Treasurer of England, the office whose staff he bore in the bronze effigy in his monument. He had great influence with Charles, though he had

little sympathy with Buckingham's war policy against France and Spain, conditioned by his experience as treasurer, perhaps too by the Catholic sympathies that had already led the Spanish ambassador Gondomar to manoeuvre to have him sent on the 1620 mission to Brussels. After Buckingham's assassination on 23 August 1628, he became the king's principal adviser: unlike Buckingham, he steadily supported a policy of peace rather than war. But his personal relations with Buckingham and his widow were good and, in 1634, when his enemies mounted a powerful attack on him, the Duchess of Buckingham was brought in to plead on his behalf. It was he who commissioned from Le Sueur in 1630, for the garden of his house at Roehampton, the famous bronze equestrian statue of Charles I, which since 1674 has stood at Charing Cross. This in itself is an indication of the modernity of his taste, or of that of his artistic advisers, among whom Gerbier was evidently one of the more important. This equestrian figure may also explain why the tomb was ordered from Besnier and perhaps Francesco Fanelli, the Genoese-based sculptor who would thereafter supply exquisite table bronzes to the king and his court and who, it has recently been suggested, had left Genoa for an unknown destination, in 1631; conceivably, perhaps, summoned to London by Weston. If this is possible, then Fanelli must have been at the English court more than three years earlier than has been assumed.[15] Le Sueur was fully occupied with his slightly over-life-size horse and man until 1633, the date he added to his signature. Weston had not yet attained the apex of his honours when he commissioned his tomb from Besnier, for it was only on 17 February 1633 that Charles created him Earl of Portland, in Dorsetshire. But the adjoining county of Hampshire had already become the centre of his interests outside London, for on 8 February 1631 Charles created him Lord Lieutenant of Hampshire and Captain of the Isle of Wight and from 8 February 1631 to November 1633, he was also Vice-Admiral of Hampshire. He seems to have intended to convert Winchester Castle, which the crown had granted, or intended to grant, to him, into his principal family seat, spending large sums on restoring and improving it for this purpose. The conception of the tomb, accordingly, cannot be dated before 1631. This ambition explains his choice of Winchester Cathedral to house his tomb, and his relegation of his original family seat of Skreens in Essex to the position of secondary estate.

In late 1631 and 1632 Weston, now in his early fifties, seems to have been much busied with the exaltation of his family. His tomb would commemorate his own great state office of Lord High Treasurer and the entrance into the higher nobility which his barony of 1629 had given. Perhaps it is significant that he conceived it as a wall-monument rather than as the isolated

monument which was of all kinds of tomb the most dignified: had he already
been an earl and not simply a baron when it was designed, his ambition
might have risen even higher. Although he was really the founder of his
family's greatness, and the four busts may represent the younger members
who were to continue its honours, he was also at the trouble and expense,
characteristic of his age, of having an elaborate pedigree made out for him in
1632 by Henry Lilly, Rouge Croix, and certified by Sir William Segar,
Garter. This obligingly connected him not with the London mercer who
was his great-grandfather, but with the great northern family of Neville and
the great Scottish family of Baliol, though it should be said that some of his
contemporaries, like Clarendon, did believe him to descend on both sides
from ancient gentry families. In such a man, the erection of a grandiose
monumental tomb in his lifetime was, from all points of view, an affirmation
to posterity of greatness achieved.

In this respect, it was typical of his age and of the social ambitions of the
newly aggrandised among the Tudor and Jacobean nobility. Less typical is
the stylistic form his tomb was given, though in itself an effigy in costly
bronze, essentially a princely medium, was an assertion of greatness of office
and degree, and of a right to eternity of fame. The tomb was placed on the
right wall of the chapel, now known as the Guardian Angel's Chapel, at the
east end of the north aisle. It has suffered much over the centuries, and its
original appearance has partly to be reconstructed from the drawing and
partly from an engraving published in 1715 in Gale's *History and Antiquities
of the Cathedral Church of Winchester*. On a low shaped base of plain grey
stone, fronted by a semicircular step, rests a white marble sarcophagus
projecting by very little more than the width of the bronze effigy from the
plinth of an architectural front. The plinth is formed of a plain pedestal of
black stone, from which rises a plain lower section of white marble and an
upper bevelled band of reddish-brown marble which turns forward along the
sides of the sarcophagus to form decorative corners before turning across its
front. Along the head of the plinth runs a moulded entablature of white
marble and a similar entablature forms the lid of the sarcophagus. The
whole of this lower composition is banded together and divided into panels
by Late Mannerist term-shaped pilasters, beginning in winged cherub-heads
carved in relief on the sunk friezes of the entablatures, turning into volutes
carved with grotesque antique masks from which depend long curling
tongues on the bands of red marble and ending beneath in simple tapering
members. In the centre of the sarcophagus a panel of white marble, enclosed
in a fleshy auricular frame – at this date a very advanced ornamental form

38 Detail of fig. 37

used only by artists from the Netherlands and France – bears the epitaph. Its
shape is echoed to either side by a shaped cartouche of white marble set
between the terms: the drawing suggests that these were originally to have
been inscribed.

Weston's effigy (fig. 38), its forms at once vigorously and monumentally
realised in bronze, lies on the sarcophagus. It is accoutred in armour, as
became his rank as knight and baron, but he also wears the heavy ceremonial
mantle of a peer, and a ruff. The mantle is skilfully pulled up over the left
arm on the outer edge to create a compact regular form under the body. His
head and shoulders are propped high on three pillows, which are treated
with a sculptural naturalism that renders very effectively their smoothly
swelling forms, divided realistically into two sections by seams. The pose of
the body is not flat, as in the traditional recumbent effigy; in a pose first
found in sixteenth-century Italian sculpture, the right leg is a little retracted,
so raising the knee, while the right hand is lifted up and once grasped the
staff which was Weston's staff of office as Lord High Treasurer. When he
lay sick in his last illness and Charles came to visit him, Weston acknow-
ledged himself to be a Catholic, and begged the king to take back his Lord
Treasurer's staff, which as an ailing man and a Catholic he had no right to
hold, only to be affectionately urged by Charles to get better and retain it.
The pose gave a designed emphasis to this ensign of office, and at the same

time animated the flat effigy with a sense of movement that is a characteristic sixteenth-century Mannerist device. In his left hand Weston holds a roll of the royal accounts which as treasurer it was his duty to prepare and supervise.

The front supported by the plinth continues the same gracefully simple counterchange of white or dove-grey, black and pinkish-red or reddish-brown marble which gives such a pleasingly restrained warmth of colour to a Late Mannerist design of sophisticatedly elegant simplicity. It is formed of a main section surmounted by a lunette with broken pediment, the whole resting on a plain broad band of black stone which sets off the effigy with a symbolically funereal gloom. At the sides the main section is set off by terms of white marble shaped as scrolling volutes terminating in classical rams' skulls from which depend long bunches of leaves. The body of this section is executed in a reddish-brown marble veined with large yellow markings: an architectural framework encloses and divides it internally into four panels. The vertical bands of this framework are ornamented with tapering pilasters in relief, carved in the centre with swags from which are suspended bunches of fruit. In each of the four panels is hollowed a niche, each once containing a bust. The three that survive have lost the pedestals that support them in the drawing. All are in contemporary costume.

Above are white marble cherub heads: the drawing shows a panel, presumably also of white marble, beneath each niche. It also suggests that the four cherub-heads were originally to have been cartouches of arms. The use of busts on tombs, so common in later English funerary art, was only just being introduced into Caroline England – one or two appear in the tomb-sculptures of Nicholas Stone, for instance – and the tomb, for this reason alone, must have appeared strikingly novel and advanced in taste at the time of its erection. In the lunette, of a pinkish-red marble, two white marble cherubs set in the recessed ground hold up Weston's arms, in a late Renaissance version of a motif already current in the late middle ages; they thrust their little arms with a melancholy air through the sides of a cartouche of true Late Mannerist fleshiness of ornamental framework, surmounting another plain cartouche, again of white marble and of fleshly illusionistic edging.

A feature of the monument which announces the Baroque is its comparative plainness of outline and decoration: there are no mounting obelisks or complex ornamental forms to give an intricately broken silhouette to its architectural design. The lunette was merely surmounted by a rising phoenix expressing, by a traditional symbol, Weston's hope of a happy

resurrection: it was also flanked at each end of the front by a burning lamp, another Renaissance funerary symbol. These features, shown in both drawing and engraving, are, like one of the busts, now missing, as are the bronze tassels once set in the corners of the cushions. The tomb shows some inequality of treatment: the marble figures certainly are by Besnier's own hand, the bronze possibly by Fanelli, while the decorative carvings are by assistants. The creation of such large tombs, rarely rapid, was in fact sometimes speeded by the practice of subcontracting the execution of parts of the work.[16] The epitaph, which calls Weston Earl of Portland, and records his death on 13 March 1635, was plainly added, according to custom, after his demise; no doubt shortly after his body had been taken from Wallingford House in Whitehall, where he died, and carried to Winchester for its burial on 24 March.

Besnier speaks of the Weston tomb as 'louvrages de M. le Tresorier' and tells Gerbier that he is still continuing his work, as already promised, on 'louvrages de Madame la Duchesse'. Madame la Duchesse can be identified, without hesitation, as Katherine Manners, the widowed Duchess of Buckingham.[17] Gerbier had served her husband, the assassinated George Villiers, as his Master of the Horse, as Keeper of York House, which the duke had rebuilt and redecorated, and as principal agent and adviser in the acquisition of pictures and sculptures to ornament its galleries and gardens. In July 1629, Gerbier was still Keeper of York House and though at that particular moment he was not on easy terms with the duchess, whom he felt was not fulfilling the financial intentions of her late lord towards him, still Besnier's letter makes it plain that early in 1632 he was enquiring from Brussels about an 'ouvrages' for the duchess in which he had had a hand. What was the 'ouvrages'? Since the letter is about the Weston tomb, also described as an 'ouvrages', we can legitimately interpret the word as referring to another tomb, which can only, in this case, be that of George Villiers, Duke of Buckingham, in Westminster Abbey, which, according to its inscription, was completed only in 1634 (fig. 39). Like the Weston tomb, it too is executed in marble and bronze, in a style which is French, so much so that it has long been attributed as a whole, to Le Sueur, who was however only responsible for its bronze work.

In spite of the extreme importance of Buckingham in his age as royal favourite and unofficial chief minister, and also as a collector and patron, it is typical of the negligence of English historians and art historians that his tomb, a major monument of its time, has never been thoroughly examined,

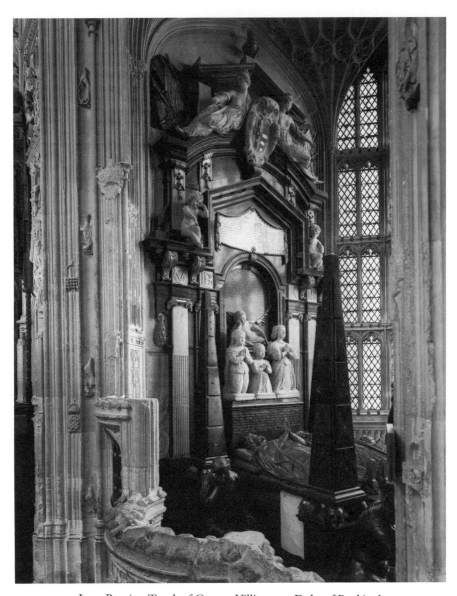

39 Isaac Besnier, Tomb of George Villiers, 1st Duke of Buckingham

either as a historical witness to what his king, his widow and his associates conceived his life and achievements to have been, or as a work of art. The long-standing prejudice against Late Mannerist and Baroque art supplies one reason for this neglect – in 1818, E.W. Brayley, the historian of Westminster Abbey and a learned and gifted antiquary, could describe it as 'ill-designed and cumbrous . . . so totally irreconcilable with everything like regular design, that it is almost impossible to describe the tomb intelligibly'.[18] A second is its site, a small chapel, the first of those on the north side of the Henry the Seventh Chapel, into which its gigantic fabric has been forced, leaving so little room around it that its forms, whose monumental scale requires ample breathing space for their correct assimilation and appreciation by the spectator, are oppressed and not perceived in their real majesty. Yet this site itself, properly comprehended, is another signal historical witness to the whole-hearted esteem and loyal affection of the first two Stuart kings for Buckingham, and the value they set on his services, for during his lifetime they had accorded him for his tomb a space in a chapel expressly reserved by will of the founder, King Henry VII, for himself and for those of royal birth. This was clearly remembered in Stuart times: John Weever writes in 1631 that Henry built 'that glorious fair chapel at Westminster, for an house of burial, for himself, his children, and such only of the blood royal, as should descend from his loins; forbidding that any other, of what degree or quality soever, should ever be interred in that sacred mould; as appears by his last will and testament'.[19] A similar favour had in fact already been conferred by Richard II on John of Waltham, Bishop of Salisbury and Treasurer of England, who was interred by royal command, in spite of many murmurs, among the kings in the Chapel Royal of the Abbey, but only under a plain slab,[20] not like Buckingham, in a tomb whose elaboration and magnificence equalled, even surpassed, some of the royal tombs in the chapel. In death then, Buckingham was singled out for exceptional royal favour, just as in life he had been raised in 1623 to the semi-princely rank of duke, then held only by the king's own second cousin, Ludovick Stuart, 2nd Duke of Lennox and 1st Duke of Richmond.

This grandiosity was, however, a reflection of contemporary taste, ever more sumptuous and elaborate in its funerary art, rather than a conscious rivalry of royal state. In considering the tomb and its design, it is not enough to examine its forms stylistically, nor would it be wise to attribute its conception entirely to the sculptor. Besnier must certainly have submitted designs for the approval of the duchess, just as he obviously submitted various designs to Weston before the Lord Treasurer gave his approval to the one

that was finally executed. But he will certainly have received instructions to make his design incorporate the elaborate sequence of Latin epitaphs which laud the duke and lament his fate. Indeed, one of these, inscribed on a gilt metal tablet and set in the wall facing the tomb proper, whose Gothic mouldings had to be cut for its insertion, had already been composed by September 1628, shortly after Villiers' assassination on 23 August, when it was submitted for royal approval as a suggested epitaph for the duke. All the epitaphs are elaborate compositions in Jacobean Latin, exalting the duke as possessing every gift of body and mind, the intimate of two kings, equally skilled in the arts of peace and war, a generous patron of letters, liberal, kind and courtly, though hated by the vulgar sort, of European fame for his heroic virtues as a true Christian and Protestant. They must have been composed by some learned man with a typical Jacobean taste for ingenuity in paradox, perhaps the duke's own chaplain, William Cradock, perhaps some other courtier-scholar, cleric or layman. Certain elements incorporated in the tomb which embody its sentiment – the inscriptions, the figures of the duke's children, the four bronze allegorical figures of his virtues at the side of the sarcophagus, the recumbent effigies of duke and duchess – must have been partly or wholly suggested by the duchess or approved by her, and almost certainly sanctioned and approved by Charles, in whose royal burial chapel at Westminster they were to figure. Gerbier himself may well have had a hand in the devising of the tomb's programme as adviser to the duchess: he represents a type of figure, in varying proportions part courtier, part *letterato*, part amateur of the arts or even amateur artist, who had come to assume a preponderant role in the artistic life and in the great ceremonies and pageants of the Renaissance, devising the inventions required for state entries, weddings, tournaments and funerals, contriving mottoes and devices and emblems, or suggesting programmes for works of art.

Like the Weston tomb, the Buckingham tomb is partly executed in stone, partly in bronze. The dominant stone is black. As on the Weston monument, but here more amply, this use of funereal black is one of the signs of the advance of a new taste in tomb sculpture, which was to make constant use of symbolic black stone for the rest of the century. The origins of the mode are to be found in the late middle ages, but sixteenth-century Mannerism had added to a medieval fondness for heraldic magnificence of colour on the tombs of the great, its own taste for various and intricate richness, expressed in the use of such materials as alabaster and coloured stones, fretted into the fantastic forms of Northern Mannerism. The comparative sobriety of the Buckingham tomb, its use of a few skilful contrasts between

black and white stone, gilt and ungilt bronze, its breadth and boldness of architectural form, again indicates, as in the Weston tomb, the incipient prevalence of a new taste which, for all its intrinsic richness, represents that preference for an elegant simplification of earlier Mannerist intricacy, and that mounting liking for a few amply treated forms, which were contributory factors in the evolution of the Baroque style in English funerary art.

This grandeur in relative simplicity of the monument sets up another visual conflict between it and the small Gothic panels ornamenting the walls of the chapel into which it is cramped. The south wall of this chapel is occupied almost to the level of the vaulting with a great architectural frontispiece from which the sarcophagus and its shaped oblong base, project. This frontispiece is of black stone, relieved by white marble pilasters topped by gilt capitals incorporating classical ram's head motifs, by square white marble panels set with large gilt-metal ciphers, by figures in white marble of the duke's children, of two weeping child geniuses above, and of two allegorical females who hold the duke's arms at the summit, and by the gilt trophies and white volutes framing the sides. The whole is ingeniously devised to incorporate some of the traditional features of such great monumental tombs, the children of the deceased, laudatory inscriptions and a prominent coat-of-arms.

Besnier has used for it a free version of the traditional form of the arch, which in Renaissance wall-tombs so frequently frames the sarcophagus, but for reasons of greater majesty – the duke is described at the beginning of his first epitaph as a prince – the tomb itself projects as a free-standing sarcophagus. The three superimposed internal stages of this frontispiece are distinguished by three forms of pediment: an arched niche, above which is a tabernacle-shaped pediment with pointed top, while over this again is a low flat semi-circular pediment. The entire design is an ingenious solution of the difficulties offered by the cramped site. It was not possible to place a monument of the required majesty of size, either laterally against the window wall where it would block the light, or along the narrow south wall of the chapel. Accordingly, the narrow south wall was utilised for the frontispiece, and the sarcophagus with its effigies and attendant figures was projected into the body of the chapel, parallel to the line of the aisle. Here at least a full view of one side of it was made possible to that passer-by so often adjured to stop in Renaissance epitaphs.

The first motif of the frontispiece, the recessed arch, opens above a plinth inscribed with the duchess's testimony to the conjugal virtues of her husband, and to her erection of this monument to his memory and as a record of his honours intended 'not as a sacrifice to vanity, but to testify to

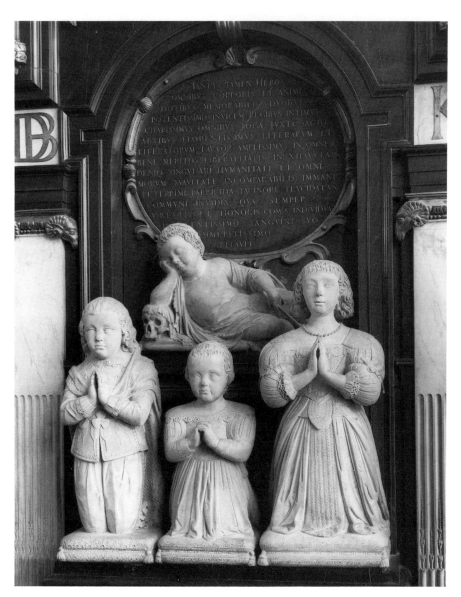

40 Detail of fig. 39

the munificence of excellent kings'. On the plinth her three living children, the most generally admired part of the tomb, perhaps because of the fleshiness of their faces, all wearing carefully described contemporary dress, kneel in a flat frontal pose (fig. 40). They are clearly by the same hand as the cherubs of the Weston tomb. On the left is the eldest surviving son, George, born on 30 January 1627/8.[21] As his father's heir, he wears a fur-lined ducal mantle: he is represented in boy's, not child's, dress, an indication that this part of the monument at least must date from a time shortly before its completion in 1634. This is confirmed by the appearance next to him in child's frock of his little brother, Francis, who was born posthumously on 2 April 1629. His presence can be taken as a proof that the design of the monument did not assume its final form until after that date. He has generally been identified as a little girl, but Buckingham's only daughter, Lady Mary, born in March 1622, is figured on the right. It was for her, after the death as an infant on 17 March 1627 of his only male child, Charles (*b.* 17 November 1625), that Buckingham obtained from the king on 27 August 1627 a grant of the dignity of Duchess of Buckingham, with remainder to her male heirs should he himself die without male issue. Accommodated with cushions, as suits their rank, Lord George, Lord Francis and Lady Mary kneel in prayer – George's cushion, as befits the heir, being richly decorated. This motif of praying children follows a still-honoured convention of late medieval art, though Protestantism, which sternly rejected medieval belief in the lawfulness or necessity of prayers for the dead, had emptied the motif of its original doctrinal significance, and left it simply as an expression of piety. Indeed, even as an expression of pious grief it was becoming out-worn, and this particular invention of the funerary art of an earlier world was to disappear wholly from tombs after that real dividing-line between the old and the new age, the middle years of the seventeenth century, had been over-passed. In later days filial piety was confined to the epitaph. Behind and above them, the dead Charles, according to another convention which can be traced back as far as the Aragazzi tomb of *c.* 1428–38 by the Florentine early Renaissance sculptor, Michelozzo, is figured as a naked cherubic infant in classical drapery: he reclines in the sleep of death, his head resting on his right arm, which is supported by a skull.

Above Charles, in the recess of the niche, a gilt oval cartouche contains the central part of the epitaph, a laudation of the duke's character and a lamentation over his untimely fate. The projecting tabernacle-shaped pediment above is supported on gilt volutes, between which are square slabs of white marble mounted with great letters of gilt metal forming the ciphers GV (George Villiers), DB (Duke of Buckingham), K (Katherine), DB

(Duchess of Buckingham). On the pediment are two weeping putti, classical descendants of the angel mourners of later medieval tomb art; in the pediment between them is a gilt funerary drape fastened to the arch by a rosette bearing the first part of the duke's epitaph, a recitation of his titles, honours and offices. On the low semi-circular pediment above, two draped female figures, long and slender, extend their right arms to summon attention as they hold over its centre a cartouche whose fleshy circular form is at this date a testimony to the Netherlandish or French origin of the sculptor. It frames the duke's shield of arms. Above, to either side of the summit of the frontispiece, are gilt metal trophies of arms, very finely designed in a French style and applied to slabs of black marble. The whole is topped by a gilt flaming funerary urn resting on a small white marble plinth.

The vast free-standing sarcophagus is of moulded black marble, set off by panels of white marble. On all three sides these panels were once decorated in their centre with applied motifs in gilt metal, long since stolen, which, according to Brayley, were tablets. The shaped body of the sarcophagus is decorated with gadroons in relief, gilt stems filling their intervals. On it rest the two gilt bronze effigies of Buckingham and his wife, that of the duke being made slightly longer. The hands of both are raised in the conventional gesture of prayer. Their heads rest on cushions, whose fringed tassels are now missing. The effigy of the duke is set to the left of a spectator standing at the extreme end of the tomb, where alone it can be seen in its entirety by the visitor. He wears armour richly decorated with a vertical band of ornament alternating with a plain vertical band decorated in relief with his cipher GDB, and with anchors crossed in saltire, the emblem of his greatest military office, that of High Admiral, which he was discharging when he was assassinated. He wears a ducal coronet and a ducal mantle, chased and engraved with ermine. The casting of the right arm was faulty, and it has been pieced and mended on the outer side of the wrist. Katherine, his duchess, daughter and heiress of Francis Manners, 6th Earl of Rutland, whom he married on 16 May 1620, wears a ruff and a jewelled stomacher over her state robes, embroidered with sprigs and rosettes, rendered in relief. She too wears her coronet, but lies only on two cushions, one less than her husband's three. As we have seen, it was she who erected her husband's tomb, and who must have inspired the poignant sentiment of mourning and the passionate sentiment of vindication that animate its sculptures and inscriptions.

The sarcophagus is so high that the effigies are almost at eye-level: this was consonant with the lofty dignity of the duke, and also gives room for the

four life-size bronze figures seated in mourning in the base, one at each corner. Two, Mars and Neptune, are male, and are placed in due precedence as figuring the heroic military virtue of the deceased duke, at the front of the tomb: the other two, generally identified as Benevolentia and Pallas, are female, and are at the rear. Their seats are formed by plinths of masonry, whose rear supports a great black obelisk resting on a gilt bronze skull. Both skulls and obelisks were popular Renaissance funerary symbols. The skulls derive from late medieval funerary art, but the obelisks also had triumphal overtones as commemorative monuments of classical antiquity – Weever in 1631 several times refers to the funerary significance of obelisks.[22] Obelisks resting on skulls appear with equal prominence on Hendrick de Keyser's tomb of William the Silent (1614–21) in the Nieuwe Kerk, Delft, with the same message of the transience of all human glory.[23] The sides of the obelisks are decorated with trapezoid panels in relief which once bore, so Brayley says, 'various ciphers and devices, as anchors, palm-branches, masks, &c., in metal which . . . have been stolen'. A stub of metal in the centre of each panel confirms that these motifs, which converted the obelisks into funeral trophies, are indeed missing: with them has also disappeared the emphasis on the transience of mortal glory signified by the supporting skulls.

The elaborate texturing and jewellery of the effigies and their enrichment with costly gilding are in deliberate contrast to the sombre simplicity of form of the four bronze mourning figures. They are traditionally despised – Brayley writes that 'their proportions are clumsy, and their attitudes tasteless and constrained', but our revived understanding of Late Mannerist art should now lead to at least some appreciation of their quality which, if not absolutely of the finest, is sufficiently high in the second rank. Their effectiveness is purely sculptural and borrows nothing from enriching ornament. Mars, the emblem of Buckingham's military prowess, occupies the most prominent corner of all – mourning in a pose of heroic pathos obviously reminiscent of Michelangelo.

The influence of some drawing by Michelangelo was noted by Margaret Whinney in Nicholas Stone's pedestal monument of the Hon. Francis Holles (d. 1622) in the Abbey, a figure close to the Mars of the Buckingham tomb, and clothed in a very similar classical armour. The god's strong sinewy body, formed on a fine rhythmic serpentine curve, is encased in a classical breastplate ornamented with a fierce shouting male mask, figuring the fury of war, like the dragon crest of his helm. Both motifs are modelled with vigorous power. Under the breastplate he wears a classic military tunic

of leather laminae; and he has besides a fringed military cloak.[24] With his left
hand he holds a cartouche-shaped shield as he sits on a drum of war, set
beside a draped bound object, possibly a broken standard, and rests his left
foot on a pair of military gauntlets. By his right foot protrudes an anchor,
now broken, to indicate that it is a naval, not a land-general that he mourns.
That he laments a High Admiral is also affirmed by the noble figure of
Neptune, at the opposite corner, represented as an old man, again strong
and sinewy, with a beard modelled in a fashion very reminiscent of Giovanni
Bologna. He rests his hand on his chin and puts his fingers into his beard: his
finely formed body is naked, except for a loose mantle lying over the left
knee and held by a strap over the right shoulder. The two female figures in
their proto-baroque amplitude of figure rendered in thick muscular forms,
are less eloquent than these two male figures, nor is their identity quite so
certain. One, that behind Mars, is half bare-breasted: she wears a tunic, but
has no identifying emblem. The other, behind Neptune, is presumably that
identified by Brayley as Pallas. If so, she would signify Buckingham's
patronage of the arts, literature and learning, and indeed the identification is
plausible, given that Buckingham is praised in his epitaph as an encourager
of letters and of lettered men, and as liberal towards all who deserved it,
while among his other honours is cited his Chancellorship of the University
of Cambridge. She too wears a classical tunic which leaves her left breast
exposed, and classical sandals: she mourns with her right hand palm upwards
on her knee. All these figures have a very correct, not an approximate,
classicism of dress.

To all these honours and achievements of Buckingham's glorious career
as friend and minister and general to two great kings, our attention is
summoned by the bronze figure of Fame, who advances at the front of the
sarcophagus between the feet of the two effigies, blowing what now appears
to be a whistle, but was probably a long trumpet, in a summons to all to hear
the achievements of Buckingham (fig. 41). Sculpturally, her conception is
very ambitious – even proto-Baroque in its pose of advancing movement,
and the figure is a singularly fine one, perhaps the finest of the whole
monument. It marks that the spectator, for the fullest view of the monu-
ment, as indeed the placing of the epitaphs declares, must position himself at
its end, where however the very small space available provides a final con-
tradiction between the princely grandeur of the tomb, designed to strike at a
distance, and the narrow chapel that holds it, blocking with its three Gothic
walls and outer enclosure an easy view from any angle.

The Buckingham monument obviously cannot have begun to be designed

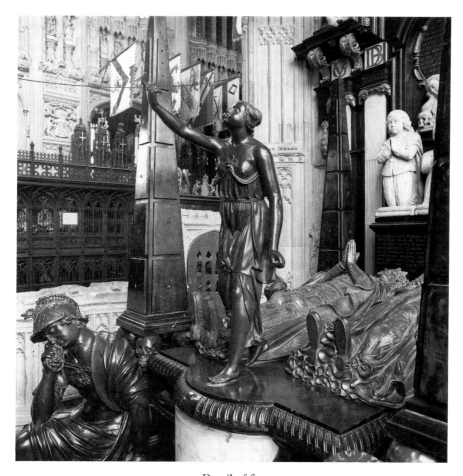

41 Detail of fig. 39

before September 1628, and, it may be suspected, was not even commis-
sioned by the duchess before Charles had been persuaded by Weston to
abandon his scheme of himself raising a tomb to his favourite, friend and
loyal servant. In his first grief Charles had summoned Weston and ordered
him to commission such a monument. 'It was reported', says an anonymous
document of late 1628 'that my Lord Weston, when the great preparation
was to the duke's funeral, told the king that if his majesty please to bestow
any great matter on the duke's funeral, he had better erect him a tomb, for
that would last for posterity, this but a day: so when the funeral was past, the
king sent for him to contrive the work of the tomb. He told his majesty that
not only our nation, but others, would talk of it, if he should make the duke a

155

tomb, and not his father.'[25] Buckingham was buried in Westminster Abbey on 18 September 1628, and this report is generally interpreted as meaning that Charles abandoned his project almost immediately. It must have been still further delayed by the great debts encumbering the duke's estate, which it took the duchess nearly two years to pay. Only when these were cleared can the duchess herself have embarked on raising so costly a monument to her husband. But given Besnier's later employment by Weston, it may have been the abortive royal plans for a Buckingham monument that first brought about his introduction to the great man's notice, almost certainly through Gerbier.

Clearly, work had been in progress before February 1632, when Besnier promises to continue it, but the ages of the three children suggest that 1630 or 1631 perhaps saw its actual inception, while the 1634 of the duchess's inscription records the year of its completion. Besnier was certainly resident in London from before April 1630, but there are no known documents that attest his residence there before that date. There is, however, unanimity that the monument of Ludovick Stuart, 1st Duke of Richmond and 2nd Duke of Lennox (1574–16 February 1623/4) (fig. 42) in the south-east chapel of the Henry the Seventh Chapel at Westminster, is by the same hand or hands as the Buckingham tomb, and indeed its four bronze figures of Virtues, recently proved to be the work of Le Sueur, have the same smooth fullness and the same ridgy folds of drapery as the four bronze mourners of the Buckingham monument. The attribution of the design of the monument entails Besnier's arrival in England some six or seven years before his documented residence in Long Acre: in itself there is nothing at all implausible in this. The duke, half French by birth,[26] was second cousin and next heir to James VI of Scotland, to whom he was Heritable Great Chamberlain, holding besides various high Scottish offices, including those of Chamberlain of the Household and Lord High Admiral. On James's accession as King of England in 1603, he came south with him, and was created on 4 May 1603 a Gentleman of the Bedchamber, and on 25 June a Knight of the Garter, and was naturalised a month later. On 6 October 1613, James created him Baron of Sethington and Earl of Richmond in the English peerage, augmenting these honours by granting him the title of Earl of Newcastle upon Tyne and 1st Duke of Richmond on 17 May 1623. He received his new title because Buckingham was also to be created a duke, and if Lennox had not been promoted to a dukedom in the English peerage, would have taken precedence in England, though a commoner by birth, of Lennox, who already a Scottish duke, was of the Stuart blood-royal. For one

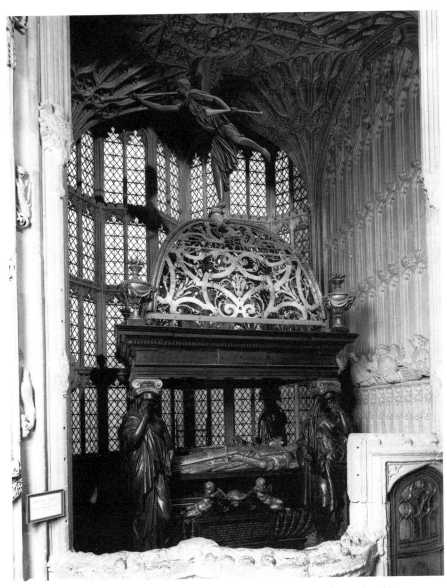

42 Isaac Besnier, Tomb of Ludovick Stuart, 1st Duke of Richmond and Lennox

day, therefore, Lennox was the only English duke, Buckingham's patent being deliberately dated a day later. He discharged diplomatic missions for his cousin, James, and was high in his favour and confidence, having helped him in his manoeuvres to secure the English crown and serving him as Lord Steward of the Household from 1615 until his sudden death on 16 February 1623/4. This brought great grief to King James, who prorogued Parliament in his sorrow, and lasting grief to Lennox's widow, Duchess Frances, the raiser of his monument.

There was, however, nothing in his career beyond his high rank and service to his royal cousin to justify the altisonant claims to widespread fame which his monument (fig. 42) embodies in its imagery. Its erector, his third wife, Frances Howard,[27] daughter of the first Lord Howard of Bindon, was a lady of strong character and great pride of birth who, after a first marriage to a wealthy London citizen, became the wife of Edward Seymour, 1st Earl of Hertford. She married the duke, who had long paid her a sort of court, on 16 June 1621, only two months after Hertford's death on 6 April. Lennox's previous marriage had been a wretched failure, but he and Frances appear to have been very happy together, and although their married life was short, only two-and-a-half years in duration, she was to declare in her will of 1639 that 'with the losse of my Lord all earthly ioyes ended with me And I ever computed his funeral daie my buriall'.[28] To understand his great monument, however, we must reckon not only with her real devotion to his memory, but also with the grandeur of rank to which she was raised by the marriage, becoming cousin to the king, with the title of the Lady Princess Duchess Dowager of Richmond and Lennox.[29] She maintained a corresponding state: when she went to her chapel in Ely House she was preceded by four officers in velvet gowns bearing white staves and by three gentlemen ushers, and followed by two ladies who bore her train and by the Countesses of Bedford and Montgomery and other ladies walking two by two behind.[30]

The project for a great tomb to the duke's memory was already being mooted by April 1624, when Abraham Darcie, a Geneva author and poet who was a member of the duke's household, addressing the duchess in an elegy, declared that God's purpose in leaving her still on earth was that she might remain

> One by whose workes obliuion should be slaine,
> One that might worthily deplore thy fate,
> And raise a TOMBE that might beseeme thy state.

Again Dr John Cleland, the duke's domestic chaplain, in dedicating the

sermon he preached on 20 April, the day after the duke's state funeral, to Esmé Stuart, Lennox's brother and successor, declared 'Loe here a Monument of man's Mortalitie, erected in haste, to represent the Death and Funerals of my good Lord, your Noble Brother, whose heroicke LIFE requires more leasure to build A MAUSOLE to his Immortal Memorie.'

As Ludovick Stuart was James's nearest relation, there is no need to account for his burial in Henry the Seventh's Chapel. Here, too, however, the monument greatly exceeded in scale the Gothic chapel allotted to it; here, too, its longer side is set parallel to the length of the chapel, in order to give a visitor the clearest view of the effigy of the principal person commemorated, the duke. Even so, no satisfactory view of it was possible then or now, and on 15 September 1628, Duchess Frances herself prayed the king 'to order a partition of stone, wherein there is a door and a window, at the entrance to the little chapel, in Westminster Abbey, where the Duke of Richmond's tomb is placed, may be removed, and an iron gate placed instead thereof'.[31] The petition was referred to the Dean and Chapter of Westminster for their opinion, but was evidently not granted. It marks the date of completion of the monument, as Margaret Whinney and Oliver Millar noted long ago.

In form the tomb consists of a great oblong canopied catafalque, supported at each corner by a great bronze figure of a mourning Virtue, rising over a huge shaped sarcophagus of black marble. On this, almost above eye-level, in consonance with their exalted degree, lie the gilt bronze effigies of Duke Ludovick and his wife, Duchess Frances. The canopy proper is of gilt metal open-work Mannerist strap-work, in which are pierced on each side letters forming inscriptions. Those on the front make the motto AVANT DARNLY under a bull crest encircled by the Garter and surmounted by a coronet. They allude to Ludovick Stuart's descent from the Stuarts of Darnley, Earls of Lennox. The corresponding motto on the other side reads QVOD VIDERI VIS ESTO and is perhaps the duke's personal motto, for it means 'Be what thou wouldst seem'. Of the two mottoes on the short side, one, CONSTANTIA CORONAT (Constancy crowns) at the head attributes the duke's successes to his constancy; the other, at the feet, reads DISTANTIA IUNGO (I join distant parts) and alludes to the bronze figure of Fame, set in left profile on the summit of the canopy, in a flying pose to express her nature, which is to pass from land to land. Poised on her right leg, she extends her left leg behind in a line which is continued above by her right arm, as she extends it to support the trumpet she blows. In her left hand she holds a second trumpet. Margaret Whinney and Charles Avery compare her

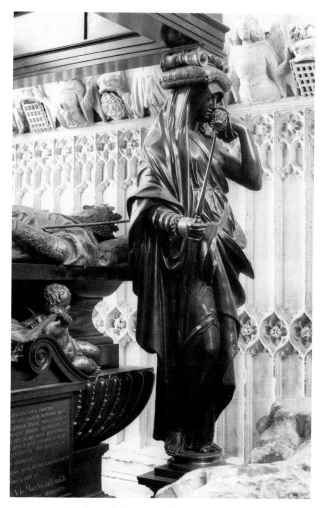

43 'Vigilance'. Caryatid from the Lennox tomb

figure to that of the naked bronze Fame set by the French sculptor Pierre Biard with the *priant* effigies on the canopy of the tomb (now destroyed) of the Duc and Duchesse d'Epernon (*c.* 1597–1612). This figure, now in the Louvre,[32] was celebrated in its day, and was also imitated, but in draped form, by Hendrick De Keyser on his tomb for William the Silent, Prince of Orange, in the Nieuwe Kerk, Delft (1614–21). Here a bronze whole-length figure of Fame holding two trumpets is poised, in a pose certainly influenced by Giovanni Bologna's *Mercury*, in the rear aperture of the tomb, at the opposite end to the seated figure in bronze of William as a victorious

160

general. This insistent use of the motif of Fame as a leading image in the celebratory aspect of the Buckingham and Richmond tombs, is then almost certainly French in inspiration. At each corner of the moulded black wooden entablature on which the canopy rests is an elegant gilt-bronze flaming urn decorated with drapes and with the rams' skulls, which we can now identify as a recurrent ornament in Besnier's art.

The design of a great canopy over the tomb represents, as already noted, a hearse or catafalque, and just as the curtained and canopied tombs of the late middle ages show the body lying on a bed, in state, waiting for burial, or for angels to fetch its soul for judgement, so it figures the lying-in-state of the deceased before interment. Although stately funerals were becoming rarer in Caroline times, according to Weever in 1631,[33] the duke was interred with all due ceremonial, in keeping with the passionate grief of his widow, who cut off her hair to express her sorrow. Although the duke himself was actually buried in Westminster Abbey on 17 February 1623/4, the day after his death an effigy was made of him and lay formally in state dressed in Parliament robes for six weeks at Hatton House. Finally, on 19 April, a state funeral was held: the effigy was put into a coach drawn by six horses, attended by a thousand mourners, and placed in a hearse in the Abbey, which was said to have equalled, in all points, that erected by Maximilian Colt for Queen Anne of Denmark, James I's wife, in 1619.[34] It was possibly this magnificent hearse of 1624 that inspired the design of the monument, rather than that of James I (d. 27 March 1625) which had a canopy supported by caryatid figures designed by Inigo Jones, and an entablature with twelve figures by Le Sueur standing upon its capitals. It may have been executed by the sculptor Nicholas Stone, perhaps to the design of Inigo Jones, for Stone had been working since 1619 as Master Mason to Jones on the Banqueting House and other royal buildings. Certainly if Jones may have walked in the duke's second great funeral procession of 19 April with others of the King's Servants as part of the royal household, the presence of 'M. Stone the stone-cutter' early in the procession in a small group, which also included the musician Cooperario and the head of the duke's chapel can only be explained if he made the duke's catafalque and effigy. Stone himself records as his only work in marble for the duchess three marble chimney pieces carved for the gallery of Hatton House. There may be more than a reminiscence of the catafalque in the tomb as executed, but the decision to have the figures cast in princely bronze must explain why Stone was not commissioned to make the duke's tomb. Yet, it was in fact Stone who had introduced the catafalque tomb into England in its latest guise. His now

largely destroyed monument of Henry Howard, 1st Earl of Northampton, the duchess's cousin, in Trinity Hospital, Greenwich, erected in 1615 after Stone's return from Hendrick De Keyser's workshop in Amsterdam, had a *priant* figure of the earl kneeling on a canopy set over a black moulded sarcophagus, with white marble figures of the four Cardinal Virtues set at the corners on pedestals protruding from the base. This design must derive from the Pilon tomb or from derivations of it, and Stone must also have known De Keyser's projects for the tomb of William the Silent.

Like so much of the magnificent funeral pageantry of the sixteenth and seventeenth centuries, Lennox's hearse of 1624 has vanished without trace. It is tantalising that we can form no impression of it from drawing or document and so judge of its relationship to the permanent tomb. The question is of interest for the history of style, since Colt's hearse for Queen Anne was a work of Mannerist medievalism, with an octagonal parapet encircling a bier supporting an effigy and surmounted by a canopy topped by a tower stuck with standards, whereas the Jones and Le Sueur hearse was plainly a work of Late Mannerist classicism. Canopied tombs simulating a hearse were not a novelty: rather, the novelty of the tomb in England lies in its combination of hearse and full-scale bronze figures of Virtues.[35] Charles Avery regards the design as distantly descended from Germain Pilon's tomb of Henri II at St Denis, which shows as we saw the corpses of the king and his wife lying on a bed under a great catafalque, or hearse, whose four pillars are each flanked by four bronze Virtues. The duke himself was, of course, half-French; his father had held the French title and estates of Aubigny, he had been brought up as a boy in France. The funeral elegies in *Frances, Duchesse Dowager of Richmond and Lenox &c, her Funerall Teares*, composed by the Genevese Abraham Darcie, are in both English and French.[36]

Whatever their degree of relationship to the Pilon tomb, the four bronze caryatid figures of Virtues certainly belong to a Mannerist tradition in tomb design which had already had various embodiments in France itself – as for instance in the four bronze Cardinal Virtues Pierre Biard made for the now destroyed tomb of François de Foix, Bishop of Aire, in the church of the Augustins at Bordeaux – and in the Netherlands, where engravings of tomb designs by Cornelis Floris probably led to its diffusion.[37] They stand on black marble plinths, to which the gilt metal letters FLRD (Francisca Ludovicus Richmondiae Dux et Ducissa) in cipher are applied, exactly like the similar ciphers are on the Buckingham monument. They support the great wooden entablature above on gilt cushions placed under gilt semi-capitals. At the rear of the monument Charity, a child sucking her left breast,

a grieving child by her left leg, stands at the duchess's head; Prudence, with mirror and serpent, is at her feet. In front, at the duke's feet, stands Hope, with her anchor, and at his head a Virtue holding a sceptre surmounted by a radiant eye, usually identified as Faith. The attribute, however, was identified in 1591 as that of Vigilance, and later by Ripa as an attribute of Modesty, meaning self-moderation. It is probably used in this sense here (fig. 43).[38] Each wears classical drapery and sandals and stands on a circular gilt moulded pedestal resting on a square gilt base. Each flexes a leg in a pose that avoids rigid frontality of the figure and animates its columnar form. The faces of all are overshadowed, like that of a hooded medieval tomb weeper, by a mantle worn over the brow, casting a mourning gloom over their countenances. All raise handkerchiefs to their eyes; down the cheeks of all except Prudence, whose nature is restraint in woe and weal, course tears, the 'funerall teares' of the elegies composed for the duchess. This eloquence of grief, exceptional in the customary Mannerist impassivity of such sculptures of Virtues, was probably figured at the behest of the duchess herself to express her passion of grief, in a typical poetical conceit in which Virtues mourn for the deceased, as angels had once mourned on medieval Italian tombs.

The sarcophagus, of black touchstone, is raised on the stepped moulded base from which, project at an angle, pedestals supporting the Virtues. It is elegantly shaped and moulded and, like the Buckingham sarcophagus, has a decoration of a band of gadroons in relief alternating with gilt stems. Its shaped lid rises to form a second pedestal for the two gilt bronze effigies; the duke lies at the front, nearest to the aisle, the duchess at the rear, their heads supported by pillows. In a gesture of close affection, he clasps the raised right hand of the duchess in his own, again a pulse of emotion that must originate with the duchess though it is not without precedent from later medieval effigies onwards. He wears a ducal mantle and coronet, and like Buckingham, armour richly decorated in relief, here with classical scrollwork. He also wears a sword, and clasps in his right hand his wand of office as Lord High Steward, his chief court office at the time of death. Over his left knee he wears his Garter. According to the Duchess herself, in an interesting document[39] which must date from after the death of her brother-in-law, Esmé, Duke of Lennox, on 30 July 1624, and before the death of James I, she notes that she had given Esmé all her late husband's Georges and Garters, except for one 'which is uppon his Effigies at Westminster', presumably his funeral effigy, rather than the bronze effigy of the tomb. The reference illustrates the close relationship that still prevailed between the

funeral effigies of royal or princely personages and their tomb effigies. At Richmond's feet lies a gilt metal coronet encircling his crest of a bull spitting fire; at his wife's, a ducal cap of maintenance, engraved to simulate fur on the brim, surmounted by her crest, a coroneted lion with a heraldic label of three round its neck. Like his wife, he wears a large ruff: she wears a coronet and her state robes as duchess. On the long sides, below each of the effigies, is a tablet of white stone, the upper end of which is surmounted by two scrolling volutes, with a gilt metal skull set between them. Two winged putti, also of gilt bronze, recline on the volutes, withdrawing a drapery from the skull: the lesson is one of the vanity of all human greatness. On the tablets themselves are inscribed, in gilt letters, the titles and achievements of the duke and the duchess. There are coats of arms in gilt metal at either end of the short sides, between the heads and feet. That at the head is encircled by the Garter, that at the foot has supporters, and as it was missing in 1818,[40] may be a replacement made during Lord Darnley's cleaning and restoration of the monument in the 1870s. The inscriptions are in Latin, and that of the duke incorporates a chronograph in the form of a verse from 2 Samuel 3: 38. In this, as in the Buckingham monument, we can see the hand of a learned chaplain or scholar in the ambience of the Richmonds: he may also have had some hand in the devising of the monument, though the design was no doubt largely Besnier's.

Here, then, are three major tombs, the design of which can be attributed to a forgotten court sculptor, working with some ability in the court style of northern Late Mannerism. As was natural, his work incorporates features traditional in English tomb art, but as a whole it imports into England a genre peculiar to Late Mannerism; the monumental tomb in which a major sculptural role is assumed by large-scale bronze figures. Further study of this neglected genre is required before Besnier's tombs can be exactly situated in their context, but there can be no doubt that his work is an expression of Franco-Flemish sculpture during a significant period of transition from the modes of the late sixteenth century, still represented at the court of England by Maximilian Colt, into those from which the Baroque was to evolve. Unlike Le Sueur, who could cut marble, but was principally a sculptor in bronze, Besnier would appear to have worked exclusively in stone – in the Weston tomb he appears to have begun by carving the four stone busts. His ambition and skill may explain why he secured such great and costly commissions for tombs from three of the most magnificent personages of the Jacobean and Caroline court.

Notes

In preparing this study, I wish to thank, for assistance of various kinds, Sir Oliver Millar, the officials and staff of the Public Record Office, the British Library, the Society of Antiquaries and Mr Tony Davies, the Chief Marshal of Westminster Abbey.

In addition I would like to thank Philip McEvansoneya who has recently informed me of his discovery of documentary proof, hitherto lacking, of Le Sueur as the artist responsible for the bronze figures on the Buckingham tomb. The document also proves that Besnier prepared the stone for the tomb. McEvansoneya is to publish his discoveries in *The Burlington Magazine* shortly.

1 John Weever, *Antient funerall monuments*, 1631, cited in the edition of London 1767, p. 254.

2 *Ibid.*, p. xi.

3 *Ibid.*

4 *Ibid.*, p. xix.

5 For this background, see introductory sections in C. Avery, 'Hubert Le Sueur, the "Unworthy Praxiteles" of King Charles i', *Walpole Society*, 48 (1982).

6 *Ibid.*

7 The importance of the Buckingham and Richmond tombs was first recognised by M. Whinney, *Sculpture in Britain 1530–1830*, Harmondsworth, 1964, pp. 35, 242–3, notes 6 and 7. Important subsequent discussion is by Avery, *Le Sueur*, pp. 142–5, who, however, like Whinney, attributes both to Le Sueur, exclusively. This attribution dates back to 1687, as noted by M. Whinney and O. Millar, *English Art 1625–1714*, Oxford, 1957, pp. 116–17. See also David Howarth, 'Charles I: Sculpture and Sculptors', in *The Late King's Goods*, Arthur MacGregor ed., Oxford, 1989, pp. 73–113, for interesting general observations on the commemoration of the dead Buckingham.

8 U. Thieme and F. Becker, *Allgemeines Lexikon der Bildenden Kunstler*, 37 vols., Leipzig 1907–50, iii, 1909, p. 531.

9 R. Gunnis, *Dictionary of British Sculptors 1660–1851*, London, 1968, p. 50.

10 Information kindly supplied in a letter of 23 January 1968 by the Archives Department of the City of Westminster Public Libraries.

11 W.H. Carpenter, *Pictorial Notices; Consisting of a Memoir of Sir Anthony Van Dyck*, London, 1844, pp. 57–64. The original, and accompanying sketch, is in the PRO, State Papers, 77/21, pt. 1, fos. 68–9.

12 The monument has to be reconstructed using the engraving in Henry Hyde, Earl of Clarendon, continued by S. Gale, *The History and Antiquities of the Cathedral Church of Winchester*, London, 1715, p. 31; see also p. 35 of the section on the monuments. Avery, *Le Sueur*, p. 166, cat. 54, rejects any attribution of the

tomb to Le Sueur, giving the tomb in its entirety to Fanelli; I agree that the bronze work is by Fanelli.

13 Carpenter's translation, corrected from the original.

14 For Weston and his family, R.E.C. Waters, *Genealogical Memoirs of the Extinct Family of Chester of Chicheley, their Ancestors and Descendants*, I, London, 1878, pp. 93–110; and, most recently, Michael van Cleave Alexander, *Charles I's Lord Treasurer*, Chapel Hill, 1975, *passim*. For Weston and Winchester Castle, M. Biddle and B. Claye, *Winchester Castle and the Great Hall*, Winchester, 1983, p. 17.

15 P. Wengraf, 'Kunst in der Republik Genoa 1528–1815', Schirn Kunsthake, Frankfurt 4 Sept. – 9 Nov., 1992. Wengraf also cites a document which establishes that Fanelli was granted a pension of £60 by Charles I in May 1635.

16 'The Note-Book and Account Book of Nicholas Stone', *Walpole Society*, 7 (1919), pp. 60, 89, 90–1.

17 She is referred to as Madame La Duchesse in Gerbier's correspondence: see W. Noel Sainsbury, *Original Unpublished Papers Illustrative of the Life of Sir Peter Paul Rubens*, London, 1859, pp. 135–6, and as the Lady Duchess in PRO, State Papers, Dom., 1628–35, *passim*.

18 E.W. Brayley and J.P. Neale, *The History and Antiquities of the Abbey Church of St Peter, Westminster*, 2 vols., London, 1818, I, separately paginated section on Henry the Seventh's Chapel, pp. 60–1.

19 Weever, *Monuments*, p. xx.

20 *Ibid.*, p. 259.

21 For Buckingham, Roger Lockyer, *Buckingham: The Life and Political Career of George Villiers, First Duke of Buckingham*, London, 1981, *passim*.

22 Weever, *Monuments*, pp. i, vii.

23 E. Neurdenburg, *Hendrick de Keyser*, Amsterdam, 1930, pp. 115–21.

24 Avery, *Le Sueur*, p. 144, derives the pose from that of a soldier in a bronze Resurrection group on the tomb of the Count of Schaumburg-Lippe at Stadthagen, by Adriaen de Vries.

25 T. Birch, *The Court and Times of Charles the First*, 2 vols., London, 1849, I, pp. 390–1. For the duke's debts and their clearance, BL Add MS. 2533, fol. 62v.

26 For Lennox, *The Complete Peerage*, G.E. Cokayne *et al.*, 13 vols., London, 1910–40, VII, pp. 604–7, and the article in *DNB*, s.v. Stuart, Ludovick. For his funeral and his principal funeral elegies and eulogies, Abraham Darcie, *Frances Dvchesse Dowager of Richmond and Lenox etc her Funerall Teares*, London, 1624, unpaginated, with references to Nicholas Stone and Inigo Jones. James Cleland, *A Monvment of Mortalitie, vpon the Death and Fvnerals of the Graciovs Prince Ludovick, Late Duke of Richmond and Lenox*, London, 1624.

27 For Duchess Frances, see W.A. Scott Robertson, 'Six Wills Relating to Cobham Hall', *Archaeologia Cantiana*, 11 (1877).

28 *Ibid.*, p. 247.

29 *Ibid.*, p. 250.

30 *Ibid.*, p. 230.

31 State Papers, Dom., 1628–9., pp. 329–30; Avery, *Le Sueur*, doc. 48. For the tomb and its inscriptions, Brayley and Neale, *Westminster*, I, separately paginated section on Henry the Seventh's Chapel, pp. 62–3.

32 L. Gonse, 'La Renommée de Cadillac', *Gazette des Beaux Arts*, ser. 2, 1886. For Queen Anne's hearse, Mrs Esdaile, 'By a Tomb-Maker who Bowed to Authority', *Illustrated London News*, 185 (18 August 1934), p. 242.

33 Weever, *Monuments*, p. xviii.

34 Robertson, 'Cobham Hall', p. 247.

35 Avery, *Le Sueur*, pp. 141–2.

36 For Darcy or Darcie, see *DNB*, s.v.

37 Avery, *Le Sueur*, p. 142.

38 For 'Vigilance' see A. Ricciardi, *Commentaria Symbolica*, 2 vols., Venice, 1591, II, fo. 190v.; C. Ripa, *Iconologia*, 1630, cited by G. de Tervarent, *Attributs et symboles dans l'art profane 1450–1600*, 2 vols., supplement and index, Geneva, 1958–64, II, p. 338.

39 Robertson, 'Cobham Hall', p. 225 note.

40 According to Brayley and Neale, *Westminster*.

9

LAUDIAN LITERATURE AND THE INTERPRETATION OF CAROLINE CHURCHES IN LONDON

John Newman

Church building during Charles I's reign is not easy to evaluate. Modern discussion has tended to concentrate on the contrast between the vigorous survival of gothic forms in buildings and fittings set up under the influence of William Laud, Bishop of London (1628–33) and then Archbishop of Canterbury until the collapse of his policies and power in 1640, and the radical classicism of the court architect, Inigo Jones, which found expression in two royal chapels, a church and the remodelling of London's cathedral.[1] But this was not the light in which contemporaries viewed the matter. As far as concerned churches, the subject of this essay, there is a good deal of published writing from the late 1630s which makes it possible to assess their thinking.

Achievements in church building at that time provoked contrary appraisals. Where one writer found cause for pride, another felt humiliation. Thus, the anonymous author of *De Templis* (1638) claimed:

Our age is very forward to good workes (let some men talke what they will to the contrary) and for their pietie in building repairing and adorning Churches, may compare almost with any former times, in the memory of man: More Churches have beene built, and adorned in the reigne of our King Charles, than in the reigne of many Kings before.[2]

Yet Foulke Robarts, writing the following year, felt that this was an extremely limited achievement:

But when we observe how private mens houses, of the later editions, doe towre it up, and advance their roofes to such an height, as quite intercepts and screenes up, the prospect of the houses of God in the Land. How the Pallaces of Knightes and

Gentlemen, draw all mens eyes upon them, while the poore Church over-topped with her Patrons Pyramids, standeth cringing behinde.[3]

In post-Reformation England the pious erection of churches and chapels, so popular in the late middle ages, had been replaced by the charitable foundation of secular institutions such as schools and almshouses. Furthermore, society was deeply divided as to what the purpose of churches should be. Were they, as the Puritans maintained, no more than convenient buildings where the faithful could meet to hear the Word of God and where Christ would come among them at Communion as servant and friend, or were they, as the Anglican liturgy suggested, holy places of worship where God was to be adored as creator and Lord?

The Puritans did not in principle reject large and spacious churches. In Wales, at Denbigh, Robert Dudley, Earl of Leicester, began in 1578 a grandly scaled church 170ft long of ten aisled bays;[4] in Scotland in the 1590s the burghers of Burntisland on the northern shore of the Firth of Forth built themselves a square church with a central steeple carried on four massive piers, and fitted galleries all round it inside.[5] In England, however, virtually no new ecclesiastical building was erected by a Puritan congregation. One exception was the brick chapel-of-ease at Buntingford, Hertfordshire, built for the Calvinist-leaning minister, Alexander Strange. It was planned as a simple rectangle but soon enlarged into a Greek cross, that is to say, was given a centralised plan.[6] The other, much more important, building which must be considered as Puritan-inspired is St Paul Covent Garden, erected in 1631–3 by the 4th Earl of Bedford.[7] This building will be discussed further below.

The mainstream Anglican position on the building and layout of churches was established, in the context of a newly defined doctrine and liturgy, in the Elizabethan Injunctions of 1561 and Bishop Jewel's *Apologia ecclesiae anglicanae* of the following year.[8] At the end of Elizabeth's reign Richard Hooker devoted a section of his *Of the Laws of Ecclesiastical Polity* to 'Sumptuousness in Churches', justifying expenditure on churches on biblical grounds, providing that it did not detract from spending on good works.[9]

James I's Canons of 1604, however, put a new emphasis on comeliness and decency in the furnishing and care of churches, and it is clear from surviving church fittings that the early decades of the seventeenth century saw much renewal and improvement.[10] Pulpits of the period from *c.* 1604–40, a golden age of preaching, survive in their hundreds, dated examples being most numerous in the 1630s.[11] Chancel screens are much

less numerous, since the Elizabethan Injunctions had ordered the retention of medieval screens once their roods and lofts had been dismantled. However, new chancel screens were erected in significant numbers in the early seventeenth century.[12] This can be connected with the developing ecclesiology of the period.

Hooker writes of the partition 'for local distinction between the clergy and the rest': 'Our churches are places provided that the people might there assemble themselves in due and decent manner, according to their several degrees and orders.'[13] The specifically Anglican nature of this division had been noted by Richard Bancroft, and its distastefulness to Puritans.[14]

Although the Canons of 1604 do not specifically mention screens among the essential fittings of a church,[15] some bishops at their visitations asked whether there was a partition and gates between 'church' (i.e. nave) and chancel;[16] though William Laud himself, in his visitation articles, never asked whether the churches in his successive diocese had screens in them.[17]

Laud's visitation articles, however, do not fully reflect his own practice in terms of the ordering of the interiors of sacred buildings. Thus of the communion table, his articles merely ask whether it is 'placed within the chancel or church, as that the minister may be best heard in his prayers and administration, and that the greater number may communicate? And is the same table so used out of divine service, or in it, as is not agreeable to the holy use of it?'[18] These words, which reflect the terms of the relevant Canon of 1604, give no hint that Laud's most controversial campaign was to regularise the placing of communion tables against the east wall of cathedral, church and chapel, on the spot where the pre-Reformation altar had stood, set 'altarwise', that is to say north–south, in the same direction as the former altar had stood, and not 'table-wise', which was merely athwart the site of the altar, at right angles to it. As early as 1616, on his appointment as Dean of Gloucester, he had antagonised his bishop by placing the communion table in this way, having it railed in and encouraging the members of the chapter to bow towards it.[19] The theological implications of this positioning of the communion table were fully aired twenty years later, after Laud, as Archbishop of Canterbury, had intervened between the vicar of Grantham and members of his congregation. John Williams, Bishop of Lincoln, in whose diocese Grantham lay, and Laud's political adversary, took the opportunity of counselling the vicar contrary to Laud's requirements, and encouraging him to move the table into a convenient position at the administration of communion. Laud was always careful to avoid calling the communion table an altar, but the implications of the fixed altarwise positioning he

favoured were thrashed out in a sequence of publications in 1636–7. His chaplain and future biographer, Peter Heylyn, learnedly demonstrated Laud's theological position in *A Coale from the Altar: Or an answer to a letter of JW to the Vicar of Grantham against the placing of the Communion Table at the east end of the Chancell* (1636), to which Bishop Williams published his witty and in places flippant response, *The holy table, name & thing, more anciently . . . and literally used under the New Testament, then that of an altar* (1637). Heylyn's book also gave the Puritan William Prynne an opportunity to launch a broadside against the archbishop with the fully explicit title, *A Quench-Coale. Or, a briefe disquisition and inquirie in what place of the Church or Chancell the Lords-Table ought to be situated . . . Wherein is evidently proved that the Lords-Table ought to be placed in the Midst of the Church, Chancell or Quire, North and South, not altarwise* (1637).

The altar/table controversy itself need not concern us further here; but the implication of the Laudian viewpoint was that the communion table should not only be at the east end and that it should be railed off, but that the space within which it stood was reserved for the celebrant, while communicants would come up only as far as the rail in order to receive. Thus the concept of a sanctuary within the chancel was revived.

Several Laudian writers went into print in these years on the wider issue of church planning. One of these, John Pocklington, was a participant in the Grantham debate. His *Altare Christianum*, published in 1637, is subtitled *The dead Vicars Plea. Wherein the Vicar of Gr[antham] being dead, yet speaketh and pleadeth out of Antiquity, against him that hath broken down his Altar.* Pocklington ranges more widely in his defence of Laud than the title of his book suggests. He discussed not only the siting and orientation of 'altars' but the consecration of churches and their proper form and arrangement. He bases himself on the practice of the early Church, quoting St Gregory Thaumaturgus, Bishop of Neocaesarea, who mentions 'five distinct places, or Roomes in Churches, set apart, for so many severall uses', from the porch to the 'communion'.[20] And in the second edition, published in response to Williams's *Holy table, name & thing*, he assessed the heritage of medieval churches in England, pointing out that they are similarly compartmentalised according to use:

Our churches by Gods mercy are a glory to our Religion . . . are fairly built of Stone, covered with Lead, beautified with goodly Glasse-windowes, Pinnacles, Battlements, have their Postures, and Altars standing towards the East, have their Porches, severall Iles, Belfreyes, Steeples, Bels. In the body of these Churches are placed Pulpits, Seats, Pewes, and the Baptisterion or Font towards the West. . . . To the

Chancels belonged the Vestry, Lavatory, Repository, and Reclinatories for hearing confessions.[21]

The other two authors, Foulke Robarts and the anonymous R.T., both write with greater detachment from current controversy. Robarts's book, *Gods Holy House and Service, According to the primitive and most Christian forme thereof*, published in 1639, is a balanced and thoughtful exposition of Laudian views. He argues for the continuation of the practice of orienting churches to the east, in imitation of primitive practice.[22] In discussing the internal division of churches, he denies that this is superstitious and claims that it accords with the practice of primitive Christians, and is furthermore

agreeable with good reason, order and comelines . . . as there be severall rancks of people, professing Church-unity, so they have their places in their severall distances. Some are unworthy to Come within the doores of the Church and therefore are to stand without. Some are fit to be received in, to be baptized: Some to be instructed in the grounds of religion and to repaire with the rest of the Congregation: Alle which is done in the nave and body of the Church. And as men profit in knowledge, and a working Faith, to discerne the Lords body They are admitted into a higher roome; where the Sacrament of the body and blood of Jesus Christ, is to be administred, at the holy Table, in the Chancell: which devideth it from the rest of the Church.[23]

Robarts alludes to other current practices in church furnishing and decoration approved by Laud and his followers, such as the erection of the royal arms, 'not for any matter of divine worship: But to professe and testifie the subjection of every soule to the higher power', and the painting of biblical sentences on the walls. On the vexed issue of images in stained glass, he enunciates the Laudian position: 'They are not there set, for any matter of worship of either God Saint or angell; but for history and ornament.' As for the font, which is the 'laver of regeneration' and so rightly set up at the lower end of the church close to the entrance, Robarts would even enclose that with rails 'more suteable to the reverence due thereunto'.[24]

The anonymous R.T.,[25] the author of *De Templis*, has a similar orientation to the other publications, and his book is dedicated to rich City merchants, who had funded two of the most notable recent ecclesiastical reconstructions: Sir Paul Pindar, who paid for the sumptuous refitting of the choir of St Paul's Cathedral at the time of Laud's restoration campaign there from 1632, and Sir John Wolstenholme, at whose expense Great Stanmore church, Middlesex, was rebuilt, the first parish church since the Reformation to be erected on new foundations. Laud, as bishop of London, consecrated

the new church in 1632. So R.T. writes from within the Laudian orbit, but
not necessarily as a deliberate promoter of Laudian ideas.

What distinguishes R.T. more than anything from the other authors is his
architectural sophistication. He is familiar with the text of Vitruvius and
quotes the opinions of Serlio. In discussing early Christian basilicas he
accepts the view that they derived their form from Roman lawcourts, also
called basilicas, 'for the Basilicae were divers galleries or porticues, joyned
together, standing upon columnes, equally distant, as Vitruvius teaches'.[26]
Sta Sophia at Constantinople and other Christian churches built on a
circular plan were derived from such heathen temples as that of Vesta in
Rome and 'the famous Pantheon', though he quotes Phil. Lonicerus's
opinion that 'The Temple of Sancta Sophia . . . excels all the rest, the roof is
vaulted and covered with lead: the figure not unlike the Pantheon in Rome,
but much greater, and higher. It stands upon stately Marble and Porphyrie
pillars.'[27] However, like the other writers, R.T. stresses that early Christian
churches were subdivided into several functionally different parts.[28]
Solomon's temple, 'the most excellent Temple in the World', was, he notes,
similarly subdivided.[29]

Not unnaturally, R.T. is concerned to justify lavish expenditure in
decorating churches: as parents clothe and adorn their children, so princes
have not been content 'when the Temples have been brought up to the very
roofes, unless they beautified them with all kind of ornaments . . . as curious
paintings, hangings, guilding, sumptuous vestments, rich gifts in mony,
chalices, plate . . .'[30]

The most noteworthy part of R.T.'s treatise is the chapter in which he
discusses contemporary church architecture.[31] He begins by stating his
assumption that churches will be oriented eastwards, though 'even in that of
late dayes some have failed', doubtless a gibe at St Paul Covent Garden. The
approach should be up a flight of steps, such as Serlio describes at St Peter's
in Rome.

In discussing church plans, R.T. rejects the circular as impractical.
Though some may favour square, oval or circular plans, as accommodating
larger congregations 'to heare Sermons, and Lectures', that is, for a Puritan
form of service, he argues for the psychological value of the long west–east
axis: 'And the man who enters the West doore from farre beholding the
Altar . . . shall find his devout soule, more rapt with divine awe and reverence
. . . in the delay and late approach unto it, than if at first he had entred
upon it.'

The spatially complex interior created by 'pillars' he sees as beautiful and

appropriate for churches, in fact 'it has beene so received a manner of building tht to leave them out, savours too much of noveltie'. Nevertheless, he conceives his pillars not like the piers of a gothic arcade but in classical form; 'Over the Capitals according to the common rules of Architecture, must run an Architrave freeze, and Coronis, which every work-man knowes how to adorne with leaves and flowers, &c. according to the order of building.' Above the entablature there should be a clerestory, where the only windows in the church should be placed. Windows placed high up are another way of differentiating a church from a secular building; they also have a psychological or spiritual value, for they 'keep our thoughts from wandring abroad, whilst our eyes have nothing but Heaven, and heavenly objects to behold'.

The chancel of a church, like the choir of a cathedral, should be set at a higher level than the nave, and should be separated from it by 'grates of wood curiously carved, or of iron, or brasse cast into comly works'. The 'place where the Communion table stands' ought to be at a yet higher level. This, he acknowledges, is normal in cathedrals and should be followed as far as possible in parish churches and private chapels. Roofs should be vaulted rather than flat, to improve audibility. The chancel should be strongly differentiated from the nave: it can have a roof of a different height and more richly adorned, and windows of a differing pattern: 'That when we shall enter into this place, more holy & divine thoughts may possesse our minds, occasioned by the differing structure, and more glorious ornaments.'

The author accepts that it may not always be possible to build a nave with aisles. In that case he advocates 'Pilasters wrought into the wall, with well framed Capitals . . . between which would bee convenient spaces to beautifie the Church, with some excellent paintings of sacred stories, which may strike into the beholder, religious, and devout Meditations.' The high-set windows will illuminate wallpaintings well, but R.T. also advocates painted glass in them, which will give 'a glorious light, and moderate that bright light, which is a hinderance to devotion'. And he quotes More's *Utopia* and Sir Henry Wotton's *Elements of Architecture* on the tendency of bright light to disperse one's thoughts and of dimness to assist in collecting them. The nave ceiling can be painted blue with gilded stars 'and then as in figure, so in colour it resembles the Hemisphear of the Heavens'. The chancel should, as we have seen, be more richly decorated than the nave, and in adorning that part of it where the communion table stands 'no cost ought to be thought too much'. So he concludes, 'Hither bring your stateliest hangings, and

adorne the wals; hither your richest carpets, and bespred the ground; hither the most glorious silks, and finest linnen, to cover the Holy table.'

R.T.'s ideal church, then, takes the form of an aisled and clerestoried nave entered from the west, with a distinct chancel separated from it by a screen and a step up, and having the altar set at the east end at a yet higher level. This is nothing other than the standard medieval English parish church. He says nothing specific about the design of windows, but his recommendation that those in the chancel should differ from those in the nave perhaps suggests that he has gothic traceried windows in mind. But the flight of steps by which the church is to be approached is an echo of classical temples, and the internal colonnades carrying entablatures and a clerestory clearly evoke the early Christian basilicas of Rome or an antique model, such as Palladio's Egyptian Hall. Here a contemporary of Inigo Jones attempts to visualise a modern building in a style that is influenced by familiarity with the classical tradition and arrives at a completely un-Jonesian solution.

Laud himself never set his ideas down in any coherent or thought-out way. He certainly never expressed a stylistic preference, though in church building, as in so much else, he was on the side of tradition; more specifically, a church was a sacramental building rather than an auditory. That was why he was hostile to galleries in churches: 'they utterly deface the grave beauty and decency of those sacred places'.[32] Burntisland church, which he saw when he accompanied the King to Scotland in 1633, he dismissed as 'for all the world like a square theatre, without any show of a church . . . And I remember, when I passed over at the Firth, I took it at first sight for a large square pigeon-house; so free was it from all suspicion of being so much as built like an ancient church.'[33]

During his years as Bishop of London, 1628–33, Laud consecrated three newly built or rebuilt churches. The two latter were St Katherine Cree within the City, the foundation stone of which had been laid on 23 June 1628, and which was consecrated on 16 January 1631, and St Giles-in-the-Fields, in the fast developing area north of Charing Cross, consecrated one week later, though rebuilt some years earlier, in 1623–5. On 17 July 1632 he consecrated Sir John Wolstenholme's new church at Great Stanmore, built on a new site more convenient than its predecessor to serve the inhabitants of his Middlesex village.[34] Two other ecclesiastical buildings erected in the 1630s on new foundations close to the centre of London may be considered alongside these, neither built under Laud's influence nor given parochial status: St Paul Covent Garden, built in 1631–3, and consecrated on

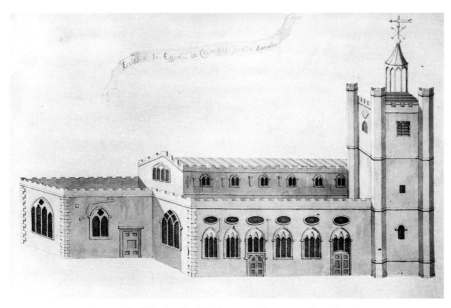

44 Anon., *St Giles-in-the-Fields*, pen and watercolour drawing

27 September 1638 as a chapel-of-ease in the parish of St Martin-in-the-Fields,[35] and the New or Broadway Chapel, built on a site in Tothill Fields, Westminster, from 1635, opened for worship in 1642 as a chapel-of-ease in the parish of St Margaret Westminster, but never consecrated.[36]

Of these five buildings, St Giles-in-the-Fields (fig. 44) was the most traditional in plan and external appearance, having a clerestoried nave 123ft in length, 57ft wide and 42ft high, a structurally separate chancel 26ft high, and a 60ft tall west tower (fig. 44). The windows throughout seem to have been pointed-headed with simplified tracery.[37] Unfortunately, no plan or interior view of the church has been found recording it before a second rebuilding in 1731–3, so it is not possible to say what form the arcades took or whether the medieval piers were replaced by classical columns as was done in the exactly contemporary reconstruction of St Nicholas, Rochester, Kent (rededicated 1624), where monumental and finely proportioned Tuscan columns took the place of the fifteenth-century piers. The evidence of the churchwardens' accounts is that the rebuilding was not merely a matter of reusing old materials, and Laud himself stated that the church was not only 'new-built from the ground' but that it was 'not wholly upon the old foundations'. It will have looked like a modern building in being faced with rubbed brick with stone dressings.[38]

The rector in whose time the church was rebuilt, Dr Roger Manwaring, was an enthusiastic supporter of Laud's liturgical reforms. His successor, Dr William Haywood, another protégé of Laud, was in 1640 the subject of a Puritan petition to Parliament, which stated that he had set up crucifixes and images of saints in his church, as a result of which we have an extremely helpful description of its interior:

The said church is divided into three parts: the Sanctum Sanctorum, being one of them, is separated from the chancell [presumably nave] by a large skreene, in the figure of a beautifull gate, in which is carved two large pillars, and three large statues: on the one side is Paul, with his sword; on the other, Barnabas, with his book; and over them, Peter, with his keyes. They are all set above with winged cherubims, and beneath supported by lions.

Seven or eight foot within this holy place is a raising by three steps, and from thence a long raile from one wall to the other, into which place none must enter but the priests and subdeacons.

The account goes on to describe the altar set against the east wall, a credence table beside it, and the rich carpets and cloths which decked them and hung round the walls of the sanctuary.[39]

The most arresting feature of the church must have been the stained glass which filled no less than eighteen windows. A document datable before 1633[40] gives the subjects of the windows, the names of the donors and dates of insertion, showing that they went in between 1625 and 1629 and were paid for by individual members of the parish. Lady Alice Dudley, donor of the screen, a set of rich plate and other fittings, was named on the commemorative tablet erected on the north gate of the churchyard; but the rebuilding and fitting out of the church was clearly a notable team effort by parishioners, doubtless co-ordinated by the rector, Dr Manwaring.

St Katherine Cree, unlike St Giles, still survives, but rather less is known about the circumstances in which it was built. Laud believed it had been rebuilt using the foundations of the previous church, but Strype, quoting early documentation, states that the north wall was set out 7ft further than its predecessor.[41] The tower of 1504 in the south-west angle was retained. In the confined site in Leadenhall Street, neither the late medieval church nor its seventeenth-century successor had a structurally separate chancel (fig. 45). The interior space is continuous from west to east, with six-bay aisles formed by Corinthian columns which carry coffered arches and a clerestory (fig. 46). The plaster ceilings are enriched with ribs and armorial bosses reminiscent of a gothic vault, though the ceiling profile is almost flat. The

two eastern bays have a richer pattern of ribs, which must indicate the
differentiation between chancel and nave. A physical separation was presum-
ably created by a screen stretching the full width of the church; as, for
example, at St John's, Leeds, of 1634. The fact that no screen is mentioned
in the inventory of the church's fittings taken in 1650 can be explained in
one of two ways; either it had been removed in the 1640s, or it was not
included in the inventory, as being a fixture, in the same way as the pulpit
was not listed though the pulpit cloth was.[42]

The church was extremely brightly lit, with large tripartite windows both
in the aisles and in the clerestory, at the west end a tall but simple five-light
window (largely hidden from 1686 by the organ) and at the east one of
strongly differentiated design, based on the east window of St Paul's
Cathedral itself, with a large rose in a square surround and five broad lights
below. Internally, the effect of the windows is gothic, but they were given

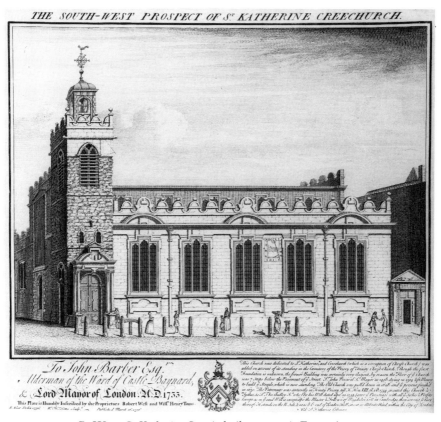

45 R. West, *St Katherine Cree* (rebuilt 1628–31). Engraving, 1736

elaborate semi-classical external surrounds, alternately with pediments. These and the crested battlements were dismantled some time before 1813.

St Katherine Cree gives the impression of a showpiece church. The architecture is exceptionally sumptuous, the use of the Corinthian order being unprecedented before Wren. A contemporary account catches the spirit of the building:

This now famously finished House of God was begun to be laid upon the 23rd Day of June in the year of our Lord God 1628 . . . This Structure, not of Brick, but built from the Ground with the choicest Free Stone might be got, without, within, and in

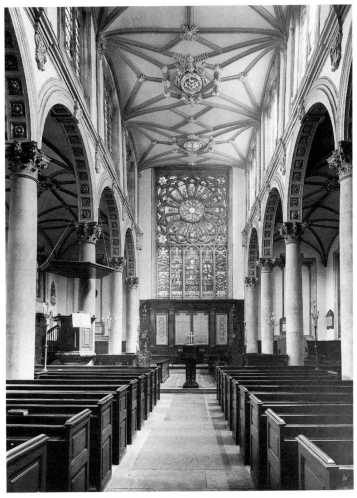

46 St Katherine Cree, interior looking east

every part of it supplied, furnished, and enriched, with whatsoever might add to its greatest Grace and Lustre ... this great, and (in our time) unparalell'd piece of Work.[43]

Both the pulpit and the communion table, it was noted, were of cedar wood.[44] It was perhaps significant that Laud's consecration ceremony for St Katherine Cree was the one which particularly provoked William Prynne's scorn and distaste. But once again, the rebuilding was largely funded by the gifts of parishioners, and the first stone was laid by a local dignitary, Martin Bond.

By comparison with these, the church of St John the Evangelist, Great Stanmore, was relatively modest. It consisted of a rectangular body 99ft by 36ft with a west tower, and was built of brick with stone dressings (fig. 47). As noted above, its particular significance is that it is the first post-Reformation parish church built on new foundations, and so unconditioned by pre-existing fabric. This was a more wholehearted attempt to build in a consistent classical idiom; though its nave was not wide enough to require internal columns. The architect-sculptor Nicholas Stone, who had acted as

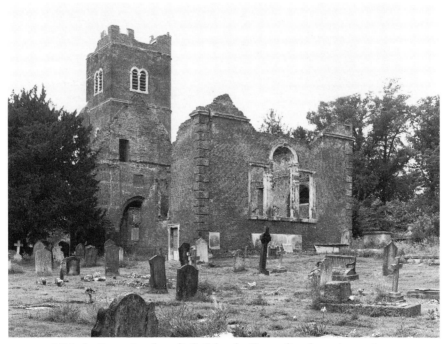

47 Nicholas Stone (attributed), St John the Evangelist, from the south-east

Master Mason at Inigo Jones's Whitehall Banqueting House, supplied the font (£12), and a 'porch' of Portland stone (£30) and later, in 1641, a monument to the founder (£200).[45] Stone was probably responsible for the design of the church itself, which, though now a ruin, retains features of a Jonesian classicism: most notably the Venetian east window and a rectangular side window with a well-detailed architrave moulding, both in Portland stone. Being parochial, Stanmore church required a bell tower, and this is the most traditional part of the building. It has three stages, with diagonal buttresses and battlements.[46] The body of the church was also battlemented, as early drawings of the church show. Internally there was a segmental plaster ceiling, but no other original feature or fitting can be identified in the two known interior views.[47]

By contrast to these, St Paul Covent Garden, built in 1631–3, was aggressively non-Laudian, as one would expect from its patron, the Puritan-inclined 4th Earl of Bedford. Most notoriously, it was built with a diametrically incorrect orientation. The great Tuscan portico at the east end of the church (fig. 48) was clearly intended to frame the entrance to the building from the square, and the blocked doorway within it must have been intended to be functional. This would have required the communion table to stand at the west end. All this was unacceptable to the Laudian viewpoint, which insisted on correct orientation, so that, as William Prynne tartly observed,

the new Church in Court [*i.e.* Covent] Garden, which as it stands now not perfectly East and West, so at first the Chancle of it stood towards the West part; Which some Prelates (without Law, Canon, and reason, I know not upon what superstitions overweaning conceit) commanded to be altered and transformed to the other end, to the great expense of the builder, the hindrance, and deformity of that good worke.[48]

Details of the Earl of Bedford's expenditure on the building bear out this claim that he had to pay for modifications, particularly the blocking of the eastern doorways, consequent on the re-orientation of the building.

More fundamentally, a church in the form of an antique temple was completely at variance with the Laudian concept of a church. The distinguished biblical scholar Joseph Mede, in his expanded sermon on churches, printed in 1638 and dedicated to Laud, pointed out that the word 'temple' was used by apostolic Christians to refer to the Temple of the true God in Jerusalem, but that otherwise they 'appropriated the name of a Temple to this notion of encloistering a Deity by an Idoll', whereas the Christian God did not dwell in temples made with hands.[49] R.T., the author of *De Templis*, while applying the word 'temple' to Christian churches,

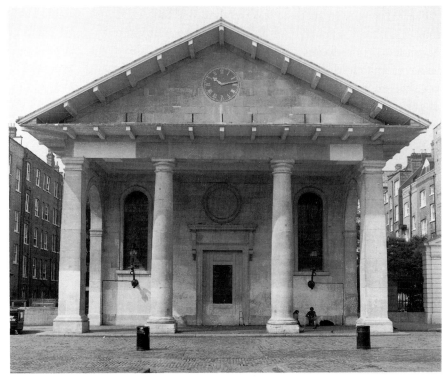

48 Inigo Jones, *St Paul Covent Garden*, from the east

points out that the Primitive Christians were said not to have done so, and quotes the reasons for this given by Cardinal Bellarmine: 'because the Jewish sacrifices offer'd in their Temple, were as yet fresh in memorie ... also because the Gentiles, call'd the places where they worshipt their Idols by the same names'.[50]

The thinking of architect and patron in this novel church design must have followed entirely different lines. If Inigo Jones's decision to design the church as a realisation of Vitruvius' description of the Tuscan temple was intended to be 'eloquent of aspirations to the purity of the early uncorrupted church',[51] he may have been picking up a conscious Puritan concept first expressed in Lord Leicester's church at Denbigh, where the piers were in the form of crude Tuscan columns.[52] As already noted, St Nicholas Rochester was another church in which the Tuscan order had already been correctly and impressively used, and the chapel of the Charterhouse (1612–14) was a third.

The church was fitted out with a communion table set on a black and white marble pavement against the east wall in proper Laudian fashion, but there seems not to have been a screen physically separating the chancel from the nave, but only a 'partition belowe the readinge deske' so that the chancel space measured 35ft 7in from east to west, and the nave 63ft 5in. The nave seating consisted of a central block of pews and lesser north and south blocks, set against the walls. Pews were also set up 'about the Chancell', perhaps a single line of communicants' seats, but 'alteration' of the pews in the chancel costing the large sum of £66.14s.6d., together with £41.16s.9d. of masons' work there about the time of the consecration, may indicate a major reordering before the bishop of London, William Juxon, was prepared to consecrate the building.[53]

However, the building at the time of its consecration was primarily designed for preaching. An 'able preachinge minister' was sought in 1638, and the pulpit was by far the most expensive fitting. The nearly square nave, 63ft 5in by 50ft, would have been well adapted as an auditory, and the exceptional unbroken width of the interior would have further detracted from the traditional appearance of a church, in spite of the semi-Laudian character of the chancel fittings.

At the Broadway Chapel (fig. 49), as Peter Guillery has shown, the order was once again almost certainly Tuscan; though the columns were used, not to form a portico, but in the normal way to distinguish nave and aisles internally (fig. 50).[54] The chapel was a correctly orientated rectangle built of brick with stone dressings and measuring internally approximately 96ft by 56ft. The internal colonnades were not, however, evenly spaced, the central intercolumniation being wider than the others and forming a cross-axis, which was emphasised externally by large shaped gables in the centre of the north and south elevations and inside by the cruciform arrangement of the plaster vaults. The gables in all four directions were of pedimental form raised up on tall scrolls, and under each was a large five-light window, round-headed but given panel tracery. The windows, then, were the only gothic feature of what was otherwise an entirely classical building.[55]

The unconventional character of the Broadway Chapel is further emphasised by the placing of the four identical doorways at the outer ends of the north and south walls, so that the building could be entered at any one of its four corners and, apart from a small west bellcote, was completely non-directional in external appearance.[56] It is impossible to reconcile a chapel of this character with Laudian prejudices, for the strong emphasis on a transverse axis would have had no meaning in the context of a Laudian

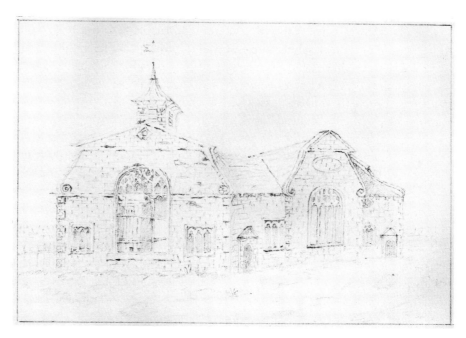

49 Anon., *Broadway Chapel*, from the south-west. Eighteenth-century watercolour, showing structure before the simplification of the gables

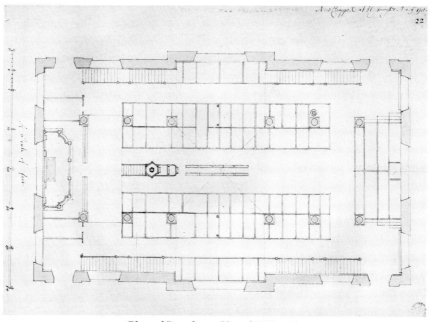

50 Plan of Broadway Chapel, Westminster

liturgy. Equally, the Broadway Chapel was not a Puritan place of worship. Its situation, close to the king's palace of Whitehall, and the influence on it of members of the chapter of Westminster Abbey, would both have made that impossible. Furthermore, the east window of the chapel contained a depiction of Pentecost in stained glass, an item which was made an article of indictment against Laud at his trial in 1646. Laud was able to call in evidence on his behalf the men who had set the window up, including the glazier Baptist Sutton, who testified that they were under orders not from Laud but from the Sub-dean of Westminster, Dr Robert Newell.[57]

The Dean of Westminster at this period was John Williams, who has been mentioned already in his other role as bishop of Lincoln. It was he who in 1626 consecrated the ground on which the Broadway Chapel was built a decade later.[58] As has been noted above, Williams was an adversary of Laud's, and in particular opposed the Laudian insistence on the fixed eastern position of the communion table. It is tempting to suggest that just at the period when Williams was advising the vicar of Grantham to retain an altar which could be moved into a convenient position for the congregation to take communion, he was promoting the construction of a chapel in West-minster which was designed for the flexible placing of the communion table, in a central position as well as against the east wall. Williams agreed with Laud about the role of beautiful surroundings in aiding worship, and enthusiastically commissioned schemes of stained glass. The typological east window in the chapel erected under his auspices at Lincoln College, Oxford (1629–30), is well known. His biographer, describing the repairs he under-took at his episcopal palace at Buckden, mentions the cloisters, 'the Windows of the Square beautified with Stories of colour'd Glass',[59] and an opponent pointed out that the east window of his episcopal chapel contained figures of apostles in the side windows, and at the east end a crucifixion scene, all which 'cannot but strike the beholders with thoughts of piety and devotion at their entrance into so holy a place'.[60] Williams himself stressed the didactic rather than devotional function of images, but there is no doubt that the Pentecost window in the Broadway Chapel would have met with his approval.

Laud's loss of power in 1640 put an end to his liturgical reforms. Puritan reaction in some places took violent form: during the 1640s screens were dismantled and stained glass destroyed. Even the partially Laudianised interior of St Paul Covent Garden was despoiled, the pulpit cut down, the rich font replaced by a simpler one, the marble-paved sanctuary swept away and a new communion table set up, apparently against the north wall.

Between 1643 and 1655 galleries were erected on three sides, and by 1670 a fourth one, against the east wall, was up, creating an interior such as the Earl of Bedford may originally have envisaged.[61]

When, at the end of the 1660s, Sir Christopher Wren came to consider design principles for the churches to be rebuilt after the Great Fire, the polarised attitudes of the 1630s were no longer relevant. Thus Wren's communion tables were always fixed, and railed in, against the east wall, just in the way Laud had required; yet galleries, anathema to Laud, were an integral feature of all Wren's large churches. Only two of his churches were provided with screens dividing chancel from nave, but the innovative planning of the Broadway Chapel, with its cross-axis, found an echo in many of them. Wren managed in a remarkable way to reconcile most of the warring prejudices of the previous generation and to devise a form of church design so well adapted to the requirements of his own and later generations that it remained normative for the ensuing century and a half.

Notes

1 Thomas Cocke, 'Le gothique anglais sous Charles 1er', *Revue de l'Art*, 30 (1975); John Summerson, 'Inigo Jones: Essay on a Master Mind', *Proceedings of the British Academy*, 50 (1965).

2 R.T., *De Templis, A Treatise of Temples: Wherein is Discovered the Ancient Manner of Building, Consecrating, and Adorning of Churches*, London, 1638, p. 183.

3 Foulke Robarts, *Gods Holy House and Service, According to the Primitive and most Christian Forme thereof*, London, 1639, p. 33.

4 Laurence Butler, 'Leicester's Church, Denbigh: an Experiment in Puritan Worship', *Journal of the British Archaeological Association*, 3rd series, 37 (1974).

5 John Gifford, *The Buildings of Scotland: Fife*, Harmondsworth, 1988, pp. 110–12.

6 Philip Plumb, *St Peter's Church Buntingford*, Buntingford, 1985.

7 *Survey of London*, F.H.W. Sheppard ed., vol. xxxvi, London, 1970, p. 103.

8 See Horton Davies, *Worship and Theology in England, from Cranmer to Hooker, 1534–1603*, Princeton, 1970.

9 Richard Hooker, *Of the Laws of Ecclesiastical Polity*, Book v, 1597, section xv; Everyman edn, 2 vols. 1968, ii, p. 50.

10 See also the evidence brought together in J. Wickham Legg, *English Orders for Consecrating Churches in the Seventeenth Century*, Henry Bradshaw Society, London, 1911–12, vol. xli, pp. lii–liv.

11 Statistics compiled from the volumes of Nikolaus Pevsner, *The Buildings of England*, give an average of 3.4 dated pulpits per year in the period 1615–29, and

6.7 per year in 1630–9. Dated pulpits are a small proportion of those which survive.

12 Aymer Vallance, *English Church Screens*, London, 1936, ch. 10.

13 Hooker, *Ecclesiastical Polity*, Book v, section xiv.

14 Hooker, Everyman edn, ii, p. 47, note.

15 *Constitutions and Canons Ecclesiastical 1604*, J.V. Bullard ed., London, 1934, pp. 84–8.

16 Vallance, *Screens*, p. 86.

17 *The Works of the most Reverend Father in God, William Laud, D.D.*, James Bliss ed., 7 vols., Oxford, 1853, v, part ii, pp. 381–477.

18 *Ibid.*, p. 405, from visitation articles for the diocese of London, 1628, a typical wording.

19 William Prynne, *Canterburies Doome*, London, 1646, pp. 75–6.

20 John Pocklington, *Altare Christianum*, London, 1637, p. 26.

21 *Ibid.*, 2nd enlarged edition, London, 1637, p. 24.

22 Robarts, *Gods Holy House and Service*, p. 40.

23 *Ibid.*, p. 41.

24 *Ibid.*, pp. 45–6.

25 He is not identified in S. Halkett and J. Laing, *Dictionary of Anonymous and Pseudonymous English Literature*, 7 vols., Edinburgh, 1926–37, index and supplement, Edinburgh, 1956, 1962.

26 R.T., *De Templis*, p. 20.

27 *Ibid.*, pp. 44, 45–6.

28 *Ibid.*, pp. 50–6.

29 *Ibid.*, p. 158.

30 *Ibid.*, p. 177.

31 *Ibid.*, p. 183–204.

32 Laud, *Works*, James Bliss ed., iii, p. 315.

33 *Ibid.*

34 John Stow, *A Survey of the Cities of London and Westminster*, J. Strype ed., 6 vols., London, 1720, ii, p. 65; John Parton, *Some Account of the Hospital and Parish of St Giles in the Fields, Middlesex*, London, 1822, pp. 192–5; Laud, *Works*, James Bliss ed., iii, pp. 213, 216.

35 *Survey of London*, F.H.W. Sheppard ed., xxxvi, p. 98.

36 Peter Guillery, 'The Broadway Chapel, Westminster, a Forgotten Exemplar', *London Topographical Record*, 26 (1990).

37 Parton, *St Giles in the Fields*, p. 207, gives the dimensions. The oval aisle windows were presumably inserted in 1670 when galleries were erected.

38 Laud, *Works*, James Bliss ed., iv, 1854, p. 249. This statement was intended to rebut the unwarranted claim in [William Prynne] *A Quench-Coale*, London, 1637, p. 219, that the church had merely been 'repaired in some of the wals, leads and seats'; Stow, *Survey*, J. Strype ed., iv, p. 79.

39 Parton, *St Giles*, p. 201.

40 Stow, *Survey*, J. Strype ed., IV, pp. 77–9.

41 *Ibid.*, II, p. 65; Laud, *Works*, James Bliss ed., IV, p. 249.

42 London, Guildhall Library, MS. 1198, vol. I, St Katherine Cree, churchwardens'
accounts, 1650–91.

43 Stow, *Survey*, J. Strype ed., II, p. 65.

44 Guildhall Library MS. 1198, vol. I, an inventory of 1650 confirms this, describ-
ing the communion table as of 'Barmoodas Caeder'.

45 'The Note-book and Account Book of Nicholas Stone', *Walpole Society*, 7 (1919),
p. 79.

46 For a discussion of the design of church towers in the 1630s, and Inigo Jones's
possible involvement in it, see Arnold Taylor, 'The Seventeenth-Century
Church Towers of Battersea (1639), Staines (1631), Crondall (1659) and
Leighton Bromswold (*c.* 1640)', *Architectural History*, 27 (1984).

47 Alan W. Ball, *The Countryside Lies Sleeping, 1685–1950, Paintings, Prints and
Drawings of Pinner, Stanmore and Other Former Villages now in the London Borough
of Harrow*, Harrow, 1981, pp. 143–62, publishes all the known drawn and
engraved views of Great Stanmore church.

48 [Prynne], *A Quench-Coale*, p. 236.

49 Joseph Mede, *Churches, this is, Appropriate Places for Christian Worship*, 1638,
p. 63.

50 R.T., *De Templis*, p. 4.

51 *Survey of London*, F.H.N. Sheppard ed., XXXVI, p. 99.

52 Butler, 'Leicester's Church', fig. 5, 7.

53 *Survey of London*, F.H.W. Sheppard ed., XXXVI, pp. 271–81, prints the building
accounts. See also British Library, Harleian MS. 1831, fos. 29r, 33v.

54 Guillery, 'Broadway Chapel', p. 107.

55 *Ibid.*, p. 112. Guillery argues that the window tracery was inserted subsequently
to the construction of the chapel, when the stained glass was inserted, but this
seems structurally improbable, and does not account for the fact that every
window in the chapel was either traceried or mullioned.

56 *Ibid.*, figs. 2, 3.

57 Laud, *Works*, James Bliss ed., IV, p. 228.

58 Guillery, 'Broadway Chapel', p. 108.

59 John Hacket, *Scrinia Reserata*, London, 1693, part 2, p. 29.

60 Pocklington, *Altare Christianum*, 2nd edn, 1637, p. 87.

61 *Survey of London*, F.H.W. Sheppard ed., XXXVI, p. 104.

10

CLARENDON AND THE ART OF PROSE PORTRAITURE IN THE AGE OF CHARLES II

Richard Ollard

What is portraiture? Obviously in some sense the representation of an individual being – not necessarily human. Everyone can call to mind portraits of horses, dogs and cats that attempt to show their individuality of character or temperament, not just to state their membership of a particular branch of the animal kingdom. Perhaps to the knowledgeable the same might be true of botanical illustration: a particular lily, growing in a bed of lilies, might disclose by the way it held its head a singularity that distinguished it from its fellows.

Identification is portraiture's most common practical use. Passports, readers tickets to the British Library, soon, it seems, credit cards must bear our likeness, however grotesque and spectral the product of the do-it-yourself photograph cubicle may be. Our family and friends might not recognise us but the total stranger on duty at the control point has no difficulty in doing so. Identification is a less ambitious aim than understanding. The official is not interested in divining by a study of our physiogonomy whether we are the kind of people who might be up to no good but whether we are the people we say we are. A likeness that is only the statement of verifiable facts about a man's physical appearance is, like the impression of his finger-prints, no more than the certification of his uniqueness. We call such a production a portrait but we do so wrongly. Perception, interpretation are of the essence. A portrait, whether in prose or in line and colour, requires an artist and a sitter. A machine cannot be substituted for the one, nor an inanimate object for the other. In this definition 'inanimate' must be taken to mean that which has never known, or by its nature could have known, the state of being alive. Portraits of the dead are common form in literature and by no means unknown in drawing and painting. Samuel

189

Cooper's drawing of his dead son is an unforgettable example from our period. Yet its dignity and pathos is enhanced by its being drawn *post vivum*. Life, when we talk of portraiture, is not simply a condition to be established by medical examination. Sculpture and statuary, so often funerary in their origin, are eloquent to contest so narrow a literalism.

If perception and interpretation are the *sine qua non* of portraiture, what is it that the artist or writer seeks to render? Different answers could be made from different ages and from different circumstances. In England medieval portraiture, literary or pictorial, aims, as a rule, at establishing the type or category to which the sitter belongs. A king should appear kingly, a saint saintly, a rich merchant rich and so on. Only in the villeins who pursue the labours of the months or cast off their inhibitions at some revel is the characterisation personal rather than hierarchical. It is the same with medieval biography: and no medieval author thought of writing the biography of a peasant. Piers Plowman might be an impressive fount of social criticism or theological exposition but no one would be interested in him as a character.

Yet to our notions of portraiture, notions which in England germinated in the early seventeenth century and flowered in the age of Charles II, character is the beginning and the end: 'O the difference of man and man' as Goneril observed. Looking round the great hall of some institution that regularly commissions portraits of its principal officers one sees what she means. We are back where we started in the middle ages. Mostly what the portraits tell us is that it was, in Admiral Lord Fisher's phrase, 'Buggins turn'. Character pertains to an individual, not to an office or a title.

'Characters' was the term that Clarendon, the greatest prose portraitist of our period, used of his own productions. It was also the word generally used in the seventeenth century for what is now termed autograph or holograph – that which is written in a man's own hand and, as such, an immediate expression of his personality. It was even used by Shakespeare and others to mean a man's external appearance and, by extension, the representation of it by a painter.

The word, as it was understood in Charles II's time, thus carried a weight of meanings each tending to emphasise the uniqueness of the individual. But it had not lost its strictly literary antecedents, known to all educated men as the title of a work by the ancient Greek author Theophrastus, which defined character by what was common to all humanity rather than by that which was peculiar to a given individual. Clarendon's great friend, John Earles, had written a best-seller before the Civil Wars which employed the term in this

sense on its very title-page: *Micro-cosmographie or a Peece of the World Dis-
covered: in Essayes and Characters.* The characters here were social and pro-
fessional types: 'an old College butler, a grave divine, a meere dull
Physitian', and so on. Like the characters in a novel they were doubtless
drawn from life but not from a single, let alone a conscious, sitter.

One notable if often forgotten feature of the prose portraiture in which
the age of Charles II was so rich is that it was executed almost entirely
behind the arras. As David Nichol Smith pointed out in the admirable
survey of the subject ('Essay on the Character') that introduces his
anthology *Characters from the Histories & Memoirs of the Seventeenth Century*
(1918) the writers that come first to mind, Clarendon, Aubrey, Bishop
Burnet, Sir Philip Warwick (figs. 51–4), published nothing of the kind in the
age itself. Certainly they had none of them read each others work and it is
next to certain that they none of them even knew of its existence. Sir Philip
Warwick's *Memoires*, published in 1701, was, as Nichol Smith points out,
'the first book to appear with notable characters of the men of the Civil
Wars and the Protectorate' ('Essay', p. xlix). Hot on its heels came
Clarendon's *History of the Rebellion*, published in two noble volumes in 1702
and 1703. Burnet, who had begun work on his *History of My Own Time* in
1683, lived to read Clarendon, as did Pepys and Evelyn, but not to see the
publication of his own first volume in 1724.

It is true that both Clarendon and Burnet had published (or in
Clarendon's case circulated) memoirs of the great noblemen to whom they,
as young men, owed some obligation of clientage. But these were, like
obituary notices and *eloges* in every age, productions in which the writer was
not, in Dr Johnson's phrase, upon oath. Burnet, characteristically, was proud
of his *Lives of the Dukes of Hamilton* (published in 1677) and tells us that Sir
Robert Moray 'gave [it] the character . . . that he did not think there was a
truer history writ since the apostles' days'.[1] Clarendon's treatment of his
own early encomium of the first Duke of Buckingham was altogether more
off-hand. He never published it himself although it first appeared in print
towards the end of his life.[2]

To celebrate a man's virtues is a fine thing: but it is different from
painting his portrait. The *Lives* that Izaak Walton wrote of Hooker, Donne,
George Herbert, Robert Sanderson and Sir Henry Wotton spring from the
first motive, not the second. But Richard Wendorf, in his original and
stimulating study of the relation between biography and portrait painting,
has drawn attention to Walton's interest in portrait painting and his resort
to metaphors drawn from it to explain his own methods and intentions.[3]

52 Canon Jackson, after Sir Peter Lely, *John Aubrey*

51 Thomas Simon, *Edward Hyde, 1st Earl of Clarendon*

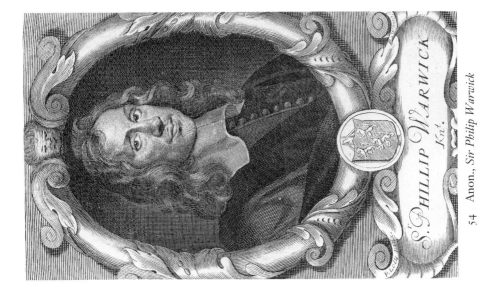

54 Anon., *Sir Philip Warwick*

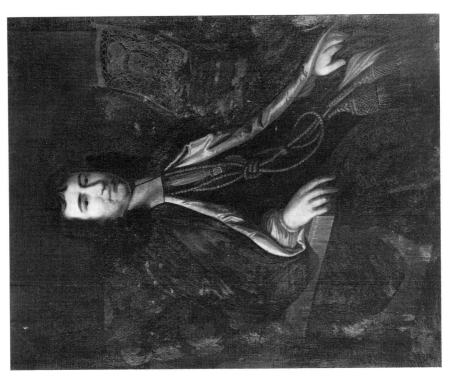

53 James Riley (after), *Bishop Gilbert Burnet*

This type of biography, classified by Wendorf as iconic, deriving as it does from the memoir and the valediction was certainly one of the streams that fed the great river, still flowing underground, that was to emerge into the sunlight at the turn of the century. One of its most valuable if unobtrusive qualities was, as Wendorf points out, the scope it gave for the portrayal of people who did not hit the headlines of history.[4]

Yet history was the true source, the headwaters of English prose portraiture. As Nichol Smith makes clear in his 'Essay', from the beginning of the seventeenth century the most eminent figures in the learned world from Bacon onwards had been calling for a native historiography to stand comparison with that of our continental neighbours. The history that all the world admired was that of Rome's classical age, in particular that of Livy and, above all, of Tacitus. His vivid narrative power, guided by insight into character and expressed in a taut, epigrammatic style, was the model on which history should be written. Those who had mastered Greek, like Clarendon's friend Hobbes, rated Thucydides even higher. But Greek, unlike Latin, was not the common acquirement of an educated man until long after the age of Charles II. Even Dr Johnson thought of it as being like lace. Hobbes's translation of Thucydides, still regarded by many scholars as the best, appeared in 1629. Hitherto the only Greek historian easily accessible to Englishmen had been Plutarch in North's often reprinted translation. And Plutarch belonged to the Hellenistic rather than the strictly Greek world. What this distinguished but oddly assorted group of ancient writers had in common was their sharply defined insistence on the importance of personal qualities in the historical process. Time spent on studying the talents, passions, weaknesses of men charged with the conduct of affairs was never time wasted.

So when Clarendon turned to the writing of history he knew that one of his first tasks must be to form a clear notion of the people he was writing about. To the professional necessity was added a moral obligation. The Civil War – or rebellion as he preferred to call it – had been a sin whose punishment had fallen unequally. Like Marvell he felt himself to have been involved in the collective guilt:

> What luckless Apple did we tast
> To make us Mortal and Thee Wast?

The rain falls on the just as well as the unjust. The England of the 1630s had been the Garden of Eden from which the subjects of Charles I, like the sons of Adam, had been expelled – in Clarendon's case literally as well as

figuratively, for he was already an exile, excluded by name from any pardon that might follow the cessation of hostilities, when he began to write.

One of the first characters whom his mind set to bring into focus was that of his closest friend, Lord Falkland, who had fallen at the first battle of Newbury in 1643. Falkland was the inspiration of Clarendon's politics and morals. No one else whom he describes felt so keenly the moral obliquity of the Civil War, no one else had exerted himself more manfully to prevent it or tried harder, once it had broken out, to bring it to an immediate end. No other figure of comparable importance – he was Secretary of State at the time of his death – was more transparently free from ambition, partisanship or selfish ends of any kind. It was therefore morally and historically imperative to establish this unselfadvertising personification of virtue and patriotism before he was overshadowed by the more dashing and dramatic figures that crowded the period that Clarendon was about to describe.

Revolving the matter in his mind Clarendon remembered that his and Falkland's old friend, John Earles, had himself composed 'a discourse . . . in memory of Lord Falkland' as a kind of pendant to his contemplation on the Book of Proverbs which Earles had read aloud to him a year or two earlier. Clarendon therefore wrote to ask for it as a source for his present work 'conceiving it to be so far from an indecorum, that the preservation of the fame and the merit of persons, and deriving the same to posterity, is no less the business of history than the truth of things'. Writing to thank him for it nine months later in this, his second letter to Earles, he amplified this manifesto:

history, which ought to transmit the virtue of excellent persons to posterity; and therefore I am careful to do justice to every man who hath fallen in the quarrel, on which side soever, as you will find by what I have written of Mr Hambden himself. I am now past that point; and being quickened by your most elegant and political commemoration of him, and from hints there, thinking it necessary to say somewhat for his vindication in such particulars as may have possibly made impression in good men, it may be I have insisted longer upon the argument than may be agreeable to the rules to be observed in such a work; though it be not much longer than Livy is in recollecting the virtues of one of the Scipios after his death. I wish it were with you that you might read it; for if you thought it unproportionable for the place where it is, I could be willingly diverted to make it a piece by itself, and enlarge it into the whole size of his life; and that way it would be sooner communicated to the world. And you know Tacitus published the life of Julius Agricola, before either of his annals or his history. I am contented that you should laugh at me for a fop in talking of Livy or Tacitus; when all I can hope for is to side Hollingshead, and Stow, or (because he is a poor knight too, and worse than either of them) Sir Richard Baker.[5]

It is tempting to believe that Earles, whose own talents in that direction had been brilliantly demonstrated, would have encouraged him. If Clarendon had adopted this plan it is clear from the passage just quoted that he would have published the book straightaway, whereas the *History*, both from the confidentiality of its sources and the candour of its assessment of powerful and eminent persons, would have to remain under wraps, certainly during the lifetime of its author. In fact, the unforeseeable demands on Clarendon's literary life made by his involvement in politics had the happy consequence that he executed two versions of his great portrait of Falkland, the first, referred to above, in Jersey in 1647 and the second at Montpellier in 1668. The immediate question was anyway settled for him by urgent indications, the first only a month or so after his letter to Earles, that his services in an active capacity might be required at a moment's notice. The first secret moves towards the second Civil War were being taken. But the incursion of great events should not distract us from the evolution of Clarendon's understanding of his art.

His half-humorous self-deprecation gives a good, but not a complete, idea of the reading he had undertaken to fit himself for his new profession. He had no doubts at all of his ability to outperform the English chroniclers he mentions. But why, one wonders, does he say nothing of Camden, whose influence on him Hugh Trevor-Roper has valuably emphasised?[6] He had, as it happens, begun to make a digest of Camden's *Britannia* just about the time of his first letter to Earles and had finished it only a fortnight before the second.[7] Perhaps to compare himself with Camden would have been at that stage presumptuous. In any case, Clarendon's admiration for him can be gauged by the presence of his portrait in the great collection of paintings made after the Restoration by this prince of prose portraitists.

The prodigious scope of Clarendon's reading during this sabbatical in Jersey is the more amazing when allowance is made for his simultaneous literary production – the first four books of the *History* were written before he was called away in the spring of 1648 – and the vast, apparently unhurried, correspondence which he conducted, nearly all of it in his own hand. The more he read, the more he wrote, the more he questioned colleagues or ex-colleagues about affairs of which he had no first-hand knowledge, the more profoundly he perceived the individuality of human beings. Essential to any true representation of that individuality was the understanding of the historical context in which it was set:

There is not a greater foundation for error than to conclude matter of right from matter of fact... There must be the Spirit of the tyme considered in all separate

Actions, as well as in expressions and wordes, many things being fitt in our tyme to be said or done, which in another would be justly censured or reprehended.[8]

Clarendon's portraiture is so often compared to Van Dyck's that it may be well to emphasise its dissimilarity. Both are masters who have had a long and wholly beneficial influence on the development of their art in England. But two prominent aspects of Van Dyck's genius are scarcely present in Clarendon – the power of empathy and the miraculous rendering of surface textures. Clarendon's figures do not look at us: we look at them. And we are given little help from light or colour or anything else that might stimulate our imagination through our senses. By general consent his two master-pieces are the two portraits already referred to: those he drew of his great friend Falkland. In the first the reader is given no clue to the physical as opposed to the psychological and intellectual impact and conformation of the sitter beyond being told that in his agony at the fact of the Civil War he 'would with a shrill and sadd Accent ingeminate the word, Peace, Peace...' The word 'shrill' is the only indication that the winning charm and generosity of mind and spirit triumphed over an unprepossessing exterior. Twenty years later this is amply rectified.

With these advantages he had one great disadvantage, which in the first entrance into the worlde, is attended with to much praejudice; in his person and presence which was in no degree attractive or promisinge; his stature was low and smaller than most mens, his motion not gracefull, and his aspecte, so farr from invitinge, that it had somewhat in it of simplicity and his voyce the worst of the three, and so untuned, that insteede of reconcilinge, it offended the eare, that no body would have expected musique from that tounge, and sure no man was less behol[den] to nature, for its recommendation into the world.[9]

Size is the quality that seems to have struck him most about a man's appearance. We are told of Sidney Godolphin, who was killed in the same year as Falkland, that 'ther was never so great a minde and spirit contayned in so little roome, so large an understandinge and so unrestrayned a fancy in so very small a body, so that the Ld Falklande used to say merrily, that he thought it was a greate ingredient into his frendshipp for Mr Godolphin, that he was pleased to be founde in his company, wher he was the properer man'.[10] The contrast between greatness of mind and poverty of physique is made even more explicit in the description of Sir Charles Cavendish, brother to the royalist general, the Marquis of Newcastle:

who was one of the most extraordinary persons of that age, in all the noble endow-ments of the mind. He had all the disadvantages imaginable in his person; which was

not only of so small a size that it drew the eyes of men upon him, but with such deformity in his little person, and an aspect in his countenance that was apter to raise contempt than application; but in this unhandsome or homely habitation there was a mind and a soul lodged that was very lovely and beautiful.[11]

Grandeur of presence is more subtly suggested. The character of Lord Capel is partly delineated in the account of the imprisonment and trial that preceded his execution. He had escaped from the Tower of London by letting himself down from his window, only to find 'the water and the mud so deep that if he had not been by the head taller than other men, he must have perished, since the water came up to his chin'. This image is sustained (he had been recaptured) by the description of his execution (which Clarendon of course could not himself have witnessed).

The Lord Capell was then called; who walked through Westminster Hall, saluting such of his friends and acquaintance as he saw there with a very serene countenance, and accompanied with his friend Dr Morly, who had been with him from the time of his sentence; at the foot of the scaffold he took his leave of him, and, embracing him, thanked him, and said he should go no further, having some apprehension that he might receive some affront by the soldiers after his death.

Morley, who for some years of the exile was Clarendon's domestic chaplain, was no doubt his source. As a royalist who had never disguised his opinions he might well have been roughly handled. This final act of courtesy and consideration, even more than the 'clear and strong voice' with which Capel professed his political and religious principles from the scaffold, completes the representation initiated with the tall figure striding unconcerned to a violent death through the crowds in Westminster Hall. 'In a word he was a man that whoever shall after him deserve best in that nation, shall never think himself undervalued, when he shall hear that his courage, virtue and fidelity is laid in the balance with, and compared to, that of Lord Capell.'[12]

These rare instances of Clarendon's physical description of the men he was studying throw into relief a quality of his mind on which he perhaps prided himself – his sense of proportion. We do not see these people's features but we are aware of their size – not as an isolated and isolating fact but in relation to the people who surrounded them. Context and proportion are Clarendon's fundamental categories. His explicit insistence on context has already been mentioned. So, obliquely, has proportion. In the letter to Earles he declares his intention of asking him whether he thinks the character of Falkland is 'unproportionable for the place where it is'. Like context, proportion is an important element of morality. Reproving Charles II for

continuing his liaison with Lady Castlemaine after his marriage he 'besought him to remember "the wonderful things which God had done for him, and for which he expected other returns than he had yet received"'.[13] The inspiration of Clarendon's portraiture is moral and social. He never imagined his figures against a vaguely suggested background: and it was their moral and social individuality that he was out to portray.

The younger contemporary furthest away from this artistic standpoint is John Aubrey. Where Clarendon suggests in broad strokes and concentrates on mass and perspective Aubrey achieves brilliance and immediacy by his minute particularity. If he can tell you that a man's father was a cordwainer from Chipping Camden he does so. Clarendon would regard such detail as beneath serious notice, smacking of that vulgarity and gossip that perhaps stimulated Lord Beaverbrook's admiration for the *Brief Lives*. Not the least surprising effect of Aubrey's art is its tendency to induce his critics to underestimate it. Even so fair and judicious a writer as Richard Wendorf, while acknowledging his 'ability to bring his characters to life', characterises his technique as a 'rude and hasty method' and concludes that its special virtue was 'the preservation of so much material that would otherwise have been lost'.[14]

Yet Aubrey's mixture of circumstantiality, moral criticism and anecdotal recollection often achieves an effect of authenticity akin to the enormous self-portrait in motion that the reader finds in Pepys's *Diary*. Neither writer is concerned to relate his observation of people to any central thesis about humanity in general. Both, writing in intimacy and not clearing their throat before an audience, make no attempt to disguise their likes and dislikes behind a façade of impartiality. The same, it may justly be urged, is true of Clarendon when he is writing to friends and not addressing posterity with a due sense of his responsibilities as an historian. This sense informed the autobiography on which he embarked during his second exile as much as it did the *History* he began in his first. The fact that he subsequently incorporated a huge amount of the *Life* with the unfinished original *History* to produce what was posthumously published as the *History of the Rebellion* is sufficient evidence of his literary intention.

But the most striking examples of the freer style he could allow himself as a portraitist pure and simple, the development perhaps of what he had in mind in his letter to Earles, are to be found in the *Characters*, printed as a supplement to the third volume of the Clarendon *State Papers*.[15] These, written in the second exile, are all four of men who were his bitter enemies. Two of them, Arlington and St Albans, he had disliked from his earliest

acquaintance. The other two, Lord Berkeley of Stratton and George Digby, 2nd Earl of Bristol, had been friends of his young manhood and early middle age. Indeed, there still remain some traces of affection in his portrait of Bristol, the only full-length study to give free rein to that keen sense of the ridiculous that both Evelyn and Pepys observed and enjoyed in the Chancellor.

Clarendon's prose portraits, like the paintings he assembled for his gallery, were intended to illustrate the history of the period through which he had lived. With very few exceptions he does not choose to depict those who had played no part in its politics or in the formulation of its ideas. It is surprising that the most determined and brilliant of his political adversaries, Shaftesbury, should have painted in his own unfinished autobiography an affectionate portrait of a country gentleman of the old school. Henry Hastings made no figure in the political, still less the intellectual, life of his time but everyone who reads this masterly portrayal understands the period better for it.[16] If the host of prose portraitists, Aubrey, Burnet, Roger North, Sir Philip Warwick, to name but a few, differed from Clarendon as much in their aims as in their technique, at least they all contributed to, indeed widened, his ideal of history, 'making the reader present at all they say and do'. Clarendon's 'they' refers specifically to the leading figures, and often the writers I have mentioned help to bring them before us with wonderful sharpness of vision. Who can forget Sir Philip Warwick's description of himself as a young, rather precious, dandified MP entering St Stephen's in 1640:

and perceived a Gentleman speaking (whom I knew not) very ordinary apparelled; for it was a plain cloth-sute, which seemed to have been made by an ill country-taylor; his linen was plain, and not very clean; and I remember a speck or two of blood upon his little band, which was not much larger than his collar; his hatt was without a hatt-band: his stature was of a good size, his sword stuck close to his side, his countenance swoln and reddish, his voice sharp & untunable, and his eloquence full of fervor?[17]

As a portrait of Cromwell this surely ranks high, enabling us better to appreciate Samuel Cooper's superlative miniature. But it is in the rendering of less exalted persons that these early prose portraitists stir our imagination to a livelier apprehension of the Stuart age, as Oliver Millar has so often done in the great exhibitions he has mounted.

Notes

1 *Burnet's History of My Own Time*, O. Airy ed., 2 vols., Oxford, 1897, I, part 1, p. 41.

2. In the third edition of Sir Henry Wotton, *Reliquiae Wottonianae* (1672).

3. Richard Wendorf, *The Elements of Life: Biography and Portrait-Painting in Stuart and Georgian England*, Oxford, 1990, pp. 45ff.

4 *Ibid.*, pp. 23 and 41.

5 Edward, Earl of Clarendon, *State Papers Collected by Edward, Earl of Clarendon, Commencing 1621*, R. Scrope and T. Monkhouse eds., 3 vols., 1767–86, Oxford, 1773, II, pp. 350 and 386. Clarendon, at that date plain Sir Edward Hyde and an impoverished exile, might be properly termed 'a poor knight'.

6 Hugh Trevor-Roper, *Renaissance Essays*, London, 1985, ch. 8, 'Queen Elizabeth's First Historian: William Camden', pp. 121–49.

7 Bodleian Library, Clarendon MS, 126, fos. 166 and 175.

8 *Ibid.*, fo. 55.

9 David Nichol Smith, *Characters from the Histories and Memoirs of the Seventeenth Century*, Oxford, 1918, p. 88.

10 *Ibid.*, p. 96.

11 Edward, Earl of Clarendon, *The Life of Edward, Earl of Clarendon*, 2 vols., Oxford, 1857, I, p. 250.

12 Nichol Smith, *Characters*, p. 124.

13 Clarendon, *Life of Clarendon*, I, p. 591.

14 Wendorf, *Elements of Life*, pp. 118 and 122.

15 Clarendon, *State Papers*, Scrope and Monkhouse eds., III, 1786. Reprinted with an introduction and notes by the present writer as *Clarendon's Four Portraits*, London, 1989.

16 Nichol Smith, *Characters*, pp. 44–7.

17 *Ibid.*, pp. 140–2.

I I

THE GREAT PICTURE OF
LADY ANNE CLIFFORD

Graham Parry

Portraits in the seventeenth century were part of family history, preserving the likeness of an individual, and accompanying it with signs of lineage, wealth and authority, but no picture of the age aspires to function as a family chronicle and intellectual history in a way comparable to Lady Anne Clifford's triptych at Appleby Castle (fig. 55). It is a unique record of a redoubtable woman's pride in her ancestry, her relations and her own accomplishments, the chief of which was her tenacious legal campaign to secure, in her own right, the hereditary titles and lands of the Cliffords; a campaign which is referred to below.[1]

The painting commemorates her victory in gaining this inheritance, and the structure of the work is conditioned by this event. The central section shows her parents, the Earl and Countess of Cumberland, and her brothers, the rightful line of the Cliffords. The left wing shows Lady Anne at the age of fifteen, when she should have inherited her estates, on the death of her father, but when, in fact, the entail which would have enabled her to inherit had been broken. The right wing portrays her as a sombre lady in her fifties, finally in possession of her entitlement. Yet the Great Picture is much more than a visual vindication of a long-contested claim, or a memorial of family piety: it is also an invaluable account of the cultural range of an eminent seventeenth-century woman, for Lady Anne was as proud of her books as she was of her ancestors.

The painting hangs in the Great Hall at Appleby Castle in Westmorland, on loan from Abbot Hall, Kendal. The central section is some 10 feet wide and 9 feet high, and the side sections are 4 feet wide. It is on canvas, and unsigned. An inscription in the central section states that the work was commissioned by Lady Anne Clifford in 1646. Lionel Cust attributed it to

202

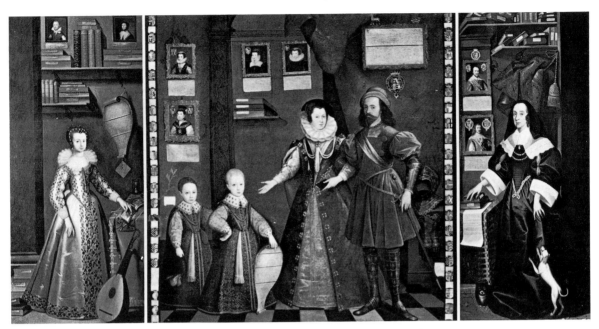

55 Jan van Belcamp, *The Great Picture of Lady Anne Clifford*, 1646

Jan van Belcamp, or to Remigius van Lemput,[2] and conventional opinion
these days sides with Belcamp. Both painters were picture-copiers associated
with the studio of Van Dyck, but Belcamp was more active and more noted
in his time: he was also engaged under Abraham van der Doort in copying
pictures in Charles I's collection. A copyist was what Lady Anne required,
for as the inscription already mentioned informs us, the family group in the
centre panel and the four portraits on the wall were all 'copies drawn out of
the originall pictures of these honourable personages'. The depiction of the
Cumberland family was based on a painting 'made about the beginning of
June 1589'; the other figures are copies of late Elizabethan portraits. The
young Lady Anne on the left is presumably a copy of a lost original, and the
background pictures on the wings are copies too. Only the figure of Lady
Anne in her black and white dress may have been painted from the life.
What was needed of the artist who made the Great Picture was a skill in
arranging all these components into a pictorial statement that corresponded
with Lady Anne's intentions. There is an undeniable stiffness about the
composition that must derive in some measure from the laboriousness of
copying; some passages in the painting, notably the handling of the cloth of
state in the centre and right sections, do not argue any great ability in the

artist, and do not seem worthy of anyone who had worked in Van Dyck's studio. The artist must, however, have been London-based, for Lady Anne was living there in 1646, when the painting was made.

There were originally two versions of the Great Picture, one hanging in Appleby Castle, the other in Skipton Castle, both seats of Lady Anne. The Skipton version, however, decayed so badly that the wings were discarded in the nineteenth century, and the centre section was subsequently destroyed in a fire.[3] It is entirely characteristic of Lady Anne that she should have commissioned two identical enormous paintings, for this action is all of a piece with her determination to preserve the records of the Clifford family as fully and in as varied a way as possible. As the Great Picture was painted in two versions, so the 'Great Books' or the Books of Record that she dictated concerning the history and ancestry of her family were written in three copies, to guard against the chances of accidental loss. By a variety of means Lady Anne paid tribute to the honour and antiquity of the Clifford family, and ensured that her own transactions were carefully recorded. Her favourite medium was the inscription: the Great Picture is crowded with highly informative statements, and stone inscriptions mark her dealings with the ancestral buildings of her northern domains. The tombs she erected for members of her own family and for her mother's kindred also provided favourable opportunities to reflect on her lineage. She had a passion for heraldry, and blazoned her descent from Norman times to the present in several locations; she raised pillars to commemorate notable events in her life; her initials in glass and wood stamp the churches she built or restored; for her private life, she kept a succession of diaries. She was a tireless memorialist.

To understand this preoccupation, and the place of the Great Picture in it, some personal details of Lady Anne's life will be helpful. Born in 1590, she was the only daughter of George Clifford, 3rd Earl of Cumberland, and of Margaret Russell, daughter of Francis, 2nd Earl of Bedford. She had two older brothers, both of whom died in childhood. According to an entail imposed by Edward II, the Clifford lands should always descend in the direct line, whether the heir was male or female. The 3rd earl, who died in 1605, broke the entail, and left his titles and his estates to his brother Francis Clifford, who now became the 4th Earl of Cumberland. Lady Anne was thus cheated of her inheritance, even though her father settled on her a portion of £15,000. Immediately, her mother challenged the right of Francis Clifford to inherit the Clifford estates, and began a suit in law on behalf of her daughter. In 1609, Lady Anne married Richard Sackville, 3rd Earl of Dor-

set, but far from finding an ally and supporter in her husband, she soon learnt that he had no interest in these northern lands and wished her to relinquish her claim in return for a considerable sum of money, which should be paid to him rather than to his wife. Several legal judgements went against Lady Anne and her mother, the Archbishop of Canterbury tried to persuade her to yield, and eventually King James determined to settle the matter of the disputed inheritance in 1617. He ruled in favour of the Earl of Cumberland, but Anne never accepted the validity of the judgement, or relinquished her claim. Time passed; the high-living Earl of Dorset died of an apoplexy in 1624, leaving Anne with two daughters. After six years of widowhood, she remarried, to Philip, 4th Earl of Pembroke, who proved to be a severe and unsympathetic husband, and at the end of 1634 she decided to live apart from him. In 1641 her uncle the Earl of Cumberland died, his titles and estates passing to his son Henry Clifford, who soon followed him to the grave, dying in 1643, and leaving only a daughter behind him. At this point, Lady Anne's tenacity was rewarded, for never having renounced her claim, or compounded for money, she inherited the Clifford lands by reversion.

She delayed her journey north to take possession for a curiously long time, some five and a half years. The Civil War was probably the major reason why she did not leave London, but we can only speculate why she did not travel north after 1646, when the fighting died down. It was at this time that she chose to summarise her life in the terms that were significant to her, in the Great Picture.

The contents and lay-out of the painting are most revealing of Lady Anne's judgement of people and ideas in relation to herself. The central place is given to her mother, the profoundest and most enduring influence in her life. Lady Margaret Russell was a notably pious woman who had a resolute mind, and who showed great competence in her dealings with the world. Much neglected by her husband, she formed an extremely close bond with her daughter, to whom she acted as chief confidante and strategist in planning the campaign to keep the Clifford estates. For Lady Anne, her mother was a model of resourcefulness and of female virtue and Christian forbearance in a society dominated by high-mettled and unprincipled men.

The closeness of mother and daughter was intense, and endured long beyond the death of Lady Margaret. Lady Anne's posthumous regard for her mother took many forms. She caused her to be buried at Appleby in the centre of her dower estates, an act that seemed to reinforce Anne's own claim to these lands. She erected a splendid memorial over her mother's

grave; the alabaster effigy is of the finest London workmanship, and its resemblance to the effigy of Queen Elizabeth in Westminster Abbey cannot be accidental. (Ultimately, Lady Anne would be buried next to her mother in the north-east corner of Appleby church.) Another memorial was the stone pillar by the roadside near Brougham Castle to mark their last mortal sight of each other in April 1616; the pillar was built forty years after their last parting, when Anne was in full possession of the lands they had so long plotted to secure. Finally, the Great Picture itself, painted in 1646, is, in its way, a memorial to Lady Margaret thirty years after her death.

Lady Anne's feelings about her father, George Clifford, 3rd Earl of Cumberland, were ambivalent. He was the source of her distinction, the bearer of a name famous since Norman times. Her own identity was overwhelmingly that of the heir of the Cliffords. Yet her father had dealt her the severest blow of her life by refusing to transmit her rightful inheritance. He had also injured her female pride by unjustly favouring the indirect male line of succession. Nonetheless, by Elizabethan standards, the Earl of Cumberland was an admirable man. He was one of the greatest seamen of the age. He had commanded a ship against the Armada in 1588, and had continued to harass the Spanish by numerous voyages to the Azores and beyond, to the West Indies. He captured Puerto Rico from the Spanish, and seized many of their ships; in short, he was a successful buccaneer. He enjoyed Queen Elizabeth's favour, and was made a Knight of the Garter in 1592. A more distinctive honour was his appointment as Queen's Champion in 1590, when Sir Henry Lee retired. His duties included defending the Queen's honour in the annual Accession Day tournaments at Whitehall, which were extravagant occasions of chivalry and romance. Cumberland is best known to us in this role through the miniature by Nicholas Hilliard in the National Maritime Museum at Greenwich, where he is armed for the tournament as the Knight of Pendragon Castle (fig. 56). Arthurian as that name sounds, it was authentically one of his castles in Westmorland, and he exploited its romantic associations in the pageants and combats that glorified the queen in the latter years of her reign.

In Hilliard's miniature, Cumberland is shown in the parade armour that he often wore for the Accession Day tilts. It has a celestial character suitable to his high-aspiring mind, and bears the optimistic imagery of gold stars upon an azure ground. Cumberland wears the same armour in the Great Picture. His helmet and gauntlets are displayed on the table behind him in the fashion common to portraits of knights in their tournament costume at this period. By depicting him thus, standing with his wife who holds a book

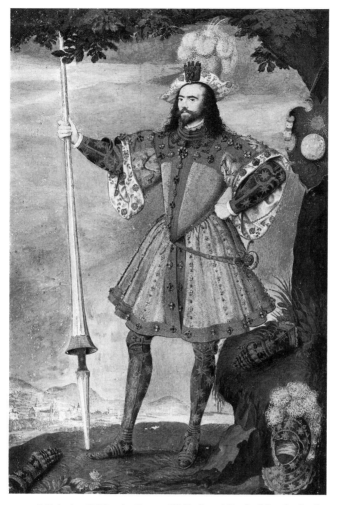

56 Nicholas Hilliard, *George Clifford, 3rd Earl of Cumberland*

of Psalms in her hand, the artist places a composite image of chivalry and piety at the centre of the Clifford family group. The earl died in London in October 1605, at the age of forty-seven, as a result of old injuries and diseases. His body was taken to Skipton, and buried in the parish church in a plain yet handsome marble tomb, splendidly set about with escutcheons. It is noteworthy that Lady Margaret his wife did not choose to be buried with him, but wished in her will to be buried with her brother in Alnwick. Striking too is Lady Anne's delay in repairing his tomb after the Civil Wars;

although she took deep satisfaction in commissioning and restoring tombs, she did not show her usual despatch in her father's case.

The two children in the centre section are Lady Anne's brothers, Robert who died in December 1589, and Francis Clifford, who died in 1591 when Anne was one year old. On the wall behind them hang the portraits of the good women of the family, her mother's sisters, Anne Countess of Warwick and Elizabeth Countess of Bath, and her father's sisters, Margaret Countess of Derby and Frances Lady Wharton. The male kindred, notably her uncle Francis Clifford who succeeded to the estates, are excluded from this little family gallery.

There is one final point to make about the centre section. In a discreet way, Lady Anne is present herself in the family group here. An inscription notes that the Clifford figures are copied from a painting made in June 1589, and then proceeds to particularise the date of Anne's conception as 1 May 1589, so that the viewer may understand that she has an embryonic existence in the painting. This is not the only case of Anne's interest in her pre-natal state. The inscription she placed on Barden Tower near Bolton Abbey when she restored it declares that she first lay in the place when in her mother's womb, and claims possession of the tower by pre-natal right. Such a sense of her rights and power existing even before her birth, reveals both an aristocratic fascination with legitimacy and an exceptional awareness of a personal identity that existed beyond her conscious self. She is the life-force of the Cliffords in its last direct expression. Her genealogical identity stretches back to the Conquest, and is traced heraldically in the coats of arms that form the border to the central section. Her conception was of high genealogical significance, and from that moment her incipient self was charged with the accumulated power of her ancestors.

Four books appear in the centre painting, all of them associated with the countess: the book of Psalms held by Lady Margaret Russell and, on the shelf behind, the Bible, the works of Seneca, that storehouse of stoical wisdom, in English, and a manuscript volume of 'Alchemist Extractions, of Distillations and excellent Medicines' that Lady Margaret had compiled herself. These are Lady Margaret's defences against the world, her equivalent to her husband's armour.

When we turn to the left-hand section showing Lady Anne at the age of fifteen, we find a crowded summary of her youthful life. It is a picture of how she has been formed, under the instruction of her tutor and her governess, whose portraits look down on her. The figure of Lady Anne is probably copied from a lost painting. The embroidered silk dress she wears belongs in

style more properly to *circa* 1615–20, rather than to 1605, when farthingales were still in fashion. Her image has many similarities with the portrait of Lady Mary Wroth holding a theorbo, attributed to Marcus Gheeraerts, at Penshurst, and dated about 1620.[4] Anne is shown with a lute with a two-angled head, and she is turning the leaves of a music book. She evidently had some talent as a musician, and she records in her diary how as a young girl 'she learned to sing and play on the Bass Viol of Jack Jenkins, my Aunt's boy'.[5] A specimen of her embroidery is displayed on the table. Throughout her long life she stitched steadily, as her diary records, and John Donne was moved to say of her, having stayed with her family for a week at Knole, 'that she knew how to discourse of all things, from Predestination to Slea-silk'.[6]

The teachers of her youth, shown in the copies of paintings on the wall, were Mrs Anne Taylor, who looked after her as a governess, and Samuel Daniel, the poet. Daniel was a competent and workmanlike man of letters, whose literary activity needed the support of patronage if he were to survive. He edged his way from one noble family to another in precarious feats of survival. His initial claim to attention was that as a young man he had translated Paolo Giovio's *Dialogo dell'Imprese*, a prime source of the ingenious devices and witty visual conceits that courtiers valued so highly, and that were always in demand at tournaments and festivals, and for amorous addresses. In the early 1590s he became part of the literary circle around the Countess of Pembroke; he became friendly with Edmund Spenser, and, under the stimulus of these new associations, his own poetic invention ran freely. He composed his attractive sonnet sequence *Delia* then, wrote closet drama, and engaged in debates on critical theory. His political dramas attracted the patronage of Fulke Greville, and towards the end of the decade he began to write those verse epistles in which moral issues were extensively reflected upon and which were much admired at the time. About 1598, the Countess of Cumberland invited him to join her household as tutor to Lady Anne. Daniel wrote verse epistles to both the countess and her daughter. The former of these is one of his finer compositions, full of stoical counsel about the uses of adversity, and tacitly acknowledging the difficulties and unhappiness of the countess's private life.

Samuel Daniel must have done much to form Lady Anne's literary and intellectual interests. He was a talented linguist, excellent in Italian, competent in French; he also had an enthusiasm for history. Daniel would have extended her cultural boundaries considerably. The books that cover the walls of the young Anne's chamber are a fair index of her reading when she was under Daniel's supervision. There is an imaginative range of works on

display, far wider than a young man at Oxford or Cambridge was likely to have been exposed to. In fact, Lady Anne's closet library provides an invaluable record of the intellectual and spiritual interests of an exceptionally well-educated aristocratic woman who was attracted to the main currents of Renaissance and Reformation thought. Some of the titles were predictable. Castiglione's *The Courtier*, translated by Sir Thomas Hoby in 1561 and frequently reprinted, was the indispensable courtesy book of the Renaissance. Sidney's *Arcadia* (folio editions 1593, 1598, and 1605) was the chivalric romance that found its proper audience among the men and women of gentle upbringing, and its fine discussions and conversations concerning love, philosophy, politics and war helped to mould the manners and expression of the courtly classes of late Elizabethan England. The works of Spenser belong to the same category, though Daniel's friendship with the poet must have given him a heightened significance in Lady Anne's eyes. The admiration she felt for Spenser expressed itself in the form that Lady Anne found most congenial, a memorial with inscriptions. As no monument had been raised over Spenser's grave in Westminster Abbey after his death in 1599, Lady Anne commissioned one from Nicholas Stone in 1620, and wrote the epitaph that includes the famous line 'The Prince of Poets in his Time'. Along with Sidney and Spenser lies a copy of Ovid's *Metamorphoses* (which Lady Anne presumably read in Golding's translation), the works of Chaucer, Tasso's romance of the First Crusade *Godfrey of Boloigne*, translated by Edward Fairfax in 1600,[7] and a copy of Cervantes' *Don Quixote*, translated into English by Thomas Shelton in 1612. Daniel's *Poems* are displayed here too, as well as his *Chronicles of England* in prose.

Montaigne's *Essays*, translated by John Florio in 1603, gave Lady Anne access to the shrewdest and most speculative mind of the French Renaissance. Florio was a friend of Samuel Daniel, who had written a commendatory poem for the *Essays*, praising their 'safe transpassage' into English, and speaking enthusiastically of 'th'intertraffique of the mind' that translation made possible between different nations and times. Lady Anne was very much the beneficiary of this 'intertraffique' of ideas, for half the books on her shelves are translations. A good number are from the French, an indication of how intellectual and spiritual life at this time was irradiated by Gallic ideas. Several translated works shown in the picture are concerned with one of the major current matters of controversy, the question of the state of nature, and whether or not it was in decline. The three volumes of Pierre De La Primaudaye's *French Academie* address this issue. First translated in 1586, with eight editions down to 1594, this was 'an

encyclopaedic study of man, the world, moral philosophy and Christian philosophy', over all of which hung a gloomy consciousness of the corruption of mankind through sin, and a pessimistic sense of the decay of nature and the fast approaching end of the world. The lively intelligence that describes the fabric of nature is subverted by the author's persistent awareness of universal corruption beneath the moon.[8]

A related work, yet with an opposite tendency, is Louis Le Roy's *Douze Livres de la Vicissitude ou Variété des Choses de l'Univers*, translated by Robert Ashley as *The Interchangeable Course of Things in the Whole World* (1594). This book chronicles the cycles of decay and renewal in the natural world, which is, in Spenser's phrase, 'eterne in mutabilitie'. Le Roy is heartened by the power of the regenerative force in nature, and is encouraged to take an optimistic view of the improvement of human knowledge through learning and invention. Ages and nations have their periods of prosperity and decline, but the present age is one on which Providence smiles. Ultimately, God will decree that the earth return to the primal chaos, but time now is favourable to man's intelligence and aspirations.

Quite the contrary opinion was held by the anti-humanist figure Cornelius Agrippa, the German author of *De Vanitate Scientiarum* (1526), translated as *The Vanity of the Arts and Sciences* in 1575. This work is a comprehensive dismissal of the value of all kinds of formal learning: mathematics, medicine, physics and metaphysics, astronomy, music, rhetoric and law are all ultimately vain, in the sense intended by the preacher in Ecclesiastes. The only valuable knowledge is the word of God in the Scriptures and the knowledge of Jesus Christ. A learned man deliberately decrying learning makes a curious spectacle, and Agrippa's book commanded attention across Europe for a century.

Another grand compendious survey of the creation on Lady Anne's shelves was provided by Salluste Du Bartas, the French Protestant poet of the later sixteenth century whose works, translated by Joshua Sylvester, enjoyed a lasting popularity in the seventeenth century. His *Divine Weeks and Works* was an epic of the creation rendered by 'silver-tongued Sylvester' into colourful, mannered verse. Description greatly outweighed doctrine in this account of the wonders of the primal world, and the book could be read as a delightful poetic encyclopaedia of natural history that abounded in praise of the creator. Yet, as he showed the ways in which God's providence sustains the world, Du Bartas emphasised the mutability that had pervaded the creation since the fall. Corruption was now endemic in the natural world, and he drew poignant comparisons between the edenic state and the

distress of fallen mankind. Du Bartas's epic revolves around similar issues that fill the books by Le Roy and Pierre De La Primaudaye, and they are related to an English book shown on the right-hand section, George Hakewill's *Apology for the Power and Providence of God*, which was another contribution to the great debate about the decay of nature that exercised European intellectuals for several generations after the Reformation.

Lady Anne's religious instruction was broadly served by her closet library. The Bible stands black and prominent on the top shelf of her books. Next to it are St Augustine's *City of God*, Eusebius' *History of the Church*, the orthodox account of the early centuries, and the works of Joseph Hall. The translation of Augustine's book by J. Healy (editions in 1610 and 1620) was dedicated to William and Philip Herbert; Philip would be Lady Anne's second husband, and this detail points up again the personal ties that linked Lady Anne with many of the books shown in the painting. Joseph Hall, who keeps such good company on the shelf, was a divine who expounded the moderate Calvinist position characteristic of the Church of England under King James, and which also formed the groundwork of Lady Anne's own faith throughout her life. Hall's sermons and meditations have a large measure of stoicism about them that Lady Anne probably responded to, for fortitude in adversity was a recurring theme of her own devotions. A more puritanical stance than Hall's is represented by John Downham's book *The Christian Warfare* (1604, much reprinted). Based on the Pauline imagery of Christian armour and the soul's combat against 'the spiritual enemies of our salvation, Satan and his assistants, the world and the flesh', Downham's lengthy book described the journey of the soul through the wilderness of this world and through the temptations of social life. There is much emphasis on the vexations of sin, and on the need for constant alertness to one's spiritual experience. Grace falls arbitrarily on sinful men and women, but faith in Christ is the essential prerequisite for salvation. Downham's skill in handling the complexities of experience and election made him a much respected spiritual leader to the Puritan wing of the church in the decades before the Civil War.

Lady Anne liked a strain of severity in her religious life. She was a product of the Elizabethan church settlement. She was austere in her devotions, but always Anglican. Calvinist in doctrine, she followed a plain form of worship; she accepted that the church should be governed by bishops, and services regulated by the Prayer Book. She honoured the sacraments, and kept the festivals of the church. Yet she disliked ceremony in religion, and Laudian innovations did not please her. Her favourite reading, according to Bishop Rainbow of Carlisle in her funeral sermon, was Paul's Epistle to the

Romans, chapter 8, which she would repeat every Sunday. This chapter contains some of Paul's most forthright statements on election and predestination and justification by faith. Puritans found in this chapter some of the most profitable texts of the New Testament. But Lady Anne could not abide the attacks on the government of the church and its modes of worship by radical Puritans, which were intensified under the Long Parliament and which eventually succeeded in dismembering the Church of England in the 1640s. When a group of religious inquisitors visited her in Appleby in Cromwellian times, she proclaimed she was of the faith 'as delivered and expounded by the Church of England, whose doctrine and discipline and worship as by law established she was bred in, and had embraced, and by God's grace would persist in it to her life's end'.[9]

The austerity of Lady Anne's religious life is further complemented by two works of antique morality on her shelves. The Manual of Epictetus (translated 1567 and 1610) is a handbook of stoical wisdom, offering extensive advice about the ways to confront misfortune, and encouraging a dispassionate self-possession in the face of adversity. Much of Epictetus' morality is compatible with Christianity, for he expressed a belief in the brotherhood of man, advised that we should love our enemies and forgive them, and reflected on the frustrations of the soul trapped in the body, yearning for release. There is a higher power that presides over the destiny of man, and the wise man knows that conscience is the guide to that power's will. Boethius' *Book of Philosophical Comfort* (1556 or 1609) also stands as a bulwark against misfortune. The author, thought Christian in the middle ages and the Renaissance, but now considered more of a Platonist than a Christian, achieves a state of philosophic calm in the hopeless conditions of imprisonment, and speaks of the pursuit of virtue and blessedness in terms that are broadly open to a Christian interpretation. To the forming of this equanimity of mind that Boethius commends goes 'much morality that agrees closely with Stoic doctrine, and is in fact largely taken from Seneca'.[10]

It is debatable whether the stoical cast of mind implied by these books of philosophy and religion genuinely reflected Anne's mood as a young woman of fifteen. In the first decade of the seventeenth century she seemed one of the sparkling ladies of the court, the frequent companion of the queen, and a notable participant in the royal masques. Her personal troubles multiplied after her marriage to Richard Sackville, for her husband turned out to be an indifferent, unfaithful and ill-tempered man who neglected her comprehensively. In reaction, it seems, she became more devout, and entered into a state of religious melancholy. It was in this phase of her life that Daniel

addressed his 'Letter to a worthy Countess' to her, and alluding to her protracted suits in law, and to her unhappiness in marriage, wrote 'it seems God hath set you as a marke of tryall, that you may be numbered among the examples of patience and substancy to other ages; and that it may be here-after your felicity to have had so little to do with felicity'.[11] The tone of this writing says much about how Lady Anne was perceived, and her stance of Christian stoicism seems well established by her early twenties.

The remaining volumes of Anne's collection show a broad curiosity about the world, uncomplicated by religious issues. Gerard's *Herbal* (1597) is still considered an excellent account of plants and their properties. Camden's *Britannia* (first published in 1586 in Latin, English translation, Philemon Holland, 1610), was one of the chief expressions of Elizabethan national pride, offering a picture of an island dense in history, and notable in achieve-ment. *Britannia* celebrated the land in all its diversity and prosperity. The enlarging geography of the globe was brought home to Lady Anne by Abraham Ortelius' 'Maps of the World', properly entitled *The Theatre of the Whole World* (1603 or 1610). The Dutch cartographer Ortelius was the friend and correspondent of Camden, and had urged him to compile the *Britannia* so that Britain could be fully known to the circles of humanist scholarship in Europe. His volume of maps with descriptive summaries of the different countries provided one of the readiest means of imagining the world elsewhere. The pair of dividers propped against the book suggests Lady Anne's active curiosity about the lands, and she no doubt traced the course of her father's voyages, which extended from the shores of America to Madagascar.

Let us now turn to the right-hand wing of the Great Picture, where Lady Anne is shown at the age of fifty-six. Wearing a full black satin dress with white lace cuffs and collar, her favourite pearls her only ornament, she already looks the part of a dowager countess, but she was not. Her second husband, Philip Earl of Pembroke, who appears in the lower of the two portraits behind her, was still alive when the picture was painted, but he had been relegated to a marginal position by Lady Anne, as were all the men in her life except her father from whom the titles derived that she so much valued. Philip Herbert looks as if he occupied the same dimension as Richard Sackville, who had died in 1624, and who is shown in the upper portrait. In fact, the Earl and Countess of Pembroke were living apart, he supporting Parliament, she the king. Lady Anne now has an air of total independence. Her companions are a cat and a dog (the cat was allowed threepence per week maintenance in the household accounts). The rumpled

statecloth suggests an indifference to the formalities of aristocratic life. The tumbled books on the two shelves above are puzzling: why the disorder? Books, however, are still important in her life, and she has chosen a fairly sombre collection to represent the concerns of her older self. One might notice here that the three female figures in the triptych, the younger and the older Anne and her mother, all rest their hands on books, as if a virtue were in them.

While the young Lady Anne fingered a music book, the dark lady in her fifties places her hand upon a Bible, and on Pierre Charron's *Book of Wisdom*. This last was a work of French neo-stoicism, translated into English in 1612, and reprinted in 1630, 1640 and 1651. Taken together, the two books register Lady Anne's fondness for reading the Bible in a context of ethical and philosophical works that were intended to induce a loftiness of self-possession and a refusal to commit one's affections to the things of this world. It is interesting to note that William Haller, the historian of Puritanism, in his account of William Walwyn the Leveller, describes Walwyn's reading during the 1640s as being dominated by the writings of Downham, William Perkins and Joseph Hall among the English theologians, Montaigne's *Essays*, Seneca, Plutarch's *Lives*, and Charron's *Of Human Wisdom*.[12] It is remarkable that books by all these authors, with the exception of Perkins, appear in the Great Picture, and this concurrence should show how close the spiritual formation of a severe Anglican and a radical Puritan might be. Calvinism and stoicism complemented each other very well, and Haller suggests that the stoical authors, by emphasising the good that firm-minded men and women are capable of, offset, to some degree, the anxiety and distress fomented by Calvinist preachers on the subject of the fall of man and its consequences, most notably election and damnation.

Plutarch's *Lives* (translated by Thomas North, 1579, with numerous editions thereafter) and his *Morals* (1580 and 1603) appear on the shelf immediately over Lady Anne's head. With them are the *Meditations* of Marcus Aurelius Antoninus (many editions after 1557), the most widely admired of the stoical mentors of antiquity. Nearby is George Strode's 'Book of Death' (1618 and 1632). Strode was a lawyer of the Middle Temple who composed his book, properly titled *The Anatomie of Mortalitie*, 'for his own private comfort'. It is an ascetic meditation scornful of the brevity and impermanence of this life, and hopeful of the resurrection. Its general tenor is similar to John Moore's *A Mappe of Mans Mortalitie* (1617), another work of Christian consolation. A much more substantial work is George Hakewill's *Apologie of the Power and Providence of God* (1618 and 1632), whose book

continued the arguments we have already encountered in the works by De La Primaudaye, Le Roy and Du Bartas concerning the decay of nature and the operation of God's providence in the world. Hakewill could not accept that nature was less vigorous than in the early ages, or men's faculties less excellent. These works of controversy were among the heavyweight volumes of the period, and Lady Anne was obviously fascinated by the subjects they debate. In retrospect, however, they do exemplify the futility of enquiry and the unprofitableness of learning that gave Francis Bacon so much cause for despair when he surveyed the intellectual life of his time.

One of the works refuted in Hakewill's *Apologie*, and also possessed by Lady Anne, was Henry Cuffe's *The Differences in the Age of Mans Life* (1603, 1633 and 1640), another presentation of the theme of the decay of nature. The thesis of this book was that man had irretrievably degenerated, and that the time of terminal dissolution was at hand. Henry Cuffe was an Oxford Grecian scholar, whose own terminal dissolution came as a result of his involvement with the Earl of Essex, for he was executed for complicity in the rebellion of 1601.

Lady Anne's religious reading in her later life is represented by a broad spectrum of works. She has Donne's *Sermons* (1640) on her shelf; they would remind her of the many times she had heard him preach. One of Donne's early preferments had been as rector of Sevenoaks, near Knole, where he carried out his duties attentively. The surviving diary for 1617 records a week's visit to Knole by Donne, and no doubt he came on other occasions. The Earl of Dorset was also an admirer of Donne (who had once, rather surprisingly, sent him six holy sonnets with a flattering poem of dedication). Then there are Bishop King's Sermons. These would be by John King, Bishop of London until 1621, a friend of Donne, and the composer of orthodox Calvinist sermons. As a further aid to devotion, Lady Anne had George Sandys's *Paraphrase upon the Psalms of David* (1636). Sandys, who was a great traveller, and an active colonist for the Virginia Company, was the godson of George Clifford, Lady Anne's father. Family relations connected her also to George Herbert, whose volume of poems *The Temple* was first published in 1633. As a kinsman of her second husband, Herbert held the living at Bemerton, a village very close to Wilton House. It is likely that he acted as chaplain to the Pembrokes, and a surviving letter suggests a close familiarity with Lady Anne. Rather more high church in pitch are the *Meditations* of William Austin (1635, 1637). Austin was a preacher at Lincoln's Inn, and his meditations upon the festivals of the church year

consist of sermons somewhat in the dry, expository manner of Lancelot Andrewes, accompanied by verses reminiscent of Crashaw.

Turning to secular subjects, we find that Lady Anne's interest in history is well represented. Her diaries record her reading, or having read to her, Josephus; here she has Ammianus Marcellinus' *Roman Historie* (translated by Philemon Holland, 1609), and two books illustrative of modern history, Philippe de Commines' memoirs of events in France (1596, 1601 and 1614), and Guicciardini's Italian history in a French edition. Then there is John Barclay's prose romance *Argenis* (translated from the Latin in 1625, 1628 and 1629), a cryptic fictionalised history of the late sixteenth-century political scene in Europe. Three contemporary English titles are nearby: Donne's *Poems* (1633), the works of Ben Jonson (1616 and 1640) and of Fulke Greville (1633). Lady Anne must have known Jonson from her years at court and her participation in the masques, though no familiarity seems to have developed between them. His works are the only dramatic pieces on her shelves; her taste did not tend in that direction, and she was probably more appreciative of the side of Jonson represented by his verse epistles. Of course, it may be that Jonson is included mainly as a memento of Lady Anne's participation in the entertainments at court. Fulke Greville, 'Servant to Queen Elizabeth, Counsellor to King James, Friend to Sir Philip Sidney', was one of the last survivors of the heroic Elizabethan days when he died in 1628. A courtier poet, he had for a brief time been a patron of Samuel Daniel, whose sonnets and closet dramas share some similarities with Greville's work.

One work deserves special attention: this is Sir Henry Wotton's *The Elements of Architecture* (1624) the first book devoted to that subject by an Englishman. Once she went north, Lady Anne became a great builder and restorer of buildings. Wotton's book gave advice on domestic architecture, relaying the benefits of his observations made in Venice and the Veneto, and as such it was no doubt instructive to Lady Anne as Countess of Pembroke when she and her husband began to rebuild Wilton House in the 1630s. We do not know which of the couple took the initiative in the reconstruction carried out in the Italianate style by Isaac de Caus and Inigo Jones; by the time the main work was under way in 1636, the earl and countess had effectively separated, but it is quite possible that the south front with its Venetian character owed something to Lady Anne's reading of Wotton. In the north of England, she had to deal with castles, not villas. She restored Skipton after the destruction of the Civil Wars, and renewed Appleby,

Brougham, Brough, Pendragon and Barden Tower after decades of neglect. She rebuilt the chapel at Brougham, the churches at Ninekirks and Mallerstang, and extensively restored Appleby church. For the most part she worked in a plain gothic style that expressed continuity with the late middle ages when the Cliffords were at the height of their power. The motive that sustained this remarkable building programme was the knowledge that she was the last of the Cliffords, and she wished to leave her properties in a completely finished condition to mark the excellence of her stewardship.

This consciousness of being the last Clifford pervaded everything Lady Anne did. It accounts for her obsession with memorials, and her desire to renovate everything to do with her family; it explains her need to clarify the genealogical lines in definitive displays of heraldry. The final chapter of the Clifford chronicle was herself, and her self-documentation was intense.[13] She wanted her family and her personal record to be full and complete, and it is to this passion that we owe the Great Picture, its display of lineage and its inventory of the furniture of the mind.

Notes

The standard biography is still *Lady Anne Clifford* by George C. Williamson, Kendal, 1922, reprinted 1967.

1 The titles Lady Anne contended were hers by right were Baroness Clifford, Westmorland, and Vescy, High Sheriff of Westmorland, and Lady of the Honour of Skipton in Craven.
2 See George C. Williamson, *Lady Anne Clifford*, 2nd edn, Kendal, 1967, p. 335.
3 See *The Diaries of Lady Anne Clifford*, D.J.H. Clifford ed., Stroud, 1990, p. 96.
4 Illustrated in Roy Strong, *The English Icon*, London, 1969, p. 267.
5 Clifford, *Diaries*, p. 27.
6 R.C. Bald, *John Donne: A Life*, Oxford, 1970, p. 324.
7 *Godfrey of Boloigne* was one of the books that Charles I had with him during his imprisonment, according to the Memoirs of Sir Thomas Herbert. Charles's choice of books overlapped with Lady Anne's to some extent: the Bible, Sandys's *Paraphrase upon the Psalms*, Spenser, and Herbert's poems. Charles also had with him Bishop Andrewes' sermons, Hooker's *Ecclesiastical Polity*, Dr Hammond's works, Villalpandus' commentary on Ezekiel, and Ariosto's *Orlando Furioso*.
8 Victor Harris, *All Coherence Gone*, London, 1966, for an extensive account of this

controversy, and in particular pp. 97–106 for the contributions of De La Primaudaye, Le Roy, and Du Bartas.

9 Edward Rainbow, *A Sermon Preached at the Funeral of the Rt Hon Anne, Countess of Pembroke, Dorset and Montgomery* . . . 1677, p. 59.

10 Bertrand Russell, *A History of Western Philosophy*, London, 1955, p. 390

11 Quoted in Joan Rees, *Samuel Daniel*, Liverpool, 1964, p. 82.

12 William Haller, *Liberty and Reformation in the Puritan Revolution*, New York, 1963, pp. 170–1.

13 Lady Anne did of course have two surviving daughters by her first marriage, and her estates were divided between these children and their husbands, who, being based in the Midlands and the south, rapidly allowed her houses and castles in the north to fall into decay.

12

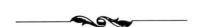

'GOLDEN HOUSES FOR SHADOWS':
SOME PORTRAITS OF THOMAS KILLIGREW
AND HIS FAMILY

Malcolm Rogers

The story of connoisseurship at the Stuart court is one of high, turbulent spirits, not pale aesthetes; of men and women at the centre of events, often rich, proud and fiercely competitive, who lived their comparatively short lives in an environment coloured by the splendour, drama and symbolism of the masques in which many of them performed. Intellectually their tastes were learned, allusive, redolent of neo-Platonic idealism and ardently Christian. Among the patrons of Van Dyck the youthful individualists – Sir Kenelm Digby, Sir John Suckling and Thomas Killigrew – gentry rather than nobility, highly creative, Roman Catholic or of Roman inclination, who seized on life with a self-dramatising recklessness, stand out. Of these none is more intriguing than Thomas Killigrew (1612–83). He was born in Lothbury, London, the son of a Cornishman, Sir Robert Killigrew (1579–1633), courtier, diplomat and concocter of drugs and cordials, a vice-chamberlain to Queen Henrietta Maria. It is said that when still a child Killigrew used to frequent the Red Bull theatre, and when the manager was looking for boys to take the part of devils, would volunteer so as to see the play for free. The spirit of devilry and a love of theatricals are recurrent themes in his life: one of the wits of the town, an habitual dramaturge and impresario, he ended up, according to Pepys, with

a fee out of the wardrobe for cap and bells, under the title of the King's foole or Jester, and may with privilege revile or jeere anybody, the greatest person, without offence, by the privilege of his place.[1]

This 'merry droll'[2] was also in his time an ardent lover, unswerving royalist, debauchee, exile, traveller and abject penitent. It is a history which can be

traced to an extent in the portraits which Killigrew commissioned and in the plays that he wrote.

Little is known of Killigrew's artistic tastes beyond the portraits of him, but some slight evidence suggests that early on, as page to Charles I from 1633, he took a lively interest in the affairs of the connoisseurs of the court circle. By 1636 he was evidently in communication with the Earl of Arundel's agent, William Petty, then buying works of art and antiquities in Italy and the Levant, for on 15 April that year Arundel's son, Lord Maltravers, writes[3] from Arundel House to Petty:

as I was yesterday wayting uppon the King his Majesty tould me that he had receaved a message from you by Mr Thomas Killigrewe, that you had bought for him a Madonna of Corregio, a picture with twoe or three heads in it by Rafaell, and the Adonis. I tould his Majesty that certainly Mr Killigrewe had mistaken the message, because I shewed his Majesty your letter of the Madonna of Corregio which sure you intended for my lord. . .

Arundel himself writes to Petty from Linz on 16/26 June 1636 of the matter:

You doe well to write to my sonne of Tom:Killigrewes businesse, which is nothinge but an idl fellowe tellinge broken pieces and packinge out the rest.

On 29 June, within days of Arundel's letter, the 'idle fellow' was married to Cecilia Crofts, daughter of Sir John Crofts of Saxham, Suffolk, and maid of honour to the queen. She was to die less than a year and a half later. Their courtship had had its ups and downs, and their friend the poet Thomas Carew penned a duet of jealousy, based on one of their quarrels, which was sung in a masque at Whitehall in 1633. Killigrew was later to include it, with acknowledgement, at the end of the second part of his comedy *Cicilia and Clorinda, or, Love in Arms*, written in 1649–50, when the jealous Lucius is finally united in marriage with his love, also Cicilia, noting that it was 'writ at my request upon a dispute held betwixt Mistress Cicilia Crofts and myself, where he was present; she being then Maid of Honour'.[4] Carew also wrote an epithalamium for the couple, 'On the Marriage of T.K. and C.C.: the Morning Stormy'.[5]

Killigrew paid his own literary compliments to his bride in his tragi-comedies *The Prisoners* (1635) and *Claricilla* (1636), both set in Sicily in allusion to her name, as is his comedy *The Princess: or, Love at First Sight*, written on a trip to Naples early in 1636 (printed in 1640). In this, the central character is also a Cicilia, sister of Facertes, King of Sicily, who

struggles against her love for Virgilius. Virgilius pours out his heart to Facertes on the subject of his 'never-enough-admired Cicilia':

> Take therefore into thy heart all the secrets of mine, and in a word, all my hopes, and all my fears, Cicilia.
>
> FACERTES: What of her, Sir?
>
> VIRGILIUS: She is all my hopes, all my wishes, and all my fears; and if she smile, I am fortunate: for know, my journey is to lay at her feet my self, and all that conquest gave me.[6]

It was presumably around the time of the marriage, perhaps a little after, that Mrs Killigrew sat to Van Dyck for a three-quarter-length portrait of which the best version is in the collection of the Earl of Bradford at Weston Park (fig. 57), with copies at Gorhambury (called Henrietta Maria); in a Danish private collection; Christie's, 17 May 1957 (166); and (possibly the same picture) Sotheby's, 9 December 1959 (105). The early provenance of the Weston Park picture is not known, and it is first recorded erroneously in an inventory of June 1735 as 'Lady Killigrew by Vandyke'.[7] In the portrait she is shown with dark brown hair, wearing a silver gown with gold buttons and a fawn gauze stole over her left shoulder. Her arms are folded in a cradling gesture over her womb, perhaps indicating that she was pregnant when the portrait was painted.[8] The couple's son Henry was born on 9 April 1637, and, if the suggestion of pregnancy is accepted, then the portrait must have been painted between her marriage and spring 1637. Around the sitter's left arm is a garland of red and white roses, and it may be that Van Dyck contrived the portrait as an echo of the celebrated painting of a garland-maker by Pausias singled out by Pliny, and cited by his friend, the Earl of Arundel's librarian, Francis Junius, in his book *De Pictura Veterum* published in Latin in 1637 and in English in 1638. Van Dyck had evidently studied the book in manuscript or as it came off the press, for he wrote to congratulate Junius on 'a most learned composition' on 14 August 1636.[9] Junius' text makes it easy to understand why Van Dyck and Killigrew (if he was involved in the commission, as must be likely) found this conceit appealing:

Pausias, being exceedingly in love with his contrey-woman Glycera, left a most famous Picture, knowne every where by the name of Stephanoplocos, that is, a woman Garland-maker; and this hath ever been esteemed his best worke, because he was enforced thereunto by the extremitie of his Passion.[10]

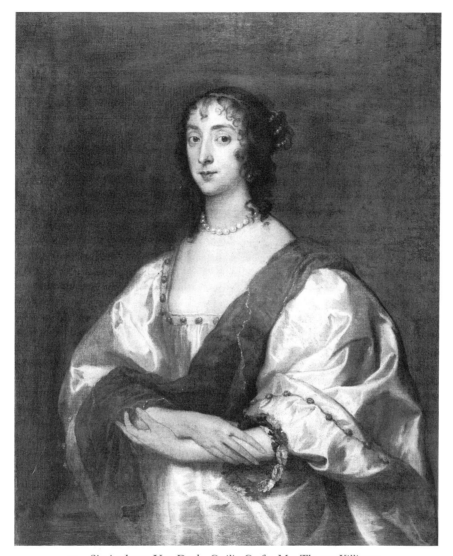

57 Sir Anthony Van Dyck, *Cecilia Crofts, Mrs Thomas Killigrew*

William Sanderson in his *Graphice* (1658) describes a somewhat similar portrait by Van Dyck, and comments:

See, see how prettily she is busied to wreath her Lilly-flowr'd branch into a chapelet, which signifies her innocent mind intent to Nature not Art, holding it forth as an emblem, that Solomon in all his loyalty came short of Nature's purity.[11]

Sanderson was a writer of no great originality or imagination – Evelyn mentions him as the 'author of two large but meane histories'[12] – and it is noteworthy that so stolid an intellect should take for granted the symbolic content of a Van Dyck portrait.

The Killigrews' happiness was short-lived, for Cecilia died on 1 January 1638, less than nine months after the birth of their child. Her sister Anne, Countess of Cleveland, died just fifteen days later on 16 January, and the poet Francis Quarles wrote his 'Sighs at the contemporary deaths' of the two sisters (published 1640). Killigrew himself marked the double loss in an important and beautiful portrait by Van Dyck: the double portrait, with a man who is likely to be his brother-in-law William Crofts, in the Royal Collection (fig. 58), a work encumbered with legend and false tradition since at least the time of George Vertue, but which Oliver Millar swept aside in the space of a catalogue entry.[13] It is signed or inscribed and dated: 'A. van,

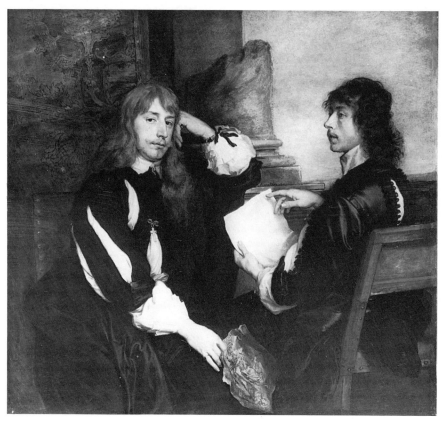

58 Sir Anthony Van Dyck, *Thomas Killigrew and (?) William, Lord Crofts*

Dyck, 1638.'; similar inscriptions are found on four other family portraits, as we shall see. Sombre in tone and restricted in its range of colours, the composition shows Killigrew on the left, dressed in black, leaning on his left elbow in the attitude of mourning and melancholy contemplation familiar from monuments and memorial portraits. In his right hand, cast down and in shadow, is a drawing on greyish-blue paper. Seated on his left is a young man likely to be Lord Crofts, again wearing black, the buttons down the back of his doublet undone, perhaps intended as an allusion to his distraction. In his left hand he holds a blank sheet of paper, to which he points with the other. Both men are linked by a swathe of black drapery which envelops the lower parts of their bodies. In the background, but central to the composition, and immediately above the blank paper, is a broken column (on the base of which Killigrew rests his elbow), conventional emblem of fortitude in adversity and of Christian stoicism – a device which Van Dyck had earlier used in his *Self-Portrait* in the Hermitage, probably painted shortly after the death of his father in December 1622. Between the heads of the two men, both painted with great sensitivity, the artist establishes a profoundly affecting emotional and stylistic counterpoint: Killigrew fixing the spectator, Crofts, almost in profile gazing at his brother-in-law, and evidently attempting to catch his attention; the one head firm and fully modelled, the other painted with a broad, apprehensive impressionism. Recently Crofts' role has been identified as consolation,[14] but this is surely not the case. The crumpled drawing which almost slips from Killigrew's fingers, and which is held in shadow, shows two female statues, surely intended to represent the dead women: the larger is perhaps intended for Cecilia, as clasped to the figure's side is a child, presumably the infant Henry. The drawing symbolises what is gone. Crofts by contrast points to the blank sheet – the present blank – reminding Killigrew of his loss, that it may be the more keenly felt.[15] It is for this reason the blank sheet is so closely allied in the composition with the broken column of fortitude. No doubt this rather trite emblematic scheme was suggested to the artist by his patron, for it is a type of symbolism dear to the English, but which might be thought alien to Van Dyck. Van Dyck resolves the symbolic elements into a poetic study in black, greys and white, and it is a tribute to his artistry that this rather simple scheme has gone unnoticed over the years.

That Killigrew placed the commission is stressed by his glance and dominant role in the composition, and it is he who displays the more prominent emblems of mourning: in all he wears three rings – probably mourning rings – on his hands, while round his left wrist on a black ribbon is

another plain gold ring, perhaps Cecilia's wedding ring, given by him in the marriage service, and now returned. On his sleeve, suspended on a ribbon tied in a bow, is a cross made of gold, the left half of which is enamelled white. This bears at its crossing a device: ƆC, two C's linked back to back to form a cross, presumably for Cecilia Crofts. A lavish display of rings in a portrait of the 1630s is most unusual, but the jewel of a cross is, in the case of a portrait of a man, perhaps without parallel. The obvious explanation is that the cross had belonged to his late wife, and indeed may have been a gift from Killigrew; the two colours, white and gold, an emblem of their union, and the cross itself a symbol of death as the gateway to eternal life.

The wearing of the cross, whether a gift or not, raises the question of Killigrew's religion, and suggests that he had by this time converted to Roman Catholicism (he had been born a Protestant), or was at least a Roman Catholic sympathiser, a situation not unusual in the court circle of Henrietta Maria or, indeed, among the patrons of Van Dyck. There is a little supporting evidence. First, we know that in 1635, the year before his marriage, Killigrew had travelled to Rome as companion to the Honourable Walter Montagu (1603?–77), son of the Earl of Manchester, and author of *The Shepherd's Paradise* (1633), a pastoral in which the queen herself had performed. Montagu had converted to Roman Catholicism in France that year, and was on his way to become a father of the Oratory there. He ended his days as Abbot of St Martin's near Pontoise.[16] Secondly, in Killigrew's play *Thomaso, or, The Wanderer*, published in 1664, and said to have been written in Madrid, perhaps in the later 1640s, the central character of the Wanderer is 'an English cavalier, who had served in the Spanish army', and is a convert. He is a heightened self-portrait, and early on Killigrew plants an illusion to his late wife on his lips:

And pray, Captain, sollicit your taylor not to fail of my clothes tomorrow; you know Saint Cicilia is my saint, and we must keep her feast to morrow.[17]

There are other pointed references to his saint, and Thomaso makes some humorous and irreverent play with the subject of the material benefits of conversion.[18] Killigrew's brother-in-law, Crofts, was also a convert. A notoriously quarrelsome hot-head, he had been in France in 1637 and had there become involved in secret communications between Anne of Austria, Queen of France, and the Cardinal Infante Ferdinand, Regent of the Netherlands. As a result he had been expelled, and according to the Revd George Garrard, in one of his gossipy letters to the Earl of Strafford, dated 9 October that year, had fled to Italy, 'being lately reconciled to the Church

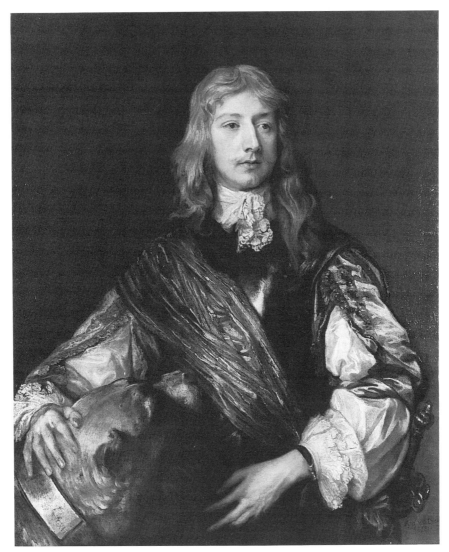

59 Sir Anthony Van Dyck, *Thomas Killigrew*

of Rome'.[19] Garrard again reports the conversion on 3 July 1638.[20] It is possible that Killigrew and Crofts were the models for Tom Careless and Ned Wild, two gallants who have completed their education in France, the heroes of Killigrew's bawdy comedy *The Parson's Wedding*, written in 1641.

Killigrew sat to Van Dyck for a second portrait in 1638, the half-length with a mastiff at Weston Park (fig. 59), a portrait virtually discovered by Oliver Millar.[21] It is similarly inscribed 'Ant van Dyck.F./.1638:', and bears

Killigrew's name and family crest of a double-headed eagle on the dog's collar. The head appears fresher and younger than in the double portrait, and the single portrait may have been painted before the double portrait. However, as the inscription suggests, it must have been completed at least three months after Cecilia's death on 1 January 1637/8 Old Style, when the new year (1638) was computed as beginning on 25 March. The characterisation is gentle, belying Killigrew's martial breastplate, sword and sash, and it may be, as *pentimenti* suggest, that, in Oliver Millar's words, the sitter was originally 'clothed in satin and not in steel'. If so, the breastplate may have been added as an emblem of fortitude. Although the ring itself is not visible, Killigrew again wears on his left wrist the black band on which in the double portrait a (?) wedding ring is suspended, and his right hand rests on the head of a mastiff, gazing up at his master, a traditional symbol of fidelity.

This portrait was not engraved in the seventeenth century, yet it seems to have been well known within Killigrew's lifetime. William Dobson based his portrait of Sir Thomas Chicheley (sold Christie's, 10 April 1992 (11)),[22] painted *c.* 1643, on the composition. Later, the portrait belonged to Sir Peter Lely,[23] who copied it,[24] as did John Greenhill,[25] who also based his portrait of William Cartwright (Dulwich Picture Gallery) on it in reverse, no doubt in compliment to Killigrew, who was the manager of Cartwright's theatre company.[26] A less affectionate adaptation is to be found in Richard Flecknoe's *The Life of Thomas the Wanderer* (1667), a satirical attack on Killigrew's alleged licentiousness, in which he writes:

Onely to make an end of depainting him, He is most commonly pictur'd with a Dog, the right embleme of his disposition; only a Mastive is too generous a beast for him, it shou'd have been rather some moungril Cur, always craving, and never satisfied, fawning on his greatest enemies to serve his ends, and those once serv'd, barking at his dearest friends; by which Dog-tricks of his, as he was an enemy to all, so he made every one an enemy to him.[27]

Although Flecknoe's interpretation differs radically from mine, his account at least suggests that portraits were habitually 'read' for their emblematic content.

Apart from the two portraits already mentioned, Killigrew commemorated his late wife in other ways. It was presumably he who commissioned from Van Dyck in 1639 the posthumous head and shoulders portrait of her in a silver gown with fawn stole (fig. 60; Swiss private collection), signed or inscribed like the other portraits: 'van Dyck pinxit./1639', with

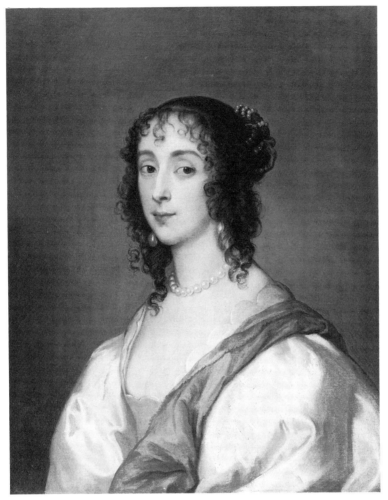

60 Sir Anthony Van Dyck, *Cecilia Crofts, Mrs Thomas Killigrew*

Cecilia's monogram of linked Cs above. The head evidently derives from the earlier portrait, and this probably accounts for its somewhat simplified technique. Small and comparatively portable, it may have been that Killigrew kept this painting by him as a reminder of his loss.[28]

In Killigrew's tragicomedy *Bellamira her Dream: or, The Love of Shadows*, written in Venice in 1650–2, much of the impenetrably complicated action centres on a painting of the Princess Bellamira which the wounded King of Naples and Sicily gives to Palanthus, his young general who loves her. It is a

miniature in a golden case which he wears around his neck 'as a relick many a day'[29] until it is stolen from him by enemy soldiers:

SOLDIER: A picture, what have we here? Golden Houses for shadows?
PALANTHUS: 'Tis so, a picture onely, after all the rest of your Injuries, restore but that and I'll freely forgive you: take the case too, onely the picture again; if you have any humanity you will not deny it; 'tis to you of no use, but to me the dearest jewel of my life; 'Tis of a friend, whose Memory I adore.[30]

The miniature is later found by one Pollidor who, to his dismay, falls in love at first sight with the sitter. His sister Phillora tells him, as he throws the miniature away, that he is powerless to resist:

Ne're cast this from you, in vain thou think'st to be rid of it; a cunning and a great Master has graved it with a powerful hand in thy heart.[31]

The miniature is again stolen, and in the play's dénouement, set in a prison where all the central characters are by coincidence in chains, Palanthus tells Pollidor of the picture he has lost:

Mine was a box of gold, enamell'd with Phillamorte and black (the sad colours that are worn by me folorn) the Cypher to ꭚ crossed, within a figure of an armed Pallas; the hair brown, the forehead calm and full of peace; Juno's eyes, fair and full of mercy; but I want Poetry to express her beauty, to which the gods have given a minde equal to all she bows to.[32]

Killigrew must have thought of Cecilia, 'the hair brown, the forehead calm and full of peace', as he wrote these lines, and of her monogram of linked Cs as he adorned his 'Golden Houses for shadows' with crossed ꭚ s. Later in the scene Phillora suggests to her brother Pollidor that his love may be dead. He reacts with alarm and gazes at the picture:

If thou be'est dead may the clouds grow hard, and the seasons be shufled again into Chaos, and destroy the seeds of nature . . .

but goes on:

Alas Phillora, death is the only thing that an honest man ought not to fear; nor did I ever apprehend him; but in the persons of them I loved their dangers make him dreadful; 'tis not these chains, nor thus to be lost in a crowd, or buried in a dungeon, frights me; 'tis fear of this and thy fate that wounds me; for I am certain we cannot dye forgotten, we are not worse than Plants. Shall I believe Phillora and Pollidor can when they perish become less than Herbs and Roots? they by dying lose neither kinde nor vertue; nay the ashes of some things my Father says are medicinable; and

death sure cannot so quench fame or vertue, but some that have virtuous minds will preserve our story.[33]

Killigrew's plays encompass many autobiographical elements, treated sometimes with tenderness, sometimes raffishly, and it is not surprising that it is in a play that we find his tribute to Van Dyck, nor that it is in an equivocal moral setting which the artist himself might well have found amusing. In *Thomaso, or The Wanderer* the plot turns on the beautiful courtesan Angelica Bianca, former mistress of a Spanish general killed in battle who has put herself up for public sale:

That's the news; know then, since the General's death she is exposed to sale; Her price and Picture hangs upon the door, where she sits in publick view drest like Aurora, and breaks like the day from her window; She is now the subject of all the Love and Envy of the Town.[34]

The portrait is seen on stage, hanging on a pillar, fully captioned with the lady's name and price, protected by two bravoes. Beside the painting hang 'two little pictures posted' (engravings), one of which the hero Thomaso later steals. Don Pedro and friends pass by:

PEDRO: 'Tis an Excellent Picture, Whose hand can it be?
CARLO: Van Dikes, and 'tis well done.
JOHAN: He was a great Master, and a Civil Pencil.
CARLO: Why, do you think he has flatter'd her?
PEDRO: By Saint Jago, he cannot; Observe her without prejudice; Is there one Grace, one beauty more then she set before his Eyes? And softness, such as pencils cannot reach; That smile, there's a grace and sweetness in it Titian could never have catch'd.[35]

It may well have been Killigrew's enthusiasm which persuaded his elder brother Sir William (1606–95) to sit to the artist for the short three-quarter-length portrait wearing black (fig. 61: private collection), inscribed, perhaps by the artist, 'SVR. WILLIVM. KILLIGRW./A. Van Dyck. pinxit./1638'.[36] The companion portrait of his wife Mary Hill, wearing a brown gown and gold mantle (fig. 62: American private collection), is inscribed in the same hand: 'My Lady Killigrew' with the remains of the artist's name and the date, 1638.[37] The inscriptions suggest that both portraits may have belonged to Thomas. Probably about the same period Killigrew's sister Ann (1607–41), wife of George Kirke, Gentleman of the King's Wardrobe, sat

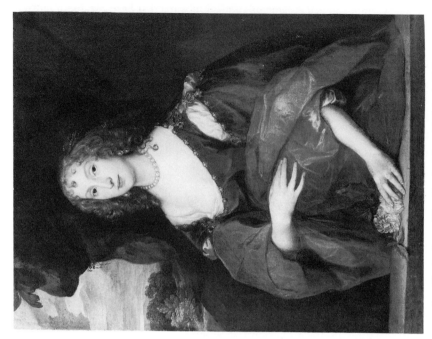

62 Sir Anthony Van Dyck, *Mary Hill, Lady Killigrew*

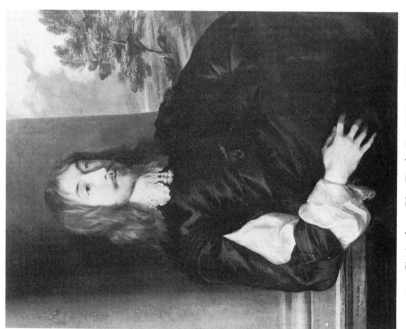

61 Sir Anthony Van Dyck, *Sir William Killigrew*

for the full-length portrait in a gold gown, now in the Huntington Library, Los Angeles.[38]

In the years following the death of his wife Killigrew continued to devote much of his time to writing plays and to travel. In September 1642 he was in London, when he was committed by warrant of Parliament to the custody of Sir John Lenthall for taking up arms for the king. Following a brief spell in the King's Bench prison, in 1644 he joined Charles I's Civil War court in Oxford, but soon after once again went on his travels. In 1647 he was with the young Prince Charles in exile in Paris. Three years later he was in Venice, where he was appointed Resident by Charles II in February 1650 (the new king was at this time enjoying an affair with Killigrew's sister Elizabeth, later Viscountess of Shannon, who, c. 1650, bore him a daughter, Charlotte). He was in Venice to borrow money for his master, and he also borrowed money for himself. The scandal of Killigrew's behaviour and thoroughgoing debauchery led in 1652 to his withdrawal, and brought an official protest to Charles from the Venetian ambassador in Paris.

This controversial period in Killigrew's life was one of intense aesthetic activity. Stimulated by the opportunities offered by Italy, and no doubt by his perception of his status as Resident, Killigrew sat for his portrait at least three times in less than three years. Two of the portraits are, however, lost. One, a small tondo, 15 inches in diameter, by Pietro Liberi (1614–87), born in Padua but working in Venice since 1641, is recorded at the family home, Thornham Hall, Norfolk, and was in the Thornham Hall sale (John D. Wood & Co., 24 March 1937, Lot 1077, 'Vandyck. Head of a Man with flowing hair').[39] It showed him head and shoulders, half turned to the left, with long hair and moustache. He sat for a second portrait on a trip to Rome on 8 September 1651 to Giovanni Angelo Canini (1617–c. 66), a pupil of Domenichino, who had been received into the Academy of St Luke in 1650, and was later to become court painter to Queen Christina of Sweden. Though Canini painted the occasional portrait, he is best known for his altarpieces and mythologies. Although the portrait of Killigrew is lost, there is a minutely detailed description of it, of the process of painting it, the brushes and pigments used, in a notebook of the English antiquary Richard Symonds, who was studying in Canini's studio at the time.[40] It depicted Killigrew, probably at half-length, with one hand visible, wearing a black cloth suit with black buttons and a cloak, and linen bands.

The one portrait of the three which survives – and it exists in several versions[41] – is the ambitious three-quarter-length by the obscure English artist, William Sheppard, painted in Venice in 1650 (fig. 63). It is signed

'WM SHEPPARD/PINXIT: VENC.' on the arm of Killigrew's chair. As with the double portrait with Lord Crofts, a picture with which it has much in common, the composition appears to have been planned according to a scheme devised by Killigrew.

It shows Killigrew, looking old for his thirty-eight years, three-quarter-length seated at a table, wearing a satin vest, tied with a sash, of oriental cast, and a Hungarian fur hat, giving him an exotic air, and evoking his travels.[42] In his hand is a document inscribed: 'KILLIGRE./RESIDEN./for:CR/in VENICE/1650'. The portrait is obviously intended to mark this crown appointment, but also has a wider commemorative purpose. His pose gives the clue, for it derives from that in the Van Dyck double portrait, and signifies, as it did there, mourning. On the wall behind Killigrew hangs a small painting of Charles I, bearing his crown and cipher, who had been executed the previous year. The portrait shows Killigrew mourning for the dead king, and also proclaims his loyalty to his successor Charles II. To emphasise the point, on the table by him, in front of what appears to be a folio of drawings, is a pile of the manuscripts of Killigrew's plays, each inscribed with its title, the whole pile resting on a copy of *Eikon Basilike*, the hagiographic tribute to Charles I which had appeared in 1649 shortly after his execution. The implication is that Killigrew's life's work was inspired by the late king. In Killigrew's hand is a manuscript lettered 'POLIDOR DREAM/ACT:PR:SCAE.I.', the opening of the first draft of *Bellamira her Dream: or, The Love of Shadows*, the tragicomedy whose subtitle suggests the evanescence of human life, and which contains the moving speech on death quoted above. There are other tokens of mourning. On his left wrist Killigrew wears the bracelet already seen in Van Dyck's single portrait of him; the black ribbon on which a ring was suspended in the double portrait, as well as what may be a memorial ring on his little finger; by his side, looking up adoringly, a faithful dog (its collar lettered 'THO KIL'), emblem of his loyalty. Given this portrait's public and royalist theme it is not surprising that Killigrew chose it to be engraved by William Faithorne as frontispiece to his collected *Comedies and Tragedies*, published after the Restoration, in 1664. It may also be that its nature as a tribute to the late king explains why so very many versions and copies of the composition exist. There are echoes of the composition in Lely's portrait of the 1st Baron Clifford of Chudleigh (Ugbrooke Park) and in the portrait of another writer, Alexander Pope with his dog Bounce attributed to Jonathan Richardson at Hagley.

Following the Venice *débâcle*, commemorated in the well-known verses by Sir John Denham, Killigrew spent much of his time in the company of

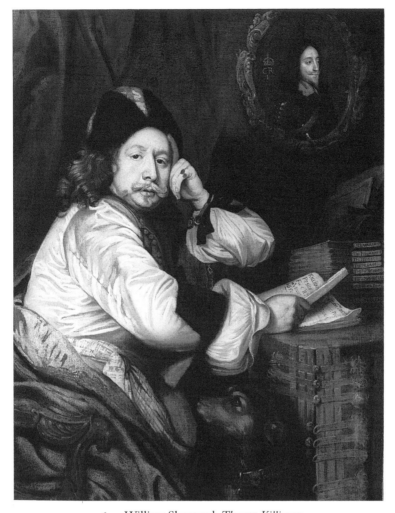

63 William Sheppard, *Thomas Killigrew*

royalist exiles in The Hague. There in 1652 he participated in the stealing and roasting of a sucking pig for a feast at the St John's Head Inn, along with William Murray, Earl of Dysart, William Crofts and Denham, 'the poet with the nose', an incident which Killigrew included (with marginal gloss) in *The Second Part of Thomaso, or The Wanderer*. Also in the Hague, in 1655, he was married for a second time, to Charlotte de Hesse, who returned with him to England at the Restoration. There Killigrew was immediately appointed Groom of the Bedchamber to Charles II, and subsequently, in 1662, Chamberlain to his Roman Catholic queen, Catherine of Braganza.

Mrs Killigrew, with whom the playwright seems to have enjoyed a stormy relationship, was appointed Keeper of the Sweet Coffer to the queen in May that year, and subsequently first Lady of the queen's Privy Chamber.

Beyond the court, under the favour of the king, Killigrew pursued a career as one of the most successful theatrical managers of the day. He managed the King and Queen's Company of players, and opened the Theatre Royal, Drury Lane, in 1663. In these years he presided over the first performances and revivals of his own plays, as well as performances of Shakespeare and Beaumont and Fletcher. His own *Parson's Wedding*, an especially ribald piece, was revived in 1664 and 1672, a *succès de scandale* performed exclusively by women. In 1673, the man who for some years had been recognised as the king's jester was appointed Master of the Revels. A number of his *facetiae* at the expense of Charles are recorded, and his tongue often got him into trouble; there was at least one attempt on his life, and the Earl of Rochester is known to have boxed his ears in the king's presence.

Killigrew appears to dash through life with an unco-ordinated and crude vigour, but there is some evidence that, towards the end, he did look back and reflect. He always wore his hair long, but in later years he allowed his beard to grow long as well, in the traditional Christian sign of penitence. His appearance must have seemed unusual to his contemporaries, though not without parallel. He is first portrayed with a full beard in an anonymous mezzotint probably of the 1670s (fig. 64), where he is shown standing in a rocky landscape as a pilgrim of St James, with his pilgrim's hat, staff, water-bottle, in a long robe which bears on its collar the traditional scallop shells and a cross.[43] The composition is reminiscent of Van Dyck's portrait at full-length of a Roman Catholic sitter, *Lord George Stuart, Seigneur d'Aubigny as a Shepherd* (National Portrait Gallery). It is a presentation especially appropriate to Killigrew, for he had spent some time in Spain in the 1640s and, indeed, may have travelled to Compostela. His dramatic self-portrait, the character of Thomaso, is styled 'The Wanderer' and Killigrew had also written a tragedy *The Pilgrim* in the 1640s, in which the hero Cosmo disguises himself in pilgrim's robes. Under the engraved image are two lines of verse:

> You see my face, and if you know my mind,
> 'Tis this: I hate myself and all mankind.

Parallels exist. In the later 1670s the Roman Catholic convert Edward Altham painted a self-portrait as a hermit (Bankes Collection, Kingston Lacy), a moralising full-length with allegorical elements arguing contempt

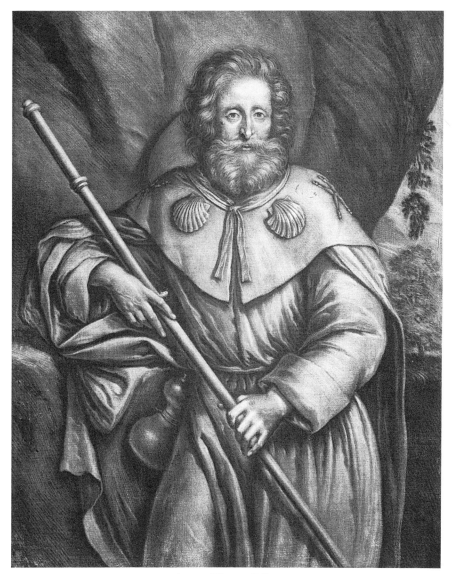

64 Anon., *Thomas Killigrew*

for worldly things and inscribed 'Post mortem summa voluptas'.[44] The medallist Abraham Simon was portrayed about the same time, perhaps by Isaac Fuller, hirsute and as a penitent (private collection),[45] and by Kneller (see p. 252) in a way which closely resembles Killigrew.[46]

That Killigrew had indeed undergone a great change of mind is under-

237

lined by the last portrait of him, painted by Willem Wissing, but known only by a mezzotint by Jan van der Vaart (fig. 65),[47] and a simplified copy formerly at Thornham Hall.[48] This shows him with hair thinner than in the mezzotint as a pilgrim, and probably dates from after 1680. It depicts Killigrew bearded as St Paul, in furred mantle with the saint's attribute of a sword, 'that which the Spirit gives you' (Ephesians, 6:17), and the instrument of his martyrdom.

The explanation why Killigrew sat for a portrait as St Paul is probably to be found in the writings of his brother Sir William, who in 1694 published his *Mid-night and Daily Thoughts. In Verse and Prose*, a series of meditations on death and the shortness of life to prepare the Christian reader for death. The general tenor is: 'Thou shouldst live evr'y moment fit to die', and a characteristic passage from his verses 'On Eternal Life' runs:

> Thus born to live, and yet ordain'd to die,
> And live again, is such a mystery,
> As only Faith can reach, and shew us how
> To out-live Death, by pious living now,
> Which will a prepossession take of Bliss.
> And such angelical transports as this,
> Will such a bless'd celestial Courage give,
> We shall be glad to die, that we may live.[49]

Sir William prefaces his meditations with a brief account of his theory of meditation entitled 'On Christian Epicureanism', which begins

If all the Epicurisms in the world were join'd in one, they could not produce one moment of such serene Delights unto the Heart of Man, as is comparable to the Soul's Joy, in a divine Elevation unto God by Meditation; for when such sacred Illuminations in Devotion do descend from above, to enlighten the Souls of pious Men with transporting Joy, ineffable, and not to be described! Tho' they be but faint Idea's of Heaven, they beget such Comforts while those holy Flames laste, that Men may guess thereby those illustrious Glories they shall participate of, when they come to the possession of their eternal Bliss in the presence of GOD, which a great reprobate become regenerate, can best judge of ... Thus St. Paul, the greatest Sinner, became an Epicurean Saint.[50]

Although these words were printed some eleven years after the death of Thomas Killigrew, they illustrate the thinking behind his own portraits as a pilgrim and as St Paul, 'the greatest Sinner', who through penitence and meditation aspired to become 'an Epicurean Saint'.

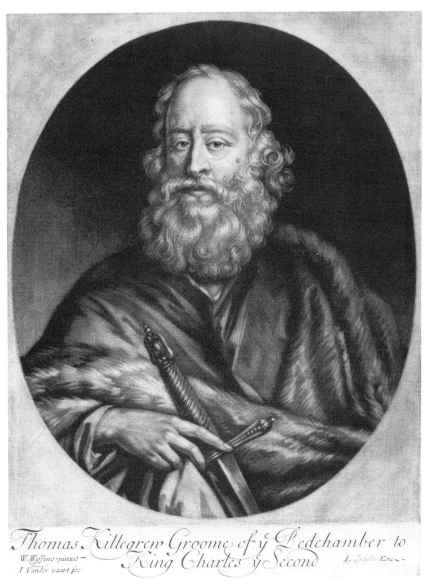

Thomas Killegrew Groome of yͤ Bedchamber to
King Charles yͤ Second

W. Wissino pinxit —
I. Vander vaart fec.

I. Smith Exc—

65　Jan van der Vaart, after Willem Wissing, *Thomas Killigrew*

In his will, dictated on 14 March 1684, four days before his death, Killigrew specifies:

My body I leave to be returned to the earth and to be decently buryed as near as conveniently may be in the vault in Westminster Abbey where my dear deceased wife [*Cecilia*] and my sister Shannon doe lye interred.[51]

The king contributed £50 towards the funeral expenses of his old and faithful servant.

Notes

1 Samuel Pepys, *The Diary of Samuel Pepys*, R. Latham and W. Matthews eds., 11 vols., London, 1970–83, IX, pp. 66–7 (13 February 1668).

2 *Ibid.*, I, p. 157 (24 May 1660).

3 F.C. Springell, *Connoisseur and Diplomat*, London, 1963, pp. 237–41.

4 Thomas Carew, *Poems*, Rhodes Dunlap ed., Oxford, 1949, pp. 50–60. Thomas Killigrew, *Comedies and Tragedies*, 1664, part 2, Act V, Sc. 1 (p. 309).

5 Carew, *Poems*, pp. 79–80.

6 Killigrew, *Comedies and Tragedies*, Act I, Sc. 3 (p. 11).

7 *A Catalogue of Pictures belonging to the R.t Hon.ble the Countess of Bradford, Which Were Sent from London to Weston in Staffordshire*, June 1735, Case 20, no. 206; transcript of the MS (whereabouts unknown), National Portrait Gallery, library.

8 Oliver Millar has suggested this interpretation of the similar gesture in Van Dyck's portrait of Henrietta Maria in a private collection, New York, painted late in 1636, when the queen was pregnant with the Princess Anne: *Age of Charles I*, Tate Gallery, London, 1972, no. 88.

9 W.H. Carpenter, *Pictorial Notices: Consisting of a Memoir of Sir Anthony Van Dyck*, London, 1844, pp. 55–6.

10 Franciscus Junius, *The Painting of the Ancients*, London, 1638, p. 49.

11 *Graphice*, p. 39. The surviving portrait closest to Sanderson's description is that of Katherine Howard, Lady d'Aubigny (National Gallery of Art, Washington), which may also have been painted about the time of the sitter's marriage.

12 *The Diary of John Evelyn*, E.S. de Beer ed., 6 vols., Oxford, 1955, IV, p. 94 (19 August 1676).

13 Oliver Millar, *The Tudor, Stuart and Early Georgian Pictures in the Collection of Her Majesty The Queen*, 2 vols., London, 1963, no. 156. G. Vertue, 'Notebooks', *Walpole Society*, 4 (1929), p. 125.

14 *Anthony Van Dyck*, Arthur K. Wheelock and Susan J. Barnes eds., National Gallery of Art, Washington, 1990, no. 84.

15 It was in this spirit that Sir Kenelm Digby in 1633 commissioned from Van Dyck a portrait of his wife Venetia on her death-bed (Dulwich Art Gallery). He writes

to his brother: 'This [the portrait] is the onely constant companion I now have
... It standeth all day over against my chaire and table ... and all night when I
goe into my chamber I sett it close by my beds side, and by the faint light of
candle, me thinkes I see her dead indeed.' *Collection for a King: Old Master
Paintings from the Dulwich Picture Gallery*, London, 1985, no. 7.

16 Alfred Harbage, *Thomas Killigrew Cavalier Dramatist 1612–1683*, Philadelphia,
1930, pp. 58–65.

17 *Comedies and Tragedies*, part 2, Act I, Sc. 1 (p. 385).

18 E.g. part 2, Act I, Sc. 4 (p. 392).

19 *The Earl of Strafford's Letters and Dispatches*, W. Knowler ed., 2 vols., 1739, II,
p. 115 (9 October 1637).

20 *Ibid.*, p. 181 (3 July 1638).

21 Oliver Millar, 'Van Dyck and Thomas Killigrew', *Burlington Magazine*, 105
(1963), p. 409.

22 Malcolm Rogers, *William Dobson*, National Portrait Gallery, London, 1983,
no. 17.

23 Millar, 'Van Dyck and Killigrew', p. 409.

24 Lely's Executors Accounts, British Library, Add. MS. 16174: 'Tho: Killigrew
after v Dike', bought by 'Mr Aston' for £4. It is possible that the copy at
Chatsworth (long thought to be the original, and from Lely's collection), may be
this copy from the Lely sale.

25 Vertue, 'Notebooks', *Walpole Society*, I, pp. 22 and 30. Whereabouts unknown.
Several other early copies are known: e.g. National Portrait Gallery, Goodwood.

26 *Mr Cartwright's Pictures*, London, Dulwich Picture Gallery, 1987, no. 19 and the
related drawing, fig. 1.

27 *The Life of Tomaso the Wanderer. An Attack upon Thomas Killigrew*. Reprinted
from the original of 1667, G. Thorn-Drury ed., London, 1925, p. 11.

28 A copy was in an English private collection in the 1950s.

29 Part 1, Act V, Sc. 3 (p. 505).

30 Part 1, Act V, Sc. 5 (p. 510).

31 Part 2, Act I, Sc. 5 (p. 527).

32 Part 2, Act III, Sc. 1 (p. 527).

33 *Ibid.*, p. 548.

34 Part 1, Act I, Sc. 1 (p. 314).

35 Part 1, Act II, Sc. 3 (p. 333).

36 Oliver Millar, *Van Dyck in England*, National Portrait Gallery, London, 1982,
no. 38.

37 When sold at Christie's, 10 July 1981 (109), it was identified as 'Cecilia Crofts,
wife of Thomas Killigrew'. The correct identification, given by the inscription,
confirms that it is Lady Killigrew, not her sister-in-law, in the double portrait
with (?) the Countess of Morton at Wilton: Lord Pembroke, *Catalogue of the
Paintings and Drawings in the Collection at Wilton House*, London, New York,

1968, no. 168, and in numerous derivatives usually said to represent Cecilia: e.g. National Gallery of Art, Washington; Christie's, 9 October 1981 (20), Sotheby's New York, 5 April 1990 (175).

38 Millar, *Van Dyck in England*, no. 35. This portrait also belonged to Lely. The sitter also appears in a three-quarter-length double portrait with a woman; said once again to be the Countess of Morton, in the Hermitage, St Petersburg.

39 Revd Edmund Farrer, *Portraits in Thornham Hall*, privately printed, Norwich, 1930, no. 121.

40 British Library, MS. Egerton 1636, fos. 23v–27v.

41 E.g. National Portrait Gallery, London (formerly at Woburn Abbey); Dyrham Park; Sudbury Hall; Sotterly Hall; Christie's, 8 December 1961 (165).

42 His costume anticipates by nearly a hundred years the hussar costume so popular in mid-eighteenth-century masquerades.

43 J. Chaloner Smith, *British Mezzotinto Portraits*, 4 parts, London, 1878–83, pt 4, 1661.

44 Jennifer Montagu, 'Edward Altham as a Hermit', in *England and the Renaissance*, E. Chaney and P. Mack eds., Woodbridge, 1990.

45 Whereabouts unknown; photograph in National Portrait Gallery, London, Archive.

46 Killigrew is distinguished by the mole on his left cheek, reversed in the mezzotint. (Editor's note: for a different interpretation as to the identity of this sitter see pp. 254 and note 45.)

47 Chaloner Smith, *Portraits*, pt 3, 1405.

48 Farrer, *Thornham Hall*, no. 122.

49 Sir William Killigrew, *Mid-night and Daily Thoughts. In Verse and Prose*, 1694, p. 43.

50 *Ibid.*, p. 5.

51 Harbage, *Dramatist*, p. 138.

13

SIR GODFREY KNELLER AS PAINTER OF 'HISTORIES' AND *PORTRAITS HISTORIÉS*

J. Douglas Stewart

When I began my doctorate with Oliver Millar in 1961, I recall him making two statements. 'If,' he said, 'one were to assemble twenty-five of the best of Kneller's paintings, one would be amazed at their quality.' As I sifted through the artist's work, wrote my thesis, and then organised an exhibition for the National Portrait Gallery, London, I realised how right Millar was about Kneller's formal capabilities.[1]

Millar's second statement about Kneller was: 'Of course he is not an intellectual painter.' At first I also accepted this idea. Thus, when I uncovered a complex iconographical programme for the Hampton Court *William III*, I assumed that persons other than the artist had been responsible.[2] Now I believe that it was Kneller himself. After all, we do have his own written explanation for the iconography of the Blenheim *Queen Anne Presenting the Plans of Blenheim to Military Merit*, a similar allegorical picture painted only a few years later.[3]

Whether we think that Kneller could invent elaborate history paintings depends on our ideas of what sort of training and intellectual equipment he acquired during his continental years, before he came to England. These ideas can profoundly affect our estimate of Kneller's character and his reputation.

In 1987 Lindsay Stainton included a fine selection of Kneller drawings in an exhibition, which certainly helped to increase his reputation as a draughtsman. But in treating Kneller's character, Stainton was negative. Describing Kneller's early English career she wrote, 'A combination of considerable technical ability and complete confidence in his own talent, or – as he would have said – genius, together with the absence of any serious competition, gave him an unchallenged position, of which he took full

advantage.' Later Stainton said of Kneller that 'his arrogance and conceit were legendary'.[4]

Against legend one may cite a contemporary, Marshall Smith, the artist's earliest English biographer, for whom Kneller was 'a gentleman of good *Morals*, True to his *Friends, Affable* and free from the least appearance of *Affectation* or *Pride*.'[5] The 'genius' reference comes from a letter to Alexander Pope in which Kneller excuses his absence from a social engagement because of ill-health, but explains that his 'genius' will be there, even if his body is not.[6] Kneller is using the word 'genius' here in its ancient sense, meaning his personal guiding spirit, rather than the modern sense of 'a genius', that is, a person of transcendent intellectual or artistic power.[7]

It was once thought that Kneller had achieved little before coming to England, and was still an immature artist. He had been a pupil of Ferdinand Bol and Rembrandt in Amsterdam, and had then gone to Italy. But these facts, far from gaining Kneller respect from early twentieth-century scholars, had instead been used against him; it was assumed that he had been too stupid, lazy and arrogant to profit from an association with a great artist. 'The matter [of Kneller being a Rembrandt pupil]', wrote Collins Baker in 1912, 'is not very important as regards Kneller's formation, though in point of sentiment there is something arresting in the thought that [Kneller] may have had Rembrandt, in his most wonderful period, leaning over his shoulder, taking his pencil with those massive fingers we know so well, and muttering strange truths; the revelation of his deep communings with life, that was no doubt beyond the puzzled Godfrey.' And what had he done in Italy? Collins Baker dismissed Marshall Smith's statement that in Venice Kneller 'was patronized by . . . patrician families . . . the Donado and Garsini [*sic*]', apparently thinking that the names were fictitious since they 'irresistibly remind[ed Collins Baker] of the families in "The Grand Panjandrum"'.[8]

To be just to Collins Baker, little was then known of Kneller's early work. When I started to look at Kneller, virtually the only pre-English works which English scholars knew were a school-boy drawing in the British Museum and the 1672 *Elijah and the Angel*, which had been acquired in 1954 for the Tate Gallery, London. Then Ellis Waterhouse discovered an engraving after Kneller's portrait of Cardinal Basadonna, a Venetian patron whom Marshall Smith had also mentioned.[9]

In my early work on Kneller, I tried to find out more about his continental period, but with little success. Only in 1975 did I discover that the 1675 Sebastiano Bombelli self-portrait at Udine was really a depiction of that artist by Kneller.[10]

Yet apart from the re-attribution of the *Sebastiano Bombelli*, and the dis-

covery of a reference by Rosalba Carriera to Kneller portraits in Venice, (including a Mocenigo portrait which further confirmed Marshall Smith), I was not able to shed much more light on Godfrey Kneller's early continental years.[11]

In 1986 this situation was dramatically changed by Werner Sumowski, who published nine new attributions to Kneller, mostly Dutch period 'history' paintings.[12] These demonstrate that by the time Kneller left Holland in 1672 he had profited greatly from his training, and had become a thoroughly competent member of the Rembrandt school with a powerful, personal style.

Meanwhile, in 1980, an exhibition organised by Albert Blankert and others had revolutionised our general view of seventeenth-century Dutch painting by showing that 'history' painting (in the sense established by Alberti in the fifteenth century and continued by later theorists) was as highly regarded in Holland as elsewhere in Europe during the first three-quarters of the century. In their concentration on scenes from the Bible (sacred history), antiquity, mythology, or their painting of *portraits histories*, Rembrandt and his school were not, as had been thought, unusual – diverging from so-called 'Dutch realism' (which turns out to be a creation, not so much of seventeenth-century Dutchmen, as nineteenth-century French critics eager to discover their own present in the past). Instead, from the art-theoretical point of view, Rembrandt and his followers were part of the European mainstream of ideas.[13]

Blankert has also suggested a connection between the Rembrandt school and contemporary literary theory. Vondel, the great Dutch tragedian, after about 1640 wrote his plays so that everything was determined by the Aristotelian concept of *peripeteia* (the sudden reversal of circumstances), which Dutch literary theorists translated as *staetveranderinge*. Blankert argues that the visual evidence suggests that Rembrandt and his school followed the same path as Vondel in portraying *peripeteia*.[14] One marvels, for example, at the number of biblical themes chosen in which an angel appears: as Blankert wryly observes, 'few events cause such profound *staetveranderinge* as the sudden appearance of an angel'.[15]

The challenge of portraying *peripeteia* could also help to explain the popularity of other themes, not involving an angel, for Rembrandt and his school. One such is the *Dismissal of Hagar*, which certainly involves a 'sudden reversal of circumstances' for all concerned.

A painting of this subject in the Alte Pinakothek, Munich (fig. 66), once given to Gerbrandt van den Eechout, is the most important of Sumowski's

67 Sir Godfrey Kneller, *Elijah and the angel*, 1672

66 Sir Godfrey Kneller, *Dismissal of Hagar, c.* 1670

new attributions to the young Kneller, and dates from about 1670.[16] There are indeed strong affinities between the Munich picture and the 1672 Tate Gallery *Elijah and the Angel* (fig. 67), and the *Self-Portrait* (Mrs A. Alfred Taubman Collection) of *c.* 1670.[17]

The Munich picture is a work of great power: sumptuous in colour, and grand in form; it finely differentiates the variety of emotions of the characters. It measures nearly 8.5 feet by 6 feet; as Sumowski says, it is the *hauptwerk* (chief work) of Kneller's early period. But no artist would paint such a picture as a speculative venture. Who was its patron?

Godfrey Kneller's earliest signed and dated work is the 1666 three-quarter-length in the Kunsthistorisches Museum, Vienna, of Johann Philipp von Schönborn, Archbishop and Elector of Mainz (1605–73), the founder of a dynasty of churchmen-art patrons.[18] The portrait had been virtually ignored by English writers. Although I had no doubts about the picture's authenticity, I wondered how the young artist came to paint such an exalted sitter.

In 1985 Gary Schwartz noted the very special 'place of the German Electors in Amsterdam history ... they were regarded as guarantors of the city's freedom. The close ties between Amsterdam and German courts were no doubt an important factor in the careers of Sandrart, Flinck and many others.'[19] Von Schönborn was an elector. It was thus natural that he would sit to an Amsterdam painter, especially one of the celebrated Rembrandt school, and who was, like Flinck and Sandrart, a German.

The Munich *Dismissal of Hagar* came from the Residenz at Wurzburg, and before that, the Festung Marienberg there.[20] Von Schönborn was also Bishop of Wurzburg, and that see remained in his family. (There is still, in the Festung Marienberg, a full-length version of Kneller's three-quarter-length Vienna portrait.[21]) I suggest that the elector was pleased with his 1666 portrait and went on, around 1670, to commission a grand history painting from the young artist.

Kneller's Tate Gallery *Elijah and the Angel* has been connected with Vertue's account, written about 1713: 'a History picture by Sr. Godf. Kneller at his house. [Whitton] represent an angel comeing to Tobit: painted in the year 1672 just before ⟨after⟩ he sett out to travel to Rome and Italy.'[22] The other occasion when Vertue noted a picture from the Tobit story was at Corsham Court around 1722: 'Tobit & the Angel. finely painted.'[23] That picture, once identified as a Caravaggio, is now given to Bartolomeo Schedoni. But it actually depicts the Archangel Raphael and Tobias, the young son of Tobit.[24]

At Corsham, Vertue confused the similar names of father Tobit and son Tobias. But that is no reason to suppose that Vertue would identify the young boy Tobias with the elderly prophet Elijah. Hence one suspects that the picture which Vertue saw at Whitton in 1713 was not the Tate Gallery canvas, but a *Tobias and the Angel*, now lost.

The Tate *Elijah and the Angel* is apparently the second version of this theme which Kneller had already painted; two copies are known of a lost original.[25] I once criticised the Tate picture as clumsy, because of the pose of Elijah, especially his legs. But could the painter of the Munich *Dismissal of Hagar* be guilty of such technical weakness?

The story of Kneller's Tate picture is related in 1 Kings, 18–19. Elijah competed on Mount Carmel against the prophets of Baal, who were destroyed. But then, Elijah had received a messenger from Queen Jezebel saying that she would have him killed: he fled across the desert of Judah to the wilds of Mount Horeb. Broken in spirit, Elijah prayed for release: 'It is enough, O Lord, take away my life.' But he did not die, he fell asleep under a juniper tree. Later he was awakened by an angel who 'Touched him, and said unto him, Arise and eat. And he looked, and behold there was a cake baken on the coals, and a cruse of water at his head. . .'

It is this moment which Kneller portrays. Is it any wonder that the prophet's lower limbs seem like those of a large rag-doll? Paralysed with fright by the apparition beside him, he seems almost unable to pull himself together. Yet his right arm shows signs that control is returning, and his head, with its surprised expression, is nobly rendered. His expression shows that he recognises the presence of the divine, and that act of *anagnorisis* (recognition) follows Aristotle's theory that the person whose circumstances are suddenly reversed (*peripeteia*) is often seen to recognise that change.[26]

Because of the circumstances of patronage, there are few pure 'history' paintings from Kneller's English period. But the artist's continued interest in the learned aspects of painting appears in his use of adjuncts to portraits such as emblems, and in *portraits historiés*. An instance of the former is found in the background fountain of the double portrait of the De Vere sisters, of *c.* 1682–3 (private collection).[27] The fountain (fig. 68) is composed of dolphins supporting a basin on which is a group with a lion being restrained by a cupid. That group is an emblem of *amor vincit omnia* (love conquers all).[28] But the shell-basin and dolphin base is an ingenious but unnoticed adaptation from Bernini's Triton Fountain in Piazza Barberini of *c.* 1642–3 (fig. 69).[29]

68 Sir Godfrey Kneller, *The De Vere sisters* (detail of fountain), *c.* 1682–3

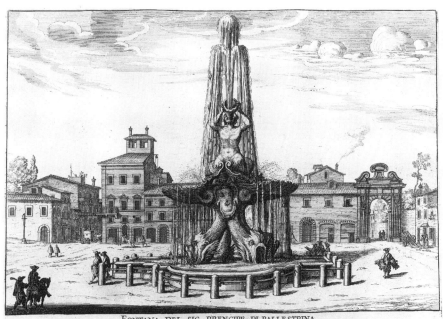

FONTANA DEL SIG. PRENCIPE DI PALLESTRINA
su la Piazza Barberina, alle radici del Quirinale in Via felice, nel Rione di Trevi, Architet.º del Cau. Gio Lorenzo Bernini.
G.B.Falda del. et inc. G.Iac Rossi le stampa in Roma alla Pace all Pru del S.P 16

69 Gian Lorenzo Bernini, *Triton Fountain*, engraving *c.* 1642–3,
Piazza Barberini, Rome

Buckeridge says that the young Kneller studied in Rome 'under the favourable influence of Carlo Maratta and the Chevalier Bernini. . .'.[30] The adaptation of the Triton Fountain for the De Vere sisters' portrait is the earliest known example of a direct influence by Bernini on Kneller. In 1686 he used the same fountain in the background of another group portrait, the Russell sisters (Woburn Abbey).[31]

In 1983 I wrote that Kneller's 1689 *Sir Isaac Newton* was 'strangely reminiscent of Bernini's *Gabriele Fonseca* in S. Lorenzo in Lucina' at Rome – part of a funeral chapel being constructed during Kneller's stay in Rome.[32] The reminiscence is less strange, in the light of Kneller's adaptation of the Bernini Triton Fountain for two other works of the 1680s; and also Kneller's use of the head of Bernini's *Proserpina* in his 1690 portrait of Grinling Gibbons, a work I shall return to later.

The Bernini connection may indeed have furthered Kneller's early English career. Marshall Smith says that in Rome the young Kneller 'was in great esteem with *Cavalier Bernini* and by him much recommended for his work. . .'[33] Sir Robert Southwell of Kingsweston had met Bernini in Rome in 1661, corresponded with him and, as late as 1695, acquired a copy of the sculptor's portrait done in Rome in 1686 by Henry Tilson, from that artist's father. Sir Robert sat to Kneller at least as early as 1679 and, together with his family, including important connections like the young Sir John Perceval, became staunch patrons of the artist for two generations. They were also patrons of Grinling Gibbons.[34]

One of Kneller's most striking portraits of the 1680s is a full-length of Abraham Simon, the medallist (1617–c. 1692) (fig. 70) now in a private collection. On the art market in the 1960s and 1970s it was variously called a 'Saint Jerome' and 'a Hermit Saint'; Albert Blankert thought it represented 'Elisha in the Desert'. I identified the sitter, on the basis of certified portraits, including an inscribed drawing by George Vertue after a lost Kneller, and a third Kneller long identified as Abraham Simon.[35]

Simon was also portrayed by other artists. He sat to Lely, about 1660, for a portrait which was in the painter's sale, and later belonged to Grinling Gibbons. It is now lost but is known through a Blootelling mezzotint (fig. 71) which shows the portrait to have been (for Lely) an unusually introspective one.[36]

George Vertue says of Simon, 'he was a perfect Cynic, so remarkable that his dress behaviour life & conversation, was all of a piece. wearing a long

beard no clean linning went on pattins in the streets was often hooted after by the boys'.[37]

Ancient Cynicism taught that one should despise material things and be concerned only with the pursuit of virtue. For Diogenes, the greatest of the Cynic teachers, poverty and disrepute are positive advantages in the pursuit of the good – the good man wants nothing. There was much interest in Cynicism in the seventeenth century. The stories of Diogenes flinging away his bowl on seeing a boy drink from a stream with cupped hands; acidly telling Alexander that he could get out of his light, when asked by that prince if he could do anything for him; and looking in vain for an honest man, were frequently painted. When Van Dyck visited the Villa Borghese during his stay in Rome, 1622–3, he drew the antique seated statue which was then thought to represent the ancient philosopher. There was even a novel, published in Amsterdam in 1684, about Diogenes coming there to search for an honest man – and, of course, failing to find one.[38]

The interest in Cynicism was connected with the revival of the related philosophy of Stoicism. Many artists were attracted to Stoicism. Poussin is only the most famous. Rubens also had a great admiration for Seneca, the greatest Roman Stoic writer; he owned a version of an antique bust then thought to represent him.[39] Another version of this 'pseudo-Seneca' bust is seen in the Kneller self-portrait (Mrs A. Alfred Taubman collection) of *c.* 1670. That picture appears to be a confession of faith by the young artist; the bust presumably indicates admiration for Senecan Stoicism.[40]

It may have been a common philosophical outlook which drew the young painter and the old medallist together. There must have been strong mutual attraction, for their association led to three Kneller portraits of Simon all painted within a few years. It says much for Kneller's tolerance and perspicacity that he could see beyond the crusty, unhygienic eccentric (whom Evelyn referred to after his death as 'the late squalid embosser')[41] to the intelligent and sensitive artist.

Indeed Kneller risked his own reputation by association with one who, by his aggressively independent behaviour, had alienated members of the nobility including the Duke of York. Simon 'was so very Testy', says Vertue, 'that upon the least fault said to be in his works. when he had done of the face of any Nobleman or Lady. he woud instantly deface it & go away'.[42]

Abraham Simon was a proud man – understandably, since he and his more famous brother Thomas became England's greatest portrait medallists. Sir George Hill wrote: 'There is nothing in any country in the Seventeenth

70 Sir Godfrey Kneller, *Abraham Simon as a pilgrim, c.* 1686–90

Century to equal the delicacy of modelling and chasing of these little portraits and the cunning of their execution has not detracted from the direct sincerity of the portraiture.'[43]

Although a Cynic, Simon was a Christian, and also learned. Vertue says of him: 'amongst other oddities he being a man of some learning had a mind to be a Clergyman but would not accept of less than a Bishops Mitre'.[44]

What appears to be still another image of Simon, a mezzotint in the British Museum (fig. 64), after an unidentified artist, has until now been called Thomas Killigrew.[45] Both the print and Kneller's full-length portrait of Simon (fig. 70) show the sitter in simple robes, long hair and beard, and with the beggar's or pilgrim's staff and hat. These are all important aspects of Simon's Cynicism; for the true Cynic, like Diogenes, did not simply shun material things; he was an active missionary for spiritual values, travelling

ABRAHAMUS SYMONDS.

P: Lely Pinxit.

A: Blooteling fecit.

71 Mezzotint by A. Blootelling, after Sir Peter Lely, *Abraham Simon*

about the world spreading the 'gospel'. For his simple needs, the Cynic relied on begging.[46]

But both the Sutherland mezzotint and Kneller's full-length of Simon have important Christian content. In the mezzotint the shells on the robe refer to the shrine of St James of Compostella in Spain, and hence to Christian pilgrimage. Kneller also depicts Simon as a pilgrim, though without the shells, and shows him looking towards a light source, while pushing back a globe, to which he is chained. Behind are beech trees, stretching from the foreground to the horizon. These probably signify, as they had done for artists such as Basaiti, Moretto and Titian, the virtue of abstinence.[47]

Two emblems and one painting may have played a part in the genesis of Kneller's full-length *Abraham Simon*. The earlier emblem (fig. 72), from Whitney's *Emblemes*,[48] shows a pilgrim passing a globe in front of a tree, and looking up at the tetragrammaton. The motto above is *Superest quod supra est*: 'what is above lives on'. Beneath the image is the inscription: 'Adue deceitfull worlde, thy pleasures I detest; Nowe, others with thy showes delude; my hope in heaven doth rest.'

Kneller's painting is also related to an emblem by Francis Quarles (fig. 73) which shows the winged soul, *Anima*, attempting to fly up to *Divine Cupid* in the sky, but finding it impossible because his leg is chained to a globe. Beneath is an inscription from St Paul's Epistle to the Philippians (1:23): 'I am in a streight betwixt two haveing a Desire to Depart & to be wth Christ.'[49]

At Bob Jones University, Greenville, there is a painting by Jan van Bijlert showing a reclining Magdalen who, with the help of an angel, is spurning a globe, and pearls, and turning instead towards a spotlit crucifix.[50] Conceivably this picture was known to Kneller.

Yet all of these images may be parallels, rather than sources, for Kneller's picture, which appears to be essentially his own invention. He portrays in monumental terms an expressive contrast between the awkward legs, one of which is chained to this world, and the quiet dignity of the upper part of the body, with its relaxed right arm across the body, and Simon's face radiant with the divine light which falls upon it. These contrasts seem analogous to those in Elijah's body in Kneller's 1672 *Elijah and the Angel*; thus the Aristotelian principles of *perepeteia* and *anagnorisis* are also adhered to in the *Abraham Simon*.

Superest quod supra est. 225

72 Geoffrey Whitney, 'Deceit', from *A Choice of Emblemes*, 1586

Kneller's full-length portrait of Abraham Simon is really a *portrait historié*. It shows Simon in the character of an elderly Christian Pilgrim weary of this world, but serenely sure of his ultimate goal in the next.[51] Although the identity of the sitter was once lost, it is interesting to note that its character as a 'history' painting was recognised in the titles it was given – 'Hermit Saint', and 'St Jerome'. We know little of the picture's provenance. Because of the sitter's scorn for earthly things, it is unlikely that it was painted for him. Either it was a commission from a third party, or else Kneller painted the picture for himself.[52]

With Kneller's *Grinling Gibbons* of *c.*1690 (Hermitage, St Petersburg) (fig. 74),[53] we seem to have an opposite case. The identity of the sitter has never been lost because, soon after the portrait was painted, John Smith made a fine mezzotint of it. Yet the 'meaning' of the picture – its character as a *portrait historié* – has been obscured.

The *Grinling Gibbons* was once at Houghton. Horace Walpole wrote that Sir Godfrey had 'shown himself as great in that portrait as the man who sat to him'; that it was 'a masterpiece not inferior to any work of Van Dyck'; and that it had 'the Freedom and nature of Van Dyck, with the colouring peculiar to Andrea Sacchi, with no part of it neglected'.[54]

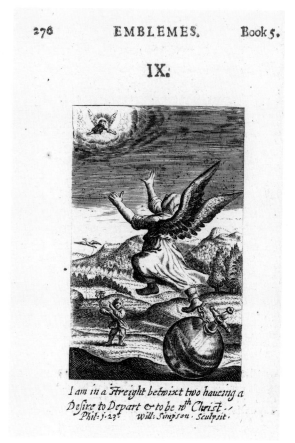

73　Francis Quarles, *Emblemes*, Book v, Emblem ix, 1635

The *Grinling Gibbons* has long puzzled me. In 1965 I was able to answer the obvious question by identifying the bust; it is a cast of the head of Proserpina (fig. 75) from the group *Pluto and Proserpina* (Rome, Villa Borghese) carved by Gian Lorenzo Bernini in 1621–2.[55] Since Gibbons was seen by at least one contemporary as a British Bernini, the choice of a work by him for Gibbons's portrait is certainly apt.[56]

But why choose the *Proserpina*, an early Bernini? Most importantly, why is Gibbons treating the bust so aggressively, with his left hand firmly on top of the head, and one of the compass points virtually stuck into Proserpina's throat? The sculptor is clearly not simply 'measuring' the bust.

The answers to these questions lie, I suggest, in Virgil's *Aeneid*, a poem in which Kneller and Gibbons had a special interest: the painter was a first

74 Sir Godfrey Kneller, *Grinling Gibbons, c.* 1690

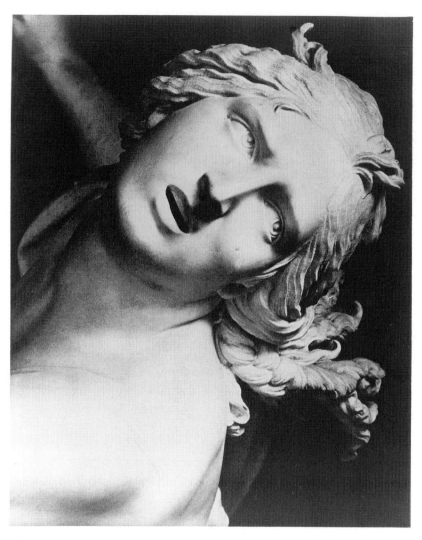

75　Gian Lorenzo Bernini, *Head of Proserpina* (detail from *Pluto and Proserpina*) *c.* 1620–2

subscriber for Dryden's translation, published in 1697, and a gatherer of second subscribers, amongst whom were the sculptor and the mezzotinter, John Smith. Kneller acted as a gatherer because he was indebted to Dryden for publishing his *Parallel betwixt Painting and Poetry* along with his own translation of De Piles's French version of Du Fresnoy's Latin poem, *De Arte Graphica*.[57]

Today we read Virgil's poem as a dramatic narrative. But from antiquity until the eighteenth century it was also read morally and allegorically. Addison wrote in the *Spectator*, 13 June 1711, of '*Virgil*, who has cast the whole System of Platonick Philosophy, so far as it relates to the Soul of Man, into beautiful allegories.'[58]

In 1480 the Florentine neo-Platonist Cristoforo Landino published a Latin allegorical poem explaining the *Aeneid*: it was entitled the *Camaldulensian Dialogues*. Its content was incorporated into Giovanni Fabrini's 1576 Italian *Aeneid*, which was reprinted frequently into the eighteenth century; and been described as 'the most famous, indeed the most philosophically ordered and complete' edition. Pietro da Cortona owned the 1641 edition.[59] The contents of Kneller's library are unknown: that it was substantial is likely from the fact that he had a book-plate. Furthermore, Kneller was familiar enough with Italian to write it, and could also read Latin.[60]

In Book VI of the *Aeneid*, the hero descends into Hades armed only with a Golden Bough. Michael Murrin has paraphrased Landino's allegory of this 'descent': 'If hell is the human body, or this world, then a trip to Hell actually signifies a contemplation of man here. Aeneas's descent into Hades is the mind's careful investigation, with learning for a guide, of the vices incident to the sensual condition of man. The process, though intellectual, is not without danger. Aeneas needs the Golden Bough of wisdom because: Proserpina is that very part of the soul which embraces nothing but the senses; and if we were to approach her without wisdom, there would be no help afterwards for what would be done to us. For those who are trapped by her there is never any hope of returning.'[61]

It is this passage in the Landino–Fabrini allegory of the *Aeneid* which appears to have inspired Kneller to use the Bernini Proserpina bust in his *Grinling Gibbons*. The compasses could stand for Prudence,[62] or Wisdom; and the aggressive way Gibbons handles the bust and the compasses is explained by the context – one must confront Proserpina with wisdom, or one is lost forever. As in the full-length portrait of Abraham Simon, we seem to have potential *perepeteia* combined with *anagnorisis*.

The forms of the *Grinling Gibbons* became, through the Smith mezzotint,

widespread. It was borrowed by the Amsterdam engraver Peter Schenk, probably about 1700, for his portrait of the sculptor Pieter van der Plas (c. 1647–1708).[63] Around 1710, an unknown English artist used the pose, but dropped most of the accessories, for his portrait *Admiral Robert Fairfax* (York City Art Gallery). Only an echo of the historicising character of the *Grinling Gibbons* remains in the admiral's dress, which, like that of Gibbons, is the so-called 'civil vest' or 'toga' – clothing which Kneller and his contemporaries thought was a true fashion of antiquity.[64]

Kneller's *Grinling Gibbons* is a formal invention of a high order, as Horace Walpole recognised. If my interpretation is accepted, the picture also has profound meaning and is in the great tradition of 'historical' portraiture developed in Amsterdam in the seventeenth century. As such, it is perhaps not unworthy to stand in company with another portrait of a man and a bust – Rembrandt's 1653 *Aristotle*, now in the Metropolitan Museum of Art, New York.[65]

Notes

Some of the ideas in this essay were first formulated in a paper given at the North Eastern American Society for Eighteenth Century Studies Conference, Worcester, Mass., in October 1989. I am grateful to Gerald Finley, Charles Pullen and Damie Stillman for help and encouragement. I am indebted to the Advisory Research Committee of Queen's University.

1 J. Douglas Stewart, *Sir Godfrey Kneller*, National Portrait Gallery, London, 1971.

2 J. Douglas Stewart, 'William III and Sir Godfrey Kneller', *Journal of the Warburg and Courtauld Institutes*, 33 (1970).

3 J. Douglas Stewart, 'Chandos, Marlborough and Kneller: Painting and "Protest" in the Age of Queen Anne', *National Gallery of Canada Bulletin*, 17 (1971), p. 28.

4 Lindsay Stainton and Christopher White, *Drawing in England from Hilliard to Hogarth*, British Museum, 1987, pp. 33, 182.

5 Marshall Smith, *The Art of Painting*, 1692, p. 23.

6 *The Correspondence of Alexander Pope*, George Sherburn ed., 5 vols., Oxford 1959, II, pp. 15–16.

7 Judith Colton, *The Parnasse françois: Titon du Tillet and the Origins of the Monument to Genius*, New Haven, 1979, pp. 1–3.

8 C.H. Collins Baker, *Lely and the Stuart Portrait Painters*, 2 vols., London 1912, II, p. 77. He misquoted Smith, *Painting*, p. 23, who correctly referred to the 'House of *Donado, Garsoni, Mocenigo*, and divers others'.

9 Smith, *Painting*, p. 23. For the Knellers mentioned here, see J. Douglas Stewart, *Sir Godfrey Kneller and the English Baroque Portrait*, Oxford, 1983, pp. 2, 5 and 8.

10 Stewart, *Baroque Portrait*, pp. 9–10.

11 *Ibid.*, p. 9.

12 Werner Sumowski, *Gemälde der Rembrandt-Schüler*, Landau, 1986, III, nos. 970–7.

13 *Gods, Saints and Heroes: Dutch Painting in the Age of Rembrandt*, National Gallery of Art, Washington, 1980, pp. 15ff.

14 Albert Blankert, *Ferdinand Bol (1616–1680): Rembrandt's Pupil*, trans. Ina Rike, Groningen, 1982, pp. 34ff.

15 Blankert, *Bol*, p. 36.

16 Sumowski, *Rembrandt-Schüler*, no. 976.

17 *Ibid.*, no. 975, and Stewart, *Baroque Portrait*, no. 12A. Ilaria Bignamini and Martin Postle, *The Artists Model: Its Role in British Art from Lely to Etty*, Kenwood, 1991, no. 9.

18 Stewart, *Baroque Portrait*, no. 652.

19 Gary Schwartz, *Rembrandt: His Life, His Paintings*, Harmondsworth, 1985, p. 26.

20 I am grateful to Dr Peter Eikemeier for answering my queries on this point.

21 Stewart, *Baroque Portrait*, p. 2, note 8.

22 Vertue, 'Notebooks', *Walpole Society*, 18 (1929–30), p. 58.

23 *Ibid.*, *Walpole Society*, 22 (1933–4), p. 11.

24 Benedict Nicolson, *Caravaggism in Europe*, 2nd edn, revised and enlarged by Luisa Vertova, 3 vols., Turin, 1989, I, p. 173.

25 Sumowski, *Rembrandt-Schüler*, no. 977.

26 Chris Baldick, *The Concise Oxford Dictionary of Literary Terms*, Oxford, 1990, p. 8. Vondel used the Latin *agnitio*: see Blankert, *Bol*, p. 35.

27 Stewart, *Baroque Portrait*, no. 639; plate 12A.

28 Jochen Becker 'Amor vincit omnia: on the closing image of Goethe's *Novelle*', *Simiolus*, 18 (1988).

29 R. Wittkower, *Gian Lorenzo Bernini*, 2nd edn, London, 1966, pp. 200–1.

30 Stewart, *Baroque Portrait*, p. 7.

31 *Ibid.*, no. 220; plate 31 and p. 37.

32 *Ibid.*, p. 48.

33 *Ibid.*, p. 7.

34 'A List of pictures at Kingsweston / taken July 1695', fos. 9 and 14, MS, Paul Mellon Center for the Study of British Art, Yale. Stewart, *Kneller*, no. 70; Stewart, *Baroque Portrait*, p. 191; Rolf Loeber, 'Arnold Quellin's and Grinling Gibbons's Monuments for Anglo-Irish Patrons', *Studies*, 72 (1983), p. 84, note 9.

35 Stewart, *Baroque Portrait*, p. 29; Blankert, *Bol*, p. 22, note 30.

36 It appeared as 'Mr Symonds' under 'Heads of Men' in Lely's sale. See Editorial, 'Sir Peter Lely's Collection', *Burlington Magazine*, 83 (1943), p. 188.

37 Vertue, 'Notebooks', *Walpole Society*, 18 (1929–30), p. 123.

38 D.R. Dudley, *A History of Cynicism*, London, 1937. For the iconography of Diogenes in northern Europe, C. Brown, *Art in Seventeenth Century Holland*, National Gallery, London, 1976, no. 38; and *Gods, Saints and Heroes*, no. 56. For Van Dyck's drawing, in the Italian sketch-book, J. Douglas Stewart, ' "Death Moved Not His Generous Mind": Allusions and Ideas, Mostly Classical, in Van Dyck's Work and Life', in *Anthony Van Dyck*, Susan J. Barnes and Arthur K. Wheelock eds., National Gallery of Art, Washington, 1990, p. 72.

39 Stewart, in *Anthony Van Dyck*, Barnes and Wheelock eds., p. 72 and nn. 36–40.

40 Stewart, *Baroque Portrait*, p. 5, n. 21A.

41 *The Diary of John Evelyn*, E.S. de Beer ed., 6 vols., Oxford, 1955, III, p. 85, note 5 (8th June 1653).

42 Vertue, 'Notebooks', *Walpole Society*, 18 (1929–30), pp. 123–4.

43 George Hill, *The Medal: Its Place in Art*, London, 1941, p. 21.

44 Vertue, *Notebooks*, *Walpole Society*, 24 (1936), p. 10.

45 The British Museum mezzotint does not seem to represent the same person as William Sheppard's portrait of Thomas Killigrew in the National Portrait Gallery (fig. 64), which was engraved by Faithorne (see David Piper, *Catalogue of Seventeenth-Century Portraits in the National Portrait Gallery, 1625–1714*, Cambridge University Press, 1963, pp. 186–7). (Editor's note: For a different interpretation of the identity of the sitter in this mezzotint see p. 236, and fig. 64.)

46 A.J. Malherbe, *The Cynic Epistles: a Study Edition*, Missoula, 1977, pp. 115, 145.

47 M.L. D'Ancona, *The Garden of the Renaissance*, Florence, 1977, pp. 62–3.

48 London, 1586, p. 255. I am indebted to Mary Cotterell Stewart for drawing this to my attention.

49 Francis Quarles, *Emblemes*, London, 1635, Book 5, IX, p. 280.

50 Peter Sutton, *Dutch Art in America*, Grand Rapids, 1986, p. 98.

51 The best-known Restoration pilgrim image is the Kingston Lacy *Edward Altham*, long attributed to Salvator Rosa. Recently this attribution has been rightly rejected, and the picture identified as a self-portrait. Jennifer Montagu, 'Edward Altham as a Hermit', in *England and the Renaissance*, E. Chaney and P. Mack eds., Woodbridge, 1990.

52 A visitor to 'Blaze Castle the seat of Lord Clifford' in 1778 saw 'in the antechamber, A hermit, by Sir Godfrey Kneller' (*Observations made during a Tour through Parts of England, Scotland and Wales ... 1780*). This may have been the large reclining portrait of Abraham Simon.

53 Stewart, *Baroque Portrait*, no. 302.

54 *Ibid.*, p. 47 and n. 48.

55 J. Douglas Stewart, 'Review of D. Green, *Grinling Gibbons*', *Burlington Magazine*, 107 (1965), p. 479.

56 See J. Douglas Stewart, 'New Light on the Early Career of Grinling Gibbons', *Burlington Magazine*, 118 (1976), p. 511.

57 Stewart, 'William III', p. 335, n. 35.

58 *The Spectator*, D. Bond ed., 5 vols., Oxford, 1965, I, p. 382.

59 H. Diane Russell, *Claude Lorraine, 1600–1682*, National Gallery of Art, Washington, 1982, p. 86 and notes 31 and 32.

60 Stewart, *Baroque Portrait*, pp. vi, 2, 49 note 59, 183.

61 Michael Murrin, *The Allegorical Epic*, Chicago, 1980, pp. 32–3.

62 Guy de Tervarent, *Attributs et symboles dans l'art profane, 1450–1600*, 2 vols., supplement and index, Geneva, 1958–64, I, p. 110.

63 Stewart, *Baroque Portrait*, p. 47, note 48.

64 D. de Marly, 'The Establishment of Roman Dress in Seventeenth-Century Portraiture', *Burlington Magazine*, 117 (1975).

65 Julius Held, *Rembrandt Studies*, Princeton, 1991, pp. 184–5.

14

MAYERNE AND HIS MANUSCRIPT

Hugh Trevor-Roper

Habent sua fata libelli

Sir Theodore de Mayerne, the most famous physician of his time, left at his death in 1655 many manuscripts, but to art historians there is one – 'the de Mayerne manuscript' *par excellence* – of particular interest. It is BL Sloane MS 2052, a volume whose content he himself described, on a formal, not to say flamboyant title-page, in his own majestic handwriting, with his proprietary Greek motto concealed like a rebus in the last flourish of his pen, as 'Pictoria, Sculptoria et quae subalternarum artium . . .'. After this ambitious start, and many folios carefully written out by him, and enriched by later marginal notes, sometimes in his own special red ink, the volume gradually sinks in status. It dissolves into a miscellany of notes, written by various hands, on paper of varying size, interspersed occasionally with alien matter. Finally, without notice or ceremony, it stops. This, it must be admitted, is a common feature of many of the manuscripts of Mayerne.

However, in spite of its disorderly character, this manuscript has been recognised, ever since its discovery in the 1840s, as a document of great importance for the techniques of North European art in the Baroque era. The first English scholar to use it described it as the most important of all original sources on that subject.[1] The German scholar who first printed it declared it 'a historical record full of lively charm, an incomparable and invaluable source for the technique of painting'.[2] To a modern Dutch scholar it is 'one of the most important sources for the technique of painting in the 17th century'.[3] Its more recent French editors have pronounced it 'a document of capital importance' for those who would revive the pictorial methods of the Old Masters.[4] The latest scholar to use it as a source has pronounced it 'one of the most fascinating documents of its kind'.[5] No student of the artistic techniques of the age of Rubens can overlook it, or, on

studying it, fail to be impressed by what one such scholar has called 'the all-embracing interest in art subjects' of its author.[6]

In this essay I do not propose – I am not qualified – to examine the technical content of this famous manuscript. That has been done by others: by the scholars to whom I have referred, and to whom I shall return at the end of this essay.[7] Meanwhile I propose to consider its external history: its origins; how it came to be compiled; its significance in Mayerne's crowded personal life; and the curious circumstances in which, after being buried for two centuries, it emerged to claim such continuing scholarly attention.

First, a brief summary of Mayerne's career.[8] Theodore de Mayerne was a Huguenot, a second-generation Huguenot. Born in Geneva to parents who had fled from the Massacre of St Bartholomew in Lyon, he had as his godfather Théodore de Bèze, the formidable Beza, Calvin's successor as the spiritual dictator of the holy city. Hence his christian name. His father, Louis, to whom he was devoted, was a Huguenot of the first, the heroic generation: self-assured, patrician in his outlook, a closet-republican in the Roman stoic mould, proud, tough and poor. The family was originally Piedmontese and their surname was Turquet: an unpatrician name which they disdained and would quietly shed, though posterity has re-imposed it. Louis's father, Etienne Turquet, had prospered by introducing the silk industry into Lyon, but that wealth had shrunk and Louis himself, a disinherited convert to Protestantism, lived precariously, following the fortunes of Henry of Navarre during the French wars of religion, and translating Spanish and Italian books. His son Theodore was brought up a strict Huguenot, educated first at Geneva, and then at the universities of Heidelberg and Montpellier. Having taken a doctorate of medicine at Montpellier, he moved to Paris, where he practised in close association with two successful Huguenot physicians, also from Geneva: Jean Ribit, sieur de la Rivière, *premier médecin* to Henri IV, and Joseph du Chesne, sieur de la Violette, famous in the learned world as Quercetanus, *médecin ordinaire* to the king. La Rivière was a semi-Paracelsian eclectic, a disciple above all of Fernel; du Chesne, an old family friend of Mayerne, was a radical Paracelsian and a Hermetist. Mayerne was greatly influenced by both men and became, through them, *médecin par quartier* to the king. As Huguenots and Paracelsians – that is, 'chemical' doctors – all three were disliked and distrusted by the established Galenist physicians who dominated the medical faculty of the University of Paris.

In 1599–1600 Mayerne went on a grand tour of Germany and Italy, accompanying as physician a young Huguenot grandee, Henri duc de

Rohan, afterwards the famous Huguenot hero. Also in the party were de Rohan's younger brother, Benjamin duc de Soubise, afterwards the prime mover in the Huguenot revolt of La Rochelle, and Henri Nompar de Caumont, the son and heir of another Huguenot hero, the Duc de la Force. With all these men and their families, Mayerne would remain closely involved. Rohan, his particular patron, was always his model and hero. Soubise, who would take refuge in England after the fall of La Rochelle, was his patient and friend. Mayerne's two youngest daughters, the last survivors of his children, would marry two sons of Henri, duc de la Force. After his return to Paris from his grand tour, Mayerne would continue his professional rise. Still under the patronage of La Rivière and du Chesne, he would become *médecin ordinaire* to Henri IV and would be involved with them in the great battle which then broke out between the king's chemical physicians and the Paris Faculty.

By 1609 La Rivière and du Chesne were both dead, and the king wished to have Mayerne as his *premier médecin*, but demanded that he qualify for the post by becoming a Roman Catholic. Mayerne refused, and next year, when the king was assassinated, he read the signs of the time and accepted a tempting offer from James I of England. He had laid his plans carefully and carried them out skilfully, managing to keep a foothold in the French court. But his intention was to settle permanently in England and to become, as he wrote in the euphoria of his warm reception there, 'a tout escient anglais'.

He never did. To the end he remained obstinately French. Though a versatile linguist, he declined, unless obliged, to speak or write English. Like many educated foreigners, he deplored English manners – the rudeness of the common people, the indolence of the gentry (and the habitual 'melancholy' bred by it), and the exorbitant taxes, from which however he contrived to be exempted. He also remained an obstinate Calvinist, in mental structure if not necessarily in doctrine. Like his father, he was patrician in his outlook, self-assured, tough and proud – perhaps also a closet-republican; but he was determined not to incur his father's poverty: he was notoriously fond of money and would become hugely rich. This character determined his private world. Although a practised courtier, the confidant of the Jacobean *beau monde*, he despised the courtier's life and pursued his own interests in a carefully protected world of his own.

It was a Huguenot world. As his heroes were the Huguenot grandees of the age of revolt, so his political ideals were those of the Calvinist republics of Geneva and the Netherlands. His two wives were Dutch. His personal circle, even in England, was always French or Dutch. His friends, collabor-

ators, amanuenses, apothecaries, the preceptors of his sons, the managers of
his finances, his house-servants, were almost all French Huguenots or
occasionally Dutch. His house in St Martin's Lane was the resort of
immigrant chemists, artists, craftsmen of all kinds, many of whom, like the
well-known medallist François Briot, who made a medallion of his patron,
lodged with him on their arrival. He was the regular defender of the French
and Dutch churches in England when they were attacked and of persecuted
foreign Protestants who appealed to him from abroad. His closest friends in
England were Huguenots or Calvinists from Geneva – the great scholar
Isaac Casaubon; the keeper of the royal horses, Antoine Bourdin, sieur de St
Antoine; the Diodati family. Abroad, his most intimate friends were 'the
Pope of the Huguenots', Pierre du Moulin; his old Huguenot apothecary
with whom he would lodge on his visits to Paris, Pierre Naudin; the
Huguenot *médecin ordinaire* of Louis XIII, François Monginot; and the
Huguenot Paracelsian doctor who was also political adviser of Paolo Sarpi in
Venice, Pierre Asselineau. Two unmarried sisters joined him in England.
He saw them both married within the fold: one to Sir Francis Biondi, *né*
Bundević, a Dalmatian Protestant who had been brought to England by Sir
Henry Wotton and would be James I's secret agent in Savoy, the other to a
Huguenot nobleman in the service of the Elector Palatine. Although he had
social aspirations – he took care to establish his claim to nobility in France –
and hoped to found a noble dynasty, he had no intention of planting it in
England. He acquired no landed property there. Instead he invested his
wealth in a feudal castle in the Calvinist Pays de Vaud, under the jurisdiction
of the Lutheran canton of Berne. It was there that he intended to make his
home, to establish, as he wrote, 'la souche de ma posterité'.

Mayerne's two worlds – the world of the court and his grand patients, and
his private world of immigrant European Calvinists – were easily compatible
in the reign of James I, 'mon bon maistre', whom he always revered. James I
liked unorthodox intellectuals, Hermetic doctors, even quacks, and he saw
himself as the patron of international Protestantism. He also liked amateur
diplomacy and found Mayerne very useful as an unofficial, often secret agent
abroad: he sent him as an emissary to Huguenot grandees and allowed him
to be the accredited agent in England of the city of Geneva and the republic
of Berne. But under Charles I things changed. Charles did not like interna-
tional Protestantism, or amateur diplomacy, or unorthodox intellectuals, or
Hermetic ideas. As his doctor he preferred Dr Harvey, who, as Aubrey
would note, 'did not care for chymistry' and spoke slightingly of chemists.
For chemists read Mayerne.

An ominous sign of the change came when Charles I, soon after his accession, refused to allow Mayerne to revisit his recently acquired Swiss castle of Aubonne. At first he merely put him off; but when the applications were renewed, he was firm, and in 1633 he positively forbade Mayerne to raise the matter again. Mayerne's medical services, he explained, were essential to him. In fact Charles I himself very seldom called on those services, and we may suspect that there were other motives: that the king was determined to keep this international busybody, with his cosmopolitan contacts and Calvinist loyalties, under control. However, the queen was devoted to him: he had a way with queens and great ladies generally. It was mortifying to the French court when Henrietta Maria, who had been sent to England with a mission to propagate the Catholic faith, meekly agreed to her husband's summary dismissal of the sound Catholic French attendants who had been imposed upon her, but refused to part with her heretical French physician. And Mayerne was compensated for the ban on his foreign travel by the grant (in partnership with the queen's Catholic doctor) of a monopoly of distilling. So appearances were kept up – for a time.

The crisis came with the dramatic political changes of 1640–1 and the ensuing Civil War. Dr Harvey then loyally followed the king to Oxford, where he would be rewarded with the Wardenship of Merton College. Mayerne made his excuses and stayed firmly in London. He had recently bought a new house in Chelsea; he would not have felt at home in Oxford; nor, I think, would he have been a successful head of a college, presiding over Laudian, ultra-royalist Fellows. He claimed that he was now too corpulent to move, but this cannot be strictly true, for in 1644, on receiving a peremptory order from the king, he trundled by coach down to Exeter, where the queen, expecting the birth of a child, was seriously ill. Otherwise he remained in Chelsea, attending his rich patients, continuing his chemical experiments, and accepting a parliamentary commission to look after the health of the younger royal children, who had been left in London.

It is true that on two occasions he threatened to emigrate in disgust to France or Holland, and made elaborate plans for the journey. But that had nothing to do with politics: it was a protest against a decision of the Parliament that he was liable to its new war taxation. When his taxes were remitted, he withdrew his threat and stayed in London. He accepted the *de facto* rule of the Parliament, hoping for a peaceful settlement. When these hopes were dashed by the outbreak of the second Civil War, he planned once again to emigrate, but he did not do so. No doubt he felt too old to move. He accepted the Republic and was pleased when Oliver Cromwell, as

Protector, renewed the old links with Geneva and the Protestant cantons of Switzerland.

Mayerne's attitude during the Civil Wars and Revolution was censured by some. He was said to have deserted the king and gone over to his enemies. It is true, no hint of royalist sympathy escaped him, and in a formal document he claimed that he had constantly demonstrated his good affection to the Parliament. In the critical months of 1648–9 the queen said that his name had become odious to her – although afterwards, for some reason, she relented. But in fact he was consistent. He was a patrician Calvinist, in English political terms a 'Presbyterian', a Whig. The private world in which he chose to move was not cavalier. Some members of his household were more radical than he. His second wife, the daughter of the resident Dutch ambassador, became the patroness of revolutionary Anabaptists. In the congregation which she supported was her husband's godson and *protégé*, Théodore Naudin, the son of his trusted apothecary in Paris: he would be involved in a conspiracy to overthrow the Protectorate – in the interest not of the king but of the radical 'Saints'.

So much for the author. What now of his famous manuscript? How does it fit into this career or express these interests?

First, it should be said that there is nothing eccentric in Mayerne's interest in the techniques of painting and decoration. The function of a physician at that time, and especially of a chemical physician, was not narrowly specialised, and many physicians had experimented with pigments, jewellery and the decorative arts. In medieval monasteries, the same dispensaries had supplied both paint and stained glass for the chapel and ointments, drugs and plasters for the infirmary. Many earlier manuscripts contain, indiscriminately, like those of Mayerne, recipes for both such categories. The de Ketham manuscript of the fifteenth century – an important source for pigments – was evidently compiled by a physician.[9] Other physicians – Richard Haydocke, John Bate – interested themselves in artists' pigments and varnishes. Mayerne was operating within a recognised tradition. The question for us is simply, how and when and in what particular circumstances did he discover this interest and decide, in the course of an exceptionally busy career as physician, chemist, courtier, diplomatist and entrepreneur – for he was all these – to devote time and energy to personal research in it?

As far as we can tell from the evidence, it was a comparatively late discovery. No early document suggests it. In his notes on his grand tour of

1599–1600 he mentions a few pictures – a fine painting by Dürer in Frankfurt am Main and the works of the Bassano family at Bassano; and in Schwatz in Tyrol he notes deposits of 'Bergblau' – that is, the azurite or blue bice which provided painters with their most popular blue pigment: an experience which he would recall later in his manuscript.[10] But these are perfunctory comments such as any tourist might make. It was in 1620 that he drew the elaborate title-page of that famous manuscript, and no observation on the decorative arts either in that volume or in any other of his manuscripts that I have seen bears an earlier date.[11] But from then onwards there are dated entries for almost every year until 1646. It seems, therefore, that Mayerne took up the study of art, and directed his chemical experiments into its materials and methods, only in middle age; for in 1620 he was forty-seven years old.

One other fact may deserve mention at this point. Among Mayerne's surviving papers there is one (and, as far as I have noted, only one) document which demonstrably came from his father. This is MS Sloane 2057, which is a translation into French, by 'Louis de Mayerne, dict Turquet', of the first part of Giorgio Vasari's *Lives* of the great painters – that is, of the introductory chapters on 'the three arts of Design: Architecture, Painting, and Sculpture'. These chapters have often been treated as a separate work: Vasari's *Lives* have generally been printed without them. This manuscript is in Louis de Mayerne's own hand, and is complete in itself, with illustrations and a much-corrected draft dedication by the translator to 'M. de Roaldès' who, we are told, had suggested the work. The dedicatee is almost certainly François de Roaldès, a distinguished jurist whose scholarly interests and liberal religious views made him a friend of Jacques Auguste de Thou and Joseph Scaliger. Roaldès had been in Lyon in 1572 and had probably known Louis de Mayerne there. He died in 1589, so the dedication was written before that date. But – perhaps because of that death – the translation was not published and was still in manuscript when Louis de Mayerne himself died in 1618. There is also, among Mayerne's papers, a fair copy of this translation, complete with the corrected text of the dedication and an index, ready for publication (MS Sloane 2001). Presumably Theodore de Mayerne acquired the first of these documents – perhaps both of them – when he went to Paris to deal with his late father's affairs. Perhaps he himself caused the fair copy to be made, intending to publish it. In any case he was clearly interested in it, for, in his father's holograph copy, he inserted marginal notes including a long note correcting Vasari on the chemistry of niello work.

Perhaps it was this document which stimulated Mayerne to further work in the same subject. The title which he gave to his own manuscript, 'Pictoria Sculptoria et quae subalternarum artium . . .', echoes Vasari's division of the arts, and the first entry in it also points indirectly at him: 'Quaeratur liber tractans de Pictura cui titulus est *Il Riposo di Raphael Borghini fiorentino*.'[12] Raffaele Borghini was the nephew of Vincenzo Borghini, prior of Florence, who was Vasari's most intimate friend, and his *Riposo*, published in 1584, is a treatise, in the form of an imaginary dialogue, on the technology of the arts: in effect, a companion volume to the work of Vasari. In one of his marginal notes to his own manuscript, Mayerne refers enigmatically to his father's book – *ex libro patris mei* – which presumably means his father's translation of Vasari.[13]

However that may be, having drawn his title-page, Mayerne set to work to collect his own material. He must have started promptly, for there are several contributions from Paul van Somer, the court painter of James I and Queen Anne, who died early in January 1621; but Mayerne knew him as a neighbour – they both lived in St Martin's Lane – and had seen him as a patient in the autumn of 1620,[14] and perhaps before.

From then on Mayerne collected detailed information wherever he could find it, on priming, pigments, oils, varnishes, repair and conservation. Sometimes he used printed sources: the German *Illuminierbuch* of Valentin Boltz von Rufach, the *Secreti Universali* of Timoteo Rossello, the popular work of the mysterious Alexius Pedemontensis, the *Chirurgia* of Paracelsus, Gerard's *Herbal*; sometimes artists' and manufacturers' manuals, or merely 'an old manuscript'. But his best information came from living sources: not only painters, engravers, miniaturists, but 'subaltern' workers: apothecaries, goldsmiths, clock-makers, cabinet-makers, artisans of all kinds, most of them, like the artists for whom they worked, Dutch, Flemish or French Huguenot immigrants to London.

Some of these men, like van Somer, were his patients – them he could question from a position of strength: he had them at his mercy. One Bouffault, for instance, 'très excellent ouvrier', yielded his 'secrets' concerning the laying of gold-leaf on glass, terra-cotta and stone, when dying.[15] Sometimes the roles were reversed. John Hoskins, painter and miniaturist – 'pictor et illuminator nulli secundus', Mayerne called him – was indeed a patient, but it was while he was engaged in painting Mayerne's portrait that he explained some of the mysteries of his art: on the composition of his colours, especially the best white paint, and the secret method whereby Holbein ensured that his silver paint would not be blackened by exposure to

the sun; 'and in fact', he added, 'look at Holbein's portraits: they are a century old, but the silver looks as if it was laid on only two days ago'.[16] Mayerne had many conversations with Hoskins in 1634–5, and it was through him, and at his studio in Bedford Square, that he met Hoskins's young nephew, who would afterwards eclipse his uncle as a miniaturist, and from him learned 'tout le secret de l'enluminure'.[17]

In 1629, when Rubens came to London as the ambassador of the King of Spain, Mayerne, like Charles I, saw and seized his chance. He commissioned a portrait of himself – the splendid portrait which Rubens sketched in London and completed in Antwerp, and which is now in Raleigh, North Carolina (fig. 76). While he sat for it, Mayerne obtained some useful tips on the master's technique: how he preserved the fluidity and vitality of his colours by dipping his brush lightly, from time to time, in spirits of turpentine, and what drying oil he used to render his varnish waterproof. Waterproofing, whether of works of art or other objects, was a problem of much concern to Mayerne. One of his sources – Captain Salé, a versatile military man in the service of the Duc de Soubise – invented (among other things) a means of waterproofing the ducal gaiters: which also found its way into Mayerne's manuscript.[18]

Rubens spoke to Mayerne, as he usually wrote, in Italian, and Mayerne recorded his statements in that language. In general he quoted his informants in the language which they used to him. The Fleming Cornelius Janssen ('bon peintre'), having become English as Johnson, spoke and was recorded in English. Van Dyck, who arrived in England to stay in 1632, varied fluently between French, Italian and Dutch. Daniel Mytens, who succeeded van Somer as court-painter and was displaced in turn by Van Dyck, and who was easily accessible to Mayerne since he too lived in St Martin's Lane, used French. 'M. Sorreau, en allemand Sorg' – that is, Hendrik Martens Zorg, a pupil of David Teniers – varied between French and German.[19]

Van Dyck and Mayerne, the greatest painter and the grandest doctor at court, had close personal relations from the start. Mayerne even invited Van Dyck to try his own special varnish, to be mixed with the colours on the palette 'in the manner of Gentileschi' – that is, of Orazio Gentileschi, that 'excellent peintre florentin' who was another of his informants. Charles I had persuaded Gentileschi, then an old man, to come to England and Mayerne was impressed by his special green pigment – as also by the work of his talented daughter Artemisia. She lived mainly in Rome and Naples, as famous (we are told) for her gallantries as for her pictures, of which,

76 Sir Peter Paul Rubens, *Sir Theodore de Mayerne*

Mayerne wrote, 'I have seen several'; for she spent the years 1638–41 in England. Van Dyck did not take to Mayerne's varnish: he found it too thick, impeding the flow of colour, and was not persuaded by Mayerne's offer to improve it by the addition of oil. Mayerne and Van Dyck had other interests in common. Both were keen alchemists. Both conducted experiments with their common friend Sir Kenelm Digby; and Van Dyck, while in England, married the daughter of the Scottish alchemist Patrick Ruthven, another neighbour of Mayerne in St Martin's Lane and a source of many of his alchemical formulae.

Two men who played a part in bringing Van Dyck to England were Nicholas Lanier, the Master of the King's Music – 'excellent musicien', says Mayerne, 'qui se plait a la peinture' (and one of Artemisia Gentileschi's many lovers) – and Lanier's brother-in-law Edward Norgate, the miniaturist and herald who was also employed at court as illuminator of royal missives to exotic oriental monarchs. It has been said that it was Van Dyck's portrait of his friend Lanier which determined Charles I to capture such an artist, and when Van Dyck duly arrived in England, it was Norgate who was his first host. Both Norgate and Lanier were friends of Mayerne, and Norgate has left an account of their co-operation. It is in the dedication of his long-unpublished work, *Miniatura, or the Art of Limning*.

'There are now more than twenty years passed', Norgate wrote, some time in the 1640s,

since, at the request of that learned physician Sir Theodore Mayerne, I wrote this ensuing discourse. His desire was to know the names, natures and property of the several colours of limning commonly used by those excellent artists of our nation who infinitely transcend those of his; the order to be preserved in preparing and manner of working those colours so prepared, as well for picture by the life as for landscape, history, arms, flowers, etc.; and that *propriis coloribus* and otherwise as in *chiaroscuro*, a species of limning frequent in Italy but a stranger in England.

It was 'to gratify so good a friend, so ingenious a gentleman', that Norgate wrote his book, which is second only to Mayerne's manuscript as a source-book for the artists' pigments of the time.[20]

Another artist with whom Mayerne was to be involved, and who would owe much to his patronage, was the famous French miniaturist Jean Petitot. Petitot, like Mayerne, had been born in Geneva, of *émigré* Huguenot parents. He had been trained as a goldsmith and then spent two years in Paris, perhaps in the shop of Jean Toutin, a Huguenot goldsmith from Chateaudun and Blois. Toutin is well known as having revived and

improved the art of enamelling on gold – an art which had been practised in Limoges in the sixteenth century but had been disused. Toutin revived it with a difference: instead of triptychs, goblets and dishes with clear enamel, he produced watches and boxes with decorative patterns or flowers painted on opaque enamel. This technique Petitot acquired, and about 1635 he came to London, no doubt attracted by the reputation of Charles I as a patron: it was in 1635 that Jean Toutin's son Henri executed the first signed and dated enamel portrait of Charles I.

In London, Petitot presented himself to the royal jeweller who gave him rings and other ornaments to enamel. This he did with such skill that the king sent for him and, recognising his talents, suggested that he might produce portraits in enamel. He was referred for guidance on portraiture to Van Dyck and for the technical problem to Mayerne. The problem was one of colour: there was a limited range of colours which could be vitrified and a red suitable for the human complexion was not one of them. Petitot was established as one of the queen's household and lodged near Mayerne in St Martin's Lane; by 1640 Mayerne had developed, from calcined peroxide of iron, a new red pigment which solved the problem; and Petitot, using Mayerne's pigments as colouring and Van Dyck's portraits as models, went on to become the greatest portrait enamellist of his time.[21]

Petitot also perfected, while in England, a new method of enamelling on copper. Since he gave this valuable 'secret' to Mayerne, who described it in detail in his papers, it too was presumably worked out in collaboration with him.[22] Petitot already owed much to Mayerne and may have made the enamelled miniature of him now in the National Portrait Gallery in London[23] (fig. 77).

Jean Petitot was joined in London by two compatriots from Geneva: his brother Joseph, described by Mayerne as 'sculpteur' – a very loose term which covered engraving and most of the 'subaltern' decorative arts – and his collaborator in enamel-work, Jean Bordier, who afterwards became his brother-in-law. Mayerne worked closely with both these men, especially with Joseph Petitot, with whom he carried out research and experiments in the gilding of leather, a subject of apparently consuming interest to him. In 1640, when Bordier was in Italy and was arrested by the Inquisition in Milan, the city of Geneva appealed, as it had often done before, to Mayerne. Mayerne went into action at once. He sought to mobilise the crypto-Catholic secretary of state, Sir Francis Windebank, to put pressure on the Spanish ambassador, and, when that failed, appealed to the queen. The queen sent for the pope's agent at court, Count Rossetti, and, through him,

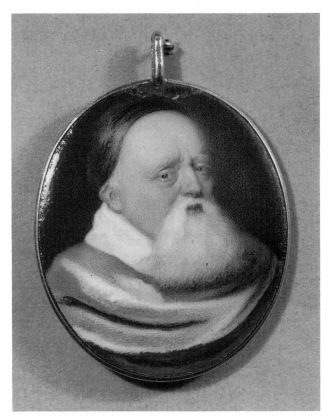

77 Jean Petitot (attributed), *Sir Theodore de Mayerne*

begged the pope's nephew, Cardinal Barberini, as 'protector of England', to
intervene. Bordier, she said, was her servant 'and also a great friend of her
chief physician, whom she desires to please'. The result was satisfactory.
Bordier, she was told, had now 'escaped' from prison: no doubt a tactful
compromise which saved faces all round.[24]

Joseph Petitot also benefited from Mayerne's patronage: in 1644 he would
write to him from Geneva expressing his gratitude for 'les infinies obliga-
tions que j'ay receu de vostre personne', and repaid him by freely passing on
the discoveries he had made abroad.[25]

As well as giving technical information about artists' methods, Mayerne's
manuscript opens a window into the artistic underworld created by the
patronage of Charles I and his court: the mobilisation of craftsmen, the
creation in London of a new economic activity, the convergence there of
groups of immigrant artisans, the diversion of the royal apothecaries, largely

under the influence of Mayerne, into the search for pigments and varnishes. Mayerne watched the building-up of the great royal collection – many of its organisers, like Sir Isaac Wake and Nicholas Lanier, were his patients and friends – and was able to see the state in which some of the best paintings from the great Mantuan collection arrived in England. The ship which brought them, he had observed, had carried a cargo of currants and several barrels of mercury sublimate; the fermentation of the former had vaporised the latter; and the pictures were found, on delivery, to be 'as black as ink'. A painter, unnamed by Mayerne, but in fact Jerome Lanier, the cousin of Nicholas,[26] undertook to clean them. He succeeded well enough with the oil paintings, but not with those in tempera: soap did them no good. Mayerne believed that he himself could have done better. His manuscript contains many recipes for the cleaning and restoration of paintings discoloured by time or dirt, carefully checked by experiment, as also for the bleaching and repair of prints, derived from 'Mark Antony, peintre bruxellois', from the royal apothecary Louis le Myre, and from M. Anceau, a bookseller in the Huguenot citadel of Sedan. Mayerne himself had visited Sedan during the crisis of French Protestantism in 1621–2 – its prince, the Duc de Bouillon, the political strategist of the Huguenots, was his patient – and Anceau visited London, and gave him his 'secrets', in 1631.[27]

Such is some of the incidental information supplied by Mayerne. Not all of it comes from the famous manuscript on which art historians have generally concentrated their attention. To discover the evidence of Jean Petitot's enamel work with Mayerne, for instance, or of John Hoskins's portrait of Mayerne (hitherto, I think, unrecorded), or of the 'secret of Holbein', we must look elsewhere. These and many other such items of information, though often headed 'Pictoria' or 'Sculptoria' or 'Tinctoria' as if destined for ultimate inclusion in that volume, are to be found in other manuscripts, sometimes grouped together under another majestic holograph title (and then, inevitably dwindling away into miscellaneous jottings), sometimes half-buried among medical nostrums – just as medical nostrums sometimes creep irrelevantly into 'the Mayerne MS.'.[28] Since these other manuscripts have been overlooked by all the editors of 'the Mayerne MS.', let us look briefly at them.

The most important and least incoherent of these secondary manuscripts, as we may call them, is MS. Sloane 1990: a volume which was identified as coming from Mayerne in the 1840s, but which then sank out of sight, eclipsed by the more spectacular MS. 2052, until it was rediscovered by A.E. Werner in 1964.[29] But many other manuscripts deserve to be

considered, and some artistic material has even strayed into Mayerne's
'Ephemerides', the formal medical records of his patients and their treat-
ment.[30] I have already mentioned some of the details supplied by these
sources. Others show Mayerne's quest for a new scarlet pigment (scarlet, he
observes, on the authority of the books of Exodus and Leviticus, is different
from crimson), for the orange-red colour 'Nacarat', and for a new red dye
for silk from cochineal; his method of extracting such a pigment from
poppy-heads; his account, derived from the Belgian painter Mark Antony, of
'the true secret of ultramarine', that inimitable but expensive blue pigment,
made from powdered lapis lazuli, which kings rationed so carefully to their
painters; and the personal demonstration of pen-and-ink portraiture given
to him by that skilful artist in mezzotinto who visited England in 1637, the
young Prince Rupert of the Rhine.[31]

These are the higher arts; but since chemistry is indivisible, they are often,
in Mayerne's manuscripts, intermingled with, even swamped by, the
'subaltern arts' from which, historically, they developed and on which they
depend. So we learn much also about marquetry and gilding, glass-work,
tapestry, dyeing, Chinese lacquer, porcelain, imitation jewels, upholstery,
waterproofing, the concotion and erasure of coloured inks; and beside the
famous names of Rubens and Van Dyck, van Somer and Mytens, Callot and
Vorsterman, Briot and Petitot, Hoskins and Cooper, we find dozens of
obscure copy-painters, jewellers, apothecaries, dyers, clock-makers and
book-binders, generally with French or Dutch names: the immigrant or
itinerant artists among whom the grandest doctor in Europe was perhaps
more at home than among his obsequious and profitable patients, the insou-
ciant, spendthrift courtiers of James I and Charles I.

With these men Mayerne was a different person, a fellow workman in his
shirt-sleeves, at the furnace and the crucible. For he did not merely listen
and question: the text of his manuscripts is accompanied by an intermittent
marginal commentary which shows his constant supervision and frequent
participation in the practical tests and experiments there recorded: 'Vidi',
'Feci', 'Expertus sum: optimum', 'inventum meum', 'Mayerne inventeur',
or, alternatively, 'falsum est: expertus sum', 'ce procédé n'a pas réussi',
'mauvais', 'fantaisie', 'ne vault rien. casse'; or perhaps only his Greek motto,
σὺν θεῷ or οὐκ ἀτὲρ θεοῦ, or his own red ink and monogram, to show his
proprietary interest. Many of his documents are written or copied by aman-
uenses, of whom he employed several, most of them, like himself, rather
untidy in their records. Perhaps it would have been better, at least for us, if
he had had a single powerful secretary to organise these disorderly notes;

but the personality and the methods, or lack of method, of the formidable master imposed themselves on the docile, colourless disciples: all of them Protestants, of course, mostly from Geneva, drawn by his patronage, or 'the *débris* of La Rochelle', rescued by him from the Huguenot *débâcle* of 1628.

The most constant of these disciples was Jean Colladon, a member of a well-known professional family in Geneva. Mayerne brought him to England in 1631, as a kind of apprentice, trained him in medicine himself, and having obtained for him, by royal mandate, a doctorate of medicine at Cambridge, took him personally to Norwich in 1636 and placed him there, for a time, under the eye of his own former apothecary. He treated him as an adopted son (his own sons being unsatisfactory), addressed him as 'mon enfant', married him to his own niece, and established him as a royal doctor under himself. Colladon served him as amanuensis, agent, messenger, general factotum to the end of Mayerne's life, and carried out research and experiments for him, especially in mechanical matters, which perhaps interested him more than medicine. His name is attached to the record of most of Mayerne's non-medical experiments. However, that does not imply independence. Colladon was not an independent character. The experiment may have been set up, and the record kept, by him, but the old maestro is always in command. The final report is checked, authenticated, initialled by Mayerne.

The existence of these two distinct sets of documents – the more or less orderly, largely holograph fair copy, assembled under the formal title 'Pictoria Sculptoria' etc, and the scattered notes, mainly by his amanuensis, but authenticated by him, which extend and supplement it – poses a question. What was the relationship between them? Comparing the two categories, we see that although some of the experiments recorded in the notes have left no trace in the 'de Mayerne manuscript', others are clearly reflected in it: indeed, some of Colladon's notes have passed almost unchanged into Mayerne's text.[32] We also note that the name of Colladon, which hovers constantly round the former, is almost totally absent from the latter,[33] which shows that he is acting merely as Mayerne's agent. Evidently the notes are raw material for the volume. If they were not all incorporated in it, that may have been through lack of time or opportunity; or perhaps Mayerne was awaiting further evidence in a continuing enquiry. Thus the investigations in which he was engaged with Joseph Petitot in the gilding of leather continued over a considerable period: it was a question of penetrating the closely guarded secrets of the Flemish artists.[34] Mayerne too had secrets to protect. His discoveries with Jean Petitot in enamelling were one: 'notés', he

had recorded, 'que ceste façon de préparer les esmaux est particulière à nous et ne doibt estre divulguée'; and his note on the discovery of the method of enamelling on copper is emphatically headed 'secret de M. Petitot, inventé le 28 Octobre 1640'.[35] Petitot, as an enamellist, is not mentioned in 'the de Mayerne manuscript'.

Of course Colladon was not the only such assistant: he did not arrive in England till 1631, eleven years after Mayerne had begun his enquiries, and he was often absent thereafter: in Aubonne, as Mayerne's agent, in 1632, in Norwich, as a physician, in 1636–7, in Geneva in 1637, in France in 1643–4, and again in 1646. But even when away from London, he was generally engaged on Mayerne's business and always under his orders. In Norwich he carried out experiments for Mayerne, and he reported to him from France – as Joseph Petitot did from Geneva – on the progress of his researches. In fact, we can envisage Mayerne as the head of a research team – something like a modern scientific professor. He began by conducting his own research, himself questioning the artists to whom he had access; later, when he was old and immobile, he relied also on others – pupils and assistants whose reports were collected and recorded for him by his understudy and secretary, Colladon. But to the end he participated personally in chemical experiments: his house in Chelsea was his laboratory.

Mayerne's method is illustrated by two comments in what appears to be a supplement or appendix to his famous manuscript (for it is written by himself throughout, with a majestic heading in his special red ink). The first comment, in French, was on a report from Joseph Petitot. 'In these first accounts', it runs 'there are many ideas which are faulty, and some which are false, but I nevertheless note them to show that knowledge of the arts does not advance everywhere at once, but little by little, and painfully, and also so that we do not fall back, with loss of time and money, into uncertainty, repeating many experiments which have already failed.' The second comment, in Latin, is on a report from Colladon: 'Note that both here and later, many details, drawn from various discussions and observations, are set down in a confused and disordered manner, so that they may be compared with my notes, which are better digested, and so finally, out of various accounts, a settled and certain method of operation can be established.'[36] In other words, abortive or inconclusive experiments, and uncertain first impressions should be recorded as part of the process of investigation, but only when they have been tested by further experiment or examination are they fit to join 'my notes, which are better digested'. It is difficult to see what those

better-digested notes can be unless they are the more carefully assembled, though still imperfect holograph, 'Pictoria, Sculptoria'.

What then was the purpose of it all? When we look at all these non-medical experiments and investigations – these *mechanica extra medicinam* as Mayerne himself described them – we are astonished at their extraordinary range and the time and energy expended on them. Even in his old age, after 1642, when Civil War has dispersed the artists of Charles I's court – when Van Dyck is dead and Petitot and Bordier have returned to France – the indefatigable old physician is still at work, organising and recording research into the methods of dyeing silk and gilding leather, seeking to extract new pigments from tropical earths, plants, beetles, barks, and adding new notes to his 'Pictoria, Sculptoria'.[37] But to what end? He was not himself an artist, or a craftsman: he did not intend to exercise the arts which he studied. Did he then seek the profits of commerce in his inventions? He was certainly fond of money and looked for pickings from industry – some of them very surprising – but it is difficult to detect an economic motive here. Rather, it seems that he was animated by a real thirst for knowledge and a desire to leave a record of the chemical discoveries to which he had been inspired by the teaching of Paracelsus and which he had now realised in both medicine and the arts. He would write a book.

That Mayerne hoped to leave a record of his chemical researches is clear from his medical manuscripts. Among them are drafts, outlines, *schemata*, elaborate title-pages. There are also some explicit statements. If only he 'might be allowed some respite from these duties at court', he wrote to the famous German surgeon Fabricius Hildanus in 1620, he would write up his medical discoveries; but at present it was impossible: he could only leave 'unformed births, to be licked into shape by more skilful writers'.[38] However, even as he wrote, he saw a possibility of escape; for in the same letter he wrote that he was now in full legal possession of his castle of Aubonne. It was a great relief, he told another friend, to have acquired 'un chez-soy dans quelque coing du monde'.[39] In other letters he sang the same tune. He was disillusioned, he wrote, with court life – a royal doctor was a mere pack-horse – and now, 'in the autumn of my age', he sighed, as his old friend du Chesne had sighed, for the freedom and leisure of life in a republic. 'At least', he wrote in 1629, 'I shall live a free man in Switzerland, to which I shall retire in order to give to the public what I have owed it so long';[40] and again, next year, to his Huguenot friend Dr Monginot in France, 'it is high time for me to take up my pen if I wish to leave to

posterity some of my dearest children – that is, the fruits of my genius – as my conscience dictates, and as my friends invite me.'[41]

Here, of course, he was thinking of his medical works, for it was as a physician that he had made his fortune and his fame. But medicine and the decorative arts were to him inseparable. Both were applications of the same science of chemistry, and his notes on both subjects follow the same method – observation, cross-examination, 'speculation', experiment – and are expressed in the same form: the same scrupulous acknowledgement of source, where derivative, and the same proprietary symbols where original. If he could have written a book on medicine, to establish and claim his discoveries there, no doubt he would have done so, and done the same for his artistic discoveries too. But he could not. In both areas he revealed the same defect: an inability to impose a final form. So, to the end of his life, his notes continued to grow. Periodically, he would seek to arrange them in formal style, promising a work of synthesis. But always other pressures intervened to prevent its completion, or the impetus ran out. When he died, they were still 'unformed births' waiting to be 'licked into shape'. But who would lick them?

Not his heirs. When he died in 1655, at the age of eighty-three, active to the end, he left a huge fortune, a mass of papers, and – inevitably, since his widow and his only surviving child followed him quickly to the grave – a series of lawsuits. In the end, the bulk of his property, including his papers, was secured by the Colladons. After the Restoration, Colladon became physician to Charles II and was knighted, but we hear very little of him. He evidently thought of publishing Mayerne's works, but when he died in 1675, nothing had appeared. Finally, after another of Mayerne's amanuenses, his godson Sir Theodore de Vaux, also a Huguenot and a physician, had published a selection of his papers, from his own copies, Colladon's son, Sir Theodore Colladon (another godson) was moved to act. He allowed some of the original papers, which he had now inherited, to be used for an official but slovenly edition of Mayerne's *Opera Medica*, which appeared in 1700. Sir Theodore Colladon died in 1712, as physician of Chelsea Hospital. His papers were then acquired by the fashionable doctor and new squire of Chelsea – the Mayerne of his age – Sir Hans Sloane. At Sloane's death, in 1753, they came to the British Museum, newly founded to receive them. By this time they were of reduced interest to the medical world. Chemical medicine had by then been absorbed, and Hermetic medicine was out of fashion.

So much for Mayerne's medical manuscripts; but what of those on the

arts, and particularly, of course, 'the Mayerne MS', 'Pictoria Sculptoria', etc.? Their history would be very different. They took far longer to emerge from the *oubliette* to which they had been consigned on Mayerne's death, but when they emerged, they would have a far longer life.

For the first century after Mayerne's death, nothing was publicly known in England about his artistic interests. No doubt this was partly due to the great caesura of the Revolution, which so rudely broke the continuity of artistic tradition in England, but partly also to his own double life. Although he moved easily in the best society – he was a *bon vivant*, who kept a good table (for he studied the culinary as well as the decorative arts) and he wrote excellent letters – his relations with his English patients were essentially professional. To them he was merely the great court doctor; his private artistic interests were known only in a restricted circle of artists and artisans, mainly foreign. Even the connoisseurs of art said nothing about them. In 1651–2 Richard Symonds, having returned to England from Italy, pursued the scattered relics of Charles I's collection and sought information on artists' techniques. Some of the artists whom he questioned had given information to Mayerne, who was still living in Chelsea.[42] But Symonds, in his notes, does not mention him. Sir William Sanderson, having been bred up at the court and employed in the diplomacy of James I, had had opportunities of knowing Mayerne personally; but in his book, *Graphice*, on the art of painting, published three years after Mayerne's death, he said nothing about him. That great virtuoso, Sir Kenelm Digby, a patient, friend and collaborator of Mayerne, exchanged many chemical secrets with him. He too was an early patron of French portrait-enamellists, and may even have inspired Charles I's interest in them.[43] Afterwards, in a famous lecture in Montpellier, he would boast of his intimacy with Mayerne.[44] But he too showed no sign of having known his artistic interests. Even such an amateur of the arts as John Evelyn, who was twenty-three when Mayerne died and seems to have known him,[45] and who himself wrote a book entitled *Sculptura*, on engraving, never commented on this precursor. The only English contemporary to record Mayerne's interest in the arts, the miniaturist Edward Norgate, did not live to publish his tribute, which remained unprinted until 1919.[46] By 1700, when Mayerne's medical works were published, his artistic interests had been totally forgotten in England.

However, in France it was different. There Jean Petitot, at the court of Louis XIV, remembered his debt to Mayerne, and from his family circle the story of their co-operation passed to his eighteenth-century biographer and so, in 1752, found its way into print. The first mention of it is in Dezallier

d'Argenville's *Abregé de la vie des plus fameux peintres*.[47] From this source it escaped back into England. It had been unknown to that scrupulous antiquary George Vertue and so to Horace Walpole when he first published his *Anecdotes of Painting* in 1762. But an anonymous correspondent alerted Walpole, who inserted a notice of it in his next edition (1767). This, however, merely recorded the limited personal revelations of Petitot: his previously undocumented period at the court of Charles I and his contact there with Mayerne. Mayerne's own manuscripts, which revealed the far wider range of his patronage and research, were still buried in the vast uncatalogued collection which had passed through the hands of the Colladons and Sloane to the British Museum.

The event which ultimately, if indirectly, brought them to light, and began the posthumous history of 'the Mayerne MS', was the fire which destroyed the old Palace of Westminster in 1834. This disaster, and the consequent building of the new palace, offered a great opportunity for the application of Vasari's three arts of architecture, sculpture and painting: an opportunity which was grasped by a group of radical utilitarian members of Parliament, eager to revive a native school of art and to engage in it the interest of the working class. At the instigation of this group, in 1841, the government of Sir Robert Peel, himself a great patron and connoisseur of painting, set up a Commission on the Fine Arts, with the Prince Consort as chairman and the painter Charles Eastlake as secretary. One of its instructions was to consider the possible use, in the new palace, of fresco painting, as 'the highest branch of the visual arts'. In its first report, largely the work of Eastlake, the Commission faced this problem, but expressed doubts about the answer. The art of fresco painting, it declared, 'depended on some technical advantages which have been lost' and which must be recovered before it could be revived.[48]

The result was a great spurt of organised historical research, the first systematic study of the technology of art in England. A pressure group set to work; evidence was demanded; and Eastlake himself was invited to collect it. A team was organised, documents sought out and published. In 1844 the work of the fifteenth-century Florentine Cennino Cennini, recently printed in Italy, was translated and published. The translator, Mrs Merrifield, was then sent to Italy to seek other early treatises, especially on fresco painting. Meanwhile, the treatise of the medieval monk Theophilus, discovered and printed by the German Erich Raspe in 1780, was edited by Robert Hendrie. The culmination of this research was a report by Eastlake himself which, on the advice of the Prince Consort, was published separately in 1847, and

dedicated (as Mrs Merrifield's treatise would be) to Sir Robert Peel. This was the first volume of Eastlake's classic work, *Materials for the History of Oil Painting*. In this he revealed, as his most important new source, a manuscript which 'Mr Robert Hendrie junior . . . has been fortunate in bringing to light from among the treasures of the British Museum . . . the manuscript of Sir Theodore de Mayerne.'

Eastlake quoted many extracts from 'the de Mayerne manuscript', but only to add that these extracts, 'numerous as they are, give but an imperfect idea of the value of de Mayerne's notes'. If he did not expand further on the manuscript, that, he explained, was because Mr Hendrie, its first discoverer, who had liberally communicated it to him, 'has stated that he intends to publish the entire work', so that 'its contents need not be further anticipated here'. Two years later, in his new edition of Walpole's *Anecdotes of Painting*, R.N. Warnum referred to the Mayerne manuscript, shortly to be published in full by Mr Hendrie, and this note was reprinted in each subsequent edition of the work. As late as 1888 readers were encouraged to expect the imminent appearance of Mr Hendrie's edition. It would never appear. By that time the original impetus had passed. The frescoes for the new Palace of Westminster, the principal purpose of the research which had incidentally uncovered the manuscript, had already been executed. They were not a great success and were already being replaced: a sad disappointment to those who had expected them to be 'the means of forming a great school of painting in this country'.[49]

However, if Mr Hendrie's ghostly edition had effectively blocked the publication of the Mayerne manuscript in England, the foreigners, to whom he had always been more sympathetic, once again came to his support. In 1902 a German painter, Ernst Berger, convinced that Mayerne was more important, because more detailed and exact, than his better-known predecessors Vasari and van Mander, published the full text of his manuscript, with a German translation and erudite notes. Unfortunately the very fidelity of Berger's transcription – the only complete transcription ever published – made it virtually unreadable: it reproduces all the disorder of the original. It is also virtually inaccessible, buried in an obscure German technical publication.

These criticisms were made, severely enough, fifty years later by the first person who sought to do what Mayerne had been unable to do for himself: to lick his 'unformed births' into a coherent shape. This was the Dutch scholar J.A. van de Graaf, who published his thesis on 'the de Mayerne manuscript' in 1958. Berger's text, said van de Graaf, leaves an impression of

chaos and is unintelligible to anyone who is not already familiar with the original. So, as an appendix to his thesis, he broke up Mayerne's material – or rather, that part of it which concerned oil painting to which he confined his interest – setting out in turn Mayerne's observations on the various stages of production: the support of the picture, the priming, the pigments, the oils, the varnish. By this method he documented his thesis that Mayerne, by recording the tradition and practice of the artists' studio, as communicated directly from master to pupil, served painting better than the humanists of the Renaissance who, by elevating it into a liberal art, severed it from its essential, technical base.

The German edition of Berger and the Dutch edition of van de Graaf were works of pure erudition addressed to specialist scholars. In this respect they differed from the publications inspired by Eastlake which had a practical aim. With the next, and latest, edition of the Mayerne manuscript we find ourselves back in the world of Eastlake; and, as in the case of Eastlake, it rested on a misconception. Eastlake's publications, and proposed publications, were initially inspired by the desire to restore the art of fresco painting, of which Mayerne in fact said almost nothing. The French edition of the Mayerne manuscript, to which I now come, was inspired by the wish to rejuvenate European art by recreating pigments ascribed – but wrongly – to Mayerne. In this story the part of the English painter, Charles Eastlake, was played by the French painter Louis Anquetin.

Louis Anquetin was a crusader. Inspired by high Platonic ideals and a deep distaste, not to say contempt, for all modern schools of art – for the romanticism of Delacroix and Géricault, the realism of Courbet, the 'absurdity' of the Impressionists – he preached, eloquently and compulsively, the doctrine of renewal by return to the Old Masters, 'les maîtres d'autrefois' celebrated by his hero Eugène Fromentin, and, in particular, to Fromentin's own hero, Rubens; for after Rubens, he believed, European art had lost both its unifying and vitalising philosophy and its traditional discipline: its technique, its formulae, its physical material – what he called its *matière picturale*. For how was it, he asked himself, that Rubens, and his pupil Van Dyck, could paint, with great speed, those splendid works in which a rich colour slid into transparency, revealing, but not merging into, the adjacent colours? With oil paint, which dries so slowly that the different colours have to be laid on in successive layers, it was technically impossible. Therefore Rubens must have possessed a secret formula, preserved in his studio but mysteriously lost by his incurious successors; and if the *métier* of painting was to be revived, that 'secret' must be re-discovered.[50]

Anquetin did not himself find this 'secret', but his eloquence and convic-
tion bought him disciples who did. One of them was Madame Camille
Versini, foundress and president of the Académie Anquetin at Nanteuil. She
would become the most active propagandist for 'the French Michelangelo'.
Another was Jacques Maroger, technical director of the Laboratory of the
Louvre. In 1930, the last year of Anquetin's life, Maroger believed that he
had discovered the elusive 'secret'. He had been led to it, he explained, by
'spectral analysis' of the paintings of the great masters – that is, by special
laboratory methods; but these findings had then been confirmed by a
scholarly study of the sources. The crucial source, he wrote, was 'the
contemporary manuscript of de Mayerne, *Pictoria Sculptoria et Quae
Subalternarum Artium*'. Maroger's 'secret' was communicated to a firm of
French chemists, who manufactured for him the pigments of the great
masters; and these pigments, we are told, having been seen and approved by
Anquetin, were appreciated and used by Augustus John and Raoul Dufy.[51]

Of the aesthetic judgements, the theories and the pigments of Anquetin,
Versini and Maroger, I am not qualified to write. For the purposes of this
essay it is enough to say that, unfortunately, the essential link in Maroger's
argument has proved weak. The vital sentence quoted by him from
Mayerne's manuscript is not in fact to be found there: it is a later observa-
tion of no authority mistakenly fathered on him by a modern writer.[52]
However, mistaken theories have often led to useful consequences, and one
of the consequences of Maroger's discovery was the publication, in 1968, by
the indefatigable Mme Versini and M. Marcel Faidutti, a chemical engineer
of Lyon, of a new edition of Mayerne's manuscript.[53] More accessible, and
better presented, than the edition of Berger, more complete than the
reorganised edition of van de Graaf, it gives – in spite of some omissions and
some errors of transcription – the best available representation of the struc-
ture, and the disorder of the original. In her introduction to it, Mme Versini
makes the purpose of the publication clear. It is not, like the previous
editions, to serve 'mere erudition', but to achieve 'direct action in the art of
painting itself, in our time': to restore the lost technique of the old masters.
Therefore it is illustrated not only by two portraits of Mayerne, but also by a
self-portrait of the modern master, Louis Anquetin.

This essay has concentrated on one part only of the life and work of
Mayerne. That part has outlived his medical work, for medical science dates
more quickly than art; but we should remember that, in his time, the
priorities were reversed. His fame then was as physician, the most admired

physician in Europe; his artistic interests were a private hobby known only to a narrow circle. Remembering this, perhaps I may conclude this essay by returning from technical and biographical minutiae to a more general question which was implicit in its beginning; why did Mayerne, in 1620, turn his attention to this subject, which had not previously engaged it, but to which thereafter he devoted such close and practical study?

He himself has left no hint. I have suggested that the discovery, in 1618, of his father's translation of Vasari may have stimulated his interest. That is mere speculation. But since we can only speculate, perhaps we may speculate a little further. For the years 1618–20 were a critical period both in public affairs and in the personal life of Mayerne.

In the summer of 1618 Mayerne went to France to settle (as he said) the affairs of his late father, but also with a secret commission from King James. Barely arrived in Paris, he suffered a terrible public affront. He was arrested and ordered to leave the country. No delay was allowed, no reason given. The affair caused a great diplomatic rumpus. Mayerne was outraged; King James was furious; diplomatic relations were broken, explanations and apologies demanded; but in vain. The French government stood its ground and said nothing. There can be no doubt that Mayerne was suspected of intrigue with the Huguenot grandees, then on the verge of revolt. For several years thereafter he kept up his umbrage, protesting his innocence and demanding redress. Failing that, he would not set foot in France, even on his way to Aubonne. Meanwhile Europe was in crisis too. In 1618 there was revolution in Prague. In 1619 the Elector Palatine was declared King of Bohemia. The Calvinists of Europe were cock-a-hoop. The Hermetic, Paracelsian ideologues declared that their apocalyptic new age had dawned: Elias Artista, the chemical Elijah, was about to return and 'make all things new'. But their triumph was short-lived. In 1620 the Battle of the White Mountain not only ended, for three centuries, the independence of Bohemia: it also sealed the fate of the Calvinist International and discredited the Hermetic Paracelsian philosophy. The severance of chemistry from ideology had begun.

Such dramatic events cannot have left Mayerne unmoved. A cosmopolitan Huguenot, he had been committed to the Calvinist International: committed politically – the confidant of the Huguenot leaders and the Palatine family, a secret agent in foreign capitals; committed intellectually: we find him in abstruse alchemical sessions with Hermetic and Paracelsian adepts, seeking to achieve 'the Great Work' of transmutation and expecting the return of Elias. But in 1618 his cover as a political agent was blown, and in

1619–20 he saw international Calvinism first hijacked, then ruined, by its extremists. In such circumstances it would not be surprising if he decided to reduce his commitment. His father's manuscript may have pointed the way. So, perhaps, did the visible new interest of the heir to the British throne. Mayerne would never disavow his Huguenot loyalties or his Hermetic ideas, but they would no longer involve him in a political programme. That left him time for other, more private interests. For now the Huguenot world, and the dominant Huguenot character, were changing. Under the impact of events, the era of great enterprises and grand illusions was passing. The next generation would be represented not by the universal men, the turbulent politicians, warrior heroes and ideological poets of his youth – a Rohan, an Agrippa d'Aubigné, a Saluste du Bartas – but by *bons bourgeois*, artisans and craftsmen, jewellers, goldsmiths, enamellists, clock-makers, engineers. In turning from Hermes Trismegistus and Elias Artista to pigments, oils and varnishes, dyed silks and *cuirs dorés*, Mayerne was moving with his co-religionists, and with the turning historical tide.

Notes

1 Sir Charles Eastlake, *Materials for a History of Oil Painting*, 2 vols., London, 1847, 1, p. ix.

2 Ernst Berger, *Quellen für Maltechnik während der Renaissance und deren Folgezeit (XVI–XVIII Jahrhundert) … nebst dem de Mayerne MS. Beiträge zur Entwicklungsgeschichte der Maltechnik, IV Folge*, Munich, 1901.

3 J.A. van de Graaf, *Het de Mayerne manuscript als bron voor de Schildertechniek van de Barok*, Mijdrecht, 1958.

4 M. Faidutti and C. Versini, *Le Manuscrit de Turquet de Mayerne*, Lyon n.d. [1968], introduction.

5 Mansfield Kirby Talley, *Portrait Painting in England: Studies in the Technical Literature before 1700* (privately printed for the Paul Mellon Center for Studies in British Art, 1981).

6 R.D. Harley, *Artists' Pigments*, London, 1970, p. 121.

7 On various technical points, I am especially grateful for the help of Miss Jo Kirby, of The National Gallery, London, Mr Edward Chaney and Miss Jennifer Richenberg.

8 In this biographical summary I shall not give source references: they can await my biography of Mayerne.

9 BL Sloane MS. 345. On it see Sir Charles Eastlake, *Materials*, 1, 281–3.

10 BL Add. MS. 20921, fo. 110v; he takes it up in BL Sloane MS. 2052, fos. 15 and 94: 'J'en ay veu à Schwatz.'

11 We may note that although he was interested in miniatures and discussed the technique with Edward Norgate, John Hoskins and Samuel Cooper, Mayerne never cites either Nicholas Hilliard or Isaac Oliver, who were very easily accessible to him since both, like himself, had court appointments. Since Oliver died in September 1617 and Hilliard in January 1619, this also suggests that Mayerne's serious interest only began in 1620.

12 MS. Sloane 2052, fo. 3. Berger, followed by van de Graaf, misreads 'Quaeratur' as 'Inceratur' – with curious consequences to their argument.

13 MS. Sloane 2052, fo. 46.

14 MS. Sloane 2066, fo. 155.

15 MS. Sloane 2052, fo. 31.

16. MS. Sloane 2048, fo. 42; 1978, fo. 54: 'ex ipsius ore Huskins, habita conabulatione dum D[ominum] Mayerne depingeret, 17 Sept 1635'.

17 Namely, MS. Sloane 2052, fos. 29, 77, 149.

18 MS. Sloane 2052, fo. 18. Berger misreads 'ocrearum' as 'olearum' (a wrong gender anyway) and translates it as 'oil'. Versini and Faidutti read it as 'ocreanum', which is meaningless (but perhaps a misprint), but then accept Berger's translation, which is also meaningless.

19 In French in MS. Sloane 2052, fos. 143–5, in German in MS. Sloane 1990, fos. 107–25, where he extends his field of expertise to silk-dyeing, confectionery, etc.

20 Norgate's *Miniatura* was not published until 1919 when it was edited by Martin Hardie from the author's fair copy (Bodleian Library, Tanner MS. 326). On the evidence of what appears to be the earliest MS. (BL Harl. MS. 6000), Hardie concluded that the 'discourse' was written between 1621 and 1626. For Norgate's particular contributions to Mayerne's work see MSS. Sloane 2052, fos. 22, 40, 97, 1600; 2072, fo. 209; 2081, fo. 49v.; and R.D. Harley, *Artists' Pigments, passim*.

21 For the interpretation of Mayerne's relations with Petitot see R.W. Lightbown, 'Jean Petitot and Jacques Bordier at the English Court', *The Connoisseur*, 168 (1968) pp. 82–91; also his 'Les Origines de la peinture en émail sur or: un traité inconnu et des faits nouveaux', *Revue de l'Art*, 5 (1969) pp. 46–54. Lightbown uses the evidence of MS. Sloane 1990, fo. 29v. ('crocus Martis corallinus seu ⟨vitriolum Martis⟩ ad summam rubedinem calcinatum'). Other confirmatory references are in MS. Sloane 2020, fo. 35v. ('rubrum ad smaltum Petitot e vitriolo Martis') and MS. Sloane 2052, fo. 122, where the same formula – yellow ochre heated in a strong fire – is said to yield 'Une couleur rouge presque comme cynabre excellente pour la carnation et pour la draperie', and is accompanied by a marginal note 'ad smalta'.

22 MSS. Sloane 2020, fo. 90, 2083, fo. 100.

23 National Portrait Gallery, London, no. 3066. P.F. Schneeberger, 'Les Peintres

sur émail genevois au XVIIᵉ siècle', *Genava*, 6 (1958), pp. 134–5, doubts the ascription of this work to Petitot on grounds of style. On the other hand it was confidently ascribed to Petitot by the miniaturist Bernard Lens, who copied it in 1710, when it belonged to Hans Sloane. Since Petitot's visit to England in the reign of Charles I, and his connection with Mayerne, were evidently not known at that time (see below p. 275), such an ascription must have rested on positive information; and since Sloane presumably acquired the miniature, as he acquired Mayerne's books and manuscripts, from the Colladon family, the ascription may have had the authority of Mayerne himself.

24 The story is set out, from the archives, by Lightbown, in his article, 'Petitot and Bordier'.

25 Petitot's letter is included in MS. Sloane 2052, fos. 164–6.

26 He is named by Richard Symonds in BL Egerton MS. 163, fo. 61, cited in Mary Beal, *A Study of Richard Symonds*, New York and London, 1984, p. 243.

27 For the Mantuan paintings and cleaning of paintings in general see MS. Sloane 2052 fos. 14, 15, 57, 110, 147; for prints, *ibid.* fos. 59–61; also Mark Stevenson, 'A 17th Century Manual for the Restoration of Prints', *Print Quarterly*, 7, 4 (1990) pp. 420–4.

28 E.g. MS. Sloane 2052, fo. 135, where a recipe for the bite of a mad dog intervenes between recipes for lacquer and drying oils; see *ibid.*, fos. 75–6, 123–33.

29 A.E. Werner, 'A "New" de Mayerne Manuscript', *Studies in Conservation*, 9, 2 (1964) pp. 130–4.

30 In MS. Sloane 2052, fo. 160, 'Discours d'un peintre flamand chez Mylord Newport, 16 Sept. 1638', Mayerne notes, 'voyez celui [le vernix] d' Adam Susinger' and 'voyez le vernix de Norgate'. But where are these recipes to be found? The answer – unstated by him – is in his medical 'Ephemerides' for 1636–8 (MS. Sloane 2072, fos. 208–9).

31 MSS. Sloane 2020, fo. 74; 2022, fos. 110, 141; 2083, fos. 96–8, 101; 1989, fo. 302; 1990, fo. 99; 3423 *passim*.

32 Compare, for instance, Mayerne's entries on Desson's 'last dictation' on varnish, on Callot's engraving, and on Captain Salé's information on oriental lacquer, as they appear in MS Sloane 2052 (fos. 43, 33, 21) with the notes on the same subjects (MSS. Sloane 1990, fo. 18v; 2020, fo. 39; 1990, fo. 41). Many other examples could be given.

33 In MS. Sloane 2052, Colladon is named only once – as a channel, not as a source (fo. 33).

34 For Mayerne and Joseph Petitot in pursuit of the secret of 'cuirs dorés' see MSS. Sloane 2020, fos. 36v, 38, 66–71; 2083, fos. 85–93; 2052, fos. 74, 164–6.

35 MSS. Sloane 1990, fos. 30–31v, 2020, fo. 90, 2083, fo. 100.

36 MS. Sloane 2083, fos. 84–5.

37 MS. Sloane 3423.

38 *Gul. Fabricii Hildani Observationum et Curationum Chirurgicarum Centuria Quarta*, Oppenheim, 1619, p. 456.

39 BL Add. MS. 20921, fo. 44v.

40 *Ibid.*, fo. 7.

41 BL Sloane MS. 2069, fo. 172.

42 E.g. Jan van Belcamp, cited as a source by Mayerne (MS. Sloane 2052, fos. 142, 160) and by Symonds, who describes him as 'an undercopier to another Dutchman' who kept the king's pictures and made copies of them for noblemen (BL MS. Egerton 1636, fo. 202, cited in Beal, *Richard Symonds*, p. 309). On Belcamp, who became Keeper of the King's Pictures, and afterwards a trustee for their sale, see M.D. Whinney and O. Millar, *English Art 1625–1714*, Oxford, 1957, p. 74, note 2; O. Millar, 'The Inventories and Valuations of the King's Goods 1649–1651', *Walpole Society*, 43 (1970–2), pp. xiv–xv, and Parry's essay herewith, pp. 202–20.

43 Digby commissioned an enamel portrait of his wife Venetia from Henri Toutin in Paris (see P. Verdier, 'An Unknown Masterpiece of Henri Toutin', *Connoisseur*, 162 (1966) pp. 2–7). The suggestion that Digby may have communicated his interest to Charles I is made by Lightbown in 'Petitot and Bordier'.

44 Sir Kenelm Digby, *A Late Discourse Made in . . . Montpellier*, 1658.

45 The chemist Nicolas le Fèbvre, in a letter to Evelyn of 23 March 1652, asks him to convey his respects to Mayerne (Evelyn MSS., Correspondence 818). I owe this reference to Michael Hunter.

46 Norgate's work circulated in manuscript and was used by other writers, but the acknowledgement to Mayerne is in the presentation copy only and was therefore inaccessible to them.

47 For the transmission of the story from Petitot to the *Abregé*, see Lightbown, 'Petitot and Bordier'. From the *Abregé*, it was cited in J[ames] B[urgess] *The Lives of the Most Eminent Painters*, 1754, and it was to this source that the anonymous correspondent directed Walpole (see *The Correspondence of Horace Walpole*, W. Lewis ed., 48 vols., New Haven and London, 1937–83, XL, pp. 237–8. But Walpole cited the story direct from the *Abregé*.)

48 For the Commission see *Parliamentary Papers, Reports of the Commission on the Fine Arts*, especially the First Report, 1842; *The Houses of Parliament*, M.H. Port ed., New Haven and London, 1976, pp. 268–76; Eastlake, *Materials*, I, pp. 141–8; and the biographical account of Eastlake printed in Eastlake, *Contributions to the Literature of the Fine Arts*, 2 vols., London, 1848 and 1870, II.

49 See the confident remarks in the preface to Mrs M.P. Merrifield, *The Art of Fresco Painting*, 1846.

50 Anquetin's views are expressed most clearly in his book *Rubens. Sa Technique. Analyse des Tableaux de la Galérie de Medicis au Louvre*, Paris, 1924; most fully in the posthumous (and therefore disorderly) compilation from his papers, *De l'Art*, edited by Camille Versini, Paris, 1970.

51 Jacques Maroger, *The Secret Formulae and Techniques of the Old Masters*, New York, 1948. See also the article by Guillaume Janneau in *Le Temps*, 4 December 1933. M. Janneau, 'l'âme de notre groupe', was honorary professor at the Conservatoire des Arts et Métiers.

52 A.E. Werner, 'The Vicissitudes of the Maroger Medium', *Studies in Conservation*, 3 (1957), pp. 80–2.

53 I would like to express here my gratitude to M. Faidutti for his generous help when I was working on this subject.

INDEX

Page numbers in italic refer to pages on which illustrations appear

Addison, Joseph, 21, 22, 259
Alcayde Jaurar Ben Abdella, 85–6
Altham, Edward: self-portrait, 128, 236
Amateur drawings, 56
Anglican church, the: altar-table
 controversy, 171, 185; attacks, 177;
 Calvinism, 80; Canons, 169–70;
 churches, building, 168–86;
 consecration, 171, 183; form and
 arrangement, 171, 183; furnishing
 and decoration, 172–3, 174, 177, 185;
 Elizabethan Injunctions, 169–70;
 orientation, 173, 181; plans, 173–5;
 Prayer Book, 73; and Puritanism,
 215
Anquetin, Louis, 286–7
d'Argenville Dezallier: *Abregé de la vie des
 plus fameux peintres*, 284
Aristotle: *anagnorisis*, 248, 254;
 peripeteia, 245, 267, 254
Arlington, 1st Earl of, 199
Arundel, 2nd Earl of, 3, 59, 74
Arundel, Countess of, 3, 7
Aubrey, John, 191, *192*, 199, 248; *Brief
 Lives* compared with Pepys's *Diary*, 199

Baker, Sir Richard, 195
Bankes, Arabella, Mrs Gilly, *114*, 115

Bankes, Mary, Lady Jenkinson, *114*, 115
Bankes, Sir Ralph, 107–31, *111*; Charles
 I, 108; collection, 108–9; dealings
 with Lely, 108–9; identification of
 sitters in portraits, 115, 117–20,;
 inventories, 108–9, 119, 121–5; *114*,
 116; Lelys, 114; misconceptions
 about portraits, 107, 112, 115;
 portraits of, 109, 112; siblings, *114*,
 115, 120
Bedford, 4th Earl of, 169, 181
Belcamp, Jan, 40, 60; ancestral
 posthumous portraits, 40; copyist,
 203, 292; Great Picture of Lady
 Anne Clifford, the, *203*, 202–18
Bérain, Jean, 115
Berger, Ernst: edition of Mayerne MS.,
 285
Berkeley of Stratton, Lord, 200
Bernini, Gian Lorenzo, 248, *249*, 250,
 256, *258*, 259; *Gabriele Fonseca*, 250,
 Pluto and Proserpina, 256, 259;
 portrait of, 250; Triton Fountain, 248
Besnier, Isaac: monuments, 132–64, *140*,
 143, *146*, *150*, *155*, *157*, *160*; sketch,
 138–9, *139*
Biard, Pierre: tomb of Duc and Duchess
 d'Epernon, 160

Bijlert, Jan van: *Magdalen*, 254

Blackfriars, 32, 39

Blathwayt, William: career, 23–7; Dyrham Park, 23–4, 26–7; sale of pictures, 26; taste, 26; uncle, 24

Bologna, Giovanni, 136, 154, 160

Bordier, Jean, 275, 276

Bosse, Abraham, 61, 62; *Manière de graver à l'eau-forte en cuivre*, 62

Boughton House, 17, 19

Bourdon, Sébastien: *Europa and the Bull*, 113; *Pan and Apollo*, 113

Brayley and Neale: history of Westminster Abbey, 147, 152, 153, 154

Briot, François, 267

Bristol, 2nd Earl of, 200

Britannia Triumphans, 68–89

Broadway Chapel, 176, *184*, 185; description, 183, 185, 186

Brune, Charles, *116*, 117

Buckden, episcopal palace, 185

Buntingford, church, 169

Burnet, Bishop Gilbert, 191, *193*; *History of My Own Time*, 191; *Lives of the Dukes of Hamilton*, 191

Burntisland, church, 169

Calvinism, 80, 266, 269, 288

Camden, William, 196, 214; *Britannia*, 196, 214

Canini, Giovanni Angelo, 233

Capel, Lord, 198

Carleton, Sir Dudley: pictures, 3

Cartwright, Thomas, 228; portrait, 228

Cartwright, William: the 'Dutch style', 27

Catholics, English, 5–6, 106, 143

Caus, Isaac de: prints of Wilton House gardens, 57

Cavendish, Sir Charles, 197–8

Champaigne, Philippe de, 58, 62

Charles I, 12, 32, 68, 90, 92, 136, 140–1, 143, 155, 274, 275; *Britanocles*, 68–9; City of London, 73–9; his collection, 108, 113, 277, 283; commemoration, 234; Commission for New Buildings, 73–9; copies of pictures, 203; dispersal of collection, 113; *Eikon Basilike*, 234; equestrian statue, 141; Maritime policies, 82–6; mark on pictures, 108; marriage, 70–1; Mayerne, 267–8; New Corporation, 73–4; Old St Pauls, 79; patronage, 274–5; Portland, 140–1, 143; Prayer Book, 80; ship money, 69–70, 82–4, 86; proposed marriage, 4–5

Charles II, 198–9

Charterhouse chapel, 182

Chéron, Louis, 19–20

City of London, 73–9; companies, 34; court, 80; liverymen, 34; Painter-Stainers Company, 37–8

Clarendon, *see* Hyde, Edward

Claydon House: pictures, 90–106

Cleland, Dr John, 158

Cleyn, Francis de: double portrait by, 115; Liberal Arts, etching, 57; *Varii Zopharii*, etching, 57, 58, 59

Clifford, Lady Anne: admiration for Edmund Spenser, 210; austerity of, 213; Bible, 215; as builder; 204, 217–18; court, 213; curiosity of, 214; Daniel, Samuel, 209; education of, 208–9; family, 204; father, 204, 206; 'Great Books', 204; 'Great Picture', *203*, 202–18, versions of, 204; Herbert, George, 216; history, 217; hereditary titles and lands, 202; husbands, 204–5, 213–14; intellectual and spiritual interests, 210; early life, 209; last of line, 218; later life, 215; melancholia, 213; mother, 205–6; parents, 202; poets, 209–10; pre-natal rights, 208; religious life, 212–14; siblings, 208

Clifford, George, 3rd Earl of Cumberland, 204, 206–7; Nicholas Hilliard, 206–7, *207*

Colladon, Jean, 279–80; family, 282

Colt, Maximilian, 161, 164

Commission against cottagers, 78

Commission for New Buildings, 73–9

Corporation of London, 73–4

Cradock, William, 148

Crofts, Cecilia, Mrs Thomas Killigrew: portrait by Van Dyck, 222, *223*, 225–6; posthumous portrait by Van Dyck, 228–9, *229*

Crofts, William, Lord: portrait by Van Dyck, 224–5, *224*

Cromwell, Sir Oliver, 271; portrait, 103; prose portrait, 200

Cullen, Lady, *116*, 117–18

Cynic philosophers, 250–2

Daniel, Samuel, 209–10

Dapper: *Beschreibung von Africa*, 84

Darcie, Abraham, 158, 162

Davenant, Sir William, 68–71

De Templis, 168, 172–5, 181

Denbigh, church, 169, 182

Denham, Sir John, 234

Devonshire, Earl of, 27

Digby, Sir Kenelm: alchemical interests, 274, 283; portrait of, 92, *93*, 94; portrait of wife, 240–1

Diogenes, 251–2

Dobson, William, 57, 228; Rowlett, Thomas, 57–8; and self-portrait, 57

Dorset, 3rd Earl of, 204–5

Dorset, 4th Earl of, 74

Dou, Gerrit: paintings by, 13, 15, 20, 26, 109; *The Young Mother*, 13, *14*

Dryden, John, 259

Dudley, Lady Alice, 177

'Dutch style' the, 16, 27–8

Dyrham Park, 23–4, 26–7

Earles, John, 190–1, 195, 196, 198, 199; *Micro-cosmographie*, 191

Eastlake, Sir Charles, 284–5

Edgehill, 77, 90, 103

Electors, Imperial, 247

Elyot, Sir Thomas: *The Boke Named the Gouernour*, 42

emblems, 248, 254

enamelling, 279–80

etching, 56, 57, 62–3

Evelyn, John, 26, 51–67, *52*, *53*, *54*, *55*, *56*, 283; Arundel, 59; catalogue of prints, 59; *Diary*, 53, 56, 59, 60, 61, 62; drawing, 53, 56, 60–1; etching by, 'London set', 51, 'Paris set', 51; and publication of, 57, 61; Henshaw, Thomas, 53, 60, 61, 66; Hinde, Thomas, 57; Hoare, Richard, 53, 56, 57, 61; Hollar, Wenceslaus, 63; landscape prints, 51–65; prints, French, 53; portrait of, engraved by Nanteuil, 61; print collection, 59–61; print collections, visits to, 60; printmaking, 59, 61; print production and publishing, 57, 58; Rowlett, Thomas, 57, 58, 59; *Sculptura*, 61–2, 283; and Stent, Peter, 51, 57; and Thynne, Lady Isabella, 51, 60; Walpole, Horace, 56, 65

Exeter, Earl of, 27

Faithorne, William, 57–8, 234; prints by, 57

Falkland, 1st viscount, 195–8

Fanelli, Francesco, 136, 141, 145

fijnschilders, 20

Flecknoe, Richard: *The Life of Thomas the Wanderer*, 228

frames, 23, 115, 119, 130

France, 60–1, 160, 162, 210, 283, 286–7

fresco painting: revival, 284

funerary monuments, English, 135, 161, 162

Gage, George, 1–11, *2*; agent, 1–6; Antwerp, 3–4; Carleton, 3; connoisseurship, 3; Jesuits, 5–6;

in London, 6, 10; marriage of Charles I, 4–5; print dedicatee, 8; portrait by Van Dyck, 1, 6; Rome, 1, 5–7; Rubens, 1, 3, 4, 6; Spanish Marriage Treaty, 5

Gale, Samuel: *History and Antiquities of the Cathedral Church of Winchester*, 142

Garrard, George, 78–9, 80, 226–7

Geldorp, George, 113, 115, 137

Gennari, Benedetto: *Lady Elizabeth Howard, Lady Felton as Cleopatra*, 118

Gentileschi, Artemisia, 272, 274

Gentileschi, Orazio, 272

Gerbier, Balthasar: Besnier, 137–8, 145; Buckingham, Duchess of, 145; Portland, 156

Gibbons, Grinling, 250, 259; portrait of, 255–60, *257*

Godolphin, Sydney, 197

Goldsmiths' Company, 38, 80

Goldsmiths' Rents, 80

Gothic forms, in church building, 168

Great Stanmore Church, 172, 175, 180–1, *180*

Greenhill, John, 228

Greenwich, 63

Greenwich Palace, 35

Greenwich revels, 35, 36

Halifax, Earl of: career, 21; character, 21; collector, 21; sale of collection, 21–2; taste, 27

Ham House: influence, 27

Hampden, John, 195

Hampton Court, 12, 13, 16, 243

Hastings, Henry, 200

Harvey, Dr William, 267, 268

Haywood, William, 177

Henrietta Maria, 68, 77, 83; circle of, 70, 83, 268, 275

Henry VIII, 33, 35, 36, 134–5

Henry, Prince of Wales, 135

Henshaw, Thomas, 53, 56, 60, 61, 66

heralds, 32, 41

Herbert, George, 216

Hermetists, 265, 288

Heylyn, Peter: *A Coale from the Altar*, 171

Hill, Mary, Lady Killigrew, 231, *232*

Hilliard, Nicholas, 206–7

Hillier, Nathaniel, 56

Hinde, Thomas, 57

history paintings, 245, 248

Hoare, Richard, 53, 56, 57, 61

Hobbes, Thomas: translation of Thucydides, 194

Holbein, 13, 33, 35–7, 40; astronomical ceiling, 35; Battle of Thérouanne, 35; dynastic wall-painting, 40; *Robert Cheeseman*, 13; secrets of his painting, 271

Hollar, Wenceslaus, 58, 59, 63, 80, *81*

Hollingshead, 195

Hoogstraten, Samuel van, 25, 25–6

Hooker, Richard: *Of the Laws of Ecclesiastical Polity*, 169

Horenbout, Lucas, 39, 40

Hoskins, John, 271–2

Howell, James: *Londinopolis*, 80; *see also* *81*

Huygens, Constantijn the Younger: *Journals*, 12

Hyde, Edward, 1st Earl of Clarendon, 102, 189–200, *192*; autobiography, 199; Buckingham, 191; *Characters*, 199; Falkland, 195–8; *History of the Rebellion*, 113, 191, 196, 199; *Life, The*, 102, 199; prose writing, 197–8; *State Papers*, 199; Van Dyck, 197

James I: building in London, 74–6; Clifford inheritance, 205; funerary monument, 161; Lennox and Richmond, 156, 158; Mayerne, 267, 288; statue, 135

Jewel, Bishop: *Apologia ecclesiae anglicanae*, 169

Johnson, Cornelius, 272

Johnson, Samuel, 107

Jones, Inigo, 12, 32, 58, 68–87, *71*, 168,
 182, *182*; architecture, nature of, 168;
 attitude to Surveyorship, 68, 87;
 Charles I, 68, 86; masques: *Britannia
 Triumphans*, 68–87; *Hymenaei*, 87;
 Temple of Love, The, 70; St Paul,
 Covent Garden, 169, 181–2, *182*, 185

Junius, Francis: *De Pictura Veterum*, 222

Juxon, William, 183

Kensington Palace, 12; inventory, 13

Keyser, Hendrick de: tomb of William
 the Silent, 153, 160; workshop,
 162

Killigrew, Lady, *see* Mary Hill

Killigrew, Thomas, 220–42, *224*, *227*, *235*,
 237, *239*, 262; artistic tastes, 221; first
 wife, 221–6; penitent, 236–40;
 Pepys, 220; plays: *Bellarmina her
 Dream; or, The Love of Shadows*, 229–
 31, 234; *Claricilla*, 221; *The Parson's
 Wedding*, 227, 236; *The Princess: or,
 Love at first Sight*, 221–2; *The
 Prisoners*, 221; *Thomaso, or, The
 Wanderer*, 226, 231, 235; religious
 beliefs, 226; theatrical manager, 236;
 portraits, 224–8, 233–9; Venice, 233

Killigrew, Mrs Thomas, *see* Cecilia Crofts

Killigrew, Sir William, *232*; *Mid-night and
 Daily Thoughts. In Verse and Prose*,
 238; portrait, 231; portrait of wife,
 232

King's Painter, the, 35, 39

Kingston Lacey, 107, 108, 109, 114, 116,
 119, 120, 238

Kirke, Ann: portrait, 231, 233

Kneller, Sir Godfrey, 243–62;
 Amsterdam, 244, 247; Bernini, 248,
 250; biography, 244, 250; Cynics,
 250–2; draughtsman, 243; Dryden,
 259; emblems, 248, 254; history
 paintings, 245, 248; *portraits historiés*,
 245, 248, 255; portrait of

Shrewsbury, 23; Rome, 250; Van
 Dyck, 255; Venice, 244–5; Virgil,
 259

 PAINTINGS: *Abraham Simon*, 237, 250–5,
 252, *253*; *De Vere sisters*, 248, *249*, 250;
 Cardinal Basadonna, 244; *Dismissal of
 Hagar*, 245, *246*, 247; *Earl of
 Shrewsbury*, 23; *Elijah and the Angel*,
 244, *246*, 247, 248, 254; *Grinling
 Gibbons*, 250, 255–60; *Johann Philipp
 von Schonborn, Archbishop and Elector of
 Mainz*, 247; *Mrs Voss with her
 Daughter Catherine*, 118–19; *Queen
 Anne Presenting the Plans of Blenheim to
 Military Merit*, 243; *The Russell Sisters*,
 250; *Sebastiano Bombelli*, 244; *Self-
 Portrait*, 247, 251; *Sir Isaac Newton*,
 250; *Tobias and the Angel* (lost), 248;
 William III, 243

Lafosse, Charles, 17, *18*, 19

Landino-Fabrini, 259

Lanier, Jerome, 277

Lanier, Nicholas, 274, 277

Laud, William, Archbishop, 80–2, 168,
 170, 176; Bishop of London, 168;
 influence as, 172–3; church planning,
 175, 181; consecrates churches, 175,
 180; dean of Gloucester, 170;
 Grantham, 170, 185; theological
 position, 171; Williams, John, 170,
 185; visitation articles, 170

Lauderdale, Duke of: the 'Dutch style',
 27

Leicester, 1st Earl of, 169, 182

Lely, Sir Peter, 22, 107–31; collection,
 109; dealer, 109, 120; sale of
 collection, 109, 118

 PAINTINGS: *Abraham Simon*, 250 (lost);
 Baron Clifford of Chudleigh, 234;
 Charles Brune, 114, *116*, 119; *Jane
 Needham, Mrs Myddleton*, 116; *Lady
 Jenkinson*, 114, 119; *Magdalen*, 109,
 110, 112; 'Mr Stafford', 116, *118*, 119;

Mrs Gilly, *114*, 119; *N. Wray*, *110*; *Sir Ralph Bankes*, 109, *111*, 119; *Viscountess Cullen*, *116*, *117*, 119
Le Sueur, Hubert, 136, 141, 145, 156, 162, 164, 165
Lincoln's Inn, 77
Livy, 194, 195
London, 36; Commission for New Buildings, 73–9; churches, 168–86; incorporation of suburbs, 73–4; merchants, 172; pageants, 41; parishes, 80–2; and *see* City of London
Londonderry plantation, 73
Louis XIV: etching by, 62

Maltravers, Lord, 221
Manwaring, Dr Roger, 117
Marie de' Medici: woodcut by, 62
Maroger, Jacques, 287
Marot, Daniel, 15–16, *18*, 27
Marot, Isaac, 16
Marot, Jean, 15
Matthew, Sir Tobie, 2–4
Mayerne, Sir Theodore, 264–89, *273*, *276*; artists in England, 271–7; art theorists and historians, 283–7; Aubonne, 267–8, 281; career, 265–6; Calvinism, 266–7, 269, 288; Charles I, 267–8; Civil War, 268–9; cleaning and restoration of pictures, 277; Colladon, Jean, 279–80, 282; Cromwell, Oliver, 268; Digby, Sir Kenelm, 274; education, 265; enamelling, 279–80; English, attitude to, 266, 281; 'Ephemerides', 278; experiments, 278–82; father, 270, 288; friends, 267; grand tour, 265–6, 269–70; Henrietta Maria, 268, 269, 275; Hermetists, 265, 288; James I, 267, 288; London house, 267; manuscripts, 264, 270, 277, after-life, 283–7 *passim*.; medal of, 267; medical practice, 265–6, 277, 278;

Norgate, Edward, 274, 283, 290, 292; research methods, 279–80, 282; minor (subaltern) arts, 275, 278; *Opera Medica*, 282; Paracelsians, 265, 281, 288; Petitot family, 274–6; physician, 287–8; pigments, 278; portrait by Rubens, 272; secret agent, 267, 288–9; Van Dyck, friendship with, 272, 274; Vasari, 270–1, 288; wives, 266, 269
Mede, Joseph, 181
Monnoyer, Jan Baptist, 17, *18*, 19
Montagu House, 17, 19–20; influence of, 27
Montagu, Ralph, Duke of: career, 17; collecting and patronage, 16–17, 19–21, 27; inventory, 19–20; taste, 20–1, 27
Montagu, Walter: *The Shepherds Paradise*, 226
Monthermer, Marquis of, 20
monumental sculpture, 132–6
Morley, Dr, 198
Mortlake Tapestry Works, 17, 58
Mytens, Daniel, 272

Nanteuil, Robert, 61
Nassau-Odijk, William Adrian van, 16
neo-Platonism, 70
New Chapel, *see* Broadway Chapel
Newell, Dr Robert, 185
Nobliers, Salomon, 137
Norgate, Edward, 32; *Miniatura*, 274, 283, 290, 292
Nottingham, 2nd Earl of, 27

Oxford: Lincoln College chapel, 185

Painter-Stainers Company, 32–50; competition, 39; court painters, 35, 40; dynasties within, 37–8, 39, 43–50; evolution, 33, 42; foreign painters, 32, 33, 34, 38–9, 40, 42; function, 34; heralds and heraldic

Painter-Stainers Company (*cont.*)
 painting, 41, 42; incorporation, 39;
 Inigo Jones, 32; kinship ties, 37;
 minute books, 33; nature of work,
 41; officers, 37; petition, 32;
 regulations, 39; Serjeant Painter, 35–
 6, 41
Painter-Stainers Hall, 32, 33, 35
painting: secret formula, 286
Paracelsians, 265, 281, 288
Parmentier, Jacques, 17, *18*, 19
Pausius, 222
Peake, Robert, 32–3, 38, 41, 58, 59; edn
 of Serlio, 71, *72*
Pearce, Edward: grotesques, 57
Peel, Sir Robert: Commission on the Fine
 Arts, 284
Pembroke, 4th Earl of, 205, 214
Pepys, Samuel, 26, 199, 220
Perelle family, 53
Petitot, Jean, 105, 274–5, *276*, 279–80,
 283–4
Petitot, Joseph, 275, 276
Petty, William, 221
pigments, 36, 234, 269, 272, 278, 286–7,
 290
pilgrim, 236–8
pilgrimage, 236–8, 254
Pilion, Germain: tomb of Henri II, 162
Pindar, Sir Paul, 172
pirates, 83–5
Pliny, 222
Plutarch, 194
Pocklington, John: *Altare Christianum*, 171
Poelenburgh, Cornelis van, 40; *Diana and
 Actaeon*, 23
Pope, Alexander: portrait, 234, 244
popes, 4, 6–7, 133
portraits historiés, 245, 248, 255
Povey, Thomas, collection, 24–6; the
 'Dutch style', 27
Pratt, Sir Roger, 108; and family;
 119–20
prints, 51–65

Privy Council, 76–7, 80, 83
proclamations, 73–4, 76–7
Prynne, William, 77, 180, 181; *A Quench-
 Coale*, 171

Quarles, Francis, 254, *256*

'R.T.': *see De Templis*
Rainborowe, Captain William, 84–6
Raphael: *Cartoons*, 13, 15; *Loggie*, 15
Resta, Padre, 23
Reynolds, Sir Joshua: opinion of Lely,
 107
Richardson, Jonathan: portrait of
 Alexander Pope attributed to, 236
Ripa, Cesare, 163
Robarts, Foulke: *Gods Holy House*, 168,
 172
Roman, Jacob, 16
Rosa, Salvator: *Empedocles throwing himself
 into the crater of Etna*, 23
Rousseau, Jacques, 17, *18*, 19
Rowlett, Thomas, 51; publication by, 57–
 9
Rubens, Sir Peter Paul: collection, 3;
 disciples, 3; Jesuit Church, Antwerp,
 3; paintings, 3–4; *Sir Theodore de
 Mayerne*, 272, *273*; *Palazzi di Genova*,
 27; pupils, 3; secrets of his painting,
 286; stoicism, 251; studio, 1, 6; Van
 Dyck, 3
Rupert of the Rhine, 57, 62, 278
Russell, Lady Margaret, 205–6, 208

St Albans, Viscount, 199
St Giles-in-the-Fields, 175–6, *176*
St John the Evangelist, Great Stanmore,
 172, 175, *180*, 180–1
St John's, Leeds, 178
St Katherine Cree, 175, 177–80, *178*, *179*
St Michael-le-Querne (St Michael's
 Cornhill), 80–2
St Nicholas, Rochester, 176, 182
St Paul's Cathedral, 172, 178; restoration,
 79–80

St Paul, Covent Garden, 169, 173, 175, 181–3, *182*, 185–6
Sallee (Rabat), 84–6, *85*
Sanderson, William: *Graphice*, 223, 283
Seneca, 251
Serjeant Painter: functions, 35–6, 41
Serlio, Sebastiano, 70, 71, 173; *The tragic scene*, 71, *72*; *Trattato*, 71
Shaftesbury, 1st Earl of, 200
Sheriffs of London and Middlesex, 77
Sheppard, William, 233–4
Shirley, Sir Robert and Lady, 7–8
Shrewsbury, 12th Earl and 1st Duke of: patron and collector, 22–3; portrait by Kneller, 23
ship money, 69, 73, 82–3, 86
Simon, Abraham: character, 250–4; portraits, 237, 250–4, *252, 253*
Smith, Marshall, 244, 250
Somer, Paul van, 271
Somers, Lord: agents, 23; career, 22; collector, 22–3; library, 22; taste, 23
Somerset, Duke and Duchess of: collectors, 27
Southwark, 38, 73–4
Southwell, Sir Robert, 250
Sovereign of the Seas, 70, 82–4
Spenser, Edmund, 210; monument, 210
Stafford, Edmund, 120, 131
Stent, Peter, 51, 57
stoicism and neo-stoicism, 251
Stone, Nicholas: architect, 180–1; catafalque tomb, 161; funerary monuments, 144, 153, 161, 210; Hendrick de Keyser, 162; Master-Mason, 181
Stow, John, 195
Stuart, Ludovick, 1st Duke of Lennox and Richmond: life, 156, 158; tomb, 156–64, *157, 160*; wife, 158–9, 163
Sunderland frames, 23, 119
Sutton, Baptist, 185
Swift, Jonathan: *Tale of a Tub*, 22
Symonds, Richard, 112, 233, 283

Tacca, Pietro, 135–6
Tacitus, 194, 195
Talman, William, 16, 27
Terbrugghen, Hendrick: *The Concert*, 23, *24*
Theophrastus, 190
Thucydides, 194
Thynne, Lady Isabella, 51, 60
Tilson, Henry: portrait of Bernine, 250
Titian: *Caesars: Galba, Salvius Otho, Vitellius*, 92; *Paul III and his Nephews*, 6
Torrigiani, Pietro, 134
Toutin, Jean, 274–5
Toutin, Henri, 275
Trentham family, 117
Tuscan architecture, 182–3

Van Dyck, Sir Anthony: arrival in England, 1–3; Arundel, 1; Antwerp, 1; Barberini, 8; Bentivoglio, 8; biography, 8; Blackfriars, 32, 39; Buckingham, 1; Clarendon, 197; Gage, George, 1–11; Holbein, 40; *Iconography*, 58, 94; James I, 2; England, 2, 8; Mayerne, 272, 274, 275; Painter-Stainers Company, 32, 40; posthumous portraits, 40; prints after, 58; Purbeck, 2; restorer, 41, 92; Rome, 4, 7, 251; Rubens, 3, 6; secret of his painting, 286; servants, 39; studio, 102, 203, 204; Titian, 7; Walpole, Horace, 255; Venice, 7; Veronese, 7
PAINTINGS: 19, 90–106, copies, 113, 115; *Abbate Cesare Scaglia*, 99; *Alvaro de Bazan*, 94, *95*; *Anne Kirke*, 231; *Anne Carr, Countess of Bedford*, 94; *Archbishop William Laud*, 94; *Bentivoglio Crucifixion* (lost), 8; *Cardinal Guido Bentivoglio*, 8, and oil sketch, 8; *Cardinal Maffeo Barberini*, 8; *Cecilia Crofts, Mrs Killigrew*, 222, *223*, second (posthumous) portrait, 228–9,

Van Dyck (*cont.*)
PAINTINGS (*cont.*)
229; *Charles I in armour*, 92, 94; *Earl of Northumberland*, 102; *Earl of Strafford*, 94, 102; *George Gage and companions*, 1, *2*, 6–7; *'Great Peece'*, 40; *Isabella Brant*, 6; *Jacomo Cachiopin*, 127; *Lamentation* (engraving), 8; *Lord George Stuart, Seigneur d'Aubigny as a Shepherd*, 236; *Lucas van Uffel*, 7; *Mary Hill*, 232, *232*; *Nicholas Lanier*, 274; *Self-Portrait* (Hermitage), 59, 225; *Sir Edmund Verney*, 90–106, *91*, *97*, *100*, *101*; *Sir Kenelm Digby*, 92, *93*, 94; *Sir Robert and Lady Shirley*, 7–8; *Sir William Killigrew*, 232, *232*; *The Continence of Scipio*, 6; *Thomas Killigrew*, *227*, 227–8; *Thomas Killigrew and William, Lord Crofts*, *224*, 224–6; *Virgin and St Catherine*, 137–8; *Virginio Cesarini*, 8

Vasari, Giorgio, 270–1, 288
Verney, Sir Edmund: family, 90–106, *91*, *97*, *100*, *101*; life, 90, 92; portraits, 90–106; comparisons between versions, 99–102; Claydon version: genesis, 92, provenance, 90, status, 90; Fitzwilliam version (loan): claims as prime original, 96, history, 96, 98–9, provenance, 96–9, restoration, 99
Verrio, Antonio: Mortlake, 17
'Versailles style', 16, 19
Versini and Faidutti: edition of Mayerne manuscript, 287
Vertue, George, 16, 17, 284; engraving by, 22; Kneller, 247, 250–1; Simon, 250–1
Villiers, George, 1st Marquis and Duke of Buckingham, 1–2, 7, 191; Charles I, 145, 147–8; children, 151; epitaph, 148; Gerbier, 148; Portland tomb, 151; tomb, *146*, 145–56, *150*, *155*;

Stuart dynasty, 147; wife, 145, 152
Villiers, John, 1st Viscount Purbeck, 2–3
Virgil: *Aeneid*, 259; Landino–Fabrini allegory of, 259
Vondel, 245
Vorsterman, Lucas, 8, 278

Wake, Sir Isaac, 277
Warwick, Sir Philip, 191, *193*; *Memoires*, 191; portrait of Cromwell, 200
Walker, Robert, 42, 57, 58, 103; *Oliver Cromwell*, 103
Walpole, Horace, 56, 65, 255, 284, 285; *Anecdotes of Painting*, 284; *Catalogue of Engravers*, 51
Weever, John: *Antient Funerall Monuments*, 134, 147, 153, 161
Westminster Abbey: monuments in, 133–64, 210
Westminster Palace: fire at, 1834, 284; frescoes in, 285
Weston, Richard, 1st Earl of Portland: Buckingham Tomb, 149, 155; Le Sueur, 141; life, 140–2; relations with Charles I, 140–1, 143; tomb in Winchester Cathedral, *139*, *140*, *143*, 142–5, 164; Winchester Castle, 141
Whitehall Palace: buildings adjacent, 79; masquing chamber, 68; room for making pigments, 36
Whitney, Geoffrey: *Emblemes*, 254, *255*
Wilkes, John, 15
William III, 12–31; artistic interests, 12; Dutch style, 13, 27; grandfather, 13; Hampton Court, 13; influence, 28; inventories, 13; Italian tastes, 13, 15, 27; Kensington Palace, 13; Marots, 15–16; parents' portraits, 13; patron and collector, 13, 15; portrait, 243; Rubens, 13; taste, 15; Verrio, 27; 'Versailles style', 27
William the Silent: tomb, *see* Keyser

Williams, John, Bishop of Lincoln, 170–1; *The holy table*, 171; Dean of Westminster, 185
Windsor, 63
Wolstenholme, Sir John, 172, 175

Wotton, Sir Henry: *The Elements of Architecture*, 217
Wray, Nicholas, 109, *110*, *111*, 112, 113
Wren, Sir Christopher, 16, 87, 186